Cliché-verre: Hand-Drawn, Light-Printed

A Survey of the Medium from 1839 to the Present

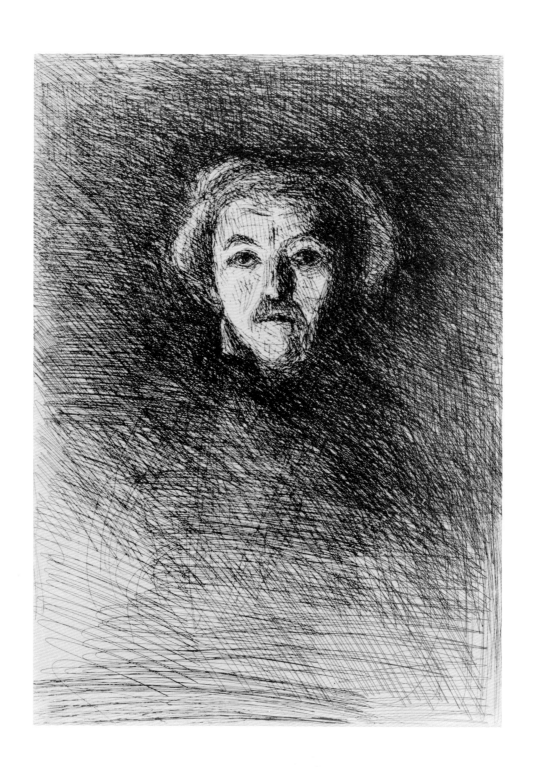

Cl... : Hand-Drawn, Light-Printed

A S... Medium from 1839 to the Present

Elizabeth

Marilyn F.

Published by The Detroit Institute of Arts 1980

This book and the exhibition it accompanies have been supported by a grant from the National Endowment for the Arts, Washington, D.C., a Federal Agency.

This book is published in connection with the exhibition "Cliché-verre: Hand-Drawn, Light-Printed, A Survey of the Medium from 1839 to the Present," organized by The Detroit Institute of Arts and presented at:

The Detroit Institute of Arts
July 12-August 21, 1980

The Museum of Fine Arts, Houston
September 11-October 23, 1980

Library of Congress Cataloging in Publication Data
Glassman, Elizabeth
 Cliché-verre, Hand-Drawn, Light-Printed.
 Catalog of an exhibition presented at the Detroit Institute of Arts, July 12-August 21, 1980, and at the Museum of Fine Arts, Houston, September 11-October 23, 1980.
 Bibliography
 Includes index
 1. Cliché-verre—Exhibitions. 2. Prints—19th century—Exhibitions. 3. Prints—20th century—Exhibitions. I. Symmes, Marilyn, joint author. II. Detroit. Institute of Arts. III. Houston, Tex. Museum of Fine Arts. IV. Title.
NE2685.G54 769'.74'017434 80-17402
ISBN 0-89558-081-0

Designed by Michael Glass Design
Typeset in Trump by Dumar Typesetting, Inc.
2,000 copies were printed on 80 lb. Warren Lustro Offset Enamel Dull by Eastern Press

4

Cover: John Bloom, *Cliché-verre: Series 2, E,* 1976 (detail), cat. no. 82

Frontispiece: Jean-Baptiste-Camille Corot, *Self-Portrait (Corot par lui-même),* 1858, cat. no. 24

Table of Contents

Lenders to the Exhibition

Public Collections

University of Michigan Museum of Art, Ann Arbor
Gernsheim Collection, Humanities Research Center,
 University of Texas at Austin
Baltimore Museum of Art (George A. Lucas Collection,
 Maryland Institute College of Art)
Henry Holmes Smith Archive, Indiana University
 Art Museum, Bloomington
Museum of Fine Arts, Boston
Art Institute of Chicago
Detroit Institute of Arts
Yale University Art Gallery, New Haven
Metropolitan Museum of Art, New York
Museum of Modern Art, New York
New York Public Library, Astor, Lenox, and Tilden
 Foundations (S. P. Avery Collection, Prints Division)
Philadelphia Museum of Art
National Collection of Fine Arts and National Portrait
 Gallery Library, Smithsonian Institution,
 Washington, D.C.
National Gallery of Art, Washington, D.C.

Private Collections

Anonymous Lenders
Wm. B. Becker Collection
Vera Berdich
Huguette Berès, Paris
John Bloom
Arnold H. Crane Collection, Chicago
Diane Escott
Ruth E. Fine
William Goodman
Steven Higgins
Sue Hirtzel
André Jammes, Paris
Lois Johnson
Mr. and Mrs. Arnold Klein
Collection Gérard Lévy, Paris
R. E. Lewis, Inc.
James Nawara
Meg Ojala
Shahrokh Rezvani (Hobbeheydar)
Galerie Sagot-Le Garrec, Paris
Jack Sal
Margo Pollins Schab, Inc.
Fritz Scholder
Mr. and Mrs. Alan E. Schwartz
Keith Smith
Jaromir Stephany
Collection Texbraun, Paris
Timothy Van Laar
Marvin Watson, Jr., Houston

Foreword

The Detroit Institute of Arts is pleased to present *Cliché-verre: Hand-Drawn, Light-Printed, A Survey of the Medium from 1839 to the Present*. Both this exhibition and the book that accompanies it are the first to be devoted exclusively to this relatively unknown cameraless, inkless printmaking technique, chronicling its history and development over almost a century and a half. While a few of the 19th-century clichés-verre, created most notably by Camille Corot and Charles-François Daubigny, have appeared in books and exhibitions on these artists or on 19th-century printmaking, most of the 19th-century prints in the medium have not been seen or studied together. Furthermore, the body of work in the technique created in our own century has been almost completely overlooked. Since a number of artists are currently working in cliché-verre (many of them, it should be noted, from Michigan), there is even more reason to have organized an exhibition that traces for artists and art historians the technical and creative evolution of this fascinating process, which mediates between printmaking and photography. At a time when the art of photography has such great appeal to an ever-broadening audience, it is hoped that the exhibition and book will stimulate more interest and activity in the cliché-verre so that its creative potential may be extended even further.

The initial idea for this exhibition was conceived by Ellen Sharp, Curator of Graphic Arts, who wanted the premiere exhibition in the new Graphic Arts Center to be one that explored important new frontiers in the graphic arts. *Cliché-verre: Hand-Drawn, Light-Printed* is a fitting achievement to inaugurate our handsome new gallery spaces and continues the Detroit Institute of Arts commitment to the presentation of exhibitions that contribute significantly to the knowledge and better understanding of a particular facet of the history of art.

As with any undertaking of this magnitude, there are numerous individuals whose participation and cooperation have made the project possible. Most of them are listed in the Acknowledgments on page nine. But I would like particularly to mention Marilyn F. Symmes, Associate Curator of Graphic Arts, for her devotion to the project and her capable handling of the major portion of the curatorial responsibilities involved in the organization of the exhibition. During two trips to study the outstanding collections of 19th-century clichés-verre in the New York Public Library and the Bibliothèque Nationale, Paris, she laid the groundwork for the selection of the 19th-century works for the exhibition and made initial contacts with the Parisian collectors whose subsequent loans are so critical to the exhibition.

In the course of her research, Ms. Symmes learned that Elizabeth Glassman, now Research Associate of the Menil Foundation and Lecturer at the University of Houston, was independently engaged in research of the 19th-century cliché-verre as part of her graduate work. Begun in 1978, their fortuitous collaboration involved lively scholarly discussions, extensive joint research, and the final selection of the prints. While they shared primary responsibility for both the catalogue and the exhibition, Ms. Sharp also played a vital guiding role in all aspects of the project. To all three I extend my gratitude and congratulations.

My thanks and deep appreciation also go to William C. Agee, Director, Museum of Fine Arts, Houston, and to his staff—in particular John Minor Wisdom, Curator of Paintings and Sculpture, and Anne Tucker, Curator of Photography—for sharing our enthusiasm for this exhibition and overseeing its presentation in Houston.

Of course, no exhibition of this sort is possible without the generosity and cooperation of the lenders. They are recognized both in the Acknowledgments and in the Listing on page six.

Finally, we wish to express our gratitude for the support of the Visual Arts Program of the National Endowment for the Arts, whose contribution helped us make *Cliché-verre: Hand-Drawn, Light-Printed* a reality.

Frederick J. Cummings
Director

Acknowledgments

In the course of gathering material on 19th- and 20th-century clichés-verre, the authors spoke and corresponded with many people who generously contributed their time and efforts to help us in our research. We are deeply indebted to the individuals who answered our countless questions, shared their knowledge on the period and the artists that nurtured the cliché-verre medium, allowed us to study documentary material and clichés-verre in their care, and, in general, encouraged and supported our venture.

The most extensive and best-documented collection of French 19th-century clichés-verre is housed in the Bibliothèque Nationale, Paris. This important repository includes glass plates as well as numerous impressions by Corot, Daubigny, Dutilleux, Huet, and others (see Appendix). While much of the research for this study was conducted at the Bibliothèque Nationale, loans from this extraordinary collection were not possible. This seeming disadvantage had the ultimate positive effect of focusing our attention on the significant cliché-verre holdings in private and gallery collections as well as those in American museums.

In Paris, our research on 19th-century clichés-verre was assisted by a number of individuals. In particular, we wish to thank: Jean Adhémar, Hugues Autexier, Mme. Janine Bailly-Herzberg, Madeleine Fidell Beaufort, Huguette Berès, François Braunschweig, Mme. Jeanne Courty, Michel Froment, Françoise Garday (Bibliothèque Nationale, Conservateur du Réserve du Cabinet des Estampes), André Jammes, Armel Jundt, François Lepage, Gérard Lévy, Bernard Marbot (Bibliothèque Nationale, Conservateur du Photographie, Cabinet des Estampes), Jean-François Méjanès (Musée du Louvre, Conservateur de la Chalcographie), Michel Melot (Bibliothèque Nationale, Conservateur, Cabinet des Estampes), Carol Neuberger, Hubert Prouté, Paul Prouté, and Jean-Claude Romand. The authors would also like to thank the descendant of the artist Constant Dutilleux, Paul Dutilleux of Douai, for his kind support and interest.

We are equally indebted to the following colleagues in England: H. J. P. Arnold, Osbert Barnard, Adrian Eeles, Arthur Gill, Valerie Lloyd, Aaron Scharf, Dr. D. Thomas, John Ward, and William Weston, in addition to Frances Carey, Antony Griffiths, and Peter Moore of the Department of Prints and Drawings, British Museum.

While we are grateful to the many people who were instrumental in providing information in response to our survey of 19th-century clichés-verre for the Appendix, certain members of prints and drawings departments of European museums deserve special thanks for sending us additional documentation: Dr. Sigrid Achenbach (Staatliche Museen Preussischer Kulturbesitz, Berlin); Erik Fischer and Ian Smith (Statens Museum for Kunst, Copenhagen); Teréz Gerszi (Szépmüvészeti Múzeum, Budapest); Mme. Chantal Oederlin (Musée d'Art et d'Histoire, Geneva); Dr. Eckhard Schaar (Hamburger Kunsthalle); and P. A. Senior (Johannesburg Art Gallery).

In this country and Canada, we are extremely grateful to the following people who facilitated our study of cliché-verre material in their collections and who gave invaluable assistance in the organization of this material for this publication: Ripley Albright (Brooklyn Museum); H. Parrott Bacot (Anglo-American Art Museum, Louisiana State University, Baton Rouge); Karen Beall and Jerald C. Maddox (Library of Congress, Washington, D.C.); William Becker, Detroit; James Bergquist, Boston; Helen Brunner (Visual Studies Workshop, Rochester); Victor Carlson and Jay Fisher (Baltimore Museum of Art); Riva Castleman, Alexandra Schwartz, and Deborah Wye (Department of Prints and Illustrated Books, Museum of Modern Art, New York); Marjorie B. Cohn (Fogg Art Museum, Cambridge); Sylvan Cole (Associated American Artists, New York); Verna Curtis (Milwaukee Art Center); Mrs. J. de Menil and Kathryn Davidson (Menil Foundation, Houston); Cleta H. Downey (University Art Museum, University of New Mexico, Albuquerque); Douglas Druik (Department of Prints and Drawings, National Gallery of Canada, Ottawa); James Enyeart, Terence Pitts, and Minnette Burges (Center for Creative Photography, University of Arizona, Tucson); Mary Fanette (Curator of the Arnold H. Crane Collection, Chicago); Richard S. Field and Rosemary Hoffman (Yale University Art Gallery, New

9

Haven); Ruth E. Fine, Tony Rosati, and Starr Siegele (Alverthorpe Gallery, National Gallery of Art, Washington, D.C.); Janet Flint, William Walker and Thomas Bower (National Collection of Fine Arts, Smithsonian Institution, Washington, D.C.); Roy Flukinger, Trudy Prescott, and Mrs. M. MacNamara (Humanities Research Center, University of Texas at Austin); Betsy G. Fryberger (Stanford University Museum of Art, California); Trisha S. Garlock (Director, World Print Council, San Francisco); Elizabeth Harris (Division of Prints, National Museum of History and Technology, Smithsonian Institution, Washington, D.C.); Pegram Harrison (Indiana University Art Museum, Bloomington); Patricia Hendricks (University Art Museum, University of Texas at Austin); Sinclair H. Hitchings (Boston Public Library); Colta Feller Ives (Department of Prints and Photographs, Metropolitan Museum of Art); Eugenia P. Janis (Department of Art, Wellesley College, Massachusetts); Harold Joachim, Anselmo Carini, Suzanne Folds McCullagh, and Esther Sparks (Department of Prints and Drawings, Art Institute of Chicago); Robert Johnson (Achenbach Foundation for Graphic Arts, San Francisco); Una E. Johnson, New York; Susan Kismaric and Ingrid Sischy (Department of Photography, Museum of Modern Art, New York); Arnold Klein, Pleasant Ridge, Michigan; Raymond E. Lewis and Joseph McDonald (R. E. Lewis, Inc., California); Peter MacGill (Light Gallery, New York); Kneeland McNulty, Ellen S. Jacobowitz, Ginny Butera, and Michael Komanecky (Department of Prints and Drawings, Philadelphia Museum of Art); Ann R. Milstein (Fogg Art Museum, Cambridge); Elizabeth Mongan, Rockport, Massachusetts; Beaumont Newhall, Sante Fe; Nancy Olson (Yale University Graduate Program, New Haven); Robert Patten and Beth Rigel Daugherty (Rice University, Houston); Susan Dodge Peters (International Museum of Photography at George Eastman House, Rochester); Louise Richards and Anne Lockhart (Department of Prints and Drawings, Cleveland Museum of Art); Andrew Robison, Lynn Gould, and Judith C. Walch (Graphic Arts Department, National Gallery of Art, Washington, D.C.); Elizabeth E. Roth and Robert Rainwater (Prints Division, New York Public Library); Eleanor Sayre, Clifford S. Ackley, Sue W. Reed, and Barbara S. Shapiro (Department of Prints, Drawings, and Photographs, Museum of Fine Arts, Boston); Margo Schab, New York; Michael Schantz (Grunwald Center for the Graphic Arts, University of California at Los Angeles); Karen Schoen (formerly with the Indiana University Art Museum, Bloomington); Dr. John Joseph Shober, Philadelphia; Joel Snyder (University of Chicago); Nesta Spink, Ann Arbor; Sean Thackrey and Sally Robertson, San Francisco; David Travis and Deborah Frumkin (Department of Photography, Art Institute of Chicago); Anne Tucker (Department of Photography, Museum of Fine Arts, Houston); Samuel Wagstaff, New York; Bret Waller, Jacqueline Slee, and Judith Keller (University of Michigan Museum of Art, Ann Arbor); and John Wisdom (Department of Painting and Sculpture, Museum of Fine Arts, Houston). Elizabeth Roth deserves special recognition, not only because she made the wealth of the cliché-verre material in the S. P. Avery collection available to our study, but also because she was the initial prompter of the authors' collaboration on this project.

For important background material on 20th-century clichés-verre, we thank the following: Anna Balakian (New York University); Richard G. Baumann (Museum of Art and Archeology, University of Missouri, Columbia); Howard Bossen (Michigan State University, East Lansing); Mary Ann Caws (Hunter College and City University of New York); Pat Gilmour, London; Félix Klee, Bern; James McQuaid, Boston; J. H. Matthews (Syracuse University and Editor, *Symposium*); Naomi Savage, Princeton; Arturo Schwarz, Milan; David Sylvester, London; and Lucien Treillard, Paris.

The authors wish further to express their gratitude to each of the contemporary artists whose work is included in this exhibition. The key insights they provided became an important source for the entries in this catalogue. Additional artists and photographers contributed to the authors' knowledge of contemporary cliché-verre: Gretchen Anderson, Thomas Barrow, Donald Blumberg, Nancy Bonior, Doreen Bortman, Lawrie Brown, Tom Carabasi, Darryl Curran, Dean Dablow, Bonnie Donahue, Fred Endsley, Tom Frank, R. E. George, Nancy Goldring, Josefina Gonzales, Maria Gonzales, Krystin Grenon, Betty Hahn, Gary Hall, Gary Hallman, Stephen Hazel, Robert Heinecken, James Henkel, Jerome Kaplan, Lou Krueger, Wayne (Rod) Lazorik, James McGarrell, Mary Meyer-Pricher, Peter Milton, Susan Mulcahy, Nathan Oliveira, Katherine Pappas-Parks, Bruce Patterson, Tom Petrillo, Sheila Pinkel, Ann Rosen, Susan Saltzer-Drucker, George Shustowicz, Sarah Steinbrook, Rene Verdugo, and Thomas Whitworth.

Sue Hirtzel, who served as technical advisor on contemporary cliché-verre, must be singled out for her tireless enthusiasm for this exhibition and her willingness to research or demonstrate the medium's various processes to elucidate them for the exhibition organizers.

The authors also gratefully acknowledge the crucial role of the staff of the Detroit Institute of Arts in the realization of this exhibition and catalogue. We are particularly indebted to Ellen Sharp, Curator of Graphic Arts, for first suggesting the exhibition and for her encouragement, creative counsel, and continuous support from the inception to the realization of this exhibition project. Terry Ann Neff is to be lauded for her invaluable expertise and care in the editing and production of this book. In addition, we give special thanks to Douglas Bulka, Yvette Coneal, Kathleen Erwin, and

volunteer Jean S. Wyatt (Graphic Arts Department); Margaret de Grace, Robert Rodgers, and the Public Relations staff; Marianne De Palma and the Development staff; Linda Downs and Patience Young (Education Department); Charles Elam; Abraham Joel and Nancy Donaldson (Conservation); Susan Rossen and Rollyn Krichbaum (Publications Department); Ingeborg Michalik; Warren Peters, Constance Wall, and Lynn Garza (Museum Research Library); Katherine Shemeld; Nemo Warr, Robert Hensleigh, and Marianne Letasi (Photography Department); Susan Weinberg and Karen Serota (Registrar's Office).

Our gratitude is extended to one and all who helped make possible this exhibition and book.

Marilyn F. Symmes
Elizabeth Glassman

Introduction

This history of the cliché-verre, from its origins in the 19th century to its contemporary permutations in the 1970s, and the accompanying exhibition, constitute a pioneering study of a graphic medium that combines elements of both printmaking and photography. Perhaps precisely because of its mixed parentage, the cliché-verre, although of distinguished lineage, has been treated like a stepchild by the art world and has not been favored with an intensive study leading to a major publication and a museum exhibition. Indeed, museums have tended to be ambivalent in their categorizing of the cliché-verre print. The organizers of this exhibition found that in most museums they had to search for clichés-verre in the photographic collections as well as in the print holdings.

Such confusion of classification comes naturally to cliché-verre. A clear definition of the process is concisely expressed in the title of the exhibition—"hand-drawn, light-printed." An image is rendered by hand on a matrix (as in printmaking). The matrix, however, is transparent and the image is replicated by the action of light through the matrix onto a light-sensitive surface (as in photography). The techniques by which this basic process is achieved have varied throughout its 140-year history.

The decision to retain the term "cliché-verre" (glass negative) was made only after extensive discussion and consideration of historical precedents and modern usage. No evidence has been found to indicate that 19th-century artists who worked in this medium actually called their prints "clichés-verre." French writers used a variety of terms. So many were in use—e.g., "cliché-glace," "dessin héliographique," "dessin sur verre bichromaté," "cliché photographique sur verre," "autographie photographique," "procédé sur verre" (and such English equivalents as "glass print," "etching on glass")—that in 1889, and again in 1891, the Congrès International de Photographie tried to select a definitive term. But its attempts were unsuccessful.

In the 20th century, the use of the word "cliché-verre" can be ascribed to one of the major cataloguers of 19th-century and 20th-century prints: Loys Delteil. Delteil used "cliché-verre" throughout the 31 volumes of his *Le Peintre-Graveur illustré*, which began publication in 1906 and was completed in 1930. The Delteil volumes are the most frequently consulted and cited references on 19th-century graphic art. Further support for the term was given by Osbert H. Barnard, who wrote the first comprehensive article in English on the medium for the April 1922 issue of the widely-read *The Print Collector's Quarterly*. Thus, cliché-verre has been used fairly consistently in this century by art historians, collectors, dealers, and artists despite the efforts of some technical manuals and encyclopedias to anglicize the term as "glass print." Although some contemporary artists and educators have devised new appellations derived from specific processes ("refraction drawing," "photopainting"), or from materials ("smoke-on-glass"), these terms do not fit general specifications.

The persistence of the term "cliché-verre" is analogous to that of "chiaroscuro," an Italian word generally applied to the first color woodcuts, developed in the 16th century, to reproduce drawings on colored paper heightened with white. Chiaroscuro (chiaroscuros or chiaroscuro woodcut) has taken precedence as the designation for these woodcuts over the more prosaic English "cameo print," the less graceful German "Helldunkelholzschnitt," and the more chic French "clairobscur." Like chiaroscuro, cliché-verre, (clichés-verre, cliché-verre print) is distinctive, lyrical, and pleasing to the ear. Thus, even though the term does not properly apply to contemporary cliché-verre prints in which Kodak film or a plastic sheet are most often used as a matrix instead of a glass plate, this publication supports time-honored tradition and perpetuates the use of "cliché-verre."

The interest of the Detroit Institute of Arts in the cliché-verre came by way of the printmaking aspect of the medium. In the fall of 1968 at Wayne State University, Aris Koutroulis, then Assistant Professor of Art and director of the lithography workshop, exhibited a group of prints, results of his experiments with a 20th-century adaptation of the cliché-verre. Collectors, curators, teachers, and students in Detroit were fascinated with the handsome, poetic images which he had created (cat. nos. 102, 103). Koutroulis continued his investiga-

13

tions of the medium and in 1971 established a course in the cliché-verre at Wayne.

A year later, Sue Hirtzel and Diane Escott, both recent recipients from Wayne of the Master of Fine Arts degree, enrolled in Koutroulis' course. These two artists found the medium eminently suited to re-creating their delicate drawings. Their experiments with non-silver printing processes were significant contributions to the development and refinement of the 20th-century cliché-verre. After a year of intense work, Escott stopped working in cliché-verre, but Hirtzel became deeply involved with the medium and since 1975 has been in charge of the cliché-verre course at Wayne. By 1977 it was obvious that a cliché-verre renascence, originated by Koutroulis and sustained by Hirtzel, was in full flower in Michigan. Fully one-fourth of the entries submitted to the 7th Biennial Exhibition of the Michigan Association of Printmakers, held in that year, were cliché-verre prints.

When the Department of Graphic Arts began in 1976 to plan the opening of our new Graphic Arts Center in 1980, we pondered various ideas for the premiere exhibition in our new galleries. We wished to present an exhibition that would have special relevance for Michigan artists and also one that would make a scholarly contribution to the field of graphic arts. Since little of substance has been published in English on the 19th-century cliché-verre and its subsequent development in the 20th century, a survey of the medium admirably fulfilled both of these objectives. Research into its history and range was commenced.

Marilyn F. Symmes, Associate Curator of Graphic Arts, began by investigating the existing bibliography on the cliché-verre as well as the holdings of museums in this country and abroad. Thanks to the interest of two prominent 19th-century print collectors, Samuel P. Avery of New York and George A. Lucas of Baltimore, there are two exceptional cliché-verre collections in the United States. The Lucas collection was given to the Maryland Institute College of Art and is now housed and administered by the Baltimore Museum of Art. The Avery collection was presented to the New York Public Library. Through Elizabeth Roth, Curator of Prints at the New York Public Library, Ms. Symmes learned that Elizabeth Glassman, a graduate student at the University of New Mexico at Albuquerque, was preparing a master's thesis on the 19th-century cliché-verre under the direction of the distinguished historian of photography, Beaumont Newhall. After conferring with Ms. Glassman, it seemed logical that we should join forces, pool our information, and pursue our mutual interest together.

Although Ms. Glassman, now Research Associate, Print Collection, Menil Foundation, Houston, and Lecturer in the History of Photography, University of Houston, assumed responsibility for the 19th-century and Ms. Symmes for the 20th-century section of the catalogue, it has been a true collaboration. Both authors have contributed to the Bibliography as well as to the Appendix. Ms. Symmes' training is primarily as a print historian; Ms. Glassman's orientation toward the cliché-verre is photographic. Since both viewpoints are appropriate to cliché-verre, they serve to enrich an exhibition and catalogue whose dual nature holds as much interest for photographic historians as for print scholars.

From the very beginning our objective has been to present the first comprehensive study of the medium, encompassing all manifestations of the cliché-verre in the 19th century and in the early 20th century. In addition, every effort has been made to locate contemporary artists in the United States and Europe who are working in the medium. Questionnaires were sent to over 200 museums, art schools, colleges, and universities in this country as well as to curators of major American and European print and photography collections. Curators in charge of contemporary collections who regularly act as jurors for international competitions were consulted. Notices of the project were placed in publications with an international readership, such as the *College Art Journal, The Print Collector's Newsletter,* and *Print News* published by the World Print Council.

Responses from institutions and artists in the United States were numerous and enthusiastic. However, few replies were received from European artists, and information from European curators was confined for the most part to 19th-century material. Therefore, it must be acknowledged that the 20th-century section of this exhibition has a decidedly American emphasis. It is chauvinistic by default. It is our hope that this exhibition and catalogue will stimulate interest in the cliché-verre and bring to light not only additional 19th-century materials but also more contemporary examples of the medium from all parts of the world.

The exhibition itself has been kept to a manageable size with quality the paramount concern. In the case of the 19th-century clichés-verre, special problems of connoisseurship involved vintage versus later-editioned impressions of certain prints. Thus, in some instances, several impressions of one image are included (cat. nos. 11, 12, 13; 20, 21; 27, 28; 34, 35, 36). It was also of great importance to locate and include where possible the rare, relatively unknown work in cliché-verre by such major 20th-century artists as Man Ray, Max Ernst, and Pablo Picasso. In selecting clichés-verre by contemporary artists, the same standards of quality were applied as for 19th-century work. Michigan artists were not given preferential treatment; of the twenty-four contemporary artists in the exhibition, only nine have worked in Michigan.

In the final stages of this project, as we reviewed photographs and slides of the works selected for the exhibition as well as actual prints, we were surprised, and

pleased, to discover that the jarring visual dichotomy that we had suspected might result from a juxtaposition of 19th- and 20th-century clichés-verre in fact did not occur. The light, movement, and space found in the clichés-verre of Corot can also be found in contemporary works. Even the colors from both centuries have a harmonious resonance—soft blues, magentas, and greens. Cliché-verre seems to lend itself to a lyrical, poetic view of the world, to linear abstraction, and to the creation of images with a sense of infinite space and light. Paul Valéry expressed this well in his comments on Corot's graphic oeuvre:

> With such abstract means—pen, pencil, [etcher's] needle—Corot achieves marvels of light and space; never have trees been more vivid, clouds more shifting, horizons broader nor the earth more solid than in these few lines on paper. Leafing through these astonishing pages, we feel that this man lived in the sight of natural things as a contemplative man lives within his thought.[1]

Another 20th-century poet, Tristan Tzara, wrote an introduction entitled "When Things Dream" to accompany the publication of a group of Rayographs by Man Ray. The concluding words of Tzara's surreal obligato can be used just as effectively to convey the mood of most clichés-verre, whether we are contemplating *Le Songeur* by Corot or *Paracelsus* by Sommer, *Futaie au Bas-Bréau* by Wacquez or *Paul's Window* by Hirtzel: "These are projections surprised in transparence, by the light of tenderness, of things that dream and talk in their sleep."[2]

Ellen Sharp

[1]
Quoted in Madeleine Harris, *Corot*, New York: Harry N. Abrams, 1979, p. 60.
[2]
Quoted in *Man Ray Photographs 1920-1934*, Hartford: James Thrall Soby, and New York: Random House, 1934, p. 84.

Color Plates

Jean-Baptiste-Camille Corot, *The Dreamer (Le Songeur)*, January 1854, cat. no. 11a

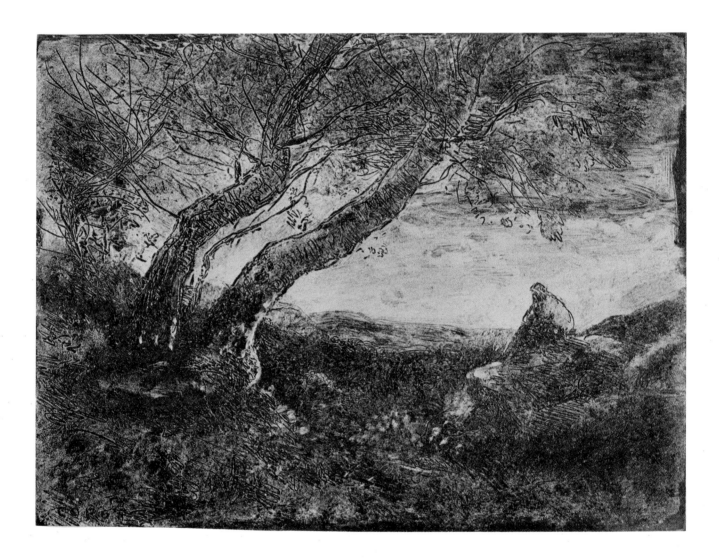

Charles-François Daubigny, *Deer (Les Cerfs)*, 1862, cat. no. 34

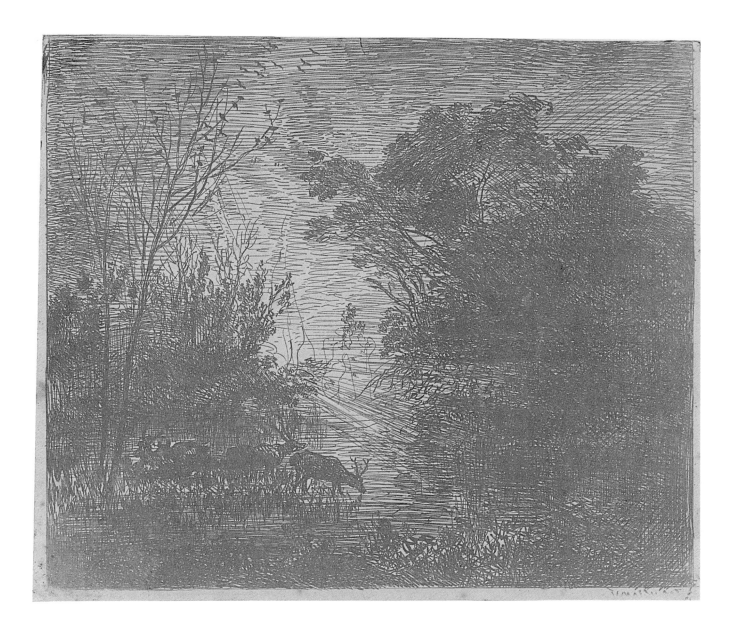

Caroline Durieux, *Frail Banner*, 1960, cat. no. 88

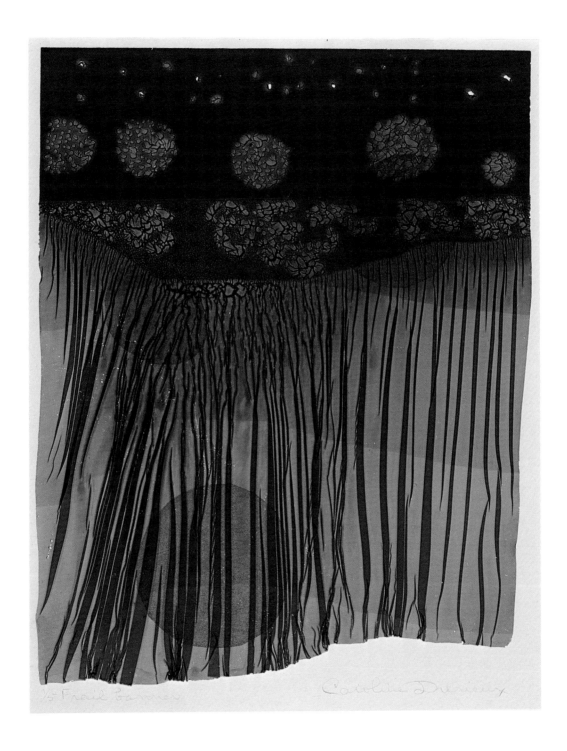

Diane Escott, *Untitled Landscape,* 1973, cat. no. 90

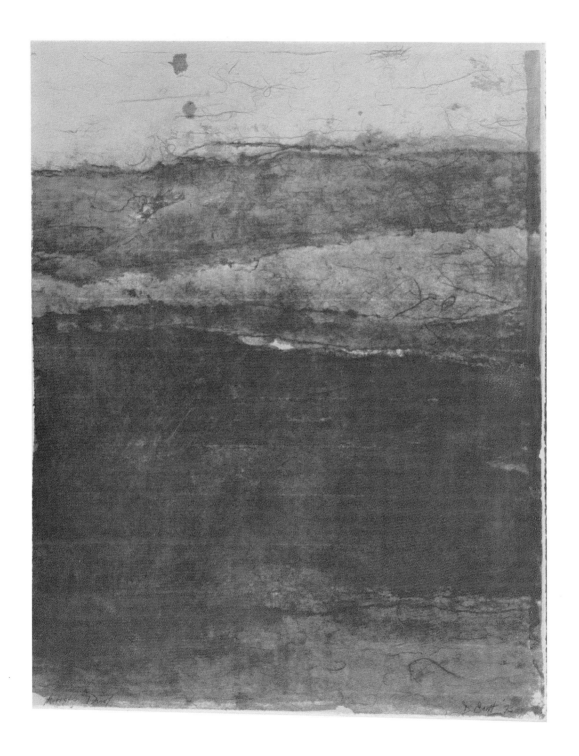

Sue Hirtzel, *Paul's Window*, 1979, cat. no. 96

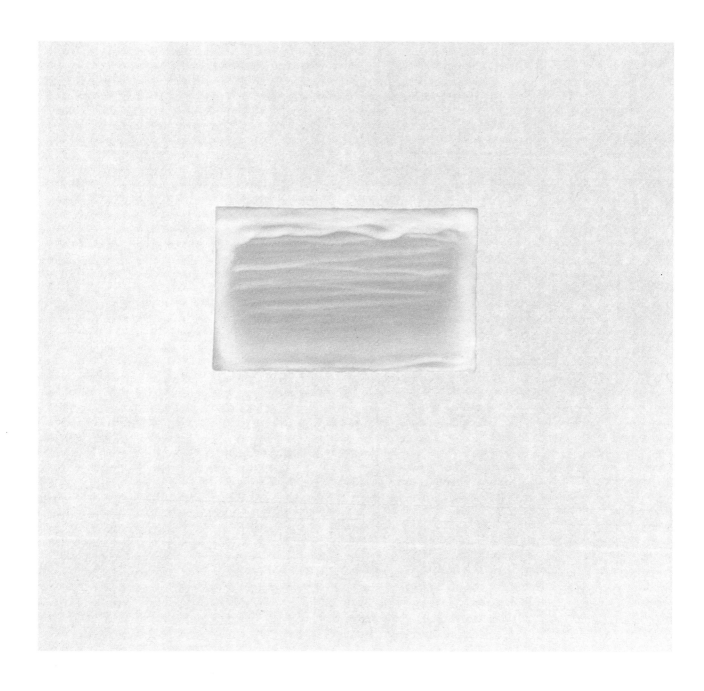

Lois Johnson, *Elmer and Ewe Knew Best*, 1973, cat. no. 97

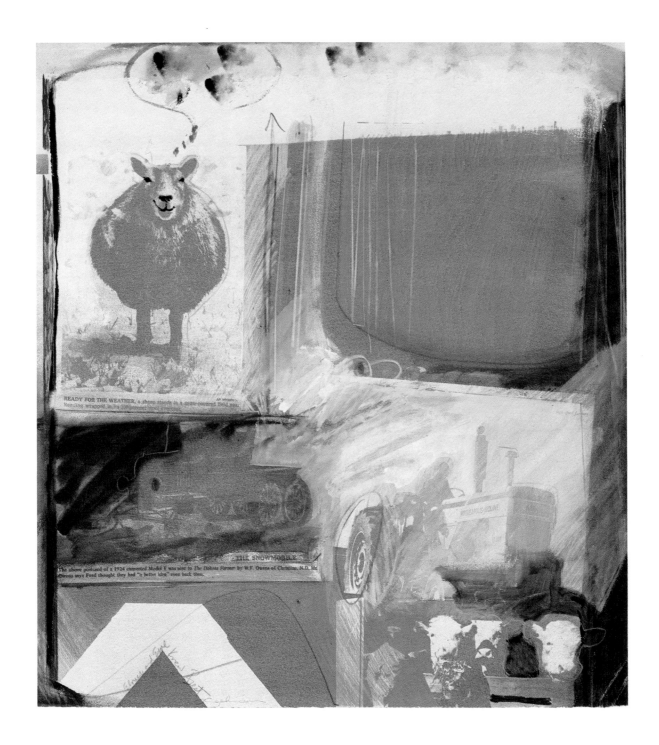

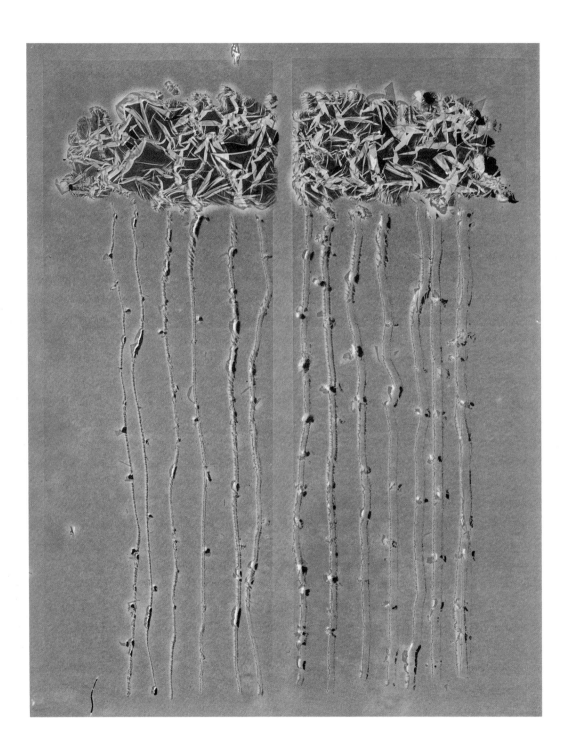

Notes to the Catalogue

The catalogue entries for each work in the exhibition are divided into 19th- and 20th-century sections with the works listed alphabetically by artist within each section. Where there is more than one work by an artist, the prints are arranged chronologically as far as possible, or according to a standardly accepted catalogue raisonné order (e.g., Loys Delteil for Corot and Daubigny).

Each entry includes title, date, type of cliché-verre print when known or glass plate matrix, signature and inscriptions if present, dimensions, catalogue raisonné reference number where applicable, and credit line. The date refers to the year in which the matrix and print were executed; when these dates differ, the date of the matrix is given followed by the date of the impression in parentheses. Sizes are given in centimeters and inches, height first. When image and sheet size coincide, one set of dimensions is given; when image and sheet differ, both measurements are indicated. When trimming of the sheet has resulted in a trimming of the image, sheet size alone is given. In the few cases where it was possible to determine plate size, these dimensions are included.

Provenance is noted only when records on the history of the specific impression are complete or when the impression is clearly marked with collectors' marks.

Titles of French works are given first in English. French titles are retained in the entries since these works are most often cited by their French titles. Translations of titles and French quotations are by the authors unless otherwise noted. In the absence of titles for heretofore unpublished 19th-century clichés-verre, the authors devised general descriptive titles.

Bibliographical abbreviations are used throughout the catalogue; full titles can be found in the Bibliography. The Bibliography is divided into five sections designated by Roman numerals and category headings. Bibliographical references have been abbreviated to: Bib., the Roman numeral of the pertinent section, and the author's name, the city of publication, or the title of the periodical. References to section V also include the artist's name, preceding that of the author. BN Inventaire refers to Paris, Bibliothèque Nationale, *Inventaire du Fonds Français après 1800*. Lugt refers to Frits Lugt, *Les Marques de collections de dessins et d'estampes*.

Loys Delteil carried over the print curators' practice of assigning states to his works on cliché-verre. Added signatures, cracked or scratched plates, he considered as additional states. Since the condition of the plate should not be considered a deliberate alteration, Delteil's practice of noting states for clichés-verre has been abandoned.

The matter of edition size occurs only in the 20th-century entries, since editioning is a 20th-century concept. The exact number of impressions of each cliché-verre printed by 19th-century artists during their lifetime cannot be fully determined. Many 20th-century artists, however, purposely printed their clichés-verre in an edition. Where known, the edition size is given in the entry. Some artists have preferred to keep their clichés-verre unique, and where this is intentional, it is so noted in the entry. Other 20th-century artists, most of whom are photographers, are unconcerned with the concept of editioning and do not keep track of how many prints have been made from the matrix. Thus, when edition size is omitted, it indicates that the artist made an indeterminate number of impressions.

Works lent by the New York Public Library (cat. nos. 9, 12, 16, 39, 46), from the Arnold H. Crane Collection, Chicago (cat. nos. 107-110), and from Margo Pollins Schab, Inc. (cat. no. 11b) could not travel and thus will be shown in Detroit only. A copy of Ehninger's *Autograph Etchings by American Artists* from the collection of Wm. B. Becker will replace the New York Public Library's copy in Houston.

Cliché-verre in the 19th Century

By Elizabeth Glassman

In 1839 the almost simultaneous announcements by Louis-Jacques-Mandé Daguerre in France and William Henry Fox Talbot in England of their revolutionary new techniques to capture likenesses shook the scientific and artistic communities. The livelihood of painters and engravers was in serious question as photography threatened to replace them at every turn. In the excitement, confusion, and fear surrounding the rash of inventions, publications, and patents was the cliché-verre, a cameraless technique for creating photographs from hand-drawn negatives, a process even today claimed by both printmaking and photography.

Actually, the cliché-verre is a hybrid of printmaking and photography. From printmaking, specifically etching, the cliché-verre borrows the act of drawing through a prepared ground, generally printer's ink (dusted white for contrast) or fogged collodion. In cliché-verre, however, the ground rests on a transparent matrix surface rather than on metal corroded with acid. The drawing is most often done with an etching needle, quill pen, or other sharp instrument. Once drawn, the plate becomes a photographic negative and exposure to the sun, as printing agent, transfers the design to light-sensitive paper.

Alternatively, the cliché-verre negative can be rendered as a monochrome painting, brushing emulsion in the form of oil paint onto the transparent matrix. Exactly opposite to the drawn plate—a subtractive procedure—the painted plate is an additive method which hinges on a fundamental principle of photography: that modulated areas of opacity, or density, in the negative convert to varying tints in the print. By modifying the applied paint, thus altering the amount of light reaching the sensitized sheet, the artist can produce a complete range of tones.

During exposure of the drawn plate, light strikes evenly through the scratched lines, thereby transferring each line to the sensitized sheet with equal intensity. Thus, forms are translated in uniform tonality. Variation in tone may be achieved either during the drawing stage, by varying the thickness of the lines, hatching, crosshatching, or during exposure, by altering the distance of the emulsion from the light-sensitive surface. In the usual method of exposure, with the drawn side of the plate in close contact with the photosensitive paper, the resulting print is sharp and crisp. When the plate is flipped, emulsion side up, the light bends and refracts as it passes through the glass, causing a halo effect, or halation. Interspersing a second sheet of glass emphasizes this softness as the light refractions spread, extending the area exposed. This procedure, which depends on the transparency of the matrix and may be applied to both the painted and drawn plates, offers a unique method of producing line and tone simultaneously.

In the 19th century, the cliché-verre offered several particular advantages unrelated to either its photographic or graphic associations. The material requirements—glass and ground or paint along with photosensitive paper—were simple. The drawing surface was portable, and the glass, though fragile, was easily obtained. Because the process did not involve the chemical manipulations of etching or the manual skills of engraving, any artist, even without previous experience, could draw directly onto the smooth glass matrix. The intervention of a copyist to redraw an original design for mass-production, a standard procedure in the early 19th century, was no longer necessary.

The 19th-century practitioner, with a few notable exceptions, focused on the reproductive aspects of the cliché-verre. But photochemical sophistication had not advanced to the point of providing an inexpensive, uniform method of replication in the cliché-verre and, by the end of the century, camera-made copies and the photographic assembly line, along with the wizardry of increasingly sophisticated photomechanical technology, superseded the hand-drawn negative.

For purposes of mass-production, the cliché-verre was more expensive and less predictable than standard reproductive methods such as copper engraving, or even the relatively new forms of lithography and wood engraving, which were invented only in the later years of the 18th century. Moreover, the cliché-verre must have seemed alien—even unattractive—to eyes accustomed

29

to the velvety relief of a deeply etched groove or the silvery gossamer of precise engraving. The cliché-verre was, by contrast, flat.

And yet the photograph did hold one advantage over engraving: the addition of tone. In contrast to engraving, in which two unvarying tones—white and black—blend visually to produce half-tones, photographic tone is continuous, changing in relation to shifting density of the negative rather than the varying balance of black and white.

It is indicative of the cliché-verre's general acceptance in both printmaking and photography that only two years after Talbot's 1839 announcement, the medium was included in two technical manuals, one a handbook for photographers, the other for printmakers. Robert Hunt, in his 1841 compendium of photographic methods, *A Popular Treatise on the Art of Photography*, described "Positive Photographs from Etchings on Glass Plates"; T. H. Fielding, in a manual of graphic processes, *The Art of Engraving*, included instructions for "photogenic etchings." Both were cliché-verre.[1]

The authors labeled the process "photographic," citing the attendant paraphernalia of glass plate and photosensitive paper, but the product they compared to etching and engraving, traditional means of replicating drawings. Despite both authors' ambivalence regarding this novel method, Hunt applauded the results, noting that "when the etching is executed by an engraver, the photograph has all the finish of a delicate copper-plate engraving." "The proof," wrote Fielding, "will resemble a mezzotint engraving."

Two functions, reproductive and autographic, run simultaneously throughout the history of the cliché-verre in the 19th century; in each case the names given the process reflect the particular orientation of the practitioner. English authors generally emphasized the reproductive aspects of the technique, labeling the process "photogenic etching," while French writers and inventors usually stressed the autographic possibilities. Adalbert Cuvelier, the photographer in Arras who introduced the medium to the painter Camille Corot, named the prints "drawings on glass for photography."[2]

The cliché-verre is a direct outgrowth of the invention of photography.[3] The fundamental principle of the cliché-verre—superimposition of a hand-drawn, transparent matrix on a light-sensitive surface—evolved from the most primitive photographic experiments. By 1839 William Henry Fox Talbot, inventor of the negative/positive process, had not only contact-printed objects, both "natural and artistic," on sensitized paper, but had also managed to fix his images, or as Talbot called them, "photogenic drawings."[4] In addition to photogenic drawings of natural objects such as ferns and leaves, Talbot executed reproductions of paintings on glass by contact-printing. Talbot described these "shadow pictures" briefly under part seven of *Some* *Account of the Art of Photogenic Drawing* (Bib. V Talbot/Talbot). The pictures thus formed, he wrote, "resemble the production of the artist's pencil more, perhaps, than any of the others."

It was not the announcement of Talbot's invention but rather the attached patent claim to all applications, both stated and implied, that spurred three English engravers to present their independent system for creating clichés-verre. James Tibbitts Willmore (1800-1863) was a respected engraver of Turner's painting. William Havell (1782-1857), a member of a large family of artists, began his career as a watercolorist, lived in China and India, and then returned to England to devote himself to oil painting. Once a prominent painter, his later years were marked by financial ruin and he died in poverty. William's younger brother Frederick James Havell (1801-1840) was also mentioned as a participant, but his ill health seems to have prevented an active role. The trio exhibited their prints before the Royal Institution on March 22, 1839 and before the Royal Society on the following day. Their first effort was a print after Rembrandt, *Faust Conjuring Mephistopheles to Appear in the Form of a Bright Star*. Immediately following their exhibition a heated dispute flared. Talbot fired letters to a leading journal, *The Literary Gazette*; William Havell and James T. Willmore, the spokesmen for the group, followed with sharp rebuttals.

That both Talbot and the Havell/Willmore group copied original designs by contact to sensitized paper is not debatable; that the former introduced the photographic process was acknowledged by Havell and Willmore; what was emphatically different in their approaches was their intent. William Havell explained an important distinction between his and Talbot's goals:

Mr. Fox Talbot's "Account of the Art of Photogenic Drawing, or the Process by which Natural Objects may be made to delineate themselves without the aid of the Artist's Pencil" is exactly the reverse of my process.

My object is to delineate the work of the artist's pencil by the Photographic process, for the knowledge of which we are indebted to the frank disclosure of Mr. F. Talbot on the 23d February.[5]

Havell stressed that he was seeking a new art, one that depended not on the fidelity of reproduction for its power but on the skill of the artist. For Talbot, the advantage and fascination of photography was precisely its mechanical nature, thus his emphasis on the reproductive aspect is not surprising.[6] Unlike a copyist, even one highly skilled, the sun intervened only chemically, never mechanically. In contrast to Talbot's photogenic drawings (produced by placing actual objects on photosensitive paper to create a negative which had to be placed again on photosensitive paper to create a posi-

tive), the Havell/Willmore process was based on painting the negative itself (an autographic negative); the resulting print was a positive photograph and the second step was eliminated.

There has been little change in the method Havell and Willmore devised, which rests on the principle of contact-printing: superimposition of a negative on a light-sensitive surface.

> Mr. J. F. Havell [sic] and Mr. Willmore, have, by covering glass with *etching ground* and smoke, sketched designs upon it. Through the glass thus exposed by the scratches, the photogenic paper receives the light, and the design, which the sun may be said to print, may be multiplied with perfect identity for ever! Designs thus produced will probably become much more common, and even more generally applicable than lithography, because all the means are more readily accessible, whilst it will receive its rank as an art, and be excellent in proportion to the skill of the artist, as a draughtsman with the etching needle.... The first report of the discovery in France alarmed the painters from nature; next, the specimens of etched plates and printed impressions alarmed the engravers; this further discovery has replaced it, as an art, in the hands of its professors. But, since the sun has turned printer, we fear that the *devils* will ultimately suffer.[7]

The comments in *The Literary Gazette* reflect both the enthusiasm and skepticism of the public. Although reproductive engravers genuinely and rightfully panicked at the threat to their livelihood, William Havell assured that with the Havell/Willmore process, their clichés-verre would

> give rise to a new employment: to the artist, in making original designs on glass, as well as copies from

in his journal, published in part by Boris Kossoy in *Image* (Bib. V Florence/Kossoy). According to an entry of January 1833, Florence first drew on glass and then, by exposing the drawn plate onto a sensitized glass, produced a negative from which he could contact-print onto paper, copies of the initial design. He utilized this technique not only to reproduce his drawings, but also his writings, an application also mentioned by Talbot. His clichés-verre, however, although fixed (using urine), are no longer extant. As with any claim to originality, Florence's experiments demand further substantiation, especially since his date of 1833 would establish the Brazilian as the originator of photography, preceding Talbot and Daguerre by at least five years.

In addition to those experimenters discussed in this book, Friedrich August Wilhelm Netto in Germany devised a method of "glass printing" which he published in 1840 in a brochure, *Die Glasdruckkunst oder Hyalotypie* (Bib. II Gernsheim, p. 567). In 1857 Robinson Elliott, an English artist experimenting with photography, secured a patent for his "improved invention for reproducing copies of old master paintings." The Elliottype applied the cliché-verre method not only to replicating drawings or paintings on glass but to reducing or enlarging them as well (Bib. III Art Journal). *The Photographic Journal* recorded the work of "a practical man" who had produced, photographically, "imitations of etchings," a process "which has been described before, but is still little known" (Bib. IV The Photographic Journal).

Even as late as 1924 the cliché-verre surfaced as independent invention. According to an article aptly titled "Clichés-Verre Again" (Bib. III The Bookman's Journal), a Singapore artist claimed to have discovered a method of creating "reproductions of etchings." The prints, however, wrote the foreign correspondent, lacked "quality" because there was "no texture and no relief"; therefore, he judged, the technique should be reserved for the amateur "anxious only to reproduce a happy drawing for a few friends." That this list is complete seems unlikely, for experiment often led to cliché-verre, a phenomenon which continued in the 20th century as well.

1

Bib. II Hunt, pp. 34-35; Bib. II Fielding, p. 103. For explanation of this catalogue's system of abbreviated bibliographical references, see Notes to the Catalogue, p. 26.

2

Not uncommonly, in one publication Cuvelier attached a second label to his method: "heliographic drawing" (Bib. III Cuvelier). In the 19th century extreme variation existed in the names applied, by both practitioners and writers, to the cliché-verre process. In fact, the situation became so confusing that the Congrès International de Photographie of 1889 appointed a panel to discuss the question of uniform designation for photographic processes. The several proposals offered did not contain any improved terminology, and the debate ended (Bib. III Congrès, pp. 37, 84-85).

3

The number of independent inventors, often working in isolation, is not suprising, for the cliché-verre technique surfaced fairly naturally with cameraless experimentation. For example, Hercules Florence, working in provincial Brazil, documented his investigations

4

Talbot's photogenic drawings were first exhibited at the Royal Institution on January 25, 1839; six days later his lengthy description was read before the Royal Society. Published accounts appeared in *The Athenaeum*, February 9, 1839 (Bib. III The Athenaeum, pp. 114-117) and *The Literary Gazette*, February 2, 1839 (Bib. III The Literary Gazette, pp. 72-75). Talbot also issued his paper, *Some Account of the Art of Photogenic Drawing, or the process by which Natural Objects may be made to delineate themselves without the aid of the Artist's Pencil*, in a pamphlet; the entire paper is reprinted in Bib. II Newhall, pp. 60-78.

5

Bib. III The Literary Gazette, March 30, 1839, p. 203.

6

Talbot did reproduce, by contact, engravings, pages from books, and paintings on glass (see Talbot's writings and also the checklist of an exhibition held at the British Association in Birmingham in August 1839 [copy in Science Museum, London]). What is difficult to decipher is which of the extant prints from the early experiments are clichés-verre and which are copies made with a camera. Although enticing, the Talbot puzzles are beyond the scope of this study. I am particularly indebted, however, to Arthur Gill, H. J. P. Arnold, John Ward, and Larry Schaaf for their aid in tracing additional Talbot material. For the purposes of this catalogue, Talbot's writings and checklist establish the fact that he did make clichés-verre; although by contact-printing drawings, etc., Talbot, like Hercules Florence in Brazil (see note 3), achieved negatives which then had to be printed again for positives, unlike the Havell/Willmore method of directly producing an autograph negative on glass.

7

Bib. III The Literary Gazette, March 23, 1839, p. 187.

pictures; it will be a source of amusement to the amateur; and an elegant employment for ladies, particularly those who can paint or draw. It is perfectly available to those who wish to publish a limited number of illustrations. . . . It will be an art *per se*.[8]

The press and the scientific community responded with unequivocal praise for the Havell/Willmore discoveries; however, whether because of the "ungentlemanly" patent fights, unpredictable results (no example of their efforts is known today), or personal misfortune (the younger Havell died in 1840), the group did not take the challenge of their unique process to their fellow artists. Another English engraver, however, did.

Around 1860 Charles Hancock used the cliché-verre plate to produce electrophotographs. The transparent glass matrix was placed on prepared zinc, exposed to light, and the zinc was then etched in relief, inked, and printed in a letterpress. The resulting print resembled a wood-engraving. Hancock had turned to the cliché-verre plate for its smooth glass surface, one easily adaptable to any drawing style and easily used by any artist, even one with no prior experience with printmaking. As the artist drew directly on the glass and there was no need for a professional copyist to intervene, fewer people were involved; consequently, costs decreased and efficiency soared.

To reach his large working class public, George Cruikshank, throughout his extended career as a humorist, caricaturist, and satirist, experimented constantly with printing techniques, searching for an accurate, inexpensive process. For example, his popular, shilling-a-set, temperance issue, *The Bottle,* was printed by glyphography, a complex, short-lived technique of drawing on packed chalk powder which coagulated, forming a cast. In April 1864, when Cruikshank was 73, he met Hancock and decided to illustrate his autobiography by Hancock's process.

Printed posthumously by Hancock in 1894, *A Handbook for Posterity, or Recollections of Twiddle-Twaddle,* contains 62 electrophotographs (which Hancock called "etchings on glass"). One example, Cruikshank's *Table Turning* (fig. 1), affirms that the world is sometimes unreasonable, often preposterous, and generally fun. Hancock included Cruikshank's affection for drawing on the glass plate in a preface:

> Mr. Hancock, what a pity you had not been alive with your invention; it would have altered the whole character of my drawings; and it is so much easier for me to draw by this method . . . in this that you bring me I feel sure every line is my own. Look at the features and fingers; they are splendid.[9]

If Cruikshank's enthusiasm was genuine, then it is curious that he did not pursue the cliché-verre technique in 1851 when Peter Wickens Fry provided him with glass plates and, presumably, printed them. Fry, a

Fig. 1
George Cruikshank (English, 1792-1878). *Table Turning.* Electrophotograph from cliché-verre negative; sheet, 22.4 x 14.6 cm (8¹³⁄₁₆ x 5¾ in.). Plate 42 from *A Handbook for Posterity, or Recollections of Twiddle-Twaddle,* published by W. T. Spenser, London, 1896. Prints Division, the New York Public Library.

leader in the photographic community, partner in the photographic studio of Elliott and Fry, and friend of Cruikshank, encouraged the artist to join him at meetings of the Photographic Society of London (now the Royal Photographic Society). According to the *Liverpool Photographic Journal,* photographs dated December 19, 1851, "etchings, by George Cruikshanks [sic] and Bartholomew, on glass, covered with Collodion and Gutta Percha," were exhibited at the Society in 1854.[10] Of these prints only the *Portrait of Peter Wickens Fry* (cat. no. 32) has been located and it seems Cruikshank did not draw on glass again until 1864, when he met Hancock.

Production costs for electrophotography were outlined in *Electrophotography or Etching on Glass,* an illustrated pamphlet published in 1864 by Joseph Cundall, London's photographic publisher, printer, editor, gallery owner, photographer, and outspoken champion of the new art.[11] To print one or two or even several copies, Cundall recommended photographic prints taken directly from the drawn glass negatives (clichés-verre), but for large orders, he suggested electrophotography, because once the electroplate was struck, the reproduction costs were minimal. To illustrate the adaptability of the glass plate, Cundall enlisted six artists to provide sketches: James Clarke Hook, Myles Birket Foster, Frederick Walker (fig. 2), William Stephen Coleman, William Paton Burton, and Harrison William Weir. Although the designs range from the simple to the sophisticated, each sketch is developed in strict linear patterning. Electrophotography's only disadvantage was that the press, a standard letterpress, only copied line drawings and could not incorporate tone. Thus, one of

the major advantages of the cliché-verre, here used as an intermediate step, was lost in the final process.

Not only was the cliché-verre print surface flat, but spatial differentiation was difficult to achieve, as all uncovered areas of the drawn plate exposed equally. The uniform light printed as one tonality, even and regular. Without variations in the negative's density, the cliché-verre technique was severely limited.

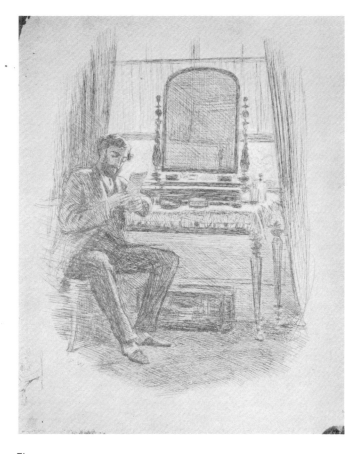

Fig. 2
Frederick Walker (English, 1840-1875). *Man, Seated beside a Dresser, Reading a Letter*. Cliché-verre; sheet, 19.6 x 13.6 cm (7¹¹⁄₁₆ x 5⁵⁄₁₆ in.). Between pp. 8 and 9 of Joseph Cundall, *Electrophotography or Etching on Glass*, published by Cundall, Downes & Co., London, 1864. British Museum, London.

To alleviate the strict linear formula and to offer the artist more latitude in conception, Harville and Pont, another team of independent inventors, developed their system of "autographic engraving."[12] Working in Paris at mid-century, they devised a complex procedure for drawing with wash, stump, roulette, and line on one plate. The collodion-covered glass plate was prepared through an elaborate series of baths; outlines and forms were then drawn with etching needle and roulette. Next, the plate was submerged in another bath and varnished before the wash and stump could be applied; tonal nuances (evident in cat. no. 72, printed by

8
Bib. III The Literary Gazette, March 30, 1839, p. 207. No evidence of the work of these elegantly employed ladies has been located; however, this is surely not a result of the lack of occasions to test the new art. Ackermann's publishing house released a "photogenic drawing box" in April 1839, which included instructions for line engravings on prepared paper. The kit was recommended to scientists but with instructions "sufficiently clear to enable ladies to practise this pleasing Art" (quoted from an advertisement in Bib. III The Literary Gazette, April 20, 1839, p. 253).

9
A Handbook for Posterity was issued by W. T. Spenser of London. In a preface dated December 1894 Hancock described his technique and cited himself as the sole inventor and producer of blocks by the method of "etching on glass," a system he devised in 1864. The process of forming relief blocks via photography was utilized extensively in France after 1875 (see Bib. III Cate).

10
Bib. III The Liverpool Photographic Journal. Bartholomew's full name is not given, though it may well refer to the successful and influential flower painter Valentine Bartholomew (1799-1879). None of Bartholomew's clichés-verre have been located. In an autograph letter to Fry dated December 12, 1849, Cruikshank, having been so taken with his first visit to the "photography meeting," accepted a second invitation. For this information, I thank Robert Patten, Rice University, Houston, who generously allowed me to view his transcribed letters and ledgers of Cruikshank, and Beth Rigel Daugherty who graciously facilitated my task. Significantly, the financial transactions between Hancock and Cruikshank were almost monthly after 1864.

11
The pamphlet, located in the Print Room of the British Museum, London, is quoted extensively in Bib. III Barnard, pp. 156-160. Cundall, a founding member of the Photographic Society of London, arranged some of England's earliest photographic exhibitions at his shop, The Photographic Institution. As a publisher, Cundall issued Philip Delamotte's *The Practice of Photography* in 1853 and authored his own manual on the collodion process, *The Photographic Primer*, in the following year. As a photographer, his work was included in Delamotte's *The Silver Sunbeam*. Additionally, he aided Lewis Carroll, printing many of his negatives (see Ruari McLean, "Joseph Cundall: A Victorian Editor, Designer, Publisher," *The Penrose Annual* 56 [1962], pp. 82-89).

The process of electrophotography was also described in Bib. IV The Builder, an illustrated weekly for architects. Hancock's process was outlined without any credit to the inventor.

12
Barthélemy Pont was a Parisian photographer; Harville has not yet been identified. The team received a French patent for their method in November 1854 and British protection the following year (Bib. III Hédiard, p. 409).

Harville and Pont) were possible because of these intermediate intensities of exposure.

Only three artists have been firmly linked to the Parisian printers, and all in 1855: Jules Noël (cat. no. 72), Paul Huet (*Vieilles Maisons à Honfleur*, Delteil 95), and Horace Vernet (by citation only).[13] Although additional names may well be added to this list, it is likely that Harville and Pont's process was not popular. For all its sophistication, the procedure was intricate and complex, demanding the watchful presence of the photographer/printer at every turn. The benefit of the cliché-verre—independence from technical and procedural interferences—was lost to the involved idiom of chemicals and collaboration.

In addition, there was the problem of marketplace. The photographic print in the mid-19th century was accepted as evidence, as witness, as document, as truth, by some as miracle, but by few as art. The cliché-verre print had neither an inherent commercial value nor a cultivated audience. While camera copies of engravings were commonplace at this period, the cliché-verre, an independent art as envisaged by Havell and Willmore, had yet to acquire the requisite approval of popular taste or popular demand.

John W. Ehninger, an American illustrator and publisher, brought the cliché-verre before the American public in 1859. To "further the interests of American art" was the aspiration Ehninger set forth in a lengthy introduction to his album, *Autograph Etchings by American Artists*, which includes 12 clichés-verre illustrating the writings of 12 American poets. The idea for the album was generated in 1857 when Ehninger received from a friend a notice from a German newspaper of a process which enabled "an artist to reproduce *ad infinitum* his own work."[14] The procedure, as related, was messy and unpredictable, but the potential of replicating direct drawings, free from the "inevitable distortions which accompany the best efforts of the engraver," stimulated the illustrator. Ehninger investigated more consistent and less complicated methods and, after some years' effort, he devised a process that was so simple as to have "universal availability" to his fellow artists.

That an artist need assume no prior technical experience was the prime advantage, Ehninger insisted, of autograph etching (as he labeled cliché-verre). His endorsement hinged not on his advocacy of the medium as sport for amateurs, but rather on his commitment to sensitive copies, not mere reproduction. Ehninger viewed the cliché-verre as original print:

> Thus you see that the artist in the act of drawing, literally engraves his own design which strikes me as being the perfection of faithful reproduction. The works thus produced bear about the same relation to a reproduction of them engraved by another hand, that an autograph letter does to a circular.

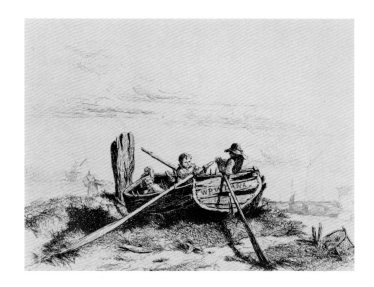

Fig. 3
William Parsons Winchester Dana (American, 1833-1927). *The Seashore*. Cliché-verre; 15 x 20.3 cm (5⅞ x 8 in.). Plate 10 from John Whetton Ehninger, *Autograph Etchings by American Artists*, published by W. A. Townsend, New York, 1859. Courtesy of the Art Institute of Chicago.

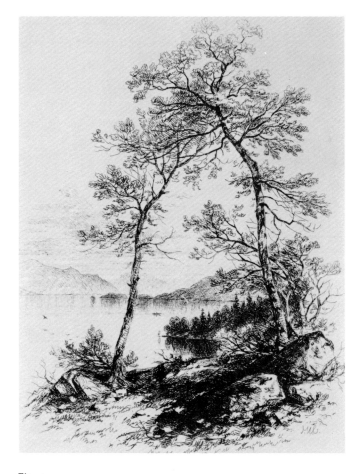

Fig. 4
John William Casilear (American, 1811-1893). *The Lake*. Cliché-verre; 20.3 x 15.4 cm (8 x 6¹/₁₆ in.). Plate 5 from John Whetton Ehninger, *Autograph Etchings by American Artists*, published by W. A. Townsend, New York, 1859. Courtesy of the Art Institute of Chicago.

As examples, Ehninger selected, or solicited, works from painters and illustrators at various stages in their careers. Thus, Asher B. Durand (cat. no. 57), the veteran member of the team, and W. P. W. Dana (fig. 3), one of the younger participants, were 37 years apart in age— a gap of more than a generation. In addition to Dana and Durand, E. Leutze, J. F. Kensett, F. O. C. Darley, J. W. Casilear (fig. 4), Eastman Johnson (cat. no. 58), S. R. Gifford, G. C. Lambdin, George Boughton, L. R. Mignot (cat. no. 59), and Ehninger himself contributed clichés-verre. The cluster of artists were experienced, talented, and, for the most part, commercially established; the combination bore all the markings of popular acclaim.

But *Autograph Etchings*, while not poorly received, was not the critical or financial success Ehninger had predicted. The press was generally apathetic and relatively few copies were sold. Certainly, numerous factors were operative,[15] but the overriding reason for this lack of interest may be simply that the cliché-verre was a separate rubric which had correspondence to etching but was not equivalent. In mid-century America, wealthy patrons commissioned paintings and the populace collected the issues of the large and numerous lithography firms, such as Currier and Ives. The etching revival, which reached its zenith in France in the 1860s, did not emerge in America until the 1870s and was strongest after the formation of etching societies late in the decade. Even as late as 1886, Ripley Hitchcock, author of *Etching in America*, included the cliché-verre simply as an experiment. Comparing "autograph etching" to its visual relative, copperplate etching, Hitchcock wrote, "They are slight, not unpleasant little sketches, suggestive of the camera, and not at all of the etching-needle."[16]

In America the cliché-verre remained a curiosity without following.[17] Like Havell and Willmore, Hancock, and Harville and Pont, Ehninger pronounced his process to be a responsive vehicle for multiplying autograph originals. Yet, for his next illustrated book, *Ye Legend of St. Gwendoline*, 1867, his first project after the Civil War, he returned to the camera to copy his drawings.[18]

13
Two clichés-verre by Vernet, *Tête d'arabe* and *Tête de cheval*, were in the collection of Germain Hédiard (Bib. III Paris, cat. no. 165). These prints are also cited by Hédiard in his 1903 article (Bib. III Hédiard).

14
This and all the Ehninger citations that follow are taken from Bib. V Ehninger/Ehninger. Ehninger's instructions from Germany signal the probability that some form of cliché-verre process was practiced there. F. A. W. Netto published his method of "glass printing" in 1840 (see note 3); it is likely that he repeated the process as published in manuals circulating to Germany from England. Likewise, German painters who learned the cliché-verre technique

in Barbizon may well have instructed their colleagues in their native country. Although German museums have been canvassed for examples of clichés-verre, thus far specific examples are limited to a few citations.

In addition to Ehninger's article, which he said was taken from the *Coelnischer Zeitung*, the April 1879 issue of *The Philadelphia Photographer*, in discussing the "etched negatives" (clichés-verre) of Messrs. Gilbert and Bacon, studio photographers in Philadelphia, mentions having seen similar examples from Germany "five years ago and more." Adolph von Menzel (1815-1905) also produced "negatives by painting," according to a report in the *Wiener Photographische Blätter* (Bib. V Menzel/Wiener Photographische Blätter). Menzel, whose early career was spent as a lithographer and illustrator, was very interested in photography and photographic reproduction; he considered photographic copies "the best kind of reproduction." A positive proof of his painted negative was inserted in an issue of *Photographische Mittheilungen* devoted to Menzel's work (Bib. V Menzel/Wiener Photographische Blätter). I wish to thank Beaumont Newhall who recently forwarded this important notice to me.

15
Bib. V Ehninger/Becker, pp. 77-78 gives several reasons for the commercial apathy, among them the rise of the carte-de-visite, audience unfamiliarity, and fears of fugitive prints. Generally, although many period photographs have faded, often considerably, the large majority of prints found in albums of *Autograph Etchings* are very stable and in pristine condition, perhaps not only because of the processing but also because of their limited use. There is no record of the project's cost, but it seems Ehninger was left with many copies: several albums were inscribed by Ehninger as gifts, e.g., a New York Public Library copy to a cousin and the Gernsheim Collection copy to his "brother brush," W. P. W. Dana (Humanities Research Center, the University of Texas at Austin). In a letter to Samuel P. Avery dated October 22, 1859, Ehninger, writing that he had run short of funds, requested payment from Avery for a commissioned painting. His restricted financial situation may have been related to his investment in *Autograph Etchings*. I am grateful to Madeleine Fidell Beaufort, who generously shared the contents of this letter.

16
Bib. II Hitchcock.

17
Few other American artists executed clichés-verre. Bib. V Ehninger/ Becker, p. 75 cites two prints not in Ehninger's album: one by Stone, another by Delessard. Their efforts have not been located. Becker (p. 78) also refers to a publication, *A Guide to Collodio-Etching*, 1881, by Benjamin Hartley, which included four clichés-verre by Hartley. Hartley did indicate in the text that he knew of Ehninger's work. The New York Public Library houses three Thomas Moran prints filed as "clichés-verre." The authors of this book propose, however, that these may be camera copies of Moran's work. The same may be true for James Hamilton, whose "clichés-verre" are cited by Arlene Jacobowitz, *James Hamilton 1819-1878, American Marine Painter*, exh. cat., The Brooklyn Museum, 1966. In addition to the work of Gilbert and Bacon (see note 14), Stephen Ferris produced at least one cliché-verre (see Appendix).

18
Ehninger had used camera reproductions prior to *Autograph Etchings* as well: his illustrations for Henry Wadsworth Longfellow's *Courtship of Miles Standish* were photographed by Mathew Brady (New York, Rudd and Carleton, 1858). Curiously, salt prints reproduced the drawings whereas albumen prints were employed for *Autograph Etchings*; the choice was unusual for *Autograph Etchings*, as the shiny flat surface further allied the clichés-verre to photography in the minds of the art-purchasing public. *Ye Legende of St. Gwendoline* was published by G. P. Putnam and Sons, New York, 1867, with photographic reproductions by Addis.

From 1857 to 1859 Ehninger developed the basic idea of cliché-verre—the utilization of a drawn surface as negative—into a refined system that extracted from both photography and printmaking. First, as did Harville and Pont in France, he substituted collodion for the stiff white lead ground. He flowed the collodion, a viscous film, onto the plate, forming a uniform, stable support for the drawing. Then Ehninger, like other practitioners of the medium before him, confronted the issue of rendering visual distinctions.

To create tonal differentiations by holding back the light from particular areas of the drawing, Ehninger selectively varnished the back of the drawn plate. Of course, unknown to Ehninger, Havell and Willmore had already used this procedure, which they borrowed from the etcher's practice of "stopping out," of holding back acid, rather than light, from parts of the drawing.[19] Additionally, Havell and Willmore envisaged the painted plate, an idea which had not occurred to Ehninger. Because of the natural variation and fluid gesture of stroke, the painted plate was composed of uninterrupted, extended tones. However, Ehninger's solution—selectively varnishing the plate—created two distinct zones of exposure and the result, as evident in Mignot's *The Tropics* (cat. no. 59), was contiguous, not continuous tone. While Ehninger's process articulated perspective, it did not create a sense of integrated space. Ranging from deft rendering of landscape vistas (Casilear), to sentimental narratives of exiles, of pilgrims who birthed America (Ehninger), the clichés-verre in *Autograph Etchings* reflect the linear style of engraved illustration. To indicate spatial planes, artists, like Kensett or Casilear, both experienced engravers (as were most of the contributors), employed traditional formal conventions of engraving. Hatching and crosshatching, and a variety of linear vocabulary offered them a more direct, satisfying, and familiar vehicle for spatial illusion.

In printmaking, drawing, and photography, as in all the visual arts, formal expression is integrally tied to, though certainly not contained by, the craft. The technique of cliché-verre eschews linear specificity for tonal fluency, detailed structure for abstract notations, textured relief for planar surface, solid mass for transparent veils. Although the cliché-verre is capable of direct, line-for-line transposition, the advantages of the medium lie in its photographic association. To use only the reproductive capacities (and surely this was enough for many in the 19th century) was not to diminish the technique's power, but to limit it. When a gifted imagination, however, encounters a medium particularly suited to it, then the individual and the craft are enhanced. This was the situation when Camille Corot was introduced to the cliché-verre in 1853.

A painter highly respected by his audience for his lyric and heroic landscapes, a man enormously loved by his friends for his gentle and jovial spirit, Corot began in 1851 to make regular visits to the home of his friend and fellow painter Constant Dutilleux in Arras, a town northeast of Paris, near Douai. Corot was then 55. Mourning the recent death of his mother, to whom he was very close, the artist sought solace in his friendship with Dutilleux.[20] Their acquaintance had started in 1847 when Dutilleux purchased one of Corot's paintings, and their friendship deepened over the years. Corot adopted the Dutilleux family as his own, and they likewise welcomed his regular visits. In fact, years after Constant Dutilleux's death (in 1865), Corot returned to Arras, to the warm welcome of the Dutilleux family.

Primarily a landscape painter, Constant Dutilleux supported himself, his wife, and his nine children by teaching art, printing lithographs, and painting portraits. Owner of an active lithography firm, Dutilleux also operated a large atelier in Arras, drawing on local talent for students. Like Corot, Dutilleux was a congenial man, an artist known for his warm, engaging personality. His studio became a meeting place for apprentice painters as well as practicing artists of the region, among whom were Adalbert Cuvelier, an amateur landscape photographer; L. Grandguillaume, professor of drawing in Arras; and lithographer and photographer Charles Desavary, who had been a student of Dutilleux and in 1858 became his son-in-law as well as business partner. Younger members included Alexandre Collette and Eugène Cuvelier, son of Adalbert.

Together the members of this group sketched, painted, and photographed, taking their equipment outside to be closer to their shared subject, the landscape. Their many field trips are documented in their paintings, sketches, photographs, and in clichés-verre. There were excursions along the Scarpe, the river which runs through the region (cat. no. 50), to the suburbs outside Arras, St.-Nicolas-les-Arras (cat. no. 16), to the farmland of friends, the property of Bellon, and even to the forest of Fontainebleau (cat. no. 49). The fields and forests offered them meaningful solitude; their spirited enclave provided faithful companionship. By day they painted; by night they exchanged ideas and interests.

Several of the group were actively involved in photography. Beside the painters' *chevalets*, the photographers stationed their cameras. Their landscape photographs, images of remarkable beauty, must have influenced the painters, as the painters' concerns surely informed the photographers (see fig. 5). The dialogue, both verbal and visual, was rich and articulate, mutually expanding their respective vocabularies.[21]

Adalbert Cuvelier was perhaps the most vocal proponent of the new art of photography and extended his inquiry to experiments without the camera. Cuvelier, in collaboration with Grandguillaume, independently invented, again, the cliché-verre technique.[22] It is not clear who first stimulated the idea. Perhaps the no-

tion surfaced by accident during a conscious search by a photographer and a draftsman to discover a pure autographic application for the most recent printing method. Perhaps seeing the smooth glass plates in Cuvelier's studio, Grandguillaume idly painted or drew on the collodion covering, thus generating the desire to print. Regardless of the circumstances, the invention must have originated early in 1853, for although Corot had visited Arras for at least two years prior, it was not until May of that year that Corot, in Arras for the wedding of Elisa Dutilleux to Alfred Robaut, executed, alongside Dutilleux, his first cliché-verre, *Le Bucheron de Rembrandt* (cat. no. 8).

Dutilleux apparently made 13 clichés-verre (substantially more than most artists who tried the technique). Corot, however, executed 66 images in the medium,

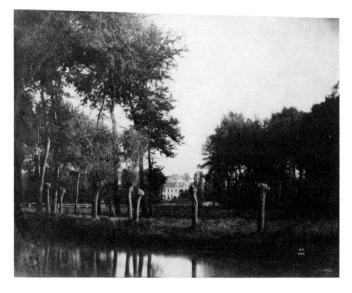

Fig. 5
Adalbert Cuvelier (French; act. 1850s). *Environs of Arras*, 1852. Photograph; 25.9 x 32.9 cm (10³⁄₁₆ x 12¹⁵⁄₁₆ in.). International Museum of Photography at George Eastman House, Rochester.

19
Bib. III The Literary Gazette, March 30, 1839, p. 203.
20
Bib. V Corot/Moreau-Nelaton, I, pp. 67-69.
21
Recorded in Bib. V Corot/Robaut, IV, pp. 298-324 are approximately 78 photographs, often by Charles Desavary, of Corot painting in the landscape. Many of the photographs are reproduced as well. The specific stylistic influence of landscape photography on Corot's paintings is explored in Bib. II Scharf, 1968, rev. ed. 1974, pp. 89-92 and Aaron Scharf, "Camille Corot and Landscape Photography," *Gazette des Beaux-Arts*, sér. 6, 59, 59 (February 1962), pp. 99-102. A detailed analysis of this influence, while important to Corot's clichés-verre, is beyond the scope of this study: so complex is the relationship, the subject could only be justly treated in an article devoted solely to Corot's clichés-verre.

22
Practically nothing is known of the biographies of Cuvelier and Grandguillaume. Grandguillaume was a professor of drawing at the Ecole du Génie in Arras. It is odd that no clichés-verre by Grandguillaume have been positively identified; certainly, he must have been a skilled draftsman. Nevertheless, his efforts may be among the several unidentified plates catalogued as School of Arras housed at the Bibliothèque Nationale, Paris.
Cuvelier was a manufacturer of oil. Moreau-Nelaton described him as "an industrialist who gave himself to photography" (Bib. V Corot/Moreau-Nelaton, p. 80). Cuvelier may have even been related to Dutilleux. Dutilleux's mother's name was Claire Catherine Cuvelier (Bib. V Dutilleux/Oursel, p. 9), a fact which may or may not be coincidental. (Dutilleux's father died of the plague on March 16, 1810, and his mother disappeared on May 3, 1811. The orphan, then only four, was raised by Henri Dutilleux, his cousin and godfather.) As Cuvelier wrote a letter to Charles Nègre dated November 12, 1861 (see cat. no. 8), we can establish his death as after that.

about two-thirds of his total graphic work.[23] Corot's clichés-verre divide chronologically into two periods. The first, in which he produced 50 works, spans the years from 1853 to 1860, a time marked by Corot's regular sojourns in Arras, which temporarily halted when Dutilleux moved to Paris in 1860. Two distinct sessions form the second group: 1871 and 1874. In 1871, seeking repose following the turbulent activities of the Paris Commune, Corot, then aged 75, traveled to Arras to visit Dutilleux's widow and Desavary, and to Douai to see the Alfred Robauts. With Robaut's prodding and offer to print, Corot drew on transfer paper, designs which were printed as transfer lithographs (Delteil's "autographies"). In Arras, Desavary provided the artist with glass plates, resulting in ten clichés-verre. Corot did six more prints in 1874, when he returned to Arras only months before his death.

As was his practice in etching and lithography, Corot completed clichés-verre only when others negotiated the maze of physical and chemical machinations. Corot was a printmaker with a proven impatience for the recipes of the craft. His initial efforts in cliché-verre were instigated by Cuvelier and Grandguillaume; they printed Corot's cliché-verre plates until 1858, when Desavary assumed the role.[24] The cause of the switch is unknown. Indeed the personalities of these early printers surely played a significant role that has yet to be adequately deciphered, and because the documentation concerning the actual production is sparse, it may remain a mystery.

Except for a very long hiatus in the 1860s during which he concentrated on etching and traveled more often to Fontainebleau than to Arras, Corot worked with the cliché-verre technique from 1853 until just before his death in 1875. He produced five plates during his first session and returned to Paris with prepared glass among his effects. That Corot's enthusiasm was intense is evidenced by the many mentions of "les verres" in letters to Dutilleux during the 1850s; he rarely, however, wrote of his paintings.[25] Sharing his fascination and zeal, Corot promoted the technique among Parisian friends such as Edouard Brandon and Antoine Chintreuil, but their experiments apparently stopped, as did Eugène Delacroix's, after one effort.

38

Fig. 6
Jean-Baptiste-Camille Corot (French, 1796-1875). *Trees on a Mountain (Les Arbres dans la montagne)*, 1856. Cliché-verre; 19 x 15.3 cm (7½ x 6 in.). Delteil 60. Bibliothèque Nationale, Paris.

Fig. 7
Jean-Baptiste-Camille Corot. *Young Mother at the Entrance of a Wood (Jeune Mère à l'entrée d'un bois)*, 1856. Cliché-verre; 33 x 26 cm (13 x 10¼ in.). Delteil 59. Bibliothèque Nationale, Paris.

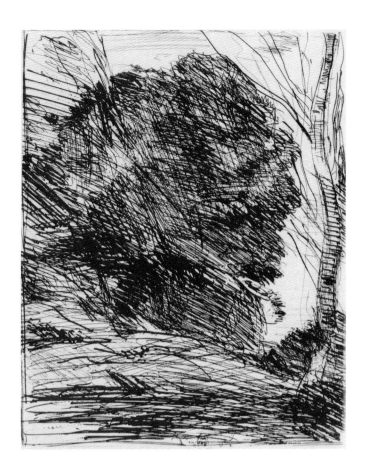

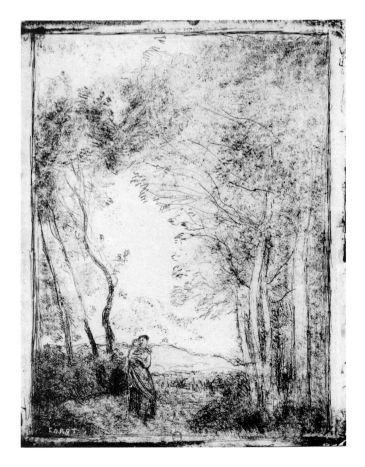

Corot's investigations are wide-ranging, diverse in execution, scale, and intent. Many of the prints are extemporaneous though fully formed sketches, in which the artist capitalized on the fluid, immediate gesture possible with the medium (fig. 6). Others are rapid abbreviations, scribbled shorthand for future compositions (cat. no. 19). Most of Corot's clichés-verre are small in scale, intimate sketches of forest interiors (cat. nos. 8, 25), but a few are large compositions, monumental in conception and execution (fig. 7). *Cavalier sous bois* captured the master's attention so firmly that he executed two versions (cat. nos. 9, 15). One composition, *Le Bain de berger* (Delteil 39), exactly repeats an earlier painting; but more often Corot did not copy but rather freely interpreted themes, many of which simultaneously occupied his painting hours in the studio (cat. nos. 18, 28).

Corot's prints in cliché-verre embody stylistic shifts related to changes in his paintings and drawings. From his earliest canvases—crisp, detailed, clearly defined landscapes encompassing deep vistas into space and in which strong light etches and individuates each form—Corot moved toward a diffuse, suggestive dissolution of contours, and more confined spatial configurations, all in a more limited tonal range.

To fix the flat masses of unarticulated tone in cliché-verre, Corot preferred the drawn plate, establishing images in broad, activated sweeps of zig-zag strokes (fig. 6). Seldom did he choose the painted technique, and when he did, the result was frequently not gradations of tone but rather dark, uninterrupted shapes, impressions of nature rather than specific physical representations of the landscape (fig. 8). To unify the solid blocks and separate lines, to curtain the distant horizon and reinforce the flat picture plane, to suggest the lush umbrella of the forest interior, Corot often enveloped the compositions in demi-tone (fig. 9). Instead of employing paint to build shifting densities in the negative, or flipping the glass to dissolve contours with halation, Corot created a random system of dots across the ground by striking the plate with the stiff bristles of a brush. The tapping, termed *tamponnage*, creates holes in the emulsion, translating to half-tone in the print.[26] *Tamponnage* realized for Corot the marriage of line and tone first applauded in the 1839 clichés-verre of Havell and Willmore.

if he did paint a cliché-verre plate in 1859, he probably would not have labeled it *"No. 1."* It is more likely that the Chicago plate is by Albert Brendel, an artist closely tied to activities at the Auberge Ganne in Barbizon. On March 7, 1859, Eugène Cuvelier married Louise Ganne and it is probable that Brendel executed his first cliché-verre at that time, since it is dated *"Mars. 59."* Furthermore, in 1903 Hédiard viewed six clichés-verre by Brendel in the Paris collection of the then widowed Louise Ganne Cuvelier: four by the drawn plate method and two by the painted plate technique (Bib. III Hédiard, p. 422). Impressions of the four drawn plates have been located (see Appendix and cat. nos 3, 4, 5), but no impressions of the painted plates seem to have survived. Hédiard called these two *Lisière de bois* (The Forest's Edge) and *Deux Chevaux s'abreuvant à une mare en forêt* (Two Horses Drinking at a Pond in the Forest). That the subject of the Chicago plate, two women at the edge of a forest, would fit Hédiard's title for Brendel's cliché-verre and that the plate is dated March 1859, increases the likelihood that this plate is indeed Brendel's first cliché-verre. Hédiard knew only one impression of the other painted plate, *Deux Chevaux s'abreuvant,* a beautiful impression which he thought recalled the manner of Daubigny's *Vaches à l'abreuvoir* (cat. no. 45).

Catalogued by Delteil under Daubigny (Bib. V Daubigny/Delteil 150) is a cliché-verre titled *Les Deux Chevaux à l'abreuvoir,* a cliché-verre which is not listed in Henriet's 1875 catalogue raisonné of Daubigny's prints (Bib. V Daubigny/Henriet). Delteil was also aware of only one impression of *Les Deux Chevaux,* the one from Hédiard's collection which Delteil himself assigned to Daubigny in the posthumous sale of Hédiard's prints (Bib. III Paris, cat. no. 141). The print, purchased by Atherton Curtis, was given to the Bibliothèque Nationale in 1943. Hédiard, who not only preferred *Deux Chevaux s'abreuvant,* but also experimented with the cliché-verre process seeking, in all probability, a reproductive method for his publications, executed a copy of the print; the reproduction, now housed in the Baltimore Museum of Art, was formerly in the collection of George A. Lucas who, in the 19th century, purchased a vast and impressive array of prints, including many clichés-verre. Lucas inscribed the impression in pencil on the verso: *Reprod. of a cliché-glace by Hédiard/c.g.—attributed by H. to Daubigny.* Did Hédiard, then, assign *Deux Chevaux s'abreuvant* to Daubigny or to Brendel and are, in fact, these two clichés-verre one and the same? Lucas may have misread Hédiard, who associated *Deux Chevaux s'abreuvant* with Daubigny's print, not with Daubigny. Or Hédiard may indeed have reattributed the print to Daubigny after their publication by him. Thematically, the cliché-verre is closer to Brendel, who most often painted horses and sheep, a penchant reflected in his drawn clichés-verre. Furthermore, that one of Daubigny's plates would have gone unprinted would have been unusual as most of his clichés-verre exist not only in several impressions but in varying printings as well. In conclusion then, it seems that the Chicago plate and Daubigny's Delteil 150, both painted plates, one unprinted in the 19th century and one rarely so, are the two missing clichés-verre by Brendel: *Lisière de bois* and *Deux Chevaux s'abreuvant à une mare en forêt.*

24
Bib. V Corot/Robaut details the printers of Corot's clichés-verre and Bib. III Melot presents this information in a useful chart which graphically illustrates the location and provenance of Corot's plates.

25
An album of Corot's letters is housed at the Bibliothèque Nationale, Paris; the texts of most of the cliché-verre references are reprinted in Bib. III Melot under documentation concerning the specific print.

26
Hédiard termed the drawn plate "à la pointe" and the painted plate "au pinceau"; labeled crisp impressions (close contact) "manière nette" and diffuse impressions (a flipped plate, printed with halation) "manière estompe"; and designated the tapping in glass "tamponnage," literally dabbing (Bib. III Hédiard, pp. 408-410).

23
Delteil lists 66 clichés-verre by Corot (Bib. V Corot/Delteil). Additionally, one other cliché-verre plate, executed in the painted plate method, has been attributed to Corot: *Women at the Forest's Edge,* Art Institute of Chicago (Bib. V Corot/Chicago, no. 223). The plate, of which no 19th-century impressions exist, is inscribed along the left edge in paint: *No. 1 Mars. 59.* Recently, Melot assigned the Chicago plate to Dutilleux (Bib. III Melot, p. 24). The manner of applying paint in small short strokes is much like Dutilleux's. Nevertheless, Dutilleux's clichés-verre are dated 1853 and 1857 and certainly,

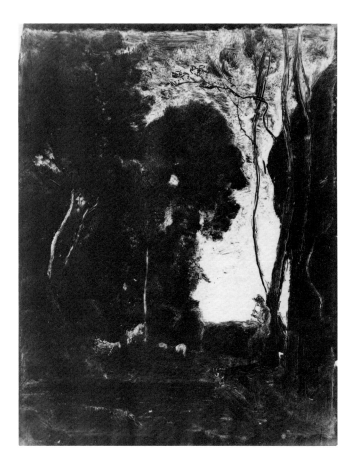

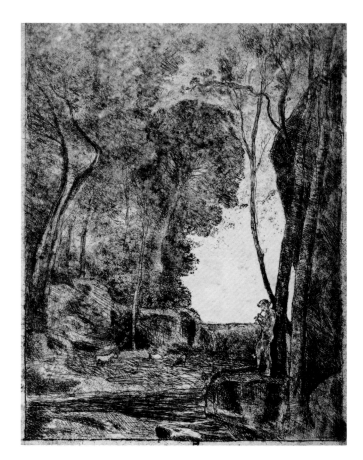

Fig. 8
Jean-Baptiste-Camille Corot. *Little Shepherd, 3rd Plate (Le Petit Berger, 3eme planche)*, c. 1856. Cliché-verre; 36.2 x 27.3 cm (14¼ x 10¾ in.). Delteil 62. Bibliothèque Nationale, Paris.

Fig. 9
Jean-Baptiste-Camille Corot. *Little Shepherd, 1st Plate (Le Petit Berger, 1er planche)*, 1855. Cliché-verre; 32.5 x 24.5 cm (12¹³⁄₁₆ x 9⅝ in.). Delteil 49. Bibliothèque Nationale, Paris.

In contrast to Corot, whose prints formed only a small portion of his total oeuvre, Charles Daubigny was a professional, highly prolific graphic artist. Prior to the commercial acceptance of his paintings, Daubigny supported himself as an illustrator; later his etchings won prizes in the Salon. When the French government honored Daubigny by commissioning an etching after a work by the 17th-century painter Claude Lorrain, and after the publication of two albums of Daubigny's own etchings in 1850 and 1851, the artist's reputation as a printmaker was secured.

Daubigny processed and editioned his etchings himself. Using standard recipes for the procedures as well as adding his own modifications, Daubigny took as much pleasure in the cuisine as in the craft of printmaking. He worked the prints through several states, changing the design, adding new elements, layering tonal patches, manipulating the surface to emphasize a specific effect—a storm moving across an open field, the glow of lantern light, the sparkling reflections of water in a wooded cove.

Daubigny applied the same methodology to his clichés-verre, except that instead of multiple states he modulated the drawings on the glass and varied their printing.[27] By applying less conventional tools, like the roulette wheel (see cat. no. 38), by painting over drawn areas to hold back the light (see cat. no. 42), by using the painted plate technique as well as the drawn method, Daubigny achieved a range of textures and moods. In addition to variations in texture, Daubigny freely explored the possible permutations of the glass matrix as well. Of Daubigny's 17 clichés-verre, completed in 1862,[28] almost every image was printed in variant impressions: with the drawn emulsion close to the photosensitive paper for crisp detail, and with the emulsion away from the paper surface, softening the line with expanded tone (see cat. nos. 35, 36).

The circumstances surrounding Daubigny's impressionistic clichés-verre remain unknown. It is curious that he waited to begin his work in this medium until nine years after Corot's first attempt, for surely he had seen examples of Corot's experimentations. The devoted friendship of the two painters was legendary: they often traveled together, painting and sketching regions of France, Holland, and Switzerland. The question of who printed Daubigny's clichés-verre is also

unresolved. The artist may have editioned some or all of the glass plates, by himself or with someone's supervision. The work may have been done in Arras, although in 1862 Dutilleux was residing in Paris. Although it is possible that Dutilleux kept prepared plates in the city and Daubigny sketched in his studio, the plates can be traced to Cuvelier's collection and consequently, Daubigny must have executed the set in Barbizon, collaborating with the young photographer Eugène Cuvelier, son of Adalbert Cuvelier, who brought the technique with him to this rural hamlet on the periphery of Fontainebleau forest.

By 1862 Barbizon had become the physical and spiritual center for a group of painters who sought a return to naturalism both in their creative endeavors as well as through their physical surroundings.[29] The explosive political events of the Revolution of 1848 and its aftermath created a restrictive artistic climate which, along with a life-threatening cholera epidemic, were important factors that had stimulated an emigration of landscape painters from Paris. Jean-François Millet and Charles Jacque established permanent residence in Barbizon in 1849, joining Théodore Rousseau, who for some time had been stationed at the popular Auberge Ganne. Constant Dutilleux became a regular registered guest at the inn, along with the Goncourt brothers, George Sand, Paul Huet, Narcisse-Virgile Diaz de la Peña, Albert Brendel, Thomas Couture, and an extended list of Parisian luminaries. After 1851 Dutilleux visited Barbizon yearly, and in 1855, he escorted his students there.[30] Most probably Eugène Cuvelier was among them.

Cuvelier was to remain in Barbizon: in March 1859 he married Louise Ganne, the attractive and vivacious daughter of the innkeeper. Corot witnessed the wedding; Rousseau and Millet were attendants; the entire community of farmers, painters, authors, musicians, critics, and villagers celebrated at a lively reception in the couple's honor.

In addition to his own work, painting and especially photographing the forest landscape, Cuvelier demonstrated to others the cameraless process he had been taught by his father in Arras. He encouraged many friends and guests at the inn to try the cliché-verre technique. A substantial number of artists experimented at Cuvelier's instigation: at least a dozen painters, and probably more, drew on glass plates at Barbizon. Indeed, it may well have been at the artists' initiative that Cuvelier ended up supervising and printing the plates. Just as the painters gathered for conversation or rainy day amusement to decorate the doors, walls, and furnishings at the Auberge Ganne, so might they have assembled to sketch cliché-verre plates. The participants included permanent residents such as Millet and Rousseau; regular visitors, among them Camille Flers and André-Adolphe Wacquez; and itinerant landscapists, for example, the German Julius Bakof, and Danish artists Frederik Kiaerskou and Axel Schovelin.

Most artists signed their plates and several indicated the year as well. The given dates are 1859, 1860, 1861, or 1862, the same year that has been assigned to Daubigny's prints. Apart from Corot's late clichés-verre (1871 and 1874) and other isolated incidences of activity, this flourish in the early 1860s represents the largest group of artists to utilize the cliché-verre process during the 19th century.[31] Although the period roughly corresponds to the work of Ehninger in America and Hancock in England, it seems that each practitioner was not aware of the others' activities. The majority of the artists' cliché-verre experiments done in Barbizon with Eugène Cuvelier were motivated by curiosity about a technique that could directly reproduce their designs. In general, their clichés-verre, although often very pleasing compositions, reflect none of the visual exploration found in the most innovative work of Corot and Daubigny. The Barbizon prints must be seen in a broader context, taking their place alongside the numerous photomechanical processes developed during the 1850s 1860s, and 1870s.[32]

27
It was very difficult, although certainly not impossible, to make changes on the glass plates: paint or oil-of-lavender could be applied behind the glass or over the dried collodion or printer's ink coating, but the additions created a second layer of density in the negative which generally created a new tonality. Daubigny did manage successfully to alter some lines of *L'Ane au pré* (cat. no. 42), but as the plate has not been located, it is impossible to know precisely what method he employed. While in the painted plate the surface could be easily manipulated when the paint was wet, smooth alterations later were more difficult.
28
Bib. V Daubigny/Henriet assigns 17 clichés-verre to Daubigny; Bib. V Daubigny/Delteil catalogues 18. For an explanation of the discrepancy, see note 23. The date 1862 is given by Henriet, by Delteil, and more recently by Bib. V Daubigny/Fidell Beaufort and by Bib. V Daubigny/Fidell Beaufort/Bailly-Herzberg.
29
See Bib. II Herbert and Bib. II New York, intro. The visitors to and activities at the Auberge Ganne, as well as in Barbizon, are discussed in Bib. II Barbizon.
30
Bib. V Dutilleux/Oursel, pp. 13-14.
31
To be sure, the early '60s culminated many Barbizon events as well: the landscapists gained official acceptance; their group exhibited together, as a unit, in 1860. Painters from all over Europe, and even America, gathered to the region. Amid what Robert Herbert called "the grand late flowering" of Barbizon art from 1864 to 1878, despite the belated recognition of the group, the Barbizon school of landscape painters was disappearing as a cohesive whole. Rousseau died in 1865, as did Dutilleux. Millet and Corot died in 1875 and Daubigny only three years later.
32
For further discussion of the particular photomechanical developments, as well as their relationship to the visual arts, see Bib. II Ivins; Bib. II Jussim; Bib. III Cate; and Dennis Cate, "The 1880's: The Prelude," *The Color Revolution, Color Lithography in France, 1890-1900,* exh. cat., Rutgers University Art Gallery, 1978, pp. 1-16.

That the cliché-verre's most vigorous period in 19th-century England, France, and America occurred in the several decades following 1853 is not mere coincidence: in the years before the 1880s, when the photographer completely replaced the copyist, experimentors invented and perfected systems to apply photography to the growing demand for accurate, inexpensive reproduction. The cliché-verre process was considered by most of the artists, inventors, and publishers, to be a novel and desirable means to achieve a direct transposition of their drawings, a copy without the intervention of a copyist.

The public attitude was expressed by two critics. As already cited, in 1886 Ripley Hitchcock in America gave cursory notice to Ehninger's album. Simultaneously in France, Henri Beraldi, in his catalogue of Corot's prints, briefly mentioned the clichés-verre (Bib. V Corot/Beraldi). In both cases the method, although worthy of reference, did not rank among the hierarchy of print techniques (beginning with etching) but rather was one more application, albeit an interesting one, of the photographic process. And yet, this in no way denigrated the cliché-verre in their eyes, for the public accepted the notion of creating drawings specifically for reproduction;[33] in fact, it was with this attitude that Charles Desavary printed Corot's clichés-verre.

Charles Desavary, who took over Dutilleux's lithography firm when his father-in-law moved to Paris in 1860, actively published photographs of Corot's drawings and paintings. He began the undertaking originally for Alfred Robaut as an aid to his brother-in-law, who was organizing a catalogue raisonné of Corot's works.[34] Among the albums of facsimiles of paintings and drawings, Desavary often included clichés-verre.[35] Usually these albumen prints were mounted on stiff board, surrounded by a green lithographed border, and embossed with the Desavary/Dutilleux stamp[36] (see cat. no. 29).

When plates were not available to Desavary, either because they had broken or were in Cuvelier's possession, Desavary sometimes printed reduced versions of the image (cat. no. 12). He printed eight plates in decreased scale, all from negatives first printed by Cuvelier and subsequently in Cuvelier's collection. The Cuvelier collection of clichés-verre, which was purchased by Albert Bouasse-Lebel around 1911, was acquired in December 1919 by Maurice Le Garrec, successor to Edmund Sagot at the Galerie Sagot-Le Garrec, Paris. The Corot plates and prints owned by Charles Desavary were bequeathed to Robaut. These items were then passed to Robaut's colleague and helper, Etienne Moreau-Nelaton, who, in 1936, gave the plates and many impressions to the Bibliothèque Nationale, Paris.

Along with the printings of Corot cliché-verre plates owned by Desavary, and reduced copies of plates belonging to Cuvelier, as well as a few photolithographic reproductions, Charles Desavary made countertype (see Glossary) impressions from plates he owned. The countertypes were produced by a variety of methods, according to Michel Melot, who consulted documents concerning Desavary's printings among some of Bouasse-Lebel's papers (now the property of Mlle. Paule Cailac, Paris).[37] Desavary made the negatives for his countertypes from the original glass plates or from impressions from the plates. The prints could be photographed with a camera or made translucent ("waxed") with vaseline or paraffin oil and contact-printed to produce a new negative. These countertype negatives were on paper and on glass; the glass, of course, having the disadvantage, like the original plates, of being fragile. Finally, the glass, or more common paper negatives, could be printed by contact or reduced onto a plate 9-by-12 cm or 13-by-18 cm. In the case of the reduced plates, it was necessary to enlarge the negative to the original scale, which again altered the quality of the original print. While sometimes these countertypes are difficult to distinguish without documentary evidence on the print, often the copies from the original plates are thin, almost rough reproductions (see cat. no. 20).

Desavary was not alone in his efforts to copy clichés-verre. The photographer Charles Nègre, at the request of Adalbert Cuvelier and Corot, executed a photo-etching of Corot's first cliché-verre Le Bucheron de Rembrandt (cat. no. 8). Alphonse-Louis Poitevin, Parisian lithographer, publisher, and photographic experimentor, applied his particular method of photolithography to reproduce Corot's Le Tombeau de Sémiramis. Even Germain Hédiard, author of the first critical article on the cliché-verre in 1903 (and in the late 19th century, of a series entitled Maîtres de la lithographie, which includes volumes on Paul Huet and Henri Fantin-Latour), experimented with reproducing clichés-verre. The trials were made, most likely, in an effort to find a sensitive means of reproduction to illustrate his many catalogues. For example, his facsimiles of four Huet drawings, catalogued in the posthumous sale of his collection as clichés-verre, are documented by Delteil (three of these have been located at the Metropolitan Museum of Art, New York).[38]

Additionally, it was probably Hédiard who, in the midst of the "color revolution," stimulated the production of clichés-verre in the blue line process (see cat. no. 34). These could have been the efforts of Alphonse-Louis Poitevin, who did numerous experiments in photography earlier in the century. Nevertheless, Hédiard is certainly the more likely candidate as the only blue line prints, all by Daubigny, have been located in the collection of George A. Lucas (now housed in the Baltimore Museum of Art), and Lucas included other Hédiard reproductions among his prints as well. Hédiard's enthusiasm with his experiments and his findings for his 1903 article must have piqued the curiosity of Charles Guérin, a painter and lithographer and relative

of Hédiard, who tried the cliché-verre process around the turn of the century (see Appendix).

Despite the fact that the cliché-verre process could not compete with increasingly sophisticated photomechanical techniques for speed, accuracy, or economy, publications and republications of 19th-century clichés-verre continued in the early decades of the 20th century. Around 1911 Albert Bouasse-Lebel, Parisian collector and publisher of religious images in St.-Sulpice, had purchased the Cuvelier collection of cliché-verre plates. Consisting not only of Corot negatives executed under Adalbert Cuvelier's supervision in Arras, the collection also contained the many drawn plates stimulated by Eugène Cuvelier in Barbizon. Curious about the techniques of printing these clichés-verre, Bouasse-Lebel enlisted the aid of Paul Desavary to pull proofs from the plates. Although Paul Desavary (1861-after 1919), son of Charles Desavary (and grandson of Constant Dutilleux) was only 13 when Corot visited Arras for the last time, Desavary *fils* had in his possession a notebook of his father's recipes and procedures.

Between 1911 and 1913, using these instructions and a special paper made by Lumière, a large manufacturer of photographic materials in Lyons, Paul Desavary reprinted many of the plates, some by Corot and Daubigny, as well as those of Millet, Rousseau, and Delacroix (Bib. III Lucerne). According to Jean Cailac, the number of impressions pulled was quite small, 10 to 15 proofs, and many, judged inferior, were destroyed. Indeed, Bouasse-Lebel impressions are fairly rare today.

Bouasse-Lebel did not specifically mark his edition in any way, except very occasionally with an initialed paraph (Lugt 67a). Nevertheless, several general indicators sometimes identify this edition. Most important, Bouasse-Lebel did not generally trim his impressions; in fact, most often the margins of the plate are clearly evident and sometimes a small border as well. Of course, the extra paper, not covered by emulsion as were the margins of the plate, is dark (see cat. no. 22). On the thin paper Paul Desavary invariably exposed the plates emulsion side down, in close contact with the sheet below. As with any printer, cliché-verre or otherwise, his characteristic touch is apparent: crisp, clear exposures, designed not to interpret the negatives but to display the fullness of what was directly painted or drawn on the plate.

In 1921 Maurice Le Garrec, who had acquired the plates from Bouasse-Lebel, reprinted 36 of the Cuvelier plates for his publication, *Quarante Clichés-Glace*. As the number of impressions issued of each image (150 plus additional impressions made for deluxe folios) was substantially larger than the quantity of impressions made in the 19th century, the public's experience of these images has generally been through the Le Garrec printing. Although like Bouasse-Lebel, Le Garrec made every effort to duplicate the character of the 19th-cen-

tury paper, the changes caused by the use of the 20th-century paper are apparent in *Le Songeur* (cat. no. 13), an image which depends so much on subtle variation of tone and open, clear definition of forms. The problem of transposition was less critical in the more straightforward linear plates, where even exposure of the negative produced an effect equal to the 19th-century printings, even though the lines are black instead

33
For example, five clichés-verre, along with seven etchings, were included in a posthumous sale for Corot at Durand-Ruel, Paris, 1876. Delteil includes documentation of clichés-verre in 19th-century sales, for example, Alfred Lebrun, 1899. Hédiard also mentions their appearance in dealer's catalogues (Bib. III Hédiard, p. 408). Melot has detailed the progressive acceptance of the cliché-verre vis-à-vis the art-purchasing public and the gradual inclusion of the cliché-verre in the catalogues raisonnés (Bib. III Melot, pp. 16-18). Henriet, who included Daubigny's clichés-verre in a catalogue raisonné as early as 1875, lamented the general weakness of the photographic printing. "One would think," he wrote, "that with the numerous processes of reproduction at our disposal today, it would be easy to obtain a transfer of clichés-glace onto lithographic stone or copper." He then went on to suggest, somewhat prophetically, that a folio of these copies would be a publication "of the highest artistic taste" (Bib. V Daubigny/Henriet, p. 154).

34
Bib. V Corot/Robaut. Alfred Robaut's father Félix-Fleury Robaut was Constant Dutilleux's cousin, as well as brother-in-law. Robaut *père* owned and operated a lithography studio in Douai in which Robaut *fils* was apprentice and later printer. After the death of Dutilleux in 1865, Alfred Robaut left Douai, and the lithography business, to be with Corot in Paris. Robaut executed one cliché-verre, after a painting by Corot (see Appendix).

35
Several albums are located in the Bibliothèque Nationale, Paris: a two-volume set of photographs of paintings, a book of facsimiles of drawings issued in 1873, and Robaut's manuscript volumes illustrated with photographs by Desavary. Mixed sets, including photographs of paintings and drawings, and clichés-verre are owned by André Jammes, Paris, and Samuel J. Wagstaff III, New York.

36
That Corot's later clichés-verre are generally printed on albumen paper whereas the earlier prints are most often found on salted paper is related to two factors: first, esthetically, salt prints more closely resemble the texture of etching paper, or, if not in high relief, are at least less blatantly flat and shiny, thus de-emphasizing their photographic origin; second, beginning in the 1850s and especially in the '70s when Desavary was printer, sensitized albumen paper was increasingly available in prepared sheets, packaged and ready for use. As a manufactured commodity, the albumen paper gave Desavary the more consistent and predictable results which he sought for even reproduction.

37
Bib. III Melot, p. 22. For a lengthy discussion of countertypes, see Bib. III Cailac.

38
Associated with Hédiard are the curious reproductions of Henri Fantin-Latour drawings (now in the collection of André Jammes, Paris). It is difficult to establish exactly how these were achieved. Surely the actual drawings were not waxed, nor were the drawings specifically created in negative values to be contact-printed to positive, as suggested by Van Deren Coke (Bib. II Coke, p. 239). For further discussion of these puzzling reproductions, see Appendix.

of brown (see cat. no. 19). Only in the plates that depended on tonal interpretation did the difference significantly affect the product.

Although Le Garrec placed his stamp (Lugt 1766a) on the verso of every print "in order," he wrote in advance publicity of the set, "to avoid any confusion between their [19th-century] impressions and the modern ones," as contemporary sensibilities recognize, printings of photographic negatives are subject to the same variances that affect printings of etching plates or lithography stones: the sensitivity of the printer, the spirit of collaboration, and the availability of specific materials.

In investigating the production of particular prints, two points became clear. First, the circumstances surrounding many printings are not specifically documented, and we are left to intelligent speculation; the evidence rests mainly in the impressions themselves. Second, that many reproductive possibilities were explored by numerous people, active at different times, becomes increasingly evident and significant. Of clichés-verre by Daubigny and Corot, there exist photolithographs, reduced photolithographs, reduced photographic prints, and countertypes. In addition to his possible exploration of color in the cliché-verre, Germain Hédiard developed his own process to reproduce clichés-verre (as well as etchings and drawings). There was activity to edition clichés-verre both contemporary with their creation (Desavary, Poitevin, and Nègre) as well as posthumously (Hédiard, Bouasse-Lebel, and Le Garrec). It is ironic that the cliché-verre process, which was designed by many to be a means of reproduction in the first place, would itself be reproduced by various methods. That the clichés-verre of Corot and Daubigny were the focus of the complex techniques may well indicate that their prints were viewed not solely as photomechanical, but as an alternate method of producing original images.

Despite the efforts of more open-minded collectors, dealers, and authors, the cliché-verre as a technique equal to the "higher" forms of printmaking, such as etching and lithography, has gained approval only slowly. (In the same vein, the photographic community in the 20th century has been similarly sluggish in recognizing the cliché-verre as photograph.) As William Ivins, with his usual perception, wrote in 1953:

44

As we look back from the middle of the twentieth century all that kind of talk and opinion [of hierarchies among techniques] seems very silly, for it has become obvious that what makes a medium artistically important is not any quality of the medium itself but the qualities of mind and hand that its users bring to it. . . .

So far as the artist was concerned [the cliché-verre] was a much more direct and simple process than etching. But because these prints were neither etchings, nor lithographs, and because they were not actually photographs made with a camera, they never became popular among collectors or public. People simply could not adjust themselves to such shocking and novel technical ideas as were exemplified in these prints. In this way tradition won out over the actual fact that here were some of the most thoroughly original and indubitably artistic prints of the century.[39]

Ironically, simultaneous with the reissues of 19th-century images during the early years of the 20th century, new clichés-verre were again being produced. Photographers, printmakers, and painters were inventing the cliché-verre process all over again. For artists of the early 20th century, the continuous gray scale of the negative and the flat surface of the print were qualities to be embraced. Precise elements inherent to the cliché-verre, its visual vocabulary, became tied to broader issues: transparency combined with superimposition, reinforced picture planes in contrast to spatial illusion, attitudes toward abstraction, experiment, and chance. Firmly rooted in the 19th century, in the varied printings of Daubigny and the powerful abstractions of Corot, in the tonal fluidity of Daubigny's painted plates and the shifting surface of Corot's *tamponnage*, the cliché-verre, as cameraless photograph, has become in the 20th century, as predicted in 1839, "an art *per se*."

39
Bib. II Ivins, pp. 114-115.

19th-Century Entries

Julius Bakof
German; 1819 Hamburg 1857

Little is known about landscape painter Julius Bakof. He left his native Hamburg in 1839 and traveled to Munich and the Alps. In 1852 Bakof was in Geneva, in the atelier of Swiss painter Alexandre Calame, who was known primarily for his many renditions of mountain summits. In Bakof's many paintings of Lake Geneva, he explored the visual effects of the seasons and the atmospheric richness of different times of the day. In the Alps, Bakof depicted ruins and forges, mountains and forests. A peripatetic traveler, he visited Bavaria, Switzerland, Paris, and, as a landscape painter, was inevitably drawn to the Fontainebleau forest. Bakof was in Paris and Barbizon from January through October of 1857; in November he returned to Hamburg, where he died before the year's end.

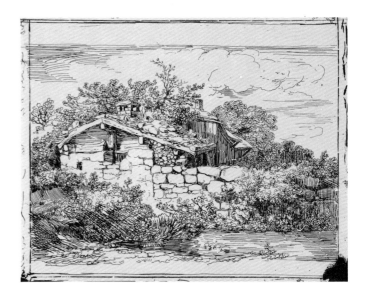

1

Cottage (Chaumière)
c. 1857 (c. 1911/13)
Signed in plate, lower left: *J. Bakof*
Image: 15.2 x 18.4 cm (6 x 7¼ in.)
Plate: 16.5 x 19.2 cm (6½ x 7⅝ in.)
Sheet: 18.1 x 22.3 cm (7⅛ x 8¾ in.)
Provenance: Albert Bouasse-Lebel, Paris
Collection Galerie Sagot-Le Garrec, Paris

Chaumière reproduces in cliché-verre the landscape genre Bakof painted and sketched: the serene mood of springtime in the country. As there are rocks on the cottage roof, perhaps to prevent snowslides, the subject may well be a scene in Switzerland, an area Bakof traveled often. Approaching the cliché-verre plate as a sketchpad, Bakof drew in a straightforward manner, outlining the forms and using hatching to delineate shadows.

Although Julius Bakof died in Hamburg late in 1857 and Eugène Cuvelier did not settle permanently in Barbizon until 1859, as *Chaumière* was located in the collection of Galerie Sagot-Le Garrec, a collection purchased from Bouasse-Lebel who, in turn, acquired the prints and plates from the Cuvelier family, it is reasonable that Bakof produced the print under Cuvelier's guidance, probably during the course of visits Cuvelier most likely made to Barbizon in the years before his marriage to Louise Ganne.

Jacques-Emile-Edouard Brandon
French; 1831 Paris 1897

Brandon entered the Ecole des Beaux-Arts, Paris, in 1849. Known primarily as a painter of genre subjects and historical scenes, Brandon followed the style of Gustave Courbet. During the years 1856 to 1863, when many of his contemporaries gathered in Barbizon, Brandon worked in Rome. Upon his return to Paris, the artist slowly gained recognition for his paintings and won several medals in the late 1860s. In his later career, Brandon concentrated on biblical themes and scenes of Brussels and Amsterdam's Jewish Quarter. Except for his early years in Rome and brief journeys north, Brandon lived and worked in Paris, where he died in 1897.

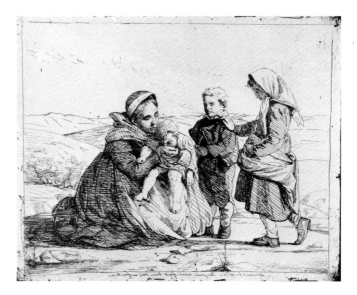

2
Souvenir of Nice—Young Mother Giving Her Child a Drink
(Souvenir de Nice—Jeune Mère fait boire son enfant)
January 1854 (c. 1911/13)
Signed and titled in plate (in reverse): lower left, *E. Brandon/54;*
lower center, *Souvenir de Nice—Une jeune mere fait boir son enfant*
Image: 15.2 x 18.9 cm (6 x 7½ in.)
Plate: 16.5 x 20 cm (6½ x 7⅞ in.)
Sheet: 19 x 21.2 cm (7½ x 8⅜ in.)
Provenance: Albert Bouasse-Lebel, Paris
Collection Galerie Sagot-Le Garrec, Paris

Like Antoine Chintreuil (cat. no. 6), Brandon executed his cliché-verre in Camille Corot's studio. In a letter to Constant Dutilleux, dated January 23, 1854, Corot included a message to Adalbert Cuvelier: "Mr. Brandon saw and was very satisfied with the result. He thanks you kindly . . ." (Bibliothèque Nationale, Paris).

Brandon's memories of Southern France are bathed in light. The strong sculptural figures, reminders of the artist's mentor Courbet, are rendered in emphatic outline. The forms emerge as solid mass, chiseled from the simple landscape background.

Albert Heinrich Brendel
German; Berlin 1827-1895 Weimar

After his training at the Berliner Akademie, Brendel moved to Paris in 1851 and studied with the celebrated history painter, Thomas Couture, and with Giuseppe Palizzi, an Italian painter living in Paris, who was known for his paintings of animals, especially goats. With Palizzi, Brendel developed his specialty in animal painting and through Couture, Brendel learned about Barbizon.

In 1852 Brendel left Paris for Southern France and Italy. By the time he returned to Paris two years later, he had decided to associate himself with the group of painters living in Barbizon. In addition to stylistic affinities with the Barbizon school, Brendel actively participated in the events at the Auberge Ganne, where he was pensionnaire. Visitors to the inn often painted a wall or piece of furniture as both decoration and documentation of their stay. Brendel contributed two of his typical scenes: one of horses, the other of sheep. By 1859 the artist gained official recognition in the Salons as an animal painter. His painting, *Bergerie à Barbizon* (Musée de Toul), upon which the cliché-verre, *Petite Bergerie*, was based, was purchased by the State in 1863.

After 1864 Brendel shifted his interests from Paris and Barbizon back to Berlin. While he continued to travel to Barbizon, the artist's work in Germany commanded most of his attention: in 1868 he was elected member of the Akademie and in 1875 he became Director of the Kunstschule, Weimar.

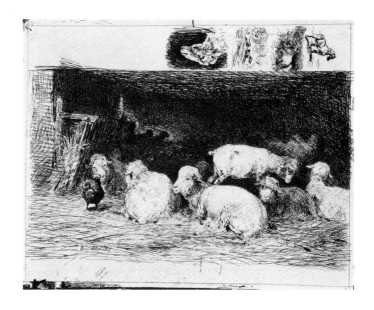

3
Sheepfold, Large Plate (Grande Bergerie)
1861 (c. 1911/13)
Signed in plate, lower left: *Brendel 61* (6 in reverse)
Image: 17.5 x 28.2 cm (6⅞ x 11¹/₁₆ in.)
Sheet: 24.2 x 29.8 cm (9½ x 11¾ in.)
Provenance: Albert Bouasse-Lebel, Paris
Collection Galerie Sagot-Le Garrec, Paris

The work of Albert Brendel is often confused with that of his contemporary Charles Jacque, so often did these artists re-create the theme of sheep—in the field and in the fold. Brendel repeated the motif in two etchings for the Société des Aquafortistes and in two clichés-verre. In the same way he regarded his etching, Brendel most often experimented with cliché-verre as a means of directly reproducing his paintings rather than as a medium for visual exploration.

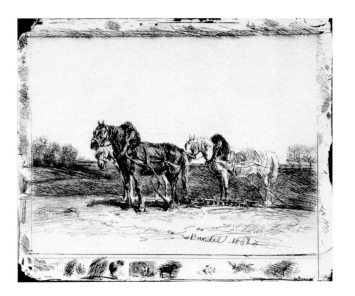

4
Three Work Horses (Trois Chevaux au labourage)
1862 (c. 1911/13)
Signed and inscribed in plate: lower right, *Brendel 1862*
(6 in reverse); margin, lower left (in reverse): *Croquis*
Image: 14 x 18.4 cm (5½ x 7¼ in.)
Plate: 16.5 x 20.3 cm (6½ x 8 in.)
Sheet: 17.8 x 21.3 cm (7 x 8⅜ in.)
Provenance: Albert Bouasse-Lebel, Paris
Collection Galerie Sagot-Le Garrec, Paris

With an economy of description, Brendel formed backgrounds in large areas of repeated zig-zag strokes and noted forms in a few outlines which are filled with parallel hatching. In the margins he often tested the effects of various strokes in small, although lively, sketches. For *Planche de croquis* (cat. no. 5) Brendel enlarged this practice and utilized the entire glass plate as sketchpad.

5
Plate of Sketches: Farm Horse; Canal Scene; Head of a Man; Horseman (Planche de croquis)
c. 1862 (c. 1911/13)
Images: horse, 17.8 x 22.9 cm (7 x 9 in.), signed in plate, lower left: *Brendel*; canal, 18.4 x 11.4 cm (7¼ x 4½ in.), signed in plate, lower right: *Brendel*; head, 4.4 x 3.8 cm (1¾ x 1½ in.); horseman, 4.1 x 6.9 cm (1⅝ x 2¹¹⁄₁₆ in.)
Sheet: 30.5 x 23.8 cm (12 x 9⅜ in.)
Provenance: Albert Bouasse-Lebel, Paris
Collection Galerie Sagot-Le Garrec, Paris

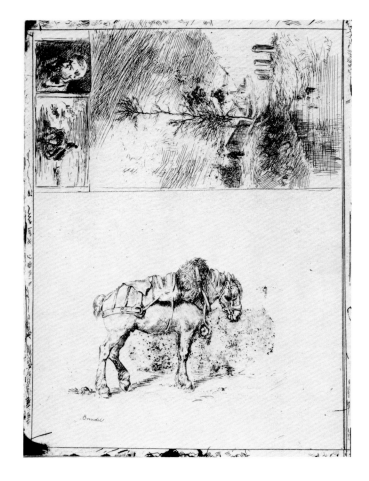

As in *Trois Chevaux au labourage* (cat. no. 4), one image of *Planche de croquis* represents another of Brendel's favorite themes—the workhorse—a preference he also shared with Jacque. By manipulating a roulette wheel (an idea Brendel may well have taken from his friend Charles Daubigny), he has rendered the suggestion of shadow. Unlike his other sketches in cliché-verre, which have the linear quality of pen and ink drawings, the single workhorse is depicted against a tonal backdrop.

49

Antoine Chintreuil
French; Pont-de-Vaux 1814-1873 Septeuil

Chintreuil, who is generally characterized as a romantic and a dreamer, declared himself a pupil of Corot early in his career. Certainly, the encouragement of *le père Corot* was crucial for the young artist, especially during the early 1840s when Chintreuil's work was consistently refused by the Salon jury. Chintreuil finally made his Salon debut in 1847.

Chintreuil left Paris in 1850 and lived the rest of his life in regions around the city, first in Bièvre, then in Septeuil. Throughout his career Chintreuil was supported emotionally by his colleagues and financially by the poet Pierre-Jean Beranger. Even though he did receive a medal at the Salon of 1867 and the Legion of Honor in 1870, Chintreuil's paintings—landscapes of clear colors and fresh tonalities—were never very much appreciated, neither by the public nor critics, until after his death.

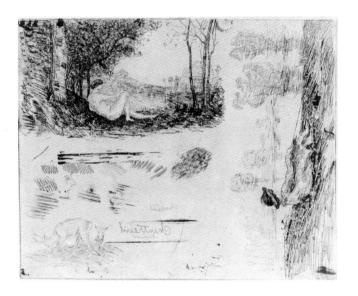

6

Plate of Sketches: Reclining Nude in Landscape and Others
January 1854
Salt print
Signed in plate: center, three times (in reverse), *Chintreuil*; upper left, base of tree (in reverse), *Chintreuil*
Inscribed on mount in brown ink across bottom: *Chintreuil, Dessin sur verre. Photog. par L. Grandguillaume, Jan. 1854*
Sheet: 15 x 18.8 cm (5⅞ x 7⁷⁄₁₆ in.)
Mount: 27.3 x 36 cm (10¾ x 14⅛ in.)
Collection Gérard Lévy, Paris

So great was Corot's enthusiasm for cliché-verre after his initial introduction to the medium in Arras, that he returned to Paris carrying prepared glass plates. He must have shown his newest prints to artists visiting his studio. Corot's excitement about this novel technique stimulated others to try it. From January 1854 we have evidence that at least two artists did draw on glass in Corot's studio: J.-E.-E. Brandon and Chintreuil.

As with so many artists, so far as we know, Chintreuil's efforts were limited to one trial, a simple sketch revealing none of the luminosity that characterizes his paintings—a product of spirited curiosity rather than of formal exploration.

Alexandre-Désiré Collette
French; Arras 1814-1876 Paris

Collette, a native of Arras, studied painting early in his career but was primarily a lithographer. Included in a collective portrait, *Les Elèves de Dutilleux* (Musée d'Arras), painted by Constant Dutilleux in 1838, Collette is seen with his fellow student and future collaborator, Charles Sanson. Collette and Sanson exhibited a reproductive lithograph in the 1844 Salon. In the same year Collette singly entered a lithograph after Raphael, signaling an area in which Collette was later to specialize, that of reproductive lithography.

Collette also contributed to many large albums of lithographs, frequent publications in early-19th-century France. Among others, he worked on a five-volume encyclopedia of ornament (1845-46), a set documenting the Exposition de l'Industrie (1849), and the *Galerie iconographique égyptienne* (1851). Collette published his largest independent lithograph series in 1860, an album of 24 plates illustrating a religious procession in Arras. In addition to his reproductive, decorative, and documentary work, Collette drew numerous portraits, applying the black lithocrayon in tight, detailed rendering, a style that remained consistent throughout his career and is evident in his cliché-verre.

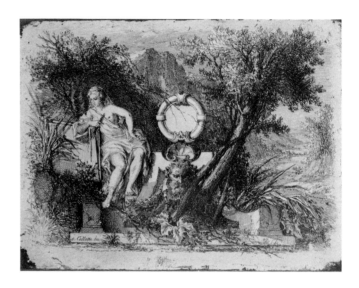

7
Allegory
Signed in plate, lower left: *A. Collette Inv.*
Image: 17.8 x 23.8 cm (7 x 9⅜ in.)
Sheet: 18.5 x 24.4 cm (7¼ x 9⅝ in.)
Collection Galerie Sagot-Le Garrec, Paris

The specific intended reference of Collette's allegorical image has been left unidentified by the artist. A draped female figure holding several paint brushes leans on an artist's portfolio; perhaps the painter's muse, she is seated on a fluted and decorated classical base amid a profusion of vines and branches. Her pensive mood is echoed in the finely drawn landscape, a towering summit unapproachable in the distance. A blank slate in the center of the composition signals that perhaps Collette intended this cliché-verre as a title page, the beginning of a project presumably never completed. Nevertheless, that Collette's cliché-verre so resembles the style of his published lithographs indicates that his exploration was most likely stimulated by the possibility of finding in this novel technique an alternative, and perhaps more sensitive, method of reproduction.

Jean-Baptiste-Camille Corot
French; 1796 Paris 1875

Born in Paris to a successful merchant family, Camille Corot began his artistic career in the studios of leading classicizing landscape painters. During these formative years Corot also traveled, sketching outdoors in the Barbizon region and along the French coast, and painting for several years in Italy. Adjusting his work to the cycle of seasons, Corot followed a pattern throughout his long career: during the warmer months he painted and sketched outdoors, compositions which he finished in the winter as large studio canvases for the Salon.

Corot's career was established slowly. Although he exhibited works in the Salons as early as 1831, Corot's first official recognition came in 1840 when the government bought his painting, *Le Petit Berger* (Musée de Metz). Corot was then 44 years old; yet another decade passed before the artist became popular with collectors and began to hire studio assistants in order to fulfill his many commissions.

Primarily a painter, Corot executed prints generally as the result of circumstance and the availability of a printer. In fact, it was often at a printer's request that Corot experimented with various techniques. During the 1850s Corot was introduced to the cliché-verre; during the '60s he investigated etching. Although Corot etched his first plate around 1845, the copper lay cast aside in his studio for 20 years, when it was retrieved by Félix Bracquemond.

As Corot's reputation grew, so did his honors and influence. In 1846 he was made Knight of the Legion of Honor. A member of the post-1848 Revolution Salon jury, Corot lobbied on the behalf of younger artists as well as his many friends. Warm friendships were an abiding aspect of Corot's life, providing him with family, traveling companions, and, often, circumstances influencing his work. Corot's close bond with Charles Daubigny began in 1852; in 1854 Corot traveled to Holland with Constant Dutilleux; and in 1874, only months before his death, Corot, while visiting Charles Desavary, executed his last group of clichés-verre.

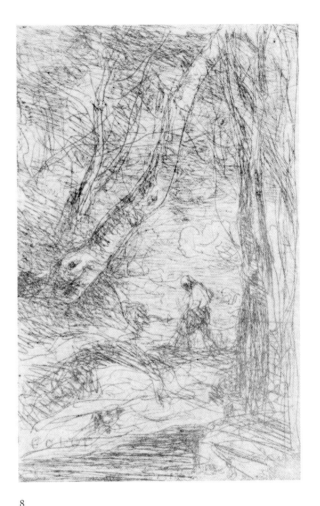

8

The Woodcutter of Rembrandt (Le Bucheron de Rembrandt)
May 1853
Salt print
Signed in plate, lower left: *COROT*
Image: 10.2 x 6.3 cm (4 x 2½ in.)
Sheet: 10.2 x 7.1 cm (4 x 2¹³⁄₁₆ in.)
Delteil 35
Metropolitan Museum of Art, New York, The Elisha Whittelsey Collection (The Elisha Whittelsey Fund, 1950)

In his first cliché-verre, *Le Bucheron de Rembrandt*, executed in May 1853, Corot paid homage to Rembrandt, the master printmaker. The tribute is appropriate; Corot approached the collodion-covered glass plate much as one would a copper plate, utilizing linear structures to build tone and form. Spontaneous, rhythmic lines suggest the shapes in quick outline, and rapid back-and-forth strokes loosely establish the shadows. Corot's conception of *Le Bucheron de Rembrandt* in

terms of etching was natural for an artist's first experiment with a new medium. Three years later in 1856, however, when Corot repeated the theme of the woodcutter (cat. no. 19, Delteil 55), specific description of form is no longer apparent and the large, fluid gesture attests to Corot's familiarity with cliché-verre. In his freest sketches we see evidence of a modern master whose private notations distill to striking abstractions.

Around 1855 the glass plate for *Le Bucheron de Rembrandt* was sent to the photographer Charles Nègre. Either at Nègre's suggestion (he experimented, invented, and patented his own method of photogravure; see Bib. II Philadelphia, pp. 428-429) or, at the artist's request, Nègre transferred the image on the fragile glass plate to a more durable matrix, steel. Nègre, however, must have been slow in pulling the photogravure proofs: in 1861 Adalbert Cuvelier wrote him requesting the return of the glass plate. "Mr. Corot," Cuvelier indicated, "asks me continually for proofs of this glass plate" (letter, Archives, A. Jammes, transcribed in Bib. III Melot, p. 262). Nègre's photogravure plate is now in the collection of André Jammes, Paris, who has pulled a modern edition on thin, laid paper: in reverse from Delteil; plate, 11 x 10.5 cm; sheet, 21.9 x 16.2 cm.

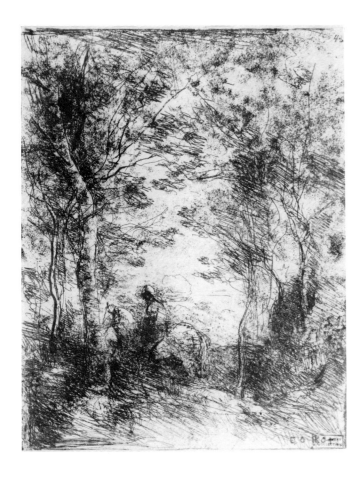

9
Horseman in the Woods, Small Plate (Le Petit Cavalier sous bois)
January 1854
Salt print
Signed in plate, lower right: *COROT*
18.7 x 15 cm (7⅜ x 5⅞ in.)
Delteil 42
Provenance: Samuel P. Avery, New York (Lugt 41)
S. P. Avery Collection, Prints Division, the New York Public Library, Astor, Lenox, and Tilden Foundations

In this and the large version of *Cavalier sous bois*, Corot created lush atmospheric effects by striking the plates with a stiff brush. The artist lifted the collodion ground in a random pattern of dots—which Hédiard called *"tamponnage."* An enveloping half-tone that unifies separate graphic elements, the *tamponnage* suggests rather than describes the foliage. The mood of the forest is serene as a solitary, unidentifiable figure rides silently through the embracing trees.

With *Cavalier sous bois*, both large and small plates, Corot established a more monumental scale in his clichés-verre, one he repeated in other lyrical landscapes (e.g., cat. nos. 18, 20, 22). That Corot truly admired his sketch of the horseman in the forest is evident not only by his repetition of the image, but also in a letter sent to his friend, Constant Dutilleux, in Arras. On January 23, 1854, Corot wrote Dutilleux requesting he remind Adalbert Cuvelier to send him in Paris the "boîte" [a box of plates?] and proofs of the man on horseback "that I love so" (Bibliothèque Nationale, Paris; Bib. III Melot, p. 264). *Le Petit Cavalier sous bois* also must have been a favorite of others, as Félix Bracquemond copied Corot's cliché-verre in etching: *Le Cheval blanc*, c. 1868.

10
The Dreamer (Le Songeur)
January 1854
Painted glass negative
Signed in plate, lower left: *COROT*
Frame: 19.1 x 24.2 cm (7½ x 9½ in.)
Delteil 43
Provenance: Cuvelier family, Paris; Albert Bouasse-Lebel, Paris;
Galerie Sagot-Le Garrec, Paris
Metropolitan Museum of Art, New York (Jacob H. Schiff Fund,
1922)

After the publication of *Quarante Clichés-Glace* in
1921, Maurice Le Garrec distributed his plates to various
museums, including the Musée du Louvre, Bibliothèque
Nationale (Paris), Museum of Fine Arts, Boston, and the
Metropolitan Museum of Art, New York (see Ap-
pendix). Le Garrec's only condition on the gift was the
guarantee that no more impressions be printed. In an
effort to "cancel" the glass plates, Le Garrec clipped the
corners after printing his 1921 impressions (see also
cat. nos. 17, 37).

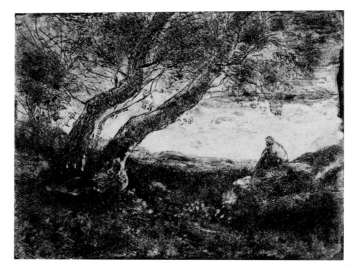

11a
The Dreamer (Le Songeur)
January 1854
Salt print
Signed in plate, lower left: *COROT*
14.6 x 19 cm (5¾ x 7½ in.)
Delteil 43
Provenance: Lessing J. Rosenwald, Jenkintown, Pennsylvania
National Gallery of Art, Washington, D.C., Lessing J. Rosenwald
Collection, 1967

11b
The Dreamer (Le Songeur)
January 1854
Salt print
Signed in plate, lower right (in reverse): *COROT*
14.9 x 19 cm (5⅞ x 7½ in.)
Delteil 43 (reversed)
Margo Pollins Schab, Inc.
Not ill.

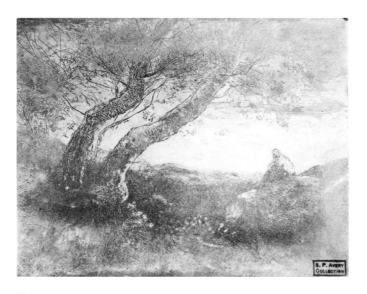

12
The Dreamer (Le Songeur)
January 1854 (1858/85)
Salt print
Reduced impression
Signed in plate, lower left: *COROT*
Sheet: 9.9 x 13 cm (3⅞ x 5⅛ in.)
Delteil 43
Provenance: Samuel P. Avery, New York (Lugt 41)
S. P. Avery Collection, Prints Division, The New York Public
Library, Astor, Lenox, and Tilden Foundations

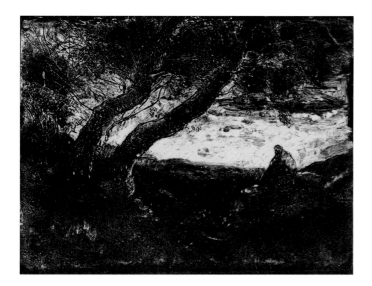

13
The Dreamer (Le Songeur)
January 1854 (1921)
Signed in plate, lower left: *COROT*
Stamped and inscribed in pencil on verso: *SL* (interlaced)
(Lugt 1766a), *38/150*
Image: 14.6 x 19 cm (5¾ x 7½ in.)
Sheet: 14.8 x 19.8 cm (5⅞ x 7¹³⁄₁₆ in.)
Delteil 43
Art Institute of Chicago (Gift of the Print and Drawing Club)

Continuing to explore the visual possibilities of the cliché-verre medium, Corot tried the painted plate technique for the first time in January 1854 (cat. no. 10). In contrast to the demi-tone achieved through *tamponnage*, in the painted plate the image is conceived tonally. The entire composition is visualized in relative tonal values: as the paint is brushed, fingered, and blotted on the glass surface, so the resultant print will reflect these shifting densities of emulsion (e.g., the thicker the opaque oil paint is on the negative, the lighter that area will appear). The act of painting on the glass surface resembles the direct, tactile manipulation of a monotype plate, but with one important distinction: the cliché-verre is a photographically printed negative. In contrast to the direct transfer of an inked positive image for a monotype impression, the cliché-verre matrix, painted in a negative fashion, is printed, in multiple copies, on light-sensitive paper.

Painting on the plate does not exclude drawing on it, however. In *Le Songeur* (cat. no. 10) Corot drew through the painted ground with the end of a brush or stick, freely delineating and modeling the figure, the tree, and the landscape. By utilizing a spectrum of technical choices—painting the plate, manipulating the surface, drawing with expressive lines of varying strengths— Corot created a landscape embodying light and movement and evoking a pensive, elegiac mood; a lone figure, stationed on a rock, contemplates the expansive distance.

Years after Corot executed the image, Charles Desavary produced, probably between 1858 and 1885, a reduced-scale impression of *Le Songeur* (cat. no. 12). Seeing the weakness of the translation (cf. the vintage impression cat. no. 11), however, Desavary must have printed only a few impressions, as the reduced images are very rare today.

In 1921 *Le Songeur* was again re-issued by Maurice Le Garrec (cat. no. 13) in his folio *Quarante Clichés-Glace.* As evidenced by the excellent condition of the plate (cat. no. 10) which was given to the Metropolitan Museum of Art by Maurice Le Garrec, the problem of excessive exposure was not caused by flaking paint which would allow too much light to reach the sensitized paper, but rather by the difference between the photographic paper and chemicals used for the 20th-century printing and those employed in the 19th century. The impression is so dark and muddy as to be almost unreadable.

14
Young Woman and Death (La Jeune Fille et la Mort)
March 1854
Salt print
Signed in plate, lower right: *COROT*
18.3 x 13.3 cm (7 3/16 x 5 1/4 in.)
Delteil 45
Museum of Fine Arts, Boston (Gift of Mr. and Mrs. Peter A. Wick)

In *La Jeune Fille et la Mort* Corot produced a smooth, flowing line by drawing into an ink film. For thin lines scratched through a tight collodion base (e.g., see cat. no. 15), Corot used a sharp, pointed etching needle, but for the broad looping strokes he employed the end of a paint brush or stick. The glass plate was covered with a layer of printer's ink, dusted with white lead, and placed

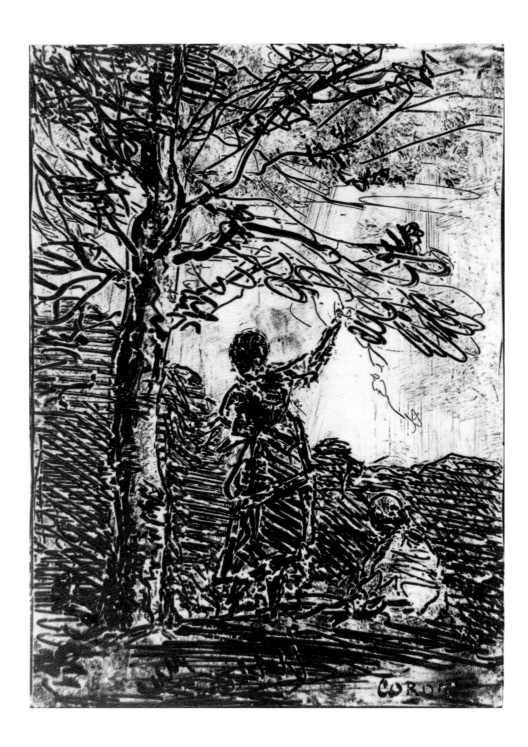

on a dark background for contrast. In this way, the drawn design appeared to the artist as black lines on a white ground, and the result could be visualized during the process.

Even though *La Jeune Fille et la Mort* is essentially linear, the gesture of the stroke through the ink is closer to the manipulation of paint. Furthermore, the varying density of the emulsion caused a residual tone (clearly visible in this superb impression from Boston), which emphasizes the painterly effect. *La Jeune Fille et la Mort* was executed, in fact, in March 1854, just months after Corot's first experiments with the painted plate technique. In his catalogue on Corot, Alfred Robaut grouped this image with the painted plates: the third series, "the paintings on glass with scratchings in the paste" (Bib. V Corot/Robaut, IV, p. 131).

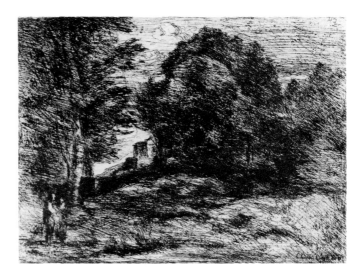

16
Tomb of Semiramis (Le Tombeau de Sémiramis)
January 1854
Salt print
Signed in plate, lower right: *COROT*
13.7 x 18.7 (5⅜ x 7⅜ in.)
Delteil 47
Provenance: Samuel P. Avery, New York (Lugt 41)
S. P. Avery Collection, Prints Division, The New York Public Library, Astor, Lenox, and Tilden Foundations

In January 1854 Corot executed *Le Tombeau de Sémiramis*, a romantic landscape evoking the mysteries of the ancient Assyrian queen. Semiramis ruled powerfully for 42 years, expanding the boundaries of her empire and establishing large cities and monuments. During the 19th century a mass of legend surrounded the personality of Semiramis, a woman who outlived several husbands and conquered many nations.

The landscape, which Melot linked to St.-Nicholas-les-Arras, a suburb of Arras (Bib. III Melot, p. 264), is conceived in extended masses of light and dark flickering across the composition. As the broad areas fuse, the eye traverses the space in a gentle motion, in contrast to some of the later landscapes, which incorporate sharper alternations of light and dark (see cat. no. 30).

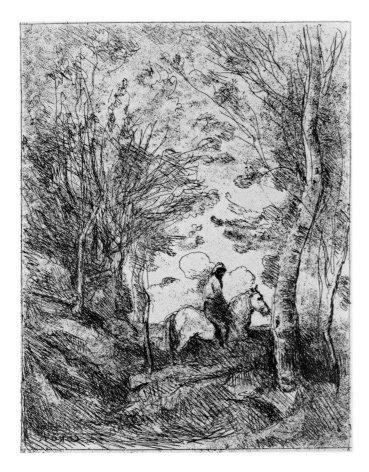

15
Horseman in the Woods, Large Plate (Le Grand Cavalier sous bois)
c. 1854
Salt print
Signed in plate, lower left (in reverse): *COROT*
28.5 x 22.6 cm (11¼ x 8⅞ in.)
Delteil 46
Provenance: Lessing J. Rosenwald, Jenkintown, Pennsylvania
National Gallery of Art, Washington, D.C., Lessing J. Rosenwald Collection, 1967
See cat. no. 9.

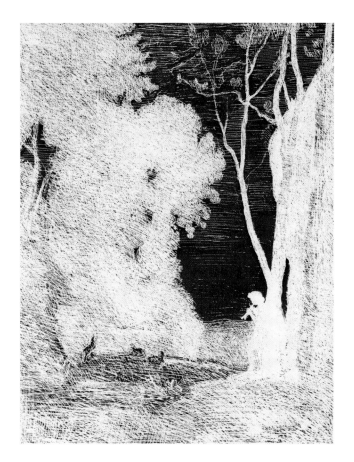

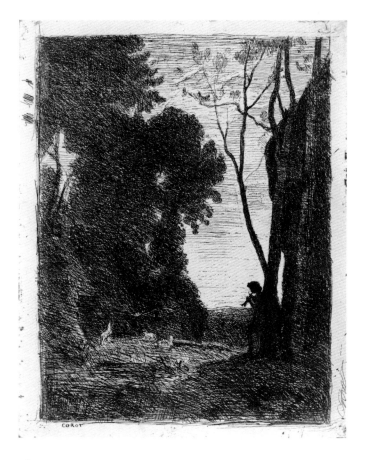

17
Little Shepherd, 2nd Plate (Le Petit Berger, 2e planche)
c. 1855
Glass plate negative
Frame: 38.1 x 30.5 cm (15 x 12 in.)
Delteil 50
Provenance: Cuvelier family, Paris; Albert Bouasse-Lebel, Paris;
Galerie Sagot-Le Garrec, Paris
Metropolitan Museum of Art, New York (Jacob H. Schiff Fund,
1922)

18
Little Shepherd, 2nd Plate (Le Petit Berger, 2e planche)
c. 1855 (1911/13)
Signed in plate margin, lower left: *COROT*
Image: 34.2 x 26.3 cm (13½ x 10⅜ in.)
Sheet: 36.9 x 29.5 cm (14½ x 11⅝ in.)
Delteil 50
Collection Mr. and Mrs. Alan E. Schwartz

Corot executed the composition of *Le Petit Berger* three times in cliché-verre. Indeed, the specific subject as well as the general format (large embracing dark forms to the extreme right and left, set in dramatic relief by the strong backlighting of the clearing in an emphatic *contrejour* effect) was one Corot had executed several times previously. One canvas of *Le Petit Berger*, exhibited at the Salon in 1840, was purchased by the State, marking a decisive point in Corot's career (now Musée de Metz; a related drawing, see Bib. V Corot/Robaut, no. 306; and an alternate painted version, see Bib. V Corot/Chicago, no. 67).

For each version of the clichés-verre, Corot utilized a different application of the technique to achieve varying effects. In the first version (fig. 9), Corot established the structure of the composition in line, then added a scrim of half-tone, the dots of *tamponnage*. The figure, too, is realized in half-tone, only instead of dots Corot painted the shepherd standing on the rock.

In contrast to the monochrome tones and gentle mood of the first plate, the second version of *Le Petit Berger*

(cat. no. 18) is realized in bold, dramatic contrasts. The subtle texture of *tamponnage* has been replaced by crisp, controlled units of line and sharp-edged, dark, massive shapes. The figure of the young boy, poised on the rock as if one with the grove behind him, emerges as silhouette from the dense crosshatching of the distant landscape.

In the third version of *Le Petit Berger* (fig. 8), Corot painted the entire plate. Bold linear slashes and staccato strikes on the collodion ground have been replaced by the enlivened gesture of brushstrokes. In contrast to his friend Dutilleux, who applied the paint in small increments, building subtle layers of density which printed as long gradations of tone, Corot constructed the monumental shapes as unified blocks, interrupted only by an occasional sweep of white. The black, looming forms are the result of the absence of paint on the glass negative.

In the three versions of *Le Petit Berger*, Corot masterfully displayed the spectrum of technique, effect, and mood possible with the cliché-verre process, ranging from linear to painterly, from studied to spontaneous, from lyric to dramatic.

19
Five Landscapes: Garden of Pericles; Painters' Path; Scribblings; Woodcutter, Large Plate; Tower of Henry VIII (Le Jardin de Périclès; L'Allée des peintres; Griffonage; Le Grand Bucheron; La Tour d'Henri VIII)
1856 (1921)
Stamped and inscribed in pencil on verso: *SL* (interlaced)
(Lugt 1766a), *140/150*
Images: garden, 15.2 x 15.9 cm (6 x 6¼ in.), signed in plate, lower left: *COROT*; path, 12.4 x 17.1 cm (4⅞ x 6¾ in.); scribblings, 14.9 x 10.2 cm (5⅞ x 4 in.); woodcutter, 14.6 x 8.5 cm (5¾ x 3⅜ in.); tower, 11.5 x 15.9 cm (4½ x 6¼ in.)
Image: 27.3 x 34.2 cm (10¾ x 13½ in.)
Sheet: 29.2 x 36.2 cm (11½ x 14¼ in.)
Delteil 52-56
Detroit Institute of Arts (Elizabeth P. Kirby Fund)

The five small images on this plate are generally found separated in 19th-century vintage impressions. For the 1921 Sagot-Le Garrec edition, of which this impression is a part, as well as for the 1911 Bouasse-Lebel printings, the glass negative was printed full sheet and the page has remained intact. The print has the character of a page from a sketchpad: Corot drawing a remembered landscape in *La Tour d'Henri VIII* or quickly establishing his ideas in *Griffonage*, one of the artist's most abstract works in cliché-verre. While many of Corot's clichés-verre were probably drawn inside in his Paris studio or at night, after a day of painting outside in Arras, the highly portable glass plates may also have been carried outdoors. Exploiting the easy surface of the plate, Corot, with an animated and vigorous line, spontaneously fixed his impressions from nature, both direct and remembered.

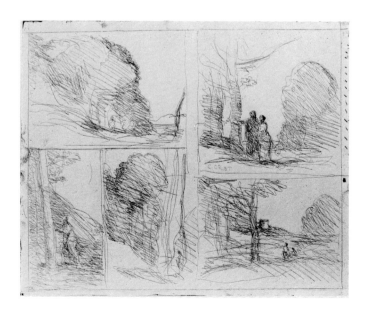

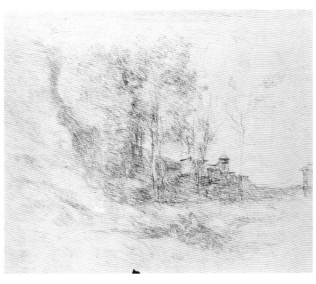

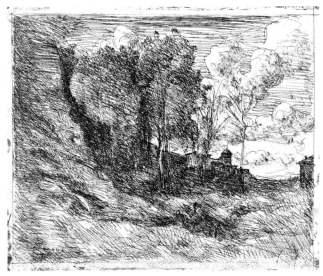

20
Souvenir of Ostia (Souvenir d'Ostie)
1855 (c. 1858/85)
Varnished salt print
Countertype impression
26.8 x 33.9 cm (10½ x 13⅜ in.)
Delteil 57
Provenance: Henri Delacroix (stamped in black on verso: *HD* [not in Lugt]); Lessing J. Rosenwald, Jenkintown, Pennsylvania
National Gallery of Art, Washington, D.C., Lessing J. Rosenwald Collection, 1967

21
Souvenir of Ostia (Souvenir d'Ostie)
1855 (1911/13)
Signed in plate, lower left (in reverse): *COROT*
Image: 26.8 x 33.9 cm (10½ x 13⅜ in.)
Sheet: 27.2 x 34.4 cm (10¹¹⁄₁₆ x 13⁹⁄₁₆ in.)
Delteil 57
Art Institute of Chicago (Gift of the Print and Drawing Club)

Ostia, the ancient town at the mouth of the Tiber River, was the harbor for Latium, Italy. Said to be the first colony of Rome, Ostia was established around 354 B.C. In the 19th century, the once flourishing trade center was farmland. The initiation of excavations of Ostia in 1854 may have stimulated Corot in the following year to evoke the memory of its ancient presence.

In contrast to the full, deep tonalities of the Chicago impression of *Souvenir d'Ostie,* the countertype impression, made by Charles Desavary (cat. no. 20), appears as a ghost of the original. The contrast is even more striking in this case, as the Chicago *Souvenir d'Ostie* is from the 1911/13 printings from Bouasse-Lebel.

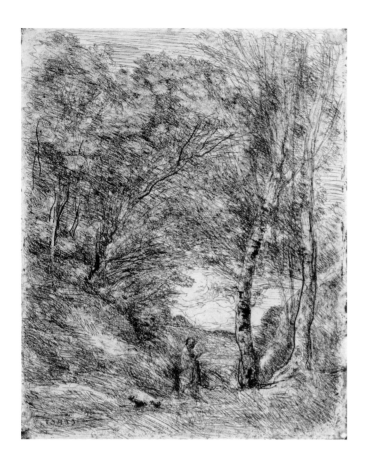

22
The Gardens of Horace (Les Jardins d'Horace)
1855 (1911/13)
Signed in plate, lower left (in reverse): *COROT*
Image: 35.6 x 28.5 cm (14 x 11¼ in.)
Sheet: 37 x 30.5 cm (14⁹⁄₁₆ x 12 in.)
Delteil 58
Provenance: Albert Bouasse-Lebel, Paris; Lessing J. Rosenwald, Jenkintown, Pennsylvania
National Gallery of Art, Washington, D.C., Lessing J. Rosenwald Collection, 1942

The Roman poet Horace was a man of humble origins and independent character. In 33 B.C. Maecenas, the Roman patron of letters, gave Horace a small property in the Sabine Hills, northeast of Rome. Although Horace remained a resident of Rome throughout his life, he spent much of his time in this countryside retreat, where he retired to meditate and write. Corot depicted Horace strolling in his "garden"; like Corot, the poet often worked outdoors. Like Corot, too, Horace never married; his many devoted friends provided him with family.

Les Jardins d'Horace, Souvenir d'Ostie (cat. no. 21) and *Le Petit Berger* (cat. no. 18) are Corot's most "finished" compositions. The large scale and complex renditions of the monumental images make these clichés-verre particularly important.

23
Ambush (L'Embuscade)
1858
Salt print
Signed in plate, lower right: *COROT* (*R* in reverse)
22.3 x 16.2 cm (8¾ x 6⅜ in.)
Delteil 64
Provenance: Constant Dutilleux (Lugt 2914); Albert Bouasse-Lebel,
Paris (Bib. III Lucerne, lot 107); Dr. Félix Somary (Bib. III London,
lot 19); R. E. Lewis, Inc., California (Bib. III San Francisco, no. 9)
National Gallery of Art, Washington, D.C. (Andrew W. Mellon
Fund, 1978)

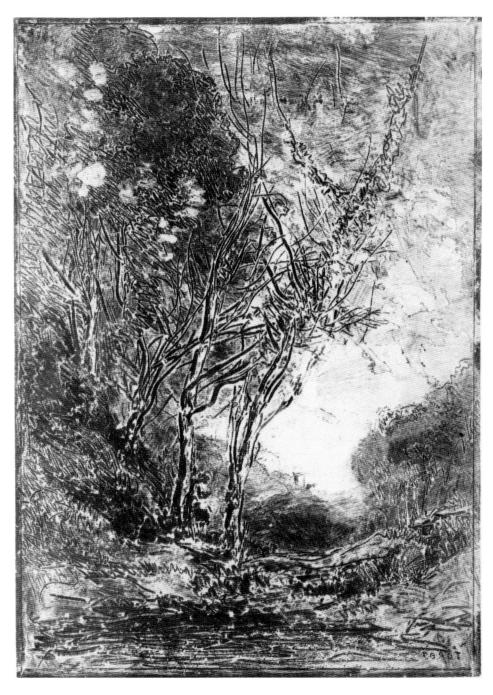

L'Embuscade: the title conjures expectations of impending disaster, a mood reinforced by the vigorous strokes and vibrant slashes of Corot's hand in this, his fifth and last, painted plate. A wash effect in the sky dramatically punctuates the brooding temper, while the dynamic suggestions of trees, broad lines which Corot quickly articulated by drawing through the pliable emulsion, appear as aggressive spikes. In the far distance Corot abbreviated the forms of towers, the Italianate buildings, once elusive on the horizon, now almost invisible across the expanse. In the foreground, on the mound to the left, almost indistinguishable in the shadows, a small figure appears to contemplate the large cluster of trees across the narrow valley. The description of the composition is curiously close to that given by Alfred Robaut for the mysterious, now apparently lost cliché-verre, *Un Philosophe*, Delteil 61 (Bib. V Corot/Robaut, no. 3182). That Corot would have drawn a variant of the image without Robaut's knowledge would be unlikely, unless, of course, years removed from the event, in the enormous task of compiling his immense study, Robaut overlooked the little figure, executed in the same shorthand as the Italian towers, and so integrated in the landscape as to be almost invisible.

This striking impression of *L'Embuscade* once belonged to Constant Dutilleux, a man noted for his highly selective and most remarkable group of Corot's clichés-verre.

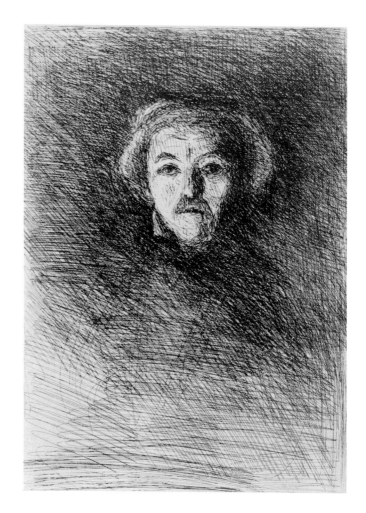

24
Self-Portrait (Corot par lui-même)
1858
Salt print
21.6 x 15.9 cm (8½ x 6¼ in.)
Delteil 69
Provenance: Albert Bouasse-Lebel, Paris (Bib. III Lucerne, lot 116); Dr. Félix Somary (Bib. III London, lot 20); R. E. Lewis, Inc., California (Bib. III San Francisco, no. 11)
Detroit Institute of Arts (Joseph H. Boyer Fund)

In 1858, at age 62, Corot drew his only self-portrait in cliché-verre. The haunting image is developed in a rich network of vigorous lines. Bold strokes create a dark void and from the black emanates a face, confronting the viewer directly and defiantly. Imagine Corot, in Dutilleux's home after a day of painting; he sits by candlelight, looks directly into the mirror, and creates this revealing self-portrait. With a bold hand, Corot dispensed with mere resemblance and presented himself in a portrait that is deeply mysterious, perhaps even melancholic. The enigmatic, penetrating image contrasts markedly with the many photographs of Corot by Charles Desavary which portray him as a jovial man sketching in the countryside. At what provocation does Corot allow his audience to glimpse another facet of the man so loved and admired by his peers?

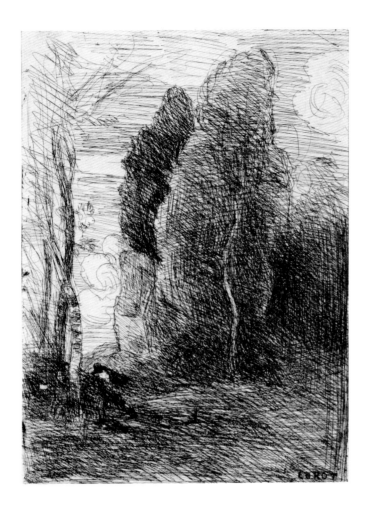

25
Hide-and-Seek (Cache-cache)
1858
Albumen print
Signed in plate, lower right: *COROT*
Sheet: 22.9 x 16.9 cm (9 x 6⅝ in.)
Delteil 70
Philadelphia Museum of Art (Purchased for the John D. McIlhenny Collection)

Cache-cache repeats a composition Corot was working on simultaneously in oil paint. Exhibited in the Salon of 1859, the painting (Musée des Beaux-Arts, Lille) was hailed by the critics as Corot's most idyllic and poetic landscape thus far. Alexandre Dumas wrote: "Corot is a poet in the style of André Chenier and Theocrites; only he writes with a paint brush" (Bib. V Corot/Paris, no. 77).

In the painting the figures and landscape are given distinct form; whereas in the cliché-verre the figures of the bacchanal are eliminated and the women playing hide-and-seek are only loosely suggested in the foreground. *Cache-cache* in cliché-verre is a rapid study in light and shade.

Corot had earlier worked on a theme simultaneously in paint and in cliché-verre. Among his first experiments in cliché-verre is *Le Bain de Berger* (Delteil 39), an exact copy of a Salon painting. Whereas the artist quite literally repeated the composition in 1853, five years and thirty-one plates later the composition was used only as a touchstone to establish general ideas, a vehicle for exploring broad visual relationships. As in *Five Landscapes* (cat. no. 19), the cliché-verre plate had become for Corot a sketchpad.

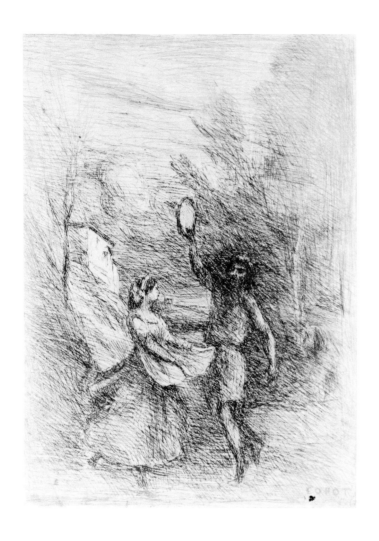

26
Saltarello (Saltarelle)
1858
Salt print
Signed in plate, lower right: *COROT*
22.5 x 16.5 cm (8⅞ x 6½ in.)
Delteil 75
Provenance: Constant Dutilleux (Lugt 2914)
Collection André Jammes, Paris

Generally, Corot's figures are embedded in the landscape, as in *Les Jardins d'Horace* (cat. no. 22) or *L'Embuscade* (cat. no. 23). Two monumental figures, however, dance a lively duet in the close foreground of *Saltarelle*. It is as if one of the Italianate towers that looms mysteriously in the far distance of many Corot prints has been approached more closely, only to find a celebration underway. All is in motion, the forms as well as the active gesture of Corot's stroke.

Saltarelle must have been a favorite image of Constant Dutilleux, for he placed his mark (Lugt 2914) on at least two other impressions besides the one exhibited here (British Museum, London; R. E. Lewis, Inc., Bib. III San Francisco, no. 13).

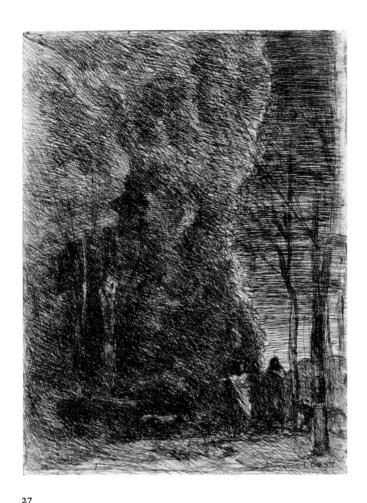

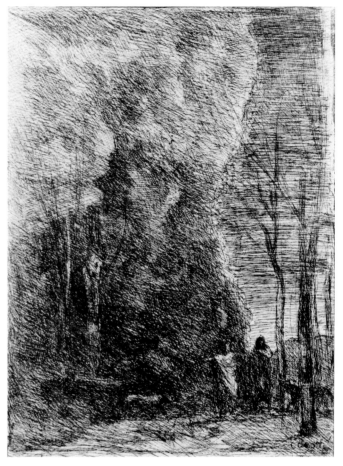

27
Dante and Virgil (Dante et Virgile)
1858
Varnished salt print
Signed in plate, lower right: *COROT*
22.3 x 16.8 cm (8¾ x 6⅝ in.)
Delteil 76
Provenance: Lessing J. Rosenwald, Jenkintown, Pennsylvania
National Gallery of Art, Washington, D.C., Lessing J. Rosenwald Collection, 1965

28
Dante and Virgil (Dante et Virgile)
1858 (c. 1890/99)
Gelatin-silver print
Signed in plate, lower right: *COROT*
Sheet: 22.3 x 17 cm (8¾ x 6¹¹⁄₁₆ in.)
Delteil 76
Detroit Institute of Arts (John S. Newberry Fund)

Although not specifically noted, it seems likely that the Detroit *Dante et Virgile* was produced by Germain Hédiard's process. While the exact nature of Hédiard's technique for reproducing clichés-verre was not recorded, marked reproductions do exist on late-19th-century photographic paper of clichés-verre by Huet and Daubigny as well as one facsimile of a Daubigny etching (Delteil 7) which has been inscribed in pencil on the verso by George A. Lucas, a collector and contemporary of Hédiard: *Procédé Hediard/après mon épreuve.*

While the Lucas prints by the "Hédiard process" are the same size as the originals, they differ in several important aspects. Rather than the mat finish of salted paper or the sheen of an albumenized surface of 19th-century impressions, these copies appear on stiff, glossy gelatin-silver paper which has generally aged to a cold green-brown. Furthermore, the margins are unmarked, indicating the prints were not made from the original

glass plates, for if they were, the stray marks in cliché-verre borders would surely be evident (see discussion cat. no. 47). Sometimes, as in the Detroit impression, one can see the curled edge of the original impression, as if, when photographing the print, a corner lifted slightly. Most important, although 19th-century impressions were never in high relief by any means, the Hédiard-process prints seem very flat. Thus, the Hédiard-process impression of *Dante et Virgile* differs from the deep tonalities of the lovely vintage impression from the National Gallery of Art (cat. no. 27). It is doubtful that Hédiard intended to deceive the public with his impressions. Nevertheless, without positive documentation, like the notations by Lucas, copies by Hédiard and others are often difficult to identify unequivocally. (See "Cliché-verre in the 19th Century," p. 42 and cat. no. 34).

Corot also painted a canvas of *Dante et Virgile* (Museum of Fine Arts, Boston) which was exhibited in the Salon of 1859. That Hédiard would wish to copy the evocative cliché-verre is, of course, not surprising, for he described this composition (along with *Le Bouquet de Belle Forière*, Delteil 71), as having a noble elegance that earned them a place of importance among Corot's images (Bib. III Hédiard, p. 416).

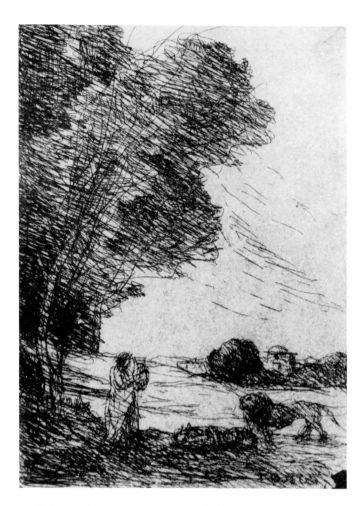

29
Orpheus Soothing Wild Beasts (Orphée charmant les fauves)
1860 (1860/85)
Albumen print
Countertype impression
Signed in plate, lower right (in reverse): *COROT*
Embossed on mount, center bottom: *CH. DESAVARY-DUTILLEUX/ARRAS/69, Rue St. Aubert/PHOTOGRAPHIE/ D'APRES C. COROT*
Image: 13.4 x 10.2 cm (5¼ x 4 in.)
Mount: 45.1 x 31.1 cm (17¾ x 12¼ in.)
Delteil 78
Philadelphia Museum of Art (Purchased for the John D. McIlhenny Collection)

Twice in 1860 Corot sketched clichés-verre on the theme of Orpheus, poet and musician, son of Apollo: *Orphée charmant les fauves* and *Orphée entraînant Eurydice* (Delteil 77). The subject occupied Corot in the studio as well: in 1861 he submitted to the Salon a painting of *Orphée ramenant Eurydice* (Private Collection, Switzerland). According to the legend, Orpheus retrieved his wife Eurydice from Hades only to lose her when, impatient to see his beloved, he turned around before completing the trip and she vanished into the shadows.

The Philadelphia impression of *Orphée charmant les fauves* was issued by Charles Desavary. Mounted on a

stiff sheet, the image is surrounded by a green lithographed border, a presentation identical to that used for Desavary's photographed reproductions of Corot's paintings. Desavary embossed the stamp of his studio on the mount. Other Desavary cliché-verre impressions from Corot's negatives are blind stamped: *CH. DESA-VARY-DUTILLEUX/ ARRAS/ 69, Rue St. Aubert* (e.g., see Bib. III San Francisco, no. 5).

In contrast to the clear negative spaces found in the Bibliothèque Nationale impression of *Orphée charmant les fauves* (Delteil 78, ill. in Bib. III Melot, p. 91), the background of the Philadelphia impression appears in mottled tones, with a purple cast, resembling the impression reproduced in Delteil (Bib. V Corot/Delteil), which, according to Melot (p. 266), is possibly a countertype from a paper negative. This, of course, is not only possible but highly probable, as the mottled background would result from the seepage of light through the woven paper fibers. It seems also that Desavary distinguished his countertype, in this case, by adding the words *photographie d'après Corot* to his blind stamp.

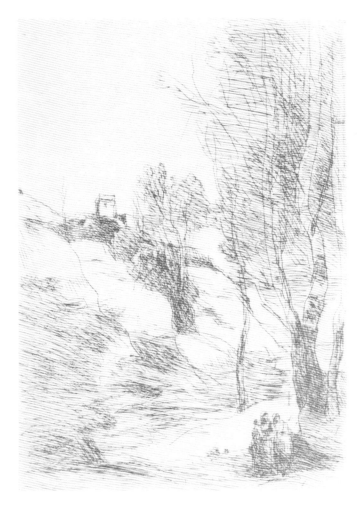

30
Souvenir of Salerno (Souvenir de Salerne)
1871
Varnished or toned salt print
16.5 x 12 cm (6½ x 4¾ in.)
Delteil 88
Provenance: Lessing J. Rosenwald, Jenkintown, Pennsylvania
National Gallery of Art, Washington, D.C., Lessing J. Rosenwald
Collection, 1967

This print is a fine example from the group of clichés-verre done during the last years of Corot's life. In *Souvenir de Salerne*, 18 years after Corot's first clichés-verre, the alternation of light and dark has become more emphatic and more abstract. Where once Corot focused attention on rendering the masses of foliage, the trees are now abbreviated in quick strokes. Emphasis has further shifted from suggesting overall atmospheric effects, as in *Le Tombeau de Sémiramis* (cat. no. 16), to building a structured spatial configuration with strict light/dark patterning.

31
The Paladins (Les Paladins)
1871
Varnished salt print
Inscribed in pencil on mount: *Corot-Les Paladins (D. 92) cliché-verre/Tirage de Robaut à 30 épreuves.*
11.2 x 16.8 cm (4⅜ x 6⅝ in.)
Delteil 92
Yale University Art Gallery, New Haven (Gift of Ralph Kirkpatrick)

The Yale impression of *Les Paladins* is inscribed on the mount: *Tirage de Robaut à 30 épreuves.* Alfred Robaut, son-in-law of Constant Dutilleux, was author of the definitive catalogue on Camille Corot (Bib. V Corot/Robaut). Of the 400 copies published in 1905, 30 were printed in a deluxe edition on Japan paper with clichés-verre tipped in. The prints were sometimes newly printed by Robaut, but were most often gathered from impressions left in Charles Desavary's studio at his death in 1885 (Bib. III Cailac). Listed as 20 images, the Robaut "edition" is generally not a reprinting but rather contemporary impressions made by Charles Desavary. The prints, as with other late impressions by Desavary, are characterized by crisp red-brown lines and clean white paper without residual tone from exposure.

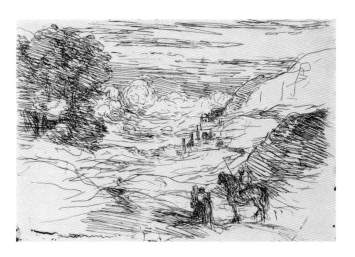

George Cruikshank
English; 1792 London 1878

The noted and highly prolific English caricaturist and satirist George Cruikshank began his long career at the age of seven working for his father Isaac Cruikshank, also a well-known caricaturist. Following the death in 1815 of the celebrated English caricaturist James Gillray, Cruikshank inherited not only his working table, but also his position as leading interpreter of the passing scene. Not one to shy away from controversy, Cruikshank, rather than simply exaggerating current societal excesses (which he did indeed do with precision), took on, in the 1820s, Napoleon and King George IV as well.

During this time, too, Cruikshank turned more frequently to book illustration, accompanying stories (often moralizing tales) with his lively designs. His publications became so popular that Cruikshank began to experiment actively to find a faithful means of reproduction still economical enough to allow his audience to purchase the little volumes cheaply; he tried etching, wood engraving, glyphography, cliché-verre, and electrophotography, to name a few.

Cruikshank's causes and interests varied throughout his long life, which encompassed events as far apart as Napoleon at Waterloo and the Paris Commune. In 1842, concurrent with the mania for daguerreotype portraits, Cruikshank satirized the "Photographic Phenomena, or the New School of Portrait Painting" in his magazine *Omnibus*; in 1847 he issued *The Bottle*, graphically illustrating the evils of drink, which he followed the next year with a sequel, *The Drunkard's Children*. In 1851, almost at age 60, he drew on glass plates for clichés-verre; and in 1864 he began, in collaboration with Charles Hancock, to produce images for his autobiography, *A Handbook for Posterity, or Recollections of Twiddle-Twaddle*, printed posthumously by Hancock using electrophotography, metal relief plates from cliché-verre negatives.

When Cruikshank died at the age of 86, he had produced over 10,000 designs. His tremendous output had extended over so many years by the end of his life that many people, unable to accept that he might still be among them, attributed his work to his grandson.

32
Portrait of Peter Wickens Fry
1851
Albumen print
Signed in plate: lower center, *Geo Cruikshank*; lower right, *Dec. 19th 1851*; top, *Etched on Glass/Dear me! how very curious!*
11.7 x 8.3 cm (4⅝ x 3¼ in.)
Gernsheim Collection, Humanities Research Center, University of Texas at Austin

Cruikshank's caricature of Peter Wickens Fry presents a bemused, bespectacled man, adjusting his vision to

view better the "curious . . . etching on glass." Fry, at whose instigation Cruikshank drew this cliché-verre print, was an active member of the photographic community in London. In 1847 he founded the Calotype Club, which included among its members Robert Hunt, Roger Fenton, Frederick Scott Archer, and Joseph Cundall. After Archer's announcement of his use of collodion for emulsion on glass plates, Fry began to exhibit photographs from his collodion negatives. He also helped Archer develop a method for producing positive appearances from backed glass negatives, the popular portrait form, ambrotype (Bib. II Gernsheim, *passim*).

As it is dated 1851, the Fry portrait is the earliest extant cliché-verre, and the Gernsheim print is the only Cruikshank cliché-verre that has been located. Drawn in thin scratched lines through a collodion base, the freely rendered likeness is very unlike the detailed, mirror daguerreotype portraits that Cruikshank satirized in the *Omnibus*.

Cruikshank again drew on coated glass plates in 1864, producing designs for his autobiography that were later printed by Charles Hancock in his process of electrophotography (see "Cliché-verre in the 19th Century," p. 32).

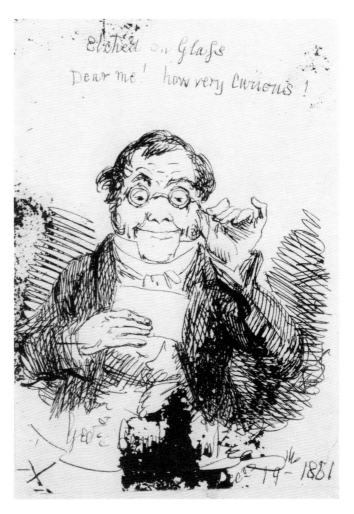

Eugène Cuvelier
French; Arras c. 1830-1900 Paris

Eugène Cuvelier's great sensitivity to photography was encouraged by his father Adalbert who, after a successful career as an oil manufacturer, had devoted himself to the art. During his student years in Arras in the atelier of Constant Dutilleux, Eugène was exposed to the techniques and esthetic of plein-air painting. These two concerns, photography and the landscape, were later embodied in his photographs, mainly scenes in the Fontainebleau forest. Working with both glass and paper negatives, Cuvelier was a most capable artist and skilled craftsman, rendering sensitive interpretations of his subjects and displaying an acute understanding of the visual potentials inherent in each process.

On March 7, 1859, Eugène Cuvelier married Louise Ganne, daughter of François Ganne who, along with his wife, operated the famous inn bearing the family name at Barbizon. Corot witnessed the wedding; J.-F. Millet and Théodore Rousseau were attendants. The ceremony was a grand event and was followed by a lively party organized by Corot.

Eugène Cuvelier, like his father, was a member of the Société Française de Photographie, where he exhibited landscape views of Barbizon and the environs of Arras. Millet, impressed with Cuvelier's work, wrote to Rousseau in 1861: "You must have seen Eugène Cuvelier. He showed me some very fine photographs taken in his own country and in the forest. The subjects are chosen with taste, and include some of the finest groups of timber that are about to disappear" (Bib. II Scharf, 1968, rev. ed. 1974, p. 92). Also, like his father, Eugène introduced many artists to the cliché-verre technique, filling in Barbizon the roles of both gentle teacher and active printer.

eye to grouping broad tonal areas. Thus, despite the stiff drawing style of *Allée en forêt,* the artist did capture the shifting movement of light and shade.

This impression seems to be unique. Curiously, however, the dark tones and the large border around the plate indicate that this impression is not a 19th-century one but was pulled in the early 20th century, perhaps by Paul Desavary for Bouasse-Lebel. Other prints in the collection of Galerie Sagot-Le Garrec seem also to have been printed by Paul Desavary (cat. nos. 1-5, 51, 52, 55, 62, 63, 69, 77, 78). Although 19th-century impressions have been located for some of these plates, they are few. The plates, along with others created in Barbizon, could have been sold by Louise Ganne Cuvelier or by an heir to Bouasse-Lebel; however, their location is unknown.

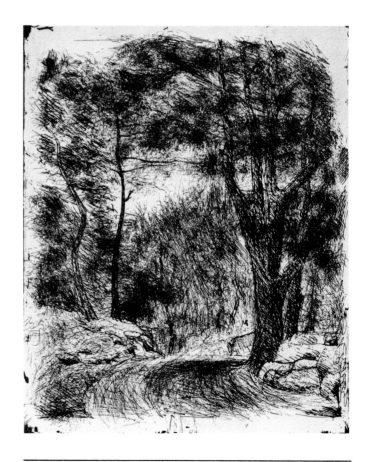

33
Forest Path (Allée en forêt)
c. 1859/62 (c. 1911/13)
Signed in plate, vertically, lower right: *E Cuvelier*
Image: 20 x 16.5 cm (7⅞ x 6½ in.)
Sheet: 24.1 x 17.9 cm (9½ x 7 in.)
Provenance: Albert Bouasse-Lebel, Paris
Collection Galerie Sagot-Le Garrec, Paris

While no clichés-verre by Adalbert Cuvelier have been located, Eugène Cuvelier did sketch one print, a path in the forest near Barbizon, a theme also rendered by Corot (Delteil 53) and Jacque (cat. no. 70). Many artists whom Eugène Cuvelier encouraged to try cliché-verre—Bakof, Brendel, Gosset, and Jacque, for example—generally applied their graphic style when drawing on glass plates. As a photographer, Cuvelier approached this composition less in terms of individual line and more with an

Charles-François Daubigny
French; 1817 Paris 1878

Daubigny began his artistic training as a young boy under the tutelage of his father, also a painter. After a brief stay in Rome—a traditional "apprenticeship" for the 19th-century painter—Daubigny returned to Paris in 1838 and supported himself making woodcut illustrations for books and magazines. In 1840 the artist spent six months in the studio of Paul Delaroche, who had also been Millet's and Gosset's teacher. Although he did submit paintings to the Salons, Daubigny devoted most of his energy during these years to printmaking. In 1849, one year after he won his first Salon prize, he received a government commission to do an etching after a composition by the 17th-century landscape painter Claude Lorrain. In 1850 and 1851 Daubigny published two albums of etchings.

Daubigny's reputation as a graphic artist was established, and critical attention slowly shifted to his canvases. He had first painted in Fontainebleau in 1843. Nevertheless, not until after his first meeting with Corot in 1852 did Daubigny focus more intensely on his paintings, landscape studies from nature. To facilitate his excursions along the Oise River, an area north of Paris which Daubigny particularly favored, he outfitted a small boat that he named, endearingly, *Le Botin (The Little Box)*. Daubigny launched his mobile studio in 1857 and in it traveled French rivers until his death.

Although he settled permanently in Auvers after 1860, Daubigny traveled intermittently throughout the decade: he went to Barbizon (where he stayed at the Auberge Ganne), to London, to Villerville along the Channel coast. During this period Daubigny was increasingly criticized for painting only his "impressions" from nature.

As an established painter, Daubigny, along with Corot, actively encouraged and supported the coming generation of painters, which included Pissarro, Manet, Monet, Cézanne, and Renoir; they, in turn, admired the immediacy of his sketches from nature and the fresh luminosity of his canvases.

34
Deer (Les Cerfs)
1862 (c. 1890/99)
Blue line print
Signed in plate margin, lower right (in reverse): *D Aubigny*
Image: 15.2 x 19 cm (6 x 7½ in.)
Sheet: 16.2 x 19.7 cm (6⅜ x 7¾ in.)
Delteil 134
Provenance: George A. Lucas, Baltimore and Paris
George A. Lucas Collection, the Maryland Institute College of Art,
Courtesy of the Baltimore Museum of Art

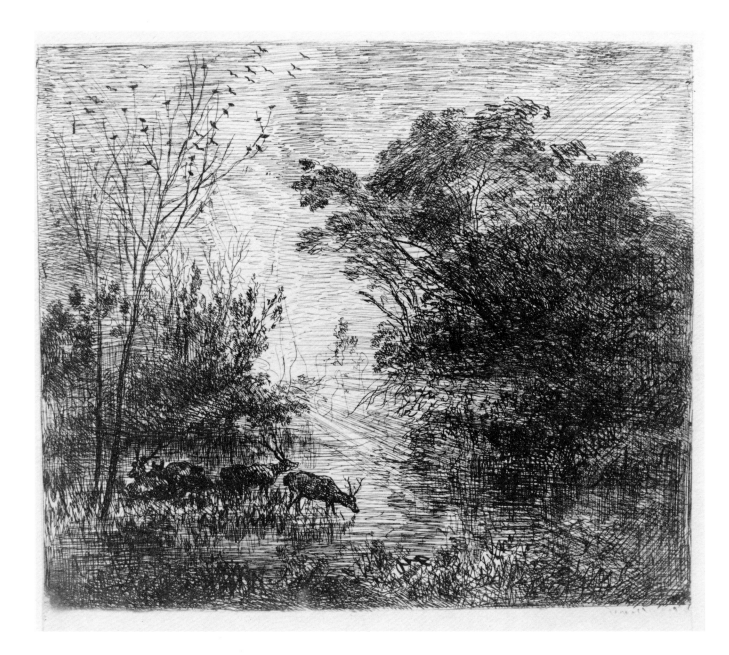

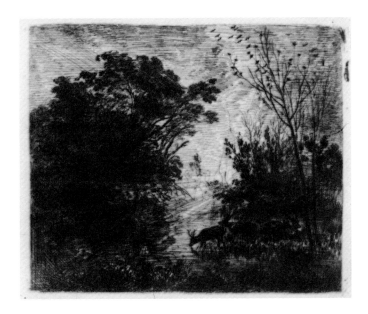

35
Deer (Les Cerfs)
1862
Image: 15.2 x 19 cm (6 x 7½ in.)
Sheet: 16.9 x 20.2 cm (6⅝ x 7¹⁵⁄₁₆ in.)
Delteil 134
Provenance: George A. Lucas, Baltimore and Paris
George A. Lucas Collection, the Maryland Institute College of
Art, Courtesy of the Baltimore Museum of Art

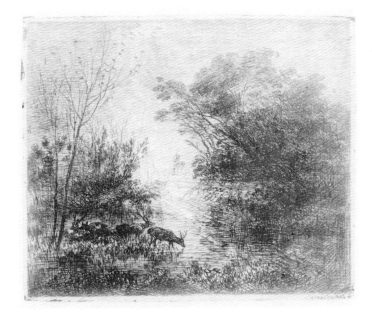

36
Deer (Les Cerfs)
1862
Salt print
Signed in plate margin, lower right (in reverse): *DAubigny*
Image: 15.2 x 19 cm (6 x 7½ in.)
Sheet: 16.2 x 19.2 cm (6⅜ x 7⁹⁄₁₆ in.)
Delteil 134
Provenance: R. E. Lewis, Inc. (Bib. III San Francisco, no. 24)
National Gallery of Art, Washington, D.C. (Andrew W. Mellon
Fund, 1978)

In *Les Cerfs* Daubigny returned to a subject he depicted several times in etching: deer in a wooded setting. The theme of the cliché-verre, however, is light; Daubigny was not concerned here with a strict graphic representation of the landscape but rather with the reflections of the setting sun. In contrast to his etchings, the clichés-verre were an experimental form, free from the rigors of public opinion and sales. Here, precise details of animals and trees, carefully described surfaces of water and grass, are obliterated by the long low rays that break through the trees in an explosion of light. Thus, Daubigny succeeded here in capturing not only the evening activity of deer beside a pond, but the crepuscular atmosphere of a light-filled glade.

Daubigny's clichés-verre are often found in varying impressions which reveal his orientation as an etcher who is sensitive to differing interpretations of his plates. He regularly experimented with or directed the printing of his clichés-verre to emphasize alternative effects. For example, the National Gallery impression of *Les Cerfs* is clear and precise, indicating that the drawn side of the plate was in close contact with the photosensitive paper. In the Lucas impression (cat. no. 35), however, the plate was flipped, emulsion side up, causing light rays to refract through the layer of glass to the sensitized sheet below. Not only were the drawn lines exposed, but the tone spread to the areas around the lines as well. This halation softens the line but also causes a densely worked area, as in the trees of *Les Cerfs*, to read as dark, solid mass. Further, in decreasing the amount of white paper (negative area), the unworked spaces appear to move forward and pop out from the page, an effect which, in *Les Cerfs*, underlines the explosive feeling of the sun's rays.

A third variation of *Les Cerfs* is a unique impression printed in the blue line process (cat. no. 34). Formulated in 1860 by French printer/photographer Alphonse-Louis Poitevin, the blue line process, or cyanofer, produces blue lines on a white ground, exactly the reverse of the cyanotype (white lines on a blue ground). The circumstances surrounding this unusual printing are not documented. The blue impressions are not mentioned by Daubigny's cataloguers: not by Henriet (Bib. V. Daubigny/Henriet) nor by Delteil (Bib. V. Daubigny/Delteil). As Germain Hédiard utilized the Lucas collection when he wrote his pioneer article on the clichés-verre (Bib. III Hédiard), it is surprising he did not mention the presence of the variant cliché-verre, most striking because of its ink-blue color.

Several printers could have made impressions in the blue line process. Poitevin, who issued a photolithograph of Corot's *Le Tombeau de Sémiramis*, may also have experimented with Daubigny's plates. As the impression is on a heavyweight wove paper, much like an etching sheet, Poitevin is a very possible candidate. It is unlikely that Paul Desavary made the blue line im-

pression, as he generally sought to create renditions closer to the standard 19th-century impressions. Moreover, although Desavary did reprint Daubigny's plates, his investigations took place between 1911 and 1913 and George A. Lucas, collector of this cliché-verre, died in 1909. A third alternative may be that the blue line prints were made by, or at least at the instigation of, Germain Hédiard. Not only was the blue line process popular around the turn of the century (a preference that coincided with the proliferation of color lithographs), but also Hédiard actively experimented with reproducing clichés-verre (see "Cliché-verre in the 19th Century," p. 42 and cat. no. 28). That Hédiard himself may have made the striking impression would account for his not including it in his article: he would have known the blue line impression was not from a 19th-century printing.

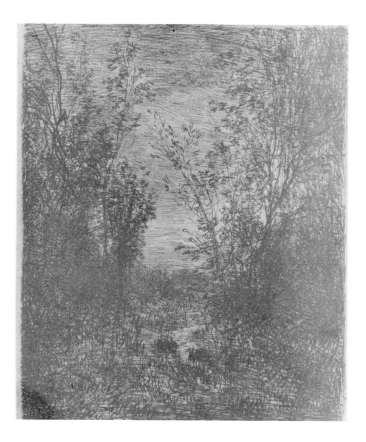

38
Brook in a Clearing (Le Ruisseau dans la clairière)
1862 (c. 1890/99)
Blue line print
Image: 19 x 15.7 cm (7½ x 6³⁄₁₆ in.)
Sheet: 19 x 16.2 cm (7½ x 6⅜ in.)
Delteil 137
Provenance: George A. Lucas, Baltimore and Paris (Lugt 1695c)
George A. Lucas Collection, the Maryland Institute College of Art, Courtesy of the Baltimore Museum of Art

In *Le Ruisseau dans la clairière* Daubigny applied his technical experience as a printmaker to the cliché-verre process. Using a roulette, a toothed wheel normally associated with etching and mezzotint, Daubigny established an additional texture in the cliché-verre, a dot pattern in the sky. As the teeth of the roulette wheel move across the ground, holes are broken through the emulsion, much like the tapping of a stiff brush or *tamponnage*, a technique often used by Corot. Unlike the random pattern of bristles, however, roulette dots appear in regular repetition. Because of the even, flat quality of the cliché-verre line, the added texture is particularly important, as it serves to differentiate the sky from the trees and ground. In contrast to the painted plate, in which emulsion is built in layers, the drawn cliché-verre depends on removing the ground in thin sections. Viewing a collodion-covered glass negative, one is acutely aware of the fragile support and surface, especially in *Le Ruisseau dans la clairière*, a highly worked image.

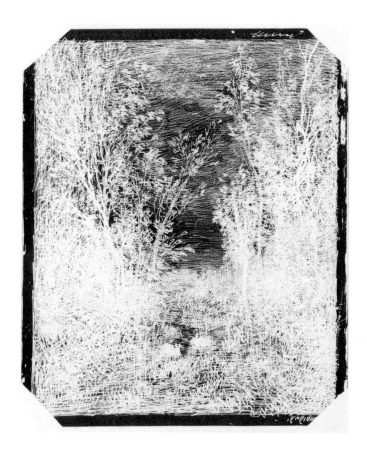

*37
Brook in a Clearing (Le Ruisseau dans la clairière)
1862
Glass plate negative
Signed in plate margin, lower right (in reverse): *Daubigny*
Image: 19 x 15.7 cm (7½ x 6³⁄₁₆ in.)
Plate: 20.3 x 16.9 cm (8 x 6⅝ in.)
Delteil 137
Provenance: Cuvelier family, Paris; Albert Bouasse-Lebel, Paris; Galerie Sagot-Le Garrec, Paris
Museum of Fine Arts, Boston (Gift of Maurice Le Garrec)
*Not in exhibition

74

39
The Large Sheep Pasture (Le Grand Parc à moutons)
1862
Varnished salt print (on Canson Frères paper?)
Signed in plate, lower right: *DAUBIGNY*
Image: 19 x 35 cm (7½ x 13¾ in.)
Sheet: 23.5 x 36.5 cm (9¼ x 14⅜ in.)
Delteil 138
Provenance: Samuel P. Avery, New York (Lugt 41)
S. P. Avery Collection, Prints Division, the New York Public
Library, Astor, Lenox, and Tilden Foundations

In *Le Grand Parc à moutons* Daubigny treated a theme often seen in the work of his associates in Barbizon, Alfred Brendel and Charles Jacque: sheep in a fold or pasture. Daubigny himself had twice executed the exact composition: in a Salon painting (1861; Mesdagmuseum, The Hague) and in etching (1860; Delteil 95). The cliché-verre, Daubigny's largest, relates practically line for line to the etching, which was published in the inaugural folio of the Société des Aquafortistes in 1862. Similar to an etching printed with residual ink, the diffusion of halation softens the line of this delicate impression, printed from a plate with emulsion side up.

The heavyweight, wove paper is similar to the paper used for an impression of *Le Gué* (Lucas Collection, Baltimore Museum of Art), which is watermarked "Canson Frères." This French etching paper, often used for printing photographs, contained a concentration of starch which gave the resultant prints a dark black tonality, evident in this impression of *Le Grand Parc à moutons.*

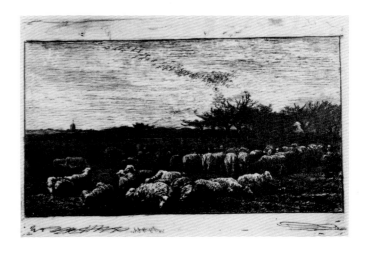

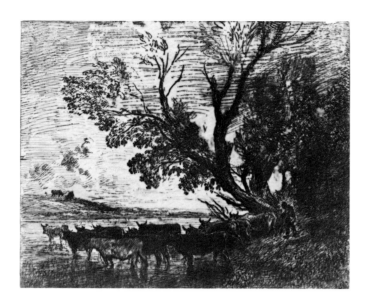

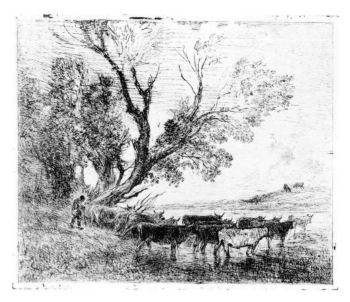

40
The Ford (Le Gué)
1862
Varnished salt print
Sheet: 27.3 x 34.7 cm (10¾ x 13¹¹⁄₁₆ in.)
Delteil 139
Provenance: Alfred Lebrun (Lugt 140); Atherton Curtis (inscribed in pencil on verso); Charles Deering (Lugt 516)
Art Institute of Chicago, Charles Deering Collection

41
The Ford (Le Gué)
1862 (1921)
Stamped and inscribed in pencil on verso: *SL* (interlaced) (Lugt 1766a), *38/150*
Sheet: 27.7 x 34.6 cm (10⅞ x 13⅝ in.)
Delteil 139
Art Institute of Chicago (Gift of the Print and Drawing Club)

A comparison between a 19th-century printing of *Le Gué* and one issued by Maurice Le Garrec in the 20th century illustrates the disparities between the two printings. Indeed, the confusion Le Garrec thought might take place between his own and vintage impressions is perhaps difficult to understand, since the differences between the two are often more striking than the similarities. Sometimes, as in *Le Songeur* by Corot (cat. no. 13), the Sagot-Le Garrec impression suffered as the deep blacks obliterated subtle variations of tone. In *Le Gué* the problem is reversed: the 19th-century impression (here from a flipped plate) is rich, dark, and bold, whereas the other is thin, pale, and awkward.

Twice in 1865 Daubigny repeated the theme of the ford; in a Salon painting and in an etching, his third contribution to the Société des Aquafortistes' folio (Delteil 118). The Sagot-Le Garrec impression is much closer in feeling to the etching, indicating the general prejudice for more realistic and less impressionistic interpretations of Daubigny's negatives. Indeed, Germain Hédiard continually praised the "clean" impressions of Daubigny clichés-verre as opposed to the "blurred" ones.

42
Donkey in a Field (L'Ane au pré)
1862
Salt print
Signed in plate, lower left (in reverse): *Daubigny*
16 x 19 cm (6⅚₁₆ x 7½ in.)
Delteil 143
Provenance: George A. Lucas, Baltimore and Paris (Lugt 1695c)
George A. Lucas Collection, the Maryland Institute College of Art,
Courtesy of the Baltimore Museum of Art

The cliché-verre process demands a sure hand: lines drawn into the ground are difficult to remove. In *Le Gué* (cat. no. 40) Daubigny attempted to change the plate by painting over selected areas, but the broad strokes read as smudges rather than as clear erasures. In *L'Ane au pré* Daubigny utilized the technique of repainting, not to alter so much as to emphasize and bring out areas of highlight. In some areas Daubigny painted over the lines, the flank of the donkey, for example; in other sections, drawn lines were applied over the painting, as in parts of the foliage in the lower right. Often the brushed emulsion did not totally cover the drawn lines, which left a ghost of their tracks.

The even tonality of the drawn cliché-verre was problematic: areas of varying emphasis were difficult to achieve. His experiments with flipping the plate, seeing the resulting halation around the lines and the tension this created, perhaps made Daubigny realize that emphasis could be achieved in the drawn plates by building lights. In *L'Ane au pré*, the sparkling whites accentuate the crisp atmosphere of the winter landscape.

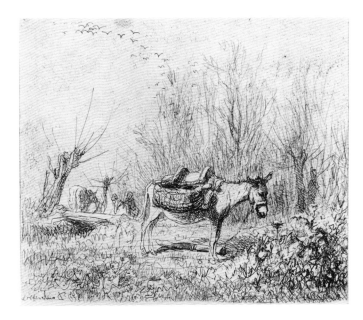

43

Night Impression (Effet de nuit)
1862
Salt print
15 x 18.8 cm (5 ⅞ x 7 ⅜ in.)
Delteil 144
Provenance: George A. Lucas, Baltimore and Paris
George A. Lucas Collection, the Maryland Institute College of Art,
Courtesy of the Baltimore Museum of Art

In contrast to *L'Ane au pré* (cat. no. 42), an image developed with sparse, thin lines, here Daubigny established a thick network of webbed crosshatchings to render the moon hovering over water. White paper and deep sepia lines blend to create the effect of moonlight emanating from the textured night sky. Reflections reveal a boat in the shadows; a dense nocturnal atmosphere embraces all the forms and delicately fuses foreground and background. Daubigny utilized the narrow tonal range inherent in the drawn plate technique to emphasis the pervading darkness and to establish an intimate space.

Since the linear cliché-verre plate is worked negatively, for *Effet de nuit* Daubigny uncovered almost all areas of the plate. In many clichés-verre, *Saltarelle* by Corot (cat. no. 26), for example, closely drawn passages read in the photographic print as dark spots. Daubigny, whose training as a printmaker guided his sure and patient hand, worked the plate so that the small individual spaces between the lines retain their separateness. The resulting clear white flecks enliven the effect of sparkling sky and shimmering water.

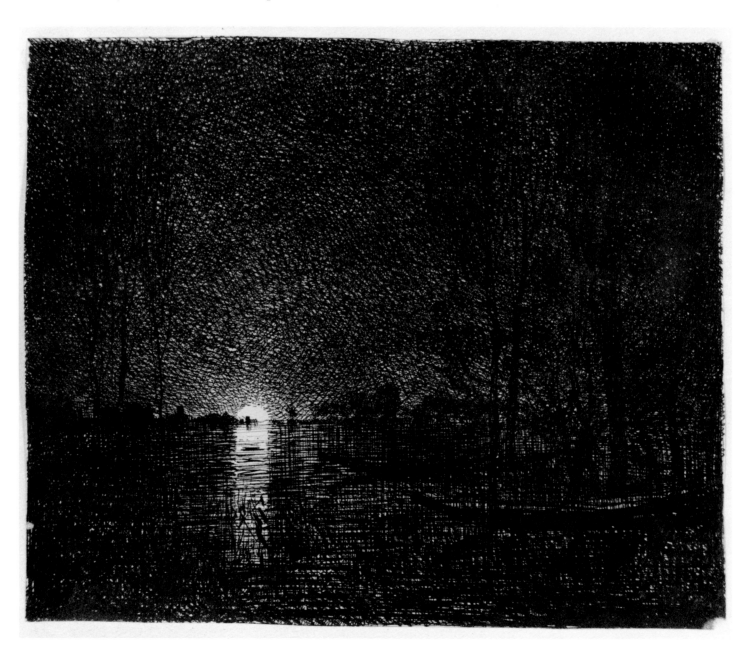

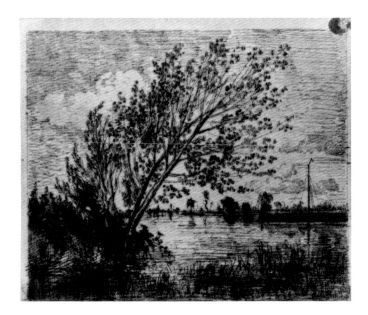

44
Cluster of Alders (Le Bouquet d'aunes)
1862
Salt print
Image: 15.9 x 19.3 cm (6¼ x 7⅝ in.)
Sheet: 16 x 19.7 cm (6⁵⁄₁₆ x 7¾ in.)
Delteil 145
Provenance: George A. Lucas, Baltimore and Paris
George A. Lucas Collection, the Maryland Institute College of Art,
Courtesy of the Baltimore Museum of Art

This delicate impression of *Le Bouquet d'aunes* has been exposed with the emulsion surface up. The diffusion of tone thus created emphasizes the springtime softness of trees in full foliage, the trembling movement of the leaves, and the crystalline glint of light spilling across the water.

45
Cows at a Watering Place (Vaches à l'abreuvoir)
1862
Salt print
Signed in plate, lower left (in reverse): *Daubigny*
Image: 15.5 x 18.6 cm (6⅛ x 7⁵⁄₁₆ in.)
Sheet: 15.9 x 19.7 cm (6¼ x 7¾ in.)
Delteil 146
Provenance: George A. Lucas, Baltimore and Paris
George A. Lucas Collection, the Maryland Institute College of Art,
Courtesy of the Baltimore Museum of Art

Of the 17 clichés-verre Daubigny produced, 16 are in the linear style. In the only example by the artist of the painted technique, *Vaches à l'abreuvoir,* the tonal range was established in relation to the density of the negative. As in *Effet de nuit* (cat. no. 43), Daubigny here explored the atmospheric impressions of light at a specific time of day, in this case sunset, not moonrise. Both compositions, too, feature a flat foreground plane which the eye traverses quickly to a broad middle-ground area. Any sense of distance implied by the strong backlighting is blocked by the emphatic horizontal element. In the linear *Effet de nuit,* carefully controlled webbed lines produce an aura of nocturnal stillness; Daubigny's animated gesture in the painted plate, however, creates a lively movement appropriate to the final moments of the day, endowing the exploding rays of sun with vivid and specific form.

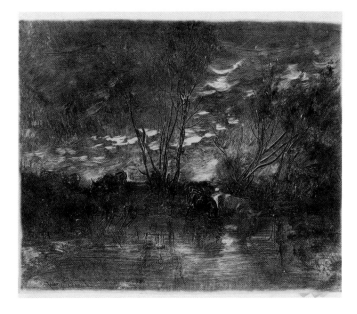

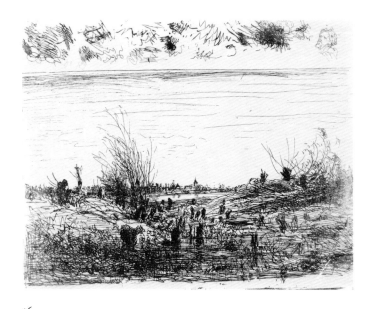

46
Pollard Willows (Souvenir of Bezon) (Les Saules étêtés [Souvenir de Bezon])
1862
Image: 21.6 x 35 cm (8½ x 13¾ in.)
Sheet: 27.6 x 35 cm (10⅞ x 13¾ in.)
Delteil 148
Provenance: Samuel P. Avery, New York (Lugt 41)
S. P. Avery Collection, Prints Division, the New York Public
Library, Astor, Lenox, and Tilden Foundations

Les Saules étêtés is a rare print, existing in only two impressions: one in the New York Public Library (exhibited here) and one in the Baltimore Museum of Art. The Baltimore impression was once in the artist's collection and bears his estate stamp (Lugt 518).

Daubigny took advantage of the fact that the cliché-verre plate presents a drawing surface free from the pull and drag of resistant metals and employed a variety of linear strokes (compare, for example, cat. nos. 42, 43). In the upper margin (remarque) of *Les Saules étêtés,* Daubigny made a kind of inventory of some of these marks, as well as including a skillfully drawn head.

Daubigny often manipulated the alternatives available to him in printing cliché-verre plates to emphasize particular effects. The plate in *Les Saules étêtés,* drawn in thin needle lines, was printed with the worked emulsion in direct contact with the photosensitive paper, resulting in an emphatic clarity appropriate to the desolate winter scene. The pool in the foreground appears frozen and still; the bleak horizon is punctuated by a row of pollard willows.

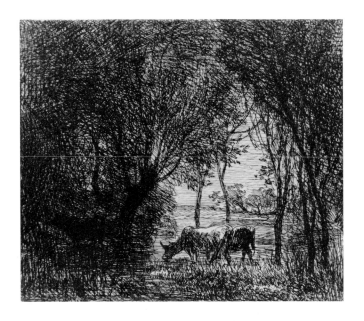

47
Cows in the Woods (Vaches sous bois)
1862 (c. 1890/99?)
Image: 15.9 x 18.6 cm (6¼ x 7⁵⁄₁₆ in.)
Sheet: 15.9 x 19 cm (6¼ x 7½ in.)
Delteil 149
Provenance: George A. Lucas, Baltimore and Paris
George A. Lucas Collection, the Maryland Institute College of Art,
Courtesy of the Baltimore Museum of Art

Daubigny signed *Vaches sous bois* in the lower right
margin of the glass plate. Curiously, the Baltimore
impression, which does have an ample margin along
the lower edge, bears no signature, nor are there any
stray marks outside the image as are generally found.
Instead, the lower margin of the image stops abruptly
like the sharp border of finished glass. (The other three
margins, which might have provided additional evi-
dence have, unfortunately, been trimmed.) Further-
more, in contrast to the majority of 19th-century cliché-
verre impressions which are found on thin salted paper
or glossy albumenized surfaces, the Baltimore impres-
sion has been printed on thick, heavyweight wove paper
and the tone of the line is deep coal-black.

As with many isolated impressions of clichés-verre,
the Baltimore *Vaches sous bois* raises more questions
than it answers. Why does the lower margin bear none
of the usual distinguishing marks from the plate? The
total absence of any stray lines seen on all other un-
trimmed impressions of *Vaches sous bois* excludes the
possibility that this impression was printed before the
signature. It does, however, suggest the alternative that
this print was made from a glass negative created by
photographing or by contact-printing an existing im-
pression (in this case one trimmed to the image).

That this unusual cliché-verre was printed in the late
19th century is supported by several findings. A similar
paper has been found in other Daubigny clichés-verre:
the blue line impressions (see cat. nos. 34, 38) and two
coal-black prints of *Les Cerfs* (Delteil 134; Baltimore
Museum of Art and the Library of Congress, Washing-
ton, D.C.). As discussed (see cat. no. 34), the blue line
prints may well have been printed between 1890 and
1900 by Germain Hédiard. Apparently the Guillemot
Company, manufacturer of photographic materials,
produced ampules for sensitizing paper to print in blue
or black lines. That George Lucas purchased his prints
before 1909, the year of his death, is obvious; but an
additional limit may be placed on the date of these
prints: the Library of Congress impression of *Les Cerfs*
belonged to Alfred Lebrun (Lugt 140), whose print, ac-
cording to Delteil, sold in 1899.

Eugène Delacroix
French; Charenton-Saint Maurice 1798-1863 Paris

Eugène Delacroix's fame—or infamy—was established in 1822 at his first Salon showing. The reaction to his entry *Dante et Virgile* (Musée du Louvre, Paris) was extreme, both damning criticism and enthusiastic praise. But the commotion was sufficient to establish Delacroix as the unofficial leader of the Romantic movement in painting.

In spite of some critics' continued hostile reaction to his work and the establishment's delay in electing him a member of the Academy, Delacroix did receive a large number of important State commissions, including, late in his career, the assignment to decorate the Chapel of the Holy Angels in the church of St.-Sulpice, Paris, a project that engaged him from 1854 to 1861. It was precisely to assist his intimate friend Delacroix in this enormous undertaking that Constant Dutilleux moved to Paris in 1860.

Delacroix's reaction to photography is well-documented. He was a charter member of the Société Française de Photographie; he actively supported the inclusion of photography in the Salons. Delacroix studied photographs to gain a thorough understanding of the human form, the weight of figures in space, the peculiarities of light on his subjects. In 1854 Delacroix collaborated with the photographer Eugène Durieu in Dieppe, arranging lights and posing models as Durieu recorded scenes for the artist's future use. On March 7, 1854, Delacroix wrote to Dutilleux:

> The possibility of studying such images [photographs Cuvelier had shown to Delacroix] would have had an influence on me that I can only guess at from the usefulness which they do have now . . . [these images] are the palpable demonstration of the real form of nature, of which before we have never had anything but very imperfect notations (Bib. V Delacroix/Joubin, III, p. 195).

In 1854 it was the camera image that captured the master's curiosity. The photograph was to Delacroix "a mirror of the object," providing information on passages of light and shade, of physical details which contributed to a greater understanding of reality (Bib. III Scharf, 1968, rev. ed. 1974, Ch. 4, "Delacroix and Photography").

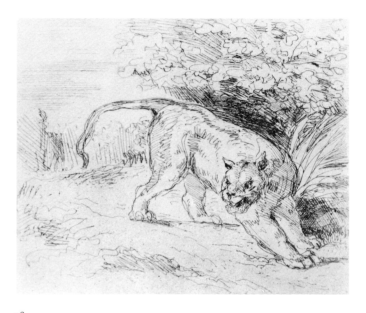

48
Tiger at Bay (Tigre en arrêt)
1854
Albumen print
Embossed on mount, lower center: *CH. DESAVARY-DUTILLEUX/ARRAS/69, Rue St. Aubert*
Sheet: 15 x 18.2 cm (5⅞ x 7⅛ in.)
Mount: 31.7 x 36.5 cm (12½ x 14⅜ in.)
Delteil 131
Detroit Institute of Arts (Abraham Borman Family Fund and Edna Burian Skelton Fund)

Delacroix was introduced to the cliché-verre technique by his friend Dutilleux. Adalbert Cuvelier had forwarded plates to Paris, where Delacroix executed *Tigre en arrêt.* For his only effort in the medium, Delacroix chose a theme he had explored previously in lithography and etching: a tiger in a clearing.

With a sharp needle Delacroix drew thin lines on the collodion-covered glass plate. To create a tone behind the tiger, an attempt to model the animal, Delacroix used a heavier line and a more vigorous stroke. The even linear quality of the drawn plate must have frustrated Delacroix, accustomed as he was to the broad tonal range possible in lithography. Important, too, in his decision not to carry forward his experiments with cliché-verre were his simultaneous photographic investigations with Eugène Durieu. Indeed, he later indicated to Cuvelier that, as his time was limited, he could not experiment further with the technique.

Charles-Paul-Etienne Desavary
French; 1837 Arras 1885

Desavary, painter and lithographer, was a student of Thomas Couture, Constant Dutilleux, and Camille Corot. In 1858 Desavary married Dutilleux's daughter Marie. Although Desavary did enter his paintings in the Salons (his first was in 1868), he earned his living primarily as a lithographer. When Dutilleux moved to Paris in 1860, he gave his son-in-law his lithography establishment at 69 rue St. Aubert, Arras.

Between 1858 and 1874 Desavary collaborated with Corot, printing the master's clichés-verre. In addition to printing loose sheets from the glass plates, Desavary issued Corot's clichés-verre mounted on stiff paper, surrounded by a green lithographed border and impressed with the stamp of his studio (see "Cliché-verre in the 19th Century," p. 42 and cat. no. 29). The presentation was identical to that of his photographed reproductions of Corot's paintings and drawings. Desavary experimented with additional means of reproducing Corot's clichés-verre as well: he produced a few photolithographs, countertypes (cat. no. 20), and reduced impressions (cat. no. 12).

As he carried forward his desire to record photomechanically Corot's large oeuvre, Desavary photographed many of the master's paintings and drawings for publication. In 1873 Desavary issued an album of facsimiles of 61 drawings (Bibliothèque Nationale, Paris). Additionally, Desavary's photographic documentation of over 600 of Corot's paintings provided a primary source of evidence for Desavary's brother-in-law Alfred Robaut when Robaut prepared his complete catalogue of Corot's work. For these enormously valuable documents, Desavary is perhaps best remembered.

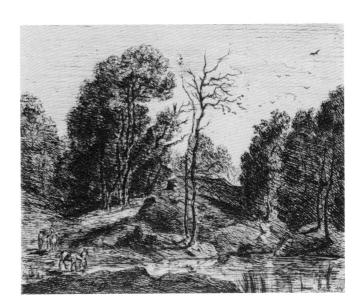

49
Horsemen in a Clearing (Souvenir of Fontainebleau) (Cavaliers dans la clairière [Souvenir de Fontainebleau])
c. 1858/72
Albumen print
Signed in plate, lower right (in reverse): *Ch. Desavary*
15.2 x 18.7 cm (6 x 7⅜ in.)
Courtesy R. E. Lewis, Inc.

Desavary executed four small clichés-verre, two drawn in thin, hair-like lines scratched across the dry, tight collodion film, and two very different in feeling, incorporating a full, deep tonality and an interest in the play of light on water.

In the first group, *Cavaliers dans la clairière* (also titled *Souvenir de Fontainebleau*, see Bib. III San Francisco, no. 34) is dominated by a lone dead tree placed emphatically in the center foreground. The horsemen are so awkwardly drawn and the depiction of the Fontainebleau forest, which inspired so many artists, so perfunctory that one hesitates to believe the cliché-verre is by the same hand that produced *Vue de Scarpe* (cat. no. 50). Perhaps it was the unfamiliarity of the terrain that accounts for the self-consciousness of this piece, for surely Desavary's clichés-verre of his own region are the more pleasing.

83

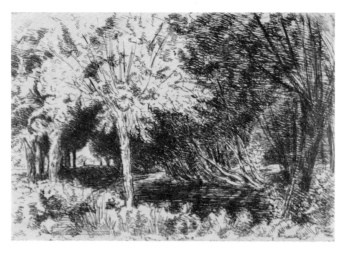

50
View of the Scarpe River (Vue de Scarpe)
c. 1858/72
Salt print
Signed in plate, lower right: *Charles Desavary*
Inscribed in ink on verso: *Ch. Desavary*
Sheet: 9.2 x 11.6 cm (3⅝ x 4⁹⁄₁₆ in.)
Collection Huguette Berès, Paris

The Scarpe, the river which runs through the Arras/ Douai area, is at once a source for irrigation and for transportation along its many canals. It offered artists like Desavary a variety of scenes of river life. The quiet landscape *Vue de Scarpe* was executed in an area of the river Desavary knew well; this impression is inscribed: *La Scarpe à droite la propriété Bellon*. Bellon was a close friend of Constant Dutilleux, and his farm was in the Arras suburb St.-Nicholas-les-Arras, a location that was also chosen for depiction by Corot (see cat. no. 16). In *Vue de Scarpe* Desavary alternated broad dark areas with unworked spaces to create a sense of the shifting of sun and shadow, the sunny fields and springtime coolness of a shaded bend.

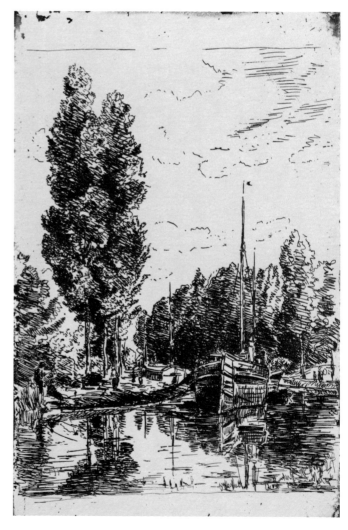

51
Boats on a Canal (Vue des bateaux)
c. 1858/72 (c. 1911/13)
Image: 13.7 x 11.5 (5⅜ x 4½ in.)
Sheet: 19 x 11.7 cm (7½ x 4⅝ in.)
Provenance: Albert Bouasse-Lebel, Paris
Collection Galerie Sagot-Le Garrec, Paris

Henri-Joseph-Constant Dutilleux
French; Douai 1807-1865 Paris

Born in Douai, Constant Dutilleux trained at the Ecole des Beaux-Arts in Paris under Louis Hersant. While pursuing his own artistic career, Dutilleux supported himself and his large family by teaching painting, drawing, and lithography. In 1830 he opened a studio in Arras and through his atelier passed over 225 students, among them Charles Desavary (his future son-in-law), Alexandre Collette, and Eugène Cuvelier. Primarily a landscape painter, Dutilleux earned additional income from the many portrait commissions he received in Arras and Douai.

Dutilleux exhibited at his first Salon in 1834 and was a regular contributor throughout his life. His visits to Paris affected him profoundly. He saw contemporary painting which influenced his art, and he met artists with whom he formed friendships of lasting significance. For example, in 1847 Dutilleux saw a painting by Corot which deeply impressed him, and he bought it. His purchase of the work led to his meeting the artist, with whom he began a lifelong friendship. Corot first visited Arras in 1851, and regularly thereafter. Together Dutilleux and Corot sketched in the area surrounding Arras; they traveled to Holland; and in 1851 Corot introduced Dutilleux to Fontainebleau, a trip that became an annual event for Dutilleux. Like Corot, Dutilleux sought every opportunity to paint directly from nature and in the sympathetic company of his colleagues.

Around Dutilleux it seems there was always a spirit of camaraderie. In 1859 he created the Society of the Friends of Art in Artois (the region of which Arras was capital). Delacroix, Corot, and Antoine-Louis Barye were honorary presidents; Millet, Huet, and Narcisse Diaz de la Peña were awarded membership in this lively association dedicated to gathering together all persons interested in the arts and to cultivating an attitude of acquisition of meritorious works (Bib. V Dutilleux/ Oursel, p. 14).

In 1860 Dutilleux left his lithography shop and studio to Charles Desavary and moved to Paris. His aim was even closer contact with his treasured friends there. In addition to his warm association with Corot, Dutilleux was an intimate and devoted friend of Delacroix. Dutilleux's move to Paris was also stimulated by his desire to assist Delacroix in completing his large commission at St.-Sulpice, Paris.

In 1865, en route to meet Corot, Dutilleux had a stroke; he died several days later in Paris.

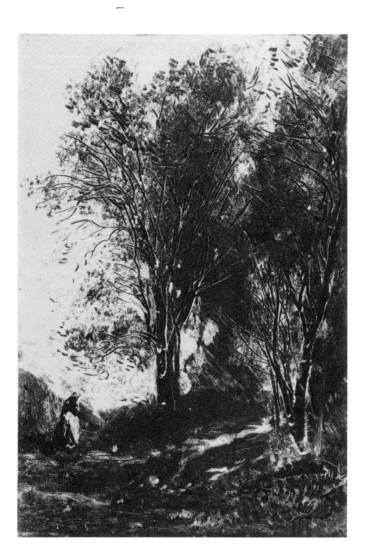

52
Edge of the Forest (Lisière de forêt)
1853 (c. 1911/13)
Image: 16.5 x 11.5 cm (6½ x 4½ in.)
Sheet: 22.9 x 17.8 cm (9 x 7 in.)
Provenance: Albert Bouasse-Lebel, Paris
Collection Galerie Sagot-Le Garrec, Paris

The clichés-verre of Dutilleux have been largely ignored in the literature primarily for two reasons. First, there are few extant impressions and consequently, the images have rarely been seen. Second, Germain Hédiard considered Dutilleux's clichés-verre minor works, stating further that he had no affinity for, or apparent interest in, the process (Bib. III Hédiard, p. 425). Yet, Dutilleux's painted plates exhibit a photographic orientation that was lacking in the work of most practitioners. Usually, 19th-century artists approached the glass plate as another surface for reproducing linear drawings. In contrast, Dutilleux's clichés-verre are, as he described them, "monochrome paintings on glass for photography."

An inscription on the Bibliothèque Nationale impression of *Lisière de forêt* indicates that Corot and

Dutilleux were working side by side in their early trials in cliché-verre; on the mount can be read: *C'est la suite de la premier Essai imaginé par Constant Dutilleux, à Arras, que Corot en fit de son côté.* While Corot's first five clichés-verre, all from 1853, were linear plates, Dutilleux most often executed his prints in the painted plate method because of its chiaroscuro effects. In fact, although Corot established an overall tone with the dots of *tamponnage,* he did not execute his first painted plate until 1854 (see cat. no. 10).

53
Man Walking in Marsh (Paysage)
c. 1853
Salt print
Signed in plate, upper left: *CD* (with cross)
14 x 19 cm (5½ x 7½ in.)
Provenance: Constant Dutilleux (Lugt 2914)
Collection André Jammes, Paris

Dutilleux most probably executed his clichés-verre in 1853 and 1857. Closely related to *Landscape: Figures on Road beside Wooded Knoll* (Appendix, Dutilleux no. 1), dated 1853, *Paysage* was most likely executed in the same year. Drawn lines establish shading on a tree as well as reiterate the feeling of the agitation of the wind across the grassy landscape. The foliage, however, is not described in individual strokes. Instead, Dutilleux used broad tonal areas to define the forms and give the impression of the atmosphere and the motion of the breeze.

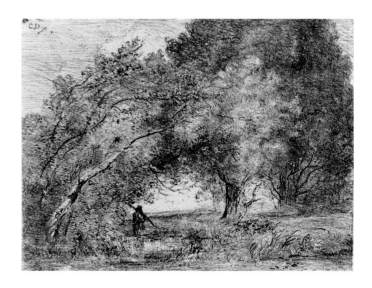

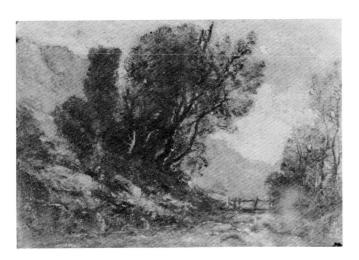

54
Landscape with Bridge over Stream
1857
Salt print
Signed in plate, lower right: *C.D.*
9.5 x 13.3 cm (3¾ x 5¼ in.)
Provenance: Constant Dutilleux (Lugt 2914)
Collection André Jammes, Paris

Landscape with Bridge over Stream, dated 1857 from an
inscription on an impression in the Bibliothèque Na-
tionale, Paris (the richest repository of clichés-verre by
Dutilleux), is from the later group of Dutilleux's clichés-
verre. In his earlier plates, Dutilleux established a com-
bination of painterly values and linear description of
form, qualities that he developed more fully in this later
composition. *Landscape with Bridge over Stream* relies
totally on the tonal vocabulary of the painted cliché-
verre technique, with the light/dark relationships and
modeled forms achieved solely through painted impasto.

In addition to painterly modulations of the surface,
Dutilleux was aware of the possible photographic inter-
pretations as well: the two impressions of *Landscape
with Bridge over Stream* in the Bibliothèque Nationale
are printed in variant tonalities, inscribed as *deux ti-
rages différents.* One impression appears in a soft rosy-
mauve tone, the other in a light oatmeal-mustard
brown; both, as well as the superb impression exhibited
here, convey a sense of the active trembling of the water
and the rustling movement of the trees.

Dutilleux painted his tonal plates in a fashion similar
to his canvases: little strokes of thick paint translate into
highlights, a quality Dutilleux was well aware of as he
inscribed one impression of *Landscape with Bridge over
Stream* (Bibliothèque Nationale): *Peinture monochrome
sur verre pour photographie.*

55
Two Boatmen in Marsh near Cluster of Trees
c. 1857 (c. 1911/13)
Image: 12 x 16.5 cm (4¾ x 6½ in.)
Sheet: 13 x 18.1 cm (5⅛ x 7⅛ in.)
Provenance: Albert Bouasse-Lebel, Paris
Collection Galerie Sagot-Le Garrec, Paris

Like the Sagot-Le Garrec collection impression of *Lisière
de forêt* (cat. no. 52), this impression, from the same col-
lection, is dark black-brown. Both are later impressions
from Dutilleux negatives. Unlike the former, however,
no 19th-century impressions of *Two Boatmen in Marsh
near Cluster of Trees* have been located.

It is not known when these impressions were printed.
Probably they were made around 1911 by Paul Desav-
ary at the behest of Bouasse-Lebel; perhaps by Maurice
Le Garrec in 1921. Curiously, the plates for the clichés-
verre were not as carefully preserved as the impres-
sions and these, like most of the others, have been lost,
misplaced, or broken. Nevertheless, as in the Sagot-Le
Garrec printings of 1921, many subtleties seen in 19th-
century impressions are obliterated by the strong con-
trast of modern paper (see also cat. no. 33).

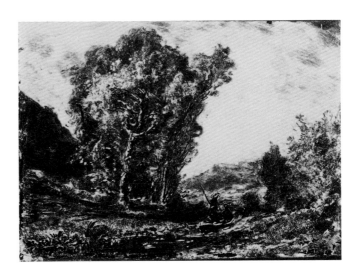

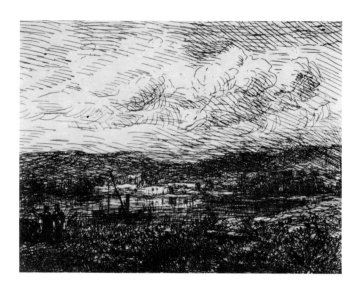

56
Evening—Fishermen (Le Soir—Pêcheurs)
c. 1857
Salt print
Inscribed in ink on verso: *Dessin sur verre, à la pointe./Ct. Dutilleux.*
12.5 x 16 cm (4⅞ x 6⁵⁄₁₆ in.)
Collection Huguette Berès, Paris

Dutilleux's linear plates are often less successful than his painted ones. In an attempt to suggest spatial variation, he overworked the plates with dense crosshatching. Because of the uniform tone created through even exposure of the paper through the removed ground, the grass, water, and hills of *Le Soir—Pêcheur* translate as one value. The flat and awkward effect contrasts with the bravura of the artist's masterful painted plates.

John Whetton Ehninger
American; New York 1827-1889 Saratoga Springs

John Whetton Ehninger, descendant of the Knicker-bocker family, a man schooled in languages and the classics, was active as an illustrator in New York during the 1850s and throughout the following two decades. After graduating from Columbia College in 1847, "Jack," as he was called by his friends (whom he likewise referred to as his "brothers brush") traveled to Europe. In Düsseldorf, Ehninger joined the many Americans in the studio of the expatriate painter Emmanuel Gottlieb Leutze.

Ehninger returned to the United States in 1850; a portrait he executed of Peter Stuyvesant for Washington Irving's *History of New York* quite suddenly established his reputation as an illustrator. Although Ehninger returned to Europe in 1851 to study with Thomas Couture in Paris, after 1853 he again settled in New York. He soon became known for his drawn illustrations, which were reproduced in many gift editions. Throughout his career Ehninger sought a method to provide the most sensitive and faithful copies of his sketches.

In 1860, one year after the publication of his album *Autograph Etchings by American Artists*, Ehninger was elected a member of the National Academy. Although Ehninger did contribute paintings to the Academy's exhibitions, both his contemporaries and posterity have concurred in their judgment that his illustrations are more important than his canvases.

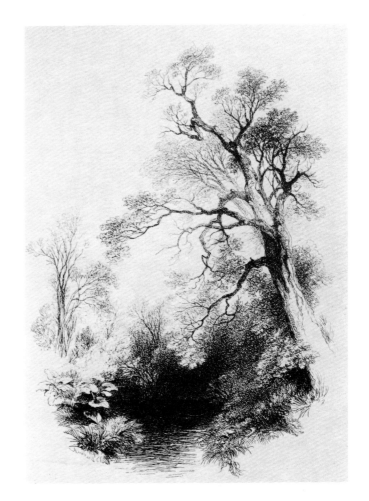

57

57-59
Autograph Etchings by American Artists
Produced by a New Application of Photographic Art, Under the Supervision of John W. Ehninger. Illustrated by Selections from American Poets.
New York, W. A. Townsend & Co.; printed by P. C. Duchochois
1859
Album of 12 albumen prints, mounted and bound
Sheet: 33.6 x 25.4 cm (13¼ x 10 in.)
Cover: 35.2 x 28.6 cm (13⅞ x 11¼ in.)

List of Plates:
1. Asher Brown Durand (1796-1886), *The Pool*
2. Emmanuel Gottlieb Leutze (1816-1868), *The Puritan*
3. John Frederick Kensett (1816-1872), *Autumn*
4. Felix Octavius Carr Darley (1822-1888), *Noon*
5. John William Casilear (1811-1893), *The Lake*
6. Eastman Johnson (1824-1906), *The Wigwam*
7. Sanford Robinson Gifford (1823-1880), *Spring*
8. George Cochran Lambdin (1830-1896), *Childhood*
9. George Henry Boughton (1833-1905), *Winter*
10. William Parsons Winchester Dana (1833-1927), *The Seashore*
11. Louis Remy Mignot (1831-1870), *The Tropics*
12. John Whetton Ehninger (1827-1889), *The Exiles*

Four copies courtesy of the Art Institute of Chicago; Library of the National Collection of Fine Arts and the National Portrait Gallery, Smithsonian Institution, Washington, D.C.; S. P. Avery Collection, Prints Division, the New York Public Library, Astor, Lenox, and Tilden Foundations (inscribed in ink on endpaper: *To my dear Cousin Dolly Brevoort/with much love from her/Cousin Jack/ Xmas 1861*); Wm. B. Becker Collection.

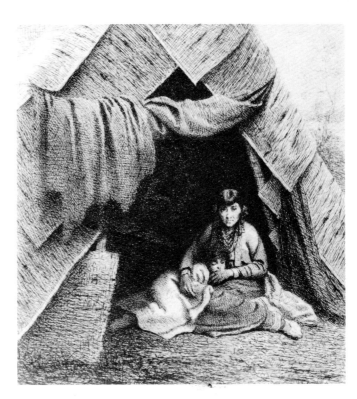

89

58

59

Twelve American artists sketched designs on glass to illustrate the poetry of twelve American authors for Ehninger's *Autograph Etchings.* The gift edition, which was printed by P. C. Duchochois, a photographer in New York, was an attempt on the part of Ehninger to produce multiple copies of original drawings without, as he wrote in the Publisher's Preface, "recourse to the intermediate aid of an engraver." While Ehninger developed his process of cliché-verre precisely because he found other graphic processes so complex as to demand years of experience with the techniques, most of the artists who contributed to *Autograph Etchings* were, at some point in their career, illustrators or reproductive engravers.

Asher B. Durand's early reputation was based on his work as an engraver. By 1859, however, Durand had long abandoned reproductive work for painting. The fact that Durand, as President of the National Academy, contributed to the volume, helped establish the seriousness of the edition. Durand's *The Pool* (cat. no. 57) is a highly specific, masterfully executed cliché-verre. As a skilled printmaker, he was sensitive to the emphatic juxtapositions of light and dark in black-and-white impressions. Patterning their placement in the limited

space, Durand alternated from rendering the foliage as black-on-white to white-on-black, a technique also used slightly by Casilear (fig. 4), who had been Durand's pupil.

Eastman Johnson, like Ehninger, studied with Leutze in Düsseldorf, and then painted in Wisconsin and Ohio from 1856 to 1858. With controlled, finely stroked hatching and crosshatching, Johnson depicted in *The Wigwam* (cat. no. 58) a universal scene: the private moments between a mother (in this case, an American Indian), looking proudly and directly at the viewer, and her sleeping child.

That scratched lines exposed evenly through the collodion-covered glass, preventing successful rendering of half-tones, was to Ehninger a severe limitation. To resolve this problem, Ehninger selectively varnished the reverse of the glass in order to hold back the light in areas where more delicate tones were desired. This effect is vividly evident in *The Tropics* (cat. no. 59), the cliché-verre by L. R. Mignot. Mignot's cliché-verre depicts the tall exotic palms and the lush vegetation of a tropical port. The scene may well be one from Ecuador, as Mignot traveled there with fellow painter Frederic Church from 1857 to 1859. While the half-tones created by varnishing the plate do succeed in providing a sense of aerial perspective, nevertheless, the tonal shift is very abrupt. Areas still remain separate and distinct rather than fused in continuous gradations.

Curiously, only four of the twelve artists used the varnished method, perhaps because most, as experienced illustrators, were more accustomed to developing spatial differentiation through techniques of drawing. W. P. W. Dana (fig. 3), to whom, in December 1859, Ehninger inscribed a copy (to his "brother brush"; Gernsheim Collection, Austin), utilized lightly drawn lines as well as varnish to separate the imagined voyage in the foreground from the actual departure behind. Ehninger's own contribution to *Autograph Etchings*, a well-executed, although sentimental illustration of "The Exiles," a poem by Henry Wadsworth Longfellow, however, was realized solely by altering the drawing. Ehninger created a number of tones by varying the density and quality of his drawn lines rather than employing his varnished method.

In the years just prior to the Civil War, the focus of *Autograph Etchings* was decidedly nationalistic; in his preface, Ehninger stated that his purpose was to further the cause of American art by making available accurate reproductions of works by some of his country's most important artists. The volume, however, does not seem to have sold well, and Ehninger's experiments with the cliché-verre were limited to this one publication (see "Cliché-verre in the 19th Century," p. 35).

Camille Flers
French; Paris 1802-1868 Annet

Flers began his studies conventionally, entering the studio of the academic painter Joseph-François Pâris, but he soon broke with strict tradition, choosing instead to work directly from nature. Around 1830 he was one of the first to move to Barbizon. Flers, who was named Knight of the Legion of Honor in 1849, regularly exhibited his paintings in the Salons from 1831 to 1863. It was, however, in the medium of pastel that his direct impressions of the landscape found their most spontaneous expression. In *L'Artiste*, 1846, Flers published an important tract on the technique of drawing with pastels.

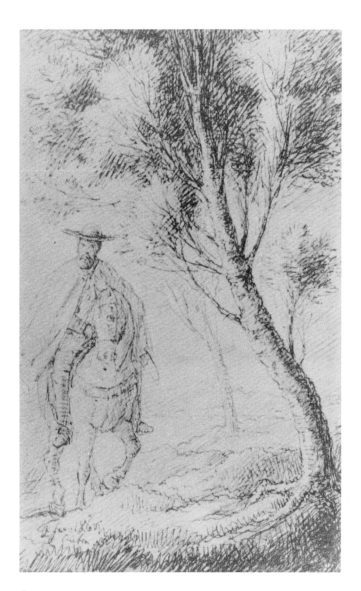

61
Portuguese Rider
1861
Signed in plate, lower left: *CF fe 1861/Cintra* (*CF* interlaced)
13.1 x 8.4 cm (5 3/16 x 3 1/4 in.)
Collection Texbraun, Paris

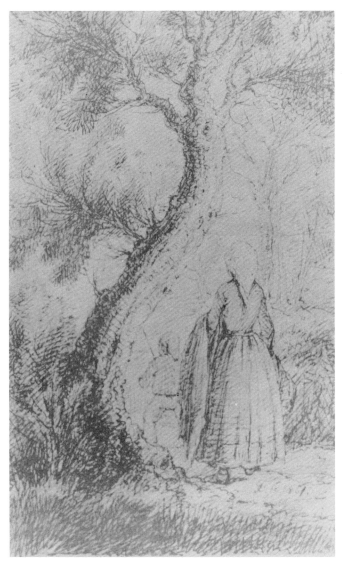

60
Peasant Woman and Boy Walking on Road
1861
Signed in plate, lower right: *CF fe 1861* (*CF* interlaced)
13.1 x 8.4 cm (5 3/16 x 3 1/4 in.)
Collection Texbraun, Paris

The paintings and pastels of Flers reflect his preoccupation with the French landscape, specifically the area around Barbizon. Always an adventurer, Flers traveled to foreign lands as well. Georges Lafenestre, in an introduction to George Gassies' memories of life in Barbizon, recorded that the "capricious" Flers voyaged to America around 1834, returning with exotic tales of his adventures (Bib. II Gassies, p. ix).

It was surely this taste for foreign sites and stimulating experiences that led Flers to Portugal, where he recorded the sights in two clichés-verre. *Portuguese Rider*, one of the two pendant pieces in this exhibition, is inscribed *Cintra*, a coastal town of Portugal.

Adolphe-François Gosset
French; 1815 Paris 1896

As a young man Gosset entered the Ecole des Beaux-Arts, Paris, where he studied with Paul Delaroche, the history painter who also taught Millet and Daubigny. A regular contributor to the Salons from 1848 to 1880, Gosset exhibited portraits and genre scenes, but it is his landscapes of the French countryside, especially the Oise River, that have been recorded by Bénézit (Bib. I Bénézit, V, p. 125).

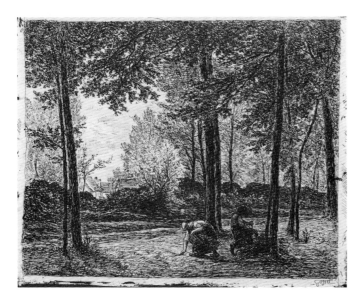

62
Woodgatherers (Les Ramasseurs de bois)
c. 1859/62 (c. 1911/13)
Signed in plate, lower right margin: *Gosset*
Image: 15 x 19 cm (5⅞ x 7½ in.)
Sheet: 17.8 x 24.1 cm (7 x 9½ in.)
Provenance: Albert Bouasse-Lebel, Paris
Collection Galerie Sagot-Le Garrec, Paris

Although not specifically initialed, this cliché-verre inscribed *Gosset* can in all probability be assigned to Adolphe-François Gosset. Just beyond the edge of the village, in the cool shade of the overhanging trees, a couple, crouching on the forest floor, collect their fuel—fallen twigs and branches. In this image of woodgathering, as in so many of Jean-François Millet's depictions of rural life, the quiet dignity of the figures elevates the simple ritual of gathering and bundling to an act of grace.

Marcelin de Groiseilliez
French; 1837 Paris 1880

Little is known about the life of landscape painter Marcelin de Groiseilliez. According to Bénézit, he began his training in the studios of Boyer and Passin (Bib. I Bénézit, V. p. 224); yet these painters are not listed in Bénézit's dictionary of artists' biographies. De Groiseilliez entered landscape paintings in the Salons from 1863 to 1879, winning a third-class medal in 1874. De Groiseilliez did visit Barbizon and, most probably, produced his cliché-verre in that center.

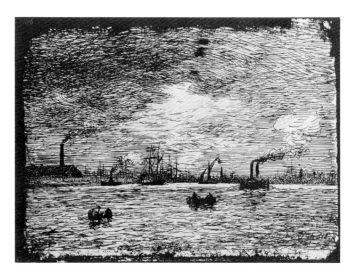

63
View of a Harbor
c. 1859/62 (c. 1911/13)
Signed in plate, lower right (in reverse): *M. de Groiseilliez*
Image: 13 x 17.7 cm (5⅛ x 7 in.)
Sheet: 14 x 19 cm (5½ x 7½ in.)
Provenance: Albert Bouasse-Lebel, Paris
Collection Galerie Sagot-Le Garrec, Paris

In this harbor view, de Groiseilliez presented a 19th-century interface of old and new. Modern steam-driven ferries are juxtaposed with traditional masted schooners. While the number of the ferries is still few, their solid round smokestacks nevertheless dominate the scene because of their belching vapors.

Paul Huet
French; 1803 Paris 1869

Trained at the Ecole des Beaux-Arts in Paris, in the Neo-classical tradition, Huet nevertheless became, along with his close friend Delacroix, a part of the Romantic revolt. Also like Delacroix, Huet was impressed by the paintings of John Constable and J. M. W. Turner, English artists more appreciated at the time in France than in their native country. A landscape painter of considerable strength, Huet was awarded many Salon prizes and, in 1841, he was conferred the Legion of Honor.

Huet was admired as both painter and printmaker. In 1829 he published his first landscape etchings; another album, exhibited at the Salon, was released in 1834. Huet was a founding member of the Société des Aqua-fortistes and contributed to the renewed respect for the tradition of painter-engraver.

A peripatetic traveler, Huet began visiting Barbizon in 1849. One of the first guests at the Auberge Ganne, he participated in the decoration of the inn along with Brendel and others. His interest in recording his impressions of the terrain and atmosphere of the area, relates Huet to his fellow painters in Barbizon. He cannot be classified with any group, however, for his powerful expressions of the landscape are uniquely his own. Labels as diverse as "pre-Impressionist," "Romantic landscapist," and "Barbizon artist" have all been applied to Huet.

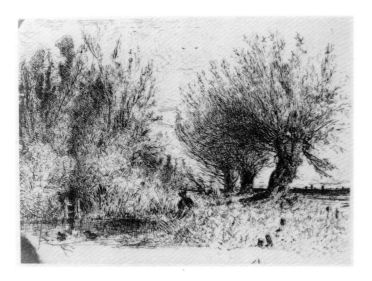

64
Banks of a Stream or Pond with Three Willows (Bords de rivière ou La Mare aux trois saules)
c. 1861/68
Varnished salt print
15.7 x 22 cm (6⅛ x 8¹¹/₁₆ in.)
Delteil 92
Provenance: R. E. Lewis, Inc. (Bib. III San Francisco, no. 36)
National Gallery of Art, Washington, D.C. (Andrew W. Mellon Fund, 1978)

According to Hédiard (Bib. III Hédiard, p. 424), Huet's first cliché-verre, *Vieilles Maisons à Honfleur* (Delteil 95), was drawn at the request of Barthélemy Pont in 1855 (see "Cliché-verre in the 19th Century," p. 34 and cat. no. 72). Although the single known impression does not carry their dry stamp, the printing quality resembles the Noël printed by Harville and Pont: dense layers of emulsion sometimes resulting in dark tones generally not integrated with the drawn lines.

Huet, it appears, was not taken with the process, since this was his only effort with the Harville/Pont team. Perhaps Huet would not have tried cliché-verre a second time had it not been for his association with Constant Dutilleux, whom he met in Paris (most likely through their mutual friend Delacroix). In 1861, according to a letter from Dutilleux to Charles Desavary, Huet, after viewing several of Corot's clichés-verre, indicated his interest in having some. Writing to Desavary, Dutilleux suggested his son-in-law also send plates so that Huet himself might try the process (Bib. III Melot, p. 23). In all probability, Desavary did forward the plates, and the result was Huet's six additional clichés-verre.

Desavary may have even envisioned a publication of clichés-verre. According to Delteil, an album of clichés-verre was produced with many (or maybe only) Huet images. A copy of this folio, titled *L'Album-Auto-Photo-graphique, Ière Série*, although reported to have been in the Bouasse-Lebel collection, has not been located. Nevertheless, the publication could well have been the work of Charles Desavary (one impression of *Marécage* with Desavary's stamp has been located in the collection of André Jammes, Paris), and because the album is titled as the first in a series, perhaps others were planned.

Surely Huet must have seen in Corot's linear clichés-verre a drawing surface receptive to his particular graphic style. In *Bords de rivière* Huet explored the variety of linear expression available in the technique. To convey the intimacy of the bucolic setting, the artist utilized thin, sparse lines, strong hatching, as well as solid blocked areas for large tonal massing, conventions he distilled and separated in the sinewy line of *Maré-cage* (cat. no. 67) and the rotund darks of *Le Torrent* (cat. no. 66).

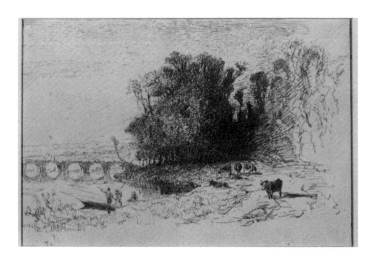

65
Bridge (Le Pont)
c. 1861/68
Varnished or toned salt print
14.5 x 22.3 cm (5¾ x 8¾ in.)
Delteil 93
Museum of Fine Arts, Boston (Special Print Fund)

The composition of *Le Pont* is very close to the format of Huet's landscape drawings: a long, slow progression from the foreground to a middle area clustered with trees. Huet suggested the grassy elements as well as larger foliage masses with his typical economy. The loose, free strokes with which Huet depicted the bucolic setting indicate the artist's ease with the drawing surface.

The glass plate for *Le Pont,* which has not been previously published, is in the Bibliothèque Nationale, Paris, labeled School of Arras. No other Huet plates have been located.

66
Torrent (Le Torrent)
c. 1861/68
Varnished or toned salt print
17 x 22.2 cm (6¹¹⁄₁₆ x 8¾ in.)
Delteil 94
Metropolitan Museum of Art, New York (Gift of M. Knoedler, 1927)

While *Le Pont* (cat. no. 65) features a calm, rural setting and an open vista across the terrain, *Le Torrent* captures an agitated state of nature in a close, limited space. It is not the quiet of grazing cows that Huet has focused on here, but rather the noisy rush of thundering water. Using a vigorous zig-zag stroke, Huet has suggested a tumultuous force of motion that calls forth a spirit of romantic grandeur, especially apparent in this impression from a flipped plate.

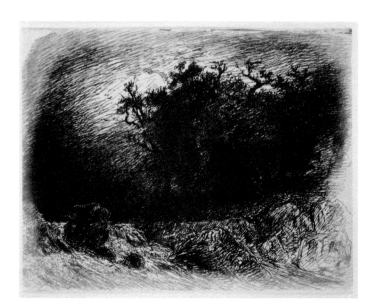

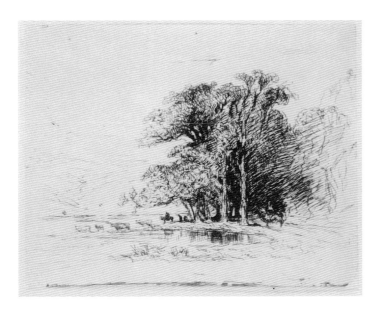

67

Marsh or Traveler (Marécage ou Le Voyageur)
c. 1861/68
Varnished or toned salt print
17.1 x 22.2 cm (6¾ x 8¾ in.)
Delteil 96
Metropolitan Museum of Art, New York (Gift of M. Knoedler, 1927)

The sparse economy of *Marécage* recalls Huet's pen drawings. With a few rambling lines, Huet suggested both the foreground plane and the distant hills. The artist alternated concentrated tones in the trees with the white unworked areas to render a sense of the shifting light on the foliage. The mood is one of peaceful harmony; a traveler, grazing cattle, and quiet grasslands.

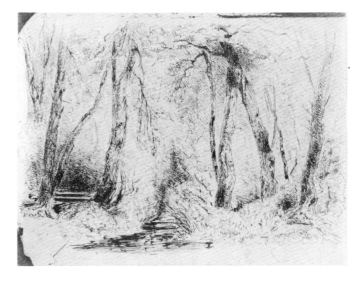

68

Brook under Trees or Forest Interior (Ruisseau sous bois ou Intérieur de forêt)
c. 1861/68
Varnished salt print
15.2 x 21.5 cm (6 x 8⁷⁄₁₆ in.)
Delteil 97
Collection André Jammes, Paris

According to Hédiard (Bib. III Hédiard, p. 424), *Ruisseau sous bois*, a scene in Saint-Cloud Park, is related to an etching from Huet's 1835 folio as well as to his 1852 Salon entry, the painting *Calme du matin* (Musée du Louvre, Paris). Huet masterfully suggested the embracing coolness of the forest interior in *Ruisseau sous bois*, a composition very much like, or perhaps a model for, the 1875 cliché-verre of Barbizon painter César de Cock (see Appendix, de Cock).

Charles-Emile Jacque
French; 1813 Paris 1894

The early career of Charles Jacque is marked by his various positions as a printmaker: he was apprentice to a mapmaker in Paris; while serving in the army, he published lithographs of military life; and during a two-year sojourn in London, Jacque worked as an illustrator. In 1838 Jacque returned to Paris, again supporting himself as an illustrator. Thus, it is not surprising that Jacque's first entry to the Salon in 1845 was an etching. Indeed, not long thereafter, in 1851, Salon officials bestowed their official recognition on Jacque's graphic work by awarding him a medal for his efforts. Jacque's output in the graphic arts was prodigious throughout his career: by 1848 he had completed around 300 prints, a figure which rose to over 470 before his death.

In 1849 Jacque moved to Barbizon along with Millet, a close friend and an artist whose work had a profound influence on him. Five years later, however, Jacque and Millet quarreled bitterly. In fact, Jacque's unpleasant nature caused breaks in his friendships with other Barbizon artists as well, including Rousseau. In 1854 Jacque left Barbizon and resettled outside Paris. Although he continued painting and printmaking, his experiments in animal husbandry, a hobby that became a passionate avocation, occupied much of his time. Jacque did gain considerable recognition as a breeder of chickens, and in 1869 he wrote and illustrated a book on the subject, *Le Poulailler*.

He nevertheless continued to exhibit at the Salons throughout the 1860s and in 1889, at the age of 76, he won a gold medal at the International Exhibition for his etching *La Bergerie bernaise*. The artist outlived most of his contemporaries, dying in 1894 at the age of 81.

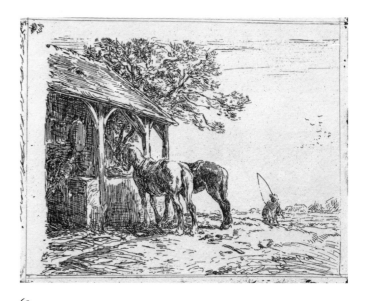

69
Work Horses near a Shed (Chevaux de labour, près d'un hangar)
c. 1859/62 (c. 1911/13)
Signed in plate, lower right (in reverse): *Ch. Jacque*
Image: 15.2 x 18.7 cm (6 x 7⅜ in.)
Sheet: 16.7 x 20.3 cm (6⁹⁄₁₆ x 8 in.)
BN Inventaire, Jacque, no. 642
Provenance: Albert Bouasse-Lebel, Paris
Collection Galerie Sagot-Le Garrec, Paris

Jacque never explored his two major animal subjects—sheep and pigs—in cliché-verre. His two prints in the medium, however, both signed but not dated, do reveal the artist's abiding affection for life in the country. Drawn in a clear graphic style, with the short, jerky, staccato line apparent in many of Jacque's etchings of the same period, the two clichés-verre depict typical Barbizon scenes: a road bending deep into the forest, farm horses after a day in the fields.

70
Road at the Entrance of a Wood (Chemin à l'entrée d'un bois)
c. 1859/62
Salt print
Signed in plate, lower left (in reverse): *Ch. Jacque*
Image: 17.6 x 13.6 cm (6⅞ x 5⅜ in.)
Sheet: 19.1 x 16.1 cm (7½ x 6⅜ in.)
BN Inventaire, Jacque, no. 643
Collection Gérard Lévy, Paris

In *Chemin à l'entrée d'un bois* there is an odd, almost
melancholic note. A man, almost indistinguishable
from the terrain, lies prone near the path. Long after-
noon shadows spill across the road; the lone figure
watches, gazing after a horse-drawn carriage as it turns
the bend, disappearing into the wooded recess.

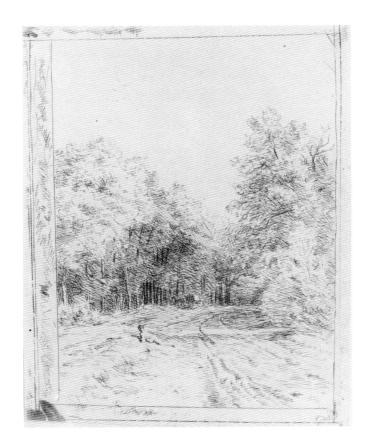

Jean-François Millet
French; Gruchy 1814-1875 Barbizon

Born in a small town in Normandy, Jean-François Millet moved in his youth to Cherbourg in order to study painting. In 1837 he relocated in Paris and entered the studio of Paul Delaroche, the celebrated history painter whose many students included Daubigny and Gosset. Although Millet's success as a painter was not immediate, by 1849 he had received sufficient acclaim and remuneration to finance a permanent move to Barbizon. He remained there throughout his life, as did his close friend Théodore Rousseau. The rural environment provided Millet with a constant source of subject matter; in the quotidian he found scenes of monumental force and tender poetry.

For Millet, public recognition came late in life. Not until 1864 did the artist win a first class medal at the Salon; and in 1868, less than a decade before his death, he was awarded the Legion of Honor.

Collectors of Millet's work admired his clichés-verre. In January 1863 Millet's biographer Alfred Sensier wrote the artist to indicate his enthusiasm for the pieces and to request additional impressions for his brother, a collector of Millet's prints (Bib. III Melot, p. 290).

71
Woman Emptying a Bucket (Femme vidant un seau)
1862
Salt print
Signed in plate, lower left (in reverse): *J. F. Millet*
Image: 28.6 x 22.2 cm (11¼ x 8¾ in.)
Sheet: 30.2 x 23.5 cm (11⅞ x 9¼ in.)
Delteil 28
Detroit Institute of Arts (John S. Newberry Fund)

As was his habit in etching, Millet reworked compositions for his two clichés-verre which he had rendered previously in paint or pastel. Related to *Femme vidant un seau* are two pastels (Brooklyn Museum; Musée du Louvre, Paris), an early painting (present location unknown), and an ink drawing (Private Collection, Paris), as well as other studies (see Bib. V Millet/Herbert, nos. 32, 132, 175). Sketching without hesitation in a thin, even stroke, Millet depicted a woman in the simple confines of a rustic courtyard pouring milk from a bucket into large round copper cans. Millet envisioned this chore—one he must have witnessed daily in his native Normandy and in Barbizon—as a private act of simple dignity.

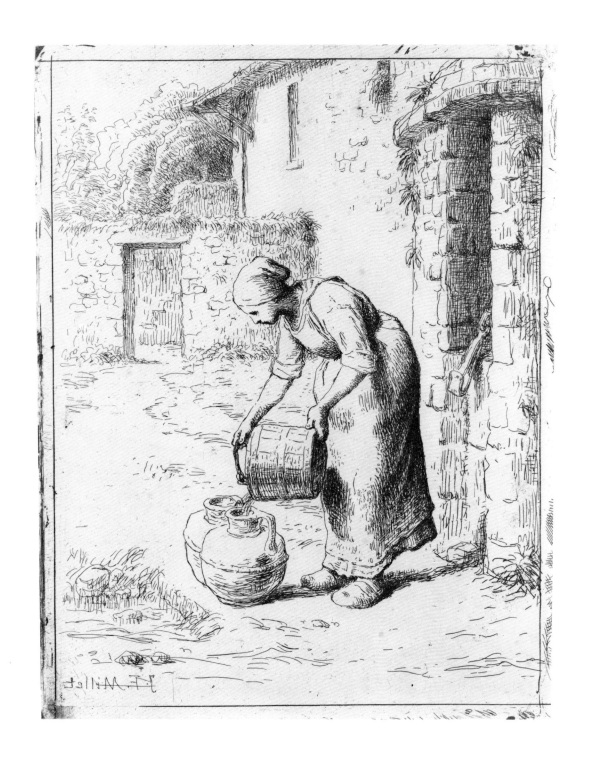

J.F.Millet

99

Jules-Achille Noël
French; Quimper 1815-1881 Algiers

After some initial study in Brest, Jules Noël moved to Paris, but it was to the Normandy coast that the watercolorist continually returned for inspiration. As a landscape painter, Noël made his Salon debut in 1840, and he was a regular contributor until 1879. His career as a painter, though steady, was never spectacular.

Noël is best remembered for his watercolors, liquid veils of color capturing the humid, enveloping mist of the Norman seascape. The transparent washes of Noël's brush also inspired Félix Buhot, his pupil at the Ecole des Beaux-Arts in Paris around 1865, to translate these soft continuous tones into aquatint.

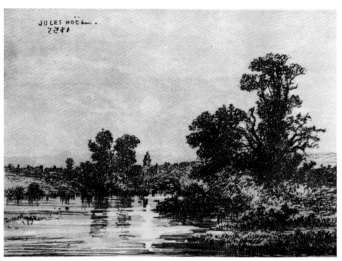

72
Moonlit Landscape
1855
Albumen print
Signed and dated in plate, upper left: *JULES NÖEL./1855* (N and *1855* in reverse)
Stamped on mount, lower right: *BREVET D'INVENTION/ S.G.D.G./Procédé HARVILLE & PONT*
Image: 8.9 x 12.7 cm (3½ x 5 in.)
Gernsheim Collection, Humanities Research Center, the University of Texas at Austin

Although Horace Vernet (Bib. III Paris, no. 165) and Paul Huet (Delteil 95) executed clichés-verre under the supervision and instigation of Harville and Pont, Noël's is the only known cliché-verre stamped with their mark. His composition, a moonlit landscape, demonstrates the unique effects possible with their complex process. Based on two stages (first drawing through a collodion ground, and then painting on the plate with wash or lifting the ground with stump and roulette), the process was well suited to the work of this watercolorist: intermediate tones suggesting reflected light could be rendered over the deep black lines of the design. Unlike Ehninger's technique of selectively varnishing the back of the plate, creating two distinct areas of drawn line, Harville and Pont's method was more closely related to the painted plate method of Cuvelier, since in both, the gesture of the brush was clearly visible. Nevertheless, in contrast to the vigorously painted plate by Daubigny (cat. no. 45), for example, the drawn lines in Jules Noël's landscape remain separate, adjacent to but not integrated with the brushed gradations of half-tone.

Jean-Amable-Amédée Pastelot
French; Moulins c. 1820-1870 Paris

Of Pastelot's life we know only pieces of information. Known primarily as a painter of costumes and ornament (he decorated a room in the Hôtel Carnavalet, Paris), Pastelot is said to have rendered flowers in the style of Narcisse Diaz de la Peña. He was a regular contributor to the Salons from 1846 to 1870. Two of his etchings were published in the folios of the Société des Aquafortistes. As a caricaturist, Pastelot contributed to some of the leading journals of the day: *Charivari, Journal Amusant, L'Illustration.*

The artist's most intense passion was, however, the theater. His aunt, Parisian actress Mademoiselle Alexis, appointed Pastelot as theater fireman and, to his delight, he was stationed nightly at the performances. His etching *Les Sorcières,* published in the December 1863 folio of the Société des Aquafortistes, reflects Pastelot's fascination with the dramatic and the imaginary. Against the penetrating backlighting of the moon's glow, a dancing goblin is silhouetted, while in the shadowy foreground, witches receive their demonic instructions.

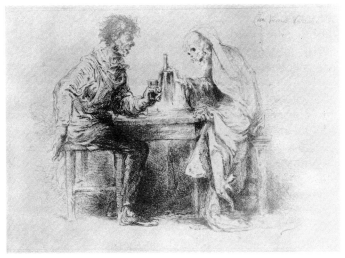

73
In Vino Veritas
c. 1868
Salt print
Signed and inscribed in plate: lower right, *Pastelot;* upper right, *In Vino Veritas!*
Image: 14 x 19.7 cm (5½ x 7¾ in.)
Mount: 25.1 x 31.2 cm (9⅞ x 12¼ in.)
Collection Ruth E. Fine

While 19th-century French clichés-verre are generally landscapes, a glaring exception occurs in the work of Pastelot. *In Vino Veritas,* for example, is a humorous depiction of an inebriated peasant toasting a draped skeleton, whose bony hand rests on a bottle of wine.

Around 1868 Pastelot produced an album of "etchings engraved on glass," or clichés-verre (see Appendix). The folio, of which the only known copy exists in the Bibliothèque Nationale, Paris, begins with a title page reminiscent of those introducing the issues of the Société des Aquafortistes. Included in the album are two landscapes, one portrait, and two *vanitas* images. *In Vino Veritas* was not part of the album, but nevertheless is closely related both stylistically and thematically. Pastelot's *vanitas* clichés-verre are crisp linear plates drawn with a vigorous spontaneity that is close to caricature.

André-Toussaint Petitjean
French; active 1860s

André-Toussaint Petitjean was a military man who fortunately had a scientific mind and a love for documentation. The album that he compiled while captain of the artillery, 1st regiment, in Mexico, from 1864 to 1866, records not only Petitjean's experimental cliché-verre prints but also the visual and social ambiance of a French army officer in the years of France's occupation of Mexico. The album is also our only bibliographical source for this artist.

Petitjean's assignment in Mexico, it seems, was to document not the military life but the flavor of the local habitat, the markets and religious processions, the physiognomy of the people and the land. Beginning with his arrival in Mexico City, heralded by a photographic reduction of a pen-and-ink drawing of Chapultepec Park, we travel with the Frenchman north along a well-traveled route, passing through Pachuca toward Monterrey. Through Petitjean's eyes we see 19th-century northern Mexico: the cities and landscape around Saltillo, Matamoros, Durango, and Mazatlan are fixed in watercolor, on collodion negatives, in inked sketches, and on the sensitized textures of salted and albumenized papers. Petitjean chronicled his route like a travelogue, forwarding images and letters to his commander stationed in Mexico City. In these letters, addressed to "mon commandant," Petitjean complains of the difficulties of obtaining photographic paper and chemicals, as well as of other hardships, such as the difficult adjustment of his Parisian palate, accustomed as he was to good wine. The tone of the letters is, however, less that of a man who desires to share curiosity than of a Parisian gentleman cut off from the things that mark his sophistication. Perhaps in his military superior, Petitjean found a kindred spirit, or even an impressionable one.

Petitjean's chronicle stops in 1866 when, presumably, he returned to France just before the French occupation of Mexico ended dramatically with the execution, outside Mexico City, of Emperor Maximilian.

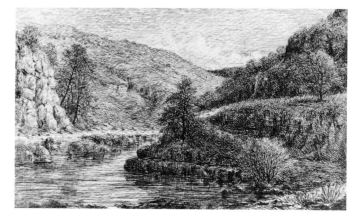

74
Petitjean Album
1864-66
Album including 3 clichés-verre, mounted and bound
Sheet: 17.3 x 26.1 cm (6¹³/₁₆ x 10¼ in.)
Album: 18 x 27 cm (7⅛ x 10⅝ in.)
List of clichés-verre:
1. *View of the Chico River, the First Stop from Durango to Mazatlan (Vue du Rio-Chico, 1ère étape de Durango à Mazatlan)*
 c. 1865
 Salt print
 Image: 5.9 x 10.1 cm (2⁵/₁₆ x 4 in.)
2. *Procession of Holy Wednesday in Durango (Procession du Mercredi-Saint à Durango)*
 1866
 Salt print
 Image: 8.7 x 12.4 cm (3⁷/₁₆ x 4⅞ in.)
3. *Mill*
 c. 1866
 Salt print
 Image: 4.4 x 8 cm (1¾ x 3⅛ in.)
Collection Texbraun, Paris

In a letter dated Durango, April 25, 1866, Petitjean included three photographs: a reproduced drawing of the execution in Matamoros of a boy of fifteen, and two examples of his "direct photographic engraving"—clichés-verre of *Procession du Mercredi-Saint à Durango* and the *Vue du Rio-Chico*—which, Petitjean wrote, "have been made by a process of my invention." This process, he continued, consisted simply of making a photographic negative by hand.

Petitjean's method was simple and direct: a bit of varnished and darkened glass and several sharp drawing tools, "that's it—all the tools with which I make my imitations of etchings. Naturally, I have added my own small adjustments to the System." Petitjean altered the tones by drawing more thinly in the distance or by painting on areas of the plate. To him, however, the most important factor "to give my images a tone far removed from that of photography" was his choice of paper. By printing on salted rather than albumenized paper, the surface was mat, not shiny, an effect he demonstrated by including a comparison of two proofs of *Vue du Rio-Chico,* one on salted paper (illustrated) and one on albumen paper. Additionally, Petitjean recommended soaking the paper in a solution of smoking tobacco or black coffee to give the sheet the appearance of China paper. For the two additional clichés-verre included in the album, Petitjean printed his proofs on salted paper.

Against the advantages of speed and simplicity, Petitjean listed only two inconveniences he experienced with his technique: drawn lines were impossible to correct, and the tiny scale tired his eyes. Nonetheless, he thought the small format would lend itself beautifully to hand-drawn cartes-de-visite "impossible to find in the shops!"

Was André-Toussaint Petitjean another independent inventor? He certainly experimented with cliché-verre in order to relieve the tedium of his existence in rural Mexico, as indicated by the tone of his letters, his many questions about events in Mexico City, and by his dictum, "monotony gives birth one day to boredom." It is possible that Petitjean saw clichés-verre by Barbizon artists before leaving Paris in 1864. He was familiar with the Société des Aquafortistes, and with their activities, led by Cadart on rue Richelieu, but whether he had heard of the clichés-verre by many of the etchers of the Société we simply do not know. In any case, his claim to his commanding officer that he was working in "a process of my invention" was safe, given his superior's certain lack of knowledge of the artistic affairs of Paris.

Pierre-Etienne-Théodore Rousseau
French; Paris 1812-1867 Barbizon

Théodore Rousseau, along with his close associate Millet, was the most constant, if not important, artistic presence in Barbizon. He received standard training in large Paris ateliers and along with the obligatory copies after 17th-century paintings by Claude Lorrain and Dutch masters, Rousseau worked directly from nature. Throughout the 1830s he traveled extensively in France, and it was during this period that he first visited the then still rustic Fontainebleau forest.

Despite the encouragement of leading contemporary artistic figures, including novelist George Sand (support that was critical during these early years of financial hardship from 1837 to 1847), Rousseau was consistently excluded from the Salon, although he had exhibited regularly from 1831 to 1836. Nevertheless, by 1849 Rousseau once again exhibited and the entries firmly established his reputation as a major landscape painter of the period.

During his early years in Barbizon, Rousseau was among the artists who gathered at the celebrated Auberge Ganne. After he established residence in the village, by 1849, his own home became another meeting place for his many artist friends. He occupied his Paris atelier only in winter.

Rousseau's financial situation fluctuated widely throughout his life. Consequently, his energies were continually diverted by the demands of producing canvases for potential collectors. Indeed, in the early 1860s the artist had to sponsor a sale of his work (and later, of his household effects). By 1867 Rousseau's dealers were again selling his paintings and drawings and, in the same year, he won highest honors at the Universal Exhibition. His enjoyment of the prestige was brief, however, as Rousseau died that same year.

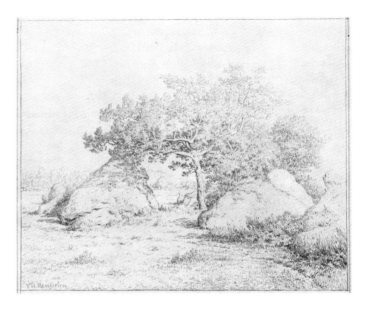

75
Cherry Tree at Plante-à-Biau (Le Cerisier de la Plante-à-Biau)
1862
Salt print
Signed in plate, lower left: *TH. Rousseau*
Image: 21.9 x 27.7 cm (8⅝ x 10⅞ in.)
Sheet: 23.8 x 30 cm (9⅜ x 11¹³⁄₁₆ in.)
Delteil 5
Provenance: William P. Babcock (Lugt 208)
Museum of Fine Arts, Boston (Bequest of William P. Babcock)

Although Delteil has suggested that Rousseau's two clichés-verre were a product of a visit to Arras in 1855 (Bib. V Rousseau/Delteil; repeated by Bib. III Barnard, p. 166), it is more likely that he executed the landscape compositions, scenes near Barbizon, under the supervision of his friend Eugène Cuvelier in their adopted village. Like Millet's two clichés-verre, Rousseau's prints were probably executed in 1862; indeed, the inseparable friends may have tried the process together. Furthermore, around 1862 Rousseau made a drawing in preparation for a canvas of the subject *Cerisier de la Plante-à-Biau* (Bib. III Melot, p. 292; Bib. V Rousseau/Paris, no. 82).

Rousseau's clichés-verre are executed in thin, sparse lines, so full of tension they appear almost coiled. Because of his spare compositions, it is imperative to view Rousseau's efforts in prints of the fullest tonality, such as the rich impression from Boston exhibited here. Without proper attention to exposure, the contrast of brilliant sunlight and dappled shade, the spatial differentiation of sculpted, massive boulders and distant village rooftops are lost in the flat, even value of less inspired printings.

Adolphe-André Wacquez
French; Sedan (Ardennes) 1814-after 1865

Wacquez, a student of Delacroix's, exhibited paintings at the Salons from 1840 through 1865. His most prolific career was, however, as an engraver. A large number of his reproductive prints, mainly after Renaissance masters (Raphael and others), are preserved in the Cabinet des Estampes, Bibliothèque Nationale, Paris. As with so many of his contemporaries, Wacquez traveled, painted, and sketched in the forest of Fontainebleau; in Barbizon he executed three clichés-verre.

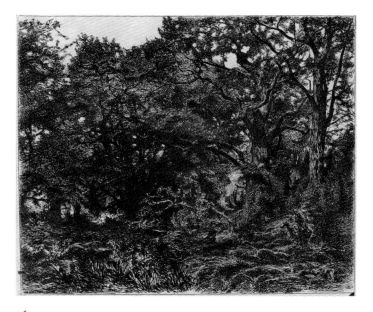

76
The Bodmer at Bas-Bréau or *Thicket at Bas-Bréau (Le Bodmer au Bas-Bréau* or *La Futaie au Bas-Bréau)*
1860
Salt print
Signed, dated, and titled in plate: lower right, *A Wacquez 1860;* lower left, *Le Bodmer au Bas Breau*
23.5 x 29.4 cm (9¼ x 11⅝ in.)
Provenance: George A. Lucas, Baltimore and Paris (Lugt 1695c)
George A. Lucas Collection, the Maryland Institute College of Art, Courtesy of the Baltimore Museum of Art

Gnarled branches, laced against the sky like a veil, and smooth textures of the cushioned forest floor inspired Wacquez to create his masterful cliché-verre, *La Futaie au Bas-Bréau.* The tension between the careful renderings of bark, grass, and branches, and the generalized softness of the pervading light produce a mood that is both sonorous and quiet, animated and still. Even if *La Futaie au Bas-Bréau* had been Wacquez's only effort in cliché-verre, it alone would justify a place of honor for the artist among the many names associated with the technique.

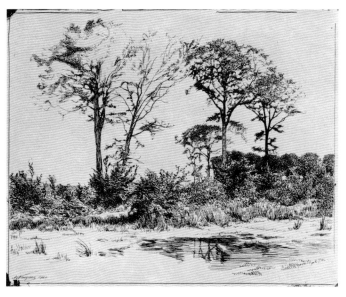

77
Trees at the Edge of a Pond (Arbres au bord d'une mare)
1860 (c. 1911/13)
Signed and dated in plate, lower left: *A Wacquez 1860*
Image: 22.6 x 28.9 cm (8⅞ x 11⅜ in.)
Sheet: 24.1 x 29.9 cm (9½ x 11¾ in.)
Provenance: Albert Bouasse-Lebel, Paris
Collection Galerie Sagot-Le Garrec, Paris

In *Arbres au bord d'une mare,* as in *La Futaie au Bas-Bréau* (cat. no. 76), Wacquez chose to concentrate on specific impressions of place, time of day, and season. The mood recalls a hot summer day: glaring, brilliant light penetrates the scene while sudden short gusts of wind, vibrating the thin limbs of the tall lean trees, provide some relief from the heat. The softly spread tones of fluttering leaves and the large, empty expanse of sky are reminiscent of early landscape photographs. In these, because of the long exposures and the emulsion's insensitivity to the full spectrum of values, the movement of the trees caused blurred sections of extended tone, and normally cloud-filled skies were blank.

78

Bodelu Farm (Ferme de Bodelu)
1860 (c. 1911/13)
Signed, dated, and titled in plate: lower left, *A Wacquez 1860;*
lower right, *Ferme de Bodelu*
Image: 22.3 x 28.6 cm (8¾ x 11¼ in.)
Sheet: 26.9 x 32.1 cm (10%₁₆ x 12⅝ in.)
Provenance: Albert Bouasse-Lebel, Paris
Collection Galerie Sagot-Le Garrec, Paris

Wacquez's graphic depiction of a farmyard scene vividly recalls the recollections made in 1907 by Georges Gassies, chronicler of life in Barbizon:

> The large farm was very picturesque and seemed made for painters; one found everything there, the large pile of manure with its warm coloration setting

off the vibrant plumage of the chickens, the old wooden plows, still used at that time, the horse collars covered with lambskin, dyed blue, and topped with enormous bells, and the atmosphere of the barns, where the grain spread on the ground was still threshed with a flail, the carts completely gray from their heavy wheels soiled by the mud of the roads, all things which give tremendous pleasure to painters interested in color (quoted in Bib. II Barbizon, p. 40).

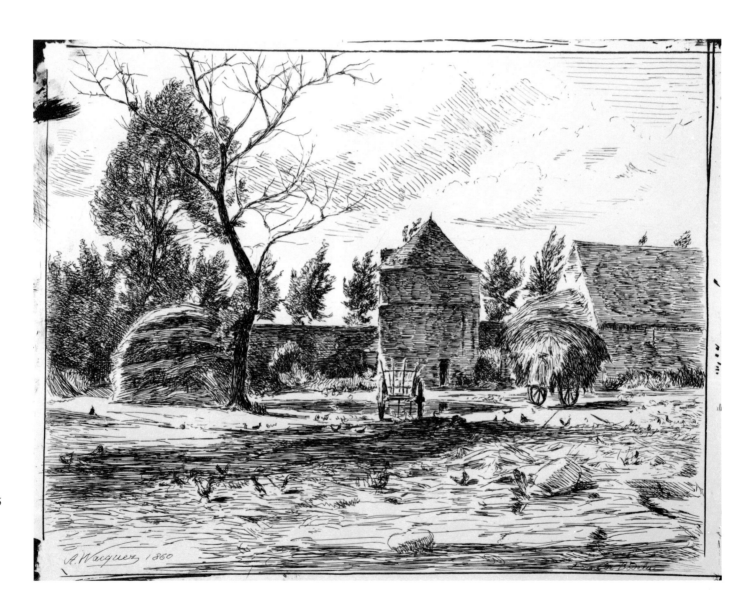

Cliché-verre in the 20th Century

By Marilyn F. Symmes

The history of the cliché-verre medium in the 20th century is not a continuous evolution. Instead, it is the story of isolated and random activity by a number of artists whose mode and style of artistic expression vary greatly. Because of the dual nature of this hand-drawn, light-printed medium, it has appealed to painters, printmakers, and photographers. Artists as diverse as Man Ray, Max Ernst, Brassai, Francis Bruguière, Gyorgy Kepes, Frederick Sommer, Caroline Durieux, Aris Koutroulis, and Fritz Scholder have been enticed to try their hand at making prints in cliché-verre.

In the 19th century the history of cliché-verre activity was relatively intense and compact: the majority of clichés-verre were produced in the 25-year period from 1851 to 1875. In England and France, 19th-century artists were generally aware of their countrymen's efforts in the medium. In contrast, many 20th-century artists were as unaware of cliché-verre in their own century as they were of their 19th-century predecessors. Since the artistic development and tradition of 19th-century cliché-verre has had little effect on most modern expressions of the medium (only a few contemporary artists actually saw 19th-century clichés-verre and credit their interest in the medium to this exposure), the reasons for the sporadic instances of cliché-verre from 1902 to the present day must be sought elsewhere. Indeed, many 20th-century clichés-verre came about either because an artist discovered the technique by chance through accidental manipulation of photographic materials—a kind of artistic version of spontaneous generation—or because an artist was creatively exploring the printing possibilities of light.

While the majority of clichés-verre created in the 19th century are similar in technique, style, and subject matter, those of the 20th century differ widely. Most 19th-century clichés-verre are linear, etching-like depictions of landscapes. In keeping with the wide variety of options available to 20th-century artists, clichés-verre are linear or tonal; figurative or abstract; black-and-white, monochromatic, or multicolored. Another obvious difference is that, like the visual arts in general, contemporary clichés-verre are often large in format, in contrast to the intimate scale of 19th-century examples.

Although the basic principle of printing a drawing with light onto a sensitized surface has been the same in both centuries, 20th-century artists have explored new ways to exploit light and transparency. Nineteenth-century artists usually made their matrices and prints in the same manner, since the materials available to them were limited and since the fundamental procedure for drawing and executing clichés-verre remained unchanged after Havell and Willmore's 1839 announcement (see "Cliché-verre in the 19th Century," p. 31). On the other hand, in the 20th century, artists introduced into cliché-verre a variety of materials and innovative drawing techniques; and advances in photographic technology have made possible smooth, even, tonal and color effects. Whereas 19th-century artists used glass as a matrix, 20th-century artists have used in addition a variety of transparent or translucent materials: film, cellophane, plastic sheets, or thin paper. Also, 19th-century clichés-verre were printed on either salted or albumenized paper, while 20th-century artists have had a choice of sensitized surfaces: gelatin-silver print, dye-transfer, cyanotype, gum bichromate, or a variety of commercially prepared printing papers. (See Glossary for definitions of the above terms.)

Is cliché-verre print or photograph? The question continually arises even though, in the 20th century, the distinctions between graphic arts and photography are often less clear than they were 100 years ago. As the works in this exhibition demonstrate, some clichés-verre look like prints (e.g., at first glance, Kent Rush's untitled print, cat. no. 113, recalls etching, Sue Hirtzel's *On the Other Side,* cat. no. 95, resembles a lithograph), and some clichés-verre look like photographs (e.g., the works of Francis Bruguière, cat. nos. 86, 87, or Yvonne Kafoury's *Light Trails No. 1,* cat. no. 99, which exhibit black-and-white tonalities and slick surfaces similar to those of camera-made photographic prints). Thus, the appearance of the prints themselves does not necessarily resolve the issue.

As already discussed in "Cliché-verre in the 19th Century," the nature of sensitized materials and the use of light make cliché-verre inherently photographic, while the means of image-making is generally graphic. De-

spite the fact that the use of light and sensitized surfaces are crucial factors in the photographic process, histories of photography have paid more attention to what the photographic apparatus, i.e., the camera, projects onto the sensitized surface, than they have to exploring cameraless photography, in which the cliché-verre figures prominently. Hand-designed, light-printed works by photographers Francis Bruguière, Gyorgy Kepes, Henry Holmes Smith, Frederick Sommer, and Jaromir Stephany qualify both as abstract photographs and as clichés-verre. The presence of drawing on the matrix (whether it be conventional drawing with pen, pencil, pointed tool, or brush; gestural drawing with a fluid substance; collage; or manipulation of emulsion) connects the cliché-verre with the realm of the graphic arts. Such graphic artists as Caroline Durieux, Vera Berdich, and Aris Koutroulis rediscovered cliché-verre and conveyed their enthusiasm for the artistic potential of this little-known and little-practiced 19th-century medium to their printmaking students. By the 1970s, one could almost view the flurry of activity in the medium as a kind of renascence, echoing the intense period of cliché-verre in the previous century. Nowhere is this revival more apparent than in Detroit, where Koutroulis' and Sue Hirtzel's keen interest in the medium has spawned a small following among contemporary Michigan artists. In the latter part of the 1970s, two talented young photographers, John Bloom and Jack Sal, independently have turned to cliché-verre, imbuing their work in the medium with extraordinary vitality and promising creative expression.

The first 20th-century occurrence of cliché-verre, although it was not actually so labeled, is recorded in an entry in the diary of Paul Klee: "9.1.1902. Today I made a nice experiment. I covered a glass plate with a layer of asphalt; with a needle, I drew a few lines into it, which I was then able to copy photographically. The result resembles an engraving."[1] Klee's diary provides no clue as to what prompted the experiment. By September 1902, Klee had completed his academic art training in Munich and had returned to Bern from a trip to Italy. Neither Klee's diary nor the available scholarly literature on Klee mentions whether he saw a 19th-century print or glass plate that might have prompted his effort. In any case, the venture must have evolved from his interest in pursuing drawing in all graphic forms. Since Klee does not indicate the subject of the drawing on the glass plate, and since no cataloguer of Klee's early graphic work has cited this print, it may be that the work no longer exists. However, the date of the entry is significant, for it documents Klee's discovery of the hand-drawn, light-printed medium a full year before Germain Hédiard's article on cliché-verre in the *Gazette des Beaux-Arts* (Bib. III Hédiard). Moreover, the entry predates the 1903-1906 period during which Klee produced his first important group of etchings.

Further mention of Klee's drawing on blackened glass plates is not noted again in his diary until June 1905, when he wrote:

A hope tempted me the other day as I drew with the needle on a blackened pane of glass. A playful experiment on porcelain had given me the idea. Thus: the instrument is no longer the black line, but the white one. The background is not light, but night. Energy illuminates: just as it does in nature. This is probably a transition from the graphic to the pictorial stage. But I won't paint, out of modesty and cautiousness!
So now the motto is, "Let there be light." Thus I glide slowly over into the new world of tonalities As I now leave the very specific and strictly graphic realm of black energy, I am quite aware that I am entering a vast region.[2]

Although this entry makes no reference to printing his drawing on glass onto photographic paper, Klee's excitement over the discovery of light/white as a powerful

1
See Bib. V Klee, p. 128 (from Diary III, entry 445). Too late for inclusion in this essay, the author discovered another discussion of Klee's early work in photography and cliché-verre. See Bib. V Klee/Baumgartner.
2
Ibid., p. 175 (Diary III, entries 632-633).

expressive tool is a hint of the belief that would be voiced later by other artists such as Man Ray and László Moholy-Nagy, whose verbal and visual ideas greatly affected the development of modern art.

Later in 1905 Klee again referred to his attempts in cliché-verre: "I cut into a black background with a needle, on a 13-by-18-cm glass plate. Then I pressed an unexposed photographic plate against it in the dark. Then I exposed it briefly and was able to develop a photographic negative. The prints made from it provide strikingly close equivalents of the original."[3] To obtain the white lines he preferred, Klee must have contact-printed his glass plate to film in order to make a positive print that would look like the glass original. Fortunately, some of these early glass plates exist (in the collection of the artist's son, Felix Klee, Bern), although the photographic prints made from them do not. However, after 1905 Klee was more interested in developing his drawing and painting on the glass surface than in making a photographic print from the hand-drawn negative. *Portrait of My Father* (fig. 10) is the best example of Klee's vigorous, yet controlled, drawing on blackened glass. The head of the bearded man is solidly modeled even though the artist's mesh-like scratchings left only minute particles of black on the plate. Apparently, Klee's interest in drawing on blackened glass and making cliché-verre prints gradually waned after the execution of this work, and he turned more to watercolor and oil painting.

A little more than 12 years after Paul Klee's exploratory encounter with printing drawings on glass photographically, the cliché-verre emerged in the New York studio of Man Ray. Since Man Ray, in true Dada fashion, was notorious for not documenting his works and for confounding art historians who attempted to catalogue and systematize his oeuvre, it should be no surprise that his work in cliché-verre is shrouded in some mystery. None of Man Ray's biographers, nor the dealers and collectors of his photographic work, have given a comprehensive account of the cliché-verre aspect of Man Ray's cameraless innovations. To date, no one has established exactly how many clichés-verre Man Ray did. Estimates from experts who knew Man Ray vary from four to forty. What is known is that the earliest extant clichés-verre are dated 1917, and that Man Ray made clichés-verre in the early 1920s and in 1941.[4] On the basis of examples seen in public and private collections and illustrated in various books and catalogues on Man Ray, the author has determined that he did at least 15 clichés-verre.[5] Compared to Man Ray's other photographic work—his portraits, figure studies, still lifes, fashion pictures, and Rayograms—his clichés-verre have received hardly any critical attention, and are regarded, in fact, as a minor facet of his total oeuvre. Because of this oversight, many important questions about Man Ray and cliché-verre cannot yet be answered.

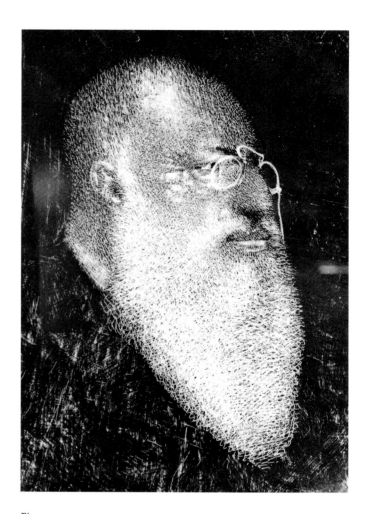

Fig. 10
Paul Klee (Swiss, 1879-1940). Detail of *Portrait of My Father (Bildnis meines Vaters)*, 1906. Ink painting on glass; 31 x 28.5 cm (12¼ x 11¼ in.). Collection Felix Klee, Bern. Photo © COSMOPRESS, Geneva/S.P.A.D.E.M., New York.

What prompted Man Ray to make clichés-verre in 1917 is not definitely known. Probably unaware of Paul Klee's drawings on glass, Man Ray might have seen or read about 19th-century clichés-verre; the fact that some impressions are inscribed *cliché-verre* indicates that the artist knew something about the tradition of the medium.

By 1917 Man Ray was in the initial phase of his career as a painter. He was aware of the movements of Fauvism, Cubism, and Expressionism, and he was soon to become a leading figure in the New York Dada group. Man Ray had taken up photography in 1915 to take pictures of his own work for his first one-man exhibition in New York. Given the imaginative and inventive nature of this artist, it is logical that he would have been fascinated by all aspects of the photographic process beyond the use of the camera. No doubt Man Ray's darkroom experiments led to his drawing on exposed (darkened) photographic plates, which resulted in the clichés-

verre of 1917. Two of his important early clichés-verre, *The Eggbeater* (cat. no. 106) and *Quartet* (fig. 11), demonstrate Man Ray's playful anthropomorphizing of inanimate objects. In *The Eggbeater*, a common kitchen utensil is transformed into a stylized portrait. In *Quartet*, the stringed instruments, music stands, and chair assume a lilting life of their own—the composition is a harmonious arrangement of lines and shapes, and the musical subject relates to some of Man Ray's paintings of that period. All of Man Ray's clichés-verre have a linear, rather than tonal, character recalling 19th-century examples of the medium.

Ironically, Man Ray's clichés-verre exhibit an obviously hand-drawn quality (as if to emphasize the absence of mechanical equipment in making the image), while his air-brushed paintings (aerographs), done in that same period, seem to deny the presence of the artist's hand and look like mechanically produced photographs. Certainly, Man Ray was purposely altering assumptions about the processes of photography and painting. What is even more remarkable is that Man Ray was exploring cameraless expression in the form of cliché-verre before his accidental darkroom discovery in Paris in 1921 of the Rayograph (or Rayogram, Man Ray's personalized method of photogram). Man Ray's clichés-verre and subsequent Rayographs are important developments in the history of cameraless photography.

After 1921 Man Ray was a key member of the Dada group in Paris. From 1922 to 1924 he reprinted impressions of clichés-verre originally executed in 1917 and created at least four more clichés-verre. While his Rayographs were greatly admired by other Dadaists, especially Tristan Tzara, and were much published and exhibited in the 1920s, Man Ray's clichés-verre apparently received little notice. Only two of his clichés-verre

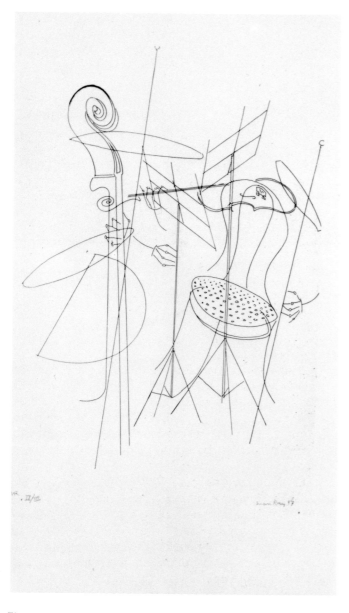

Fig. 11
Man Ray (American, 1890-1976). *Quartet*, 1917 (1970). Cliché-verre; 50 x 28.5 cm (19¹¹⁄₁₆ x 11¼ in.). Collection Arturo Schwarz, Milan.

3
Ibid., p. 177 (Diary III, entry 639).

4
Often the dating is subject to confusion, because, even though Man Ray usually signed and dated his clichés-verre, occasionally two impressions of the same cliché-verre (e.g., see cat. no. 106) bear two different dates. Either Man Ray had a faulty memory when he dated impressions made from plates executed years earlier (or when he signed and dated previously uninscribed impressions years after they were made); or, the date on the cliché-verre simply indicates the date of the printing of the impression, and does not refer to the date of the execution of the matrix.

5
In addition to the five in the exhibition (cat. nos. 106-110), the list of clichés-verre by Man Ray is as follows: 1) *Quartet*, 1917 (ill. Bib. V Man Ray/Schwarz, p. 242 and in Bib. V Man Ray/New York, p. 13); 2) *Abstract*, 1917 (Collection Arnold H. Crane, Chicago); 3) *Automaton*, 1917 (ill. Schwarz, p. 242 and New York, p. 49); 4) *Portrait of Kiki*, 1922 (ill. Schwarz, p. 87); 5) *(Abstract Composition)*, 1941 (ill. New York, p. 95); 6) *(Abstract Composition)*, 1941 (ill. New York, p. 97); 7) *(Pair of Hands and an Eye)*, 1941 (ill. New York, p. 99); 8) *(Head of a Woman)*, 1941 (ill. New York, p. 101); 9) *(Metronome? and Hand)*, 1941 (ill. New York, p. 103); 10) *(Head of a Woman*, cancelled impression), 1941 (Private Collection, Paris). As of this writing, it could not be determined if the 1968 publication, *Les Treize Clichés vierges*, which contains 13 illustrations by Man Ray, some dated 1955, are clichés-verre or photographs of etchings. The book was printed in an edition of 550 numbered examples by Sergio Tosi, Milan. Obviously, more research on Man Ray's clichés-verre is needed. It is hoped that this publication will prompt further study.

were published—one in 1922 and another in 1925.[6] This raises such questions as why did Man Ray print so few impressions, and why did they not receive more attention since the art world could not have been totally unaware of them.

Although Man Ray did not produce any more clichés-verre in the late 1920s, his photographic expertise was instrumental in the printing of Max Ernst's 19 frottages used for the illustrations for René Crevel's *Mr. Knife Miss Fork* (see cat. no. 89).[7] Ernst had discovered frottage in 1925. It was a drawing technique in which he placed paper atop a textured surface (like wood), and, with a pencil, vigorously rubbed across the paper, thereby obtaining a "shadow" of the texture. Ernst transformed these drawings, which were directly derived from nature, into strange visions. Combinations of frottaged textures in the same drawing resulted in bizarre, imaginary pictures. By 1931 when *Mr. Knife Miss Fork* appeared, Ernst was a mature artist of age 40 who had already produced major publications in frottage (*Histoire Naturelle*, 1926), and collage (*La Femme 100 têtes*, 1929). As Werner Spies has pointed out, Ernst often used unconventional methods to reproduce his works,[8] so it is not surprising that he chose a photographic process to print his frottage drawings for *Mr. Knife Miss Fork*. By using the actual drawings themselves as the matrix, Ernst could be certain that all the textural nuances of frottage would be exactly replicated (although negatively) in the print. These illustrations have never before been regarded as clichés-verre. The colophon of *Mr. Knife Miss Fork* states that the book contains "nineteen original photograms by Max Ernst." The word "photograms" is actually a misnomer that has been perpetuated in subsequent catalogues on Ernst, for as prints made from a hand-drawn matrix onto photographic paper, the illustrations could not be more in keeping with the definition of the cliché-verre process.[9] Moreover, these 19 clichés-verre mark the first time in the history of the medium that tonally drawn (as distinguished from tonally painted or linear) images were recreated by the cameraless process.

An example of one of Ernst's original frottage drawings that was used as a matrix for Plate X of *Mr. Knife Miss Fork* is *A Bird Comes Flying* (fig. 12). In this image a rubbing of a textured piece of wood has been transformed into an expanse of sea, whereas the upper part, with the soaring bird[10] carrying a letter in its beak, was derived from an embossed postcard.[11] The drawing was placed face down on photographic paper, and after exposure to light, the photographic paper was developed. The resulting print (fig. 13) looks like a ghostly apparition of the original drawing—an effect no doubt desired by both Ernst and Crevel to correspond to the phantasmal nature of the story.

A few years after the publication of *Mr. Knife Miss Fork*, Brassai (Gyula Halász) made a group of 12 Surreal-

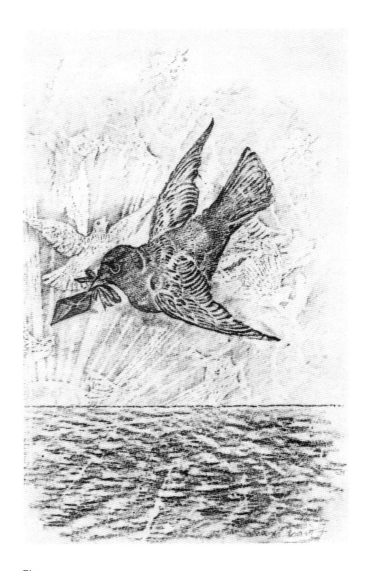

Fig. 12
Max Ernst (German, 1891-1976). *A Bird Comes Flying (Kommt ein Vogel geflogen . . .)*, 1931. Frottage; 18 x 11.6 cm (7 1/16 x 4 9/16 in.). Private Collection, Texas.

ist cliché-verre images that not only differ technically and stylistically from Ernst's illustrations, but also introduce a photographic element that had not before been part of the tradition of the medium. Also, in contrast to the quality of fantasy evoked by the text and images of *Mr. Knife Miss Fork*, Brassai's clichés-verre reveal a Surrealism that is not just illusionary. Instead, Brassai's images evoke a subconscious blend of perceptions of reality with unreality, a notion echoed by the title *Transmutations*, which Brassai assigned to the group of 12 clichés-verre (cat. no. 85).

Brassai's fame as a photographer dates from the 1930s. As illustrations in the issues of the lavish Surrealist journal *Minotaure* attest, Brassai was an important Parisian photographer of the work of various Surrealist artists, and he knew many of them personally. Brassai probably knew of Crevel's book and Ernst's illustra-

tions, but that was not what inspired him to try the cliché-verre medium.

As he himself stated in the 1967 Introduction to the *Transmutations* portfolio, Brassai was totally unaware of the clichés-verre done by Corot, Daubigny, and Millet when he first attempted to engrave on photographic plates in 1934-35. Only years later did Brassai learn of the fine cliché-verre collection at Paris' Bibliothèque Nationale and of the history of the medium. Instead, Brassai traced the origin of the idea that resulted in *Transmutations* back to Picasso's creative urge to draw on any available surface, even on Brassai's abandoned photographic plate.

As Brassai has related in his book *Conversations avec Picasso*,[12] one day in 1932 Brassai inadvertently left an

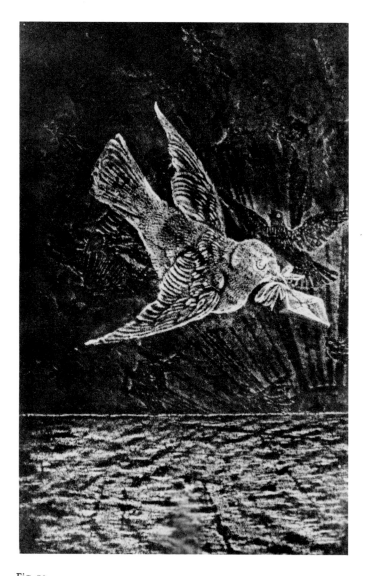

Fig. 13
Max Ernst. . . . *On handsome postcards . . .*, 1931. Cliché-verre; 17.7 x 11.6 cm (7 x 4⁹⁄₁₆ in.). Plate X from René Crevel, *Mr. Knife Miss Fork*, published by the Black Sun Press, Paris, 1931. Private Collection, Texas.

6
In Bib. V Man Ray/Schwarz, pp. 351, 352, there is a reference to the publication of a cliché-verre in the January 1922 issue of *Aventure* (Paris, 3, p. 17) and in *Les Feuilles libres* (Paris, May-June 1925, 6, 40, p. 218). *Automaton* (1917) was reproduced in *Aventure; Portrait of Kiki* (1922) was illustrated in *Les Feuilles libres*.
7
According to Werner Spies (Bib. V Ernst/Spies and Kannertz, p. 13, and Bib. V Ernst/Leppien, pp. ix, 12, cat. no. 13), the prints were made from Ernst's original frottage drawings in the studio of Man Ray.
8
Bib. V Ernst/Spies and Kannertz, pp. 12-13.
9
Either the publisher, Black Sun Press, was not familiar with the term cliché-verre as the proper name for the specific process employed in printing Ernst's images, or the publisher considered "cliché-verre" an imprecise term, since hand-drawn *glass* negatives were not used by Ernst in executing the images. If the latter supposition is true, the publisher probably selected the more general term "photogram" to connote the cameraless photographic prints derived from hand-drawn paper matrices. However, a photogram, as it is now understood by photographers and experts in the history of photography, is unique and made without a matrix, and the photogram process is not synonymous with "contact-printing." Since Ernst's drawings were used as a matrix, like a camera negative, and contact-printed 255 times onto light-sensitive paper to make the edition of the illustrations for the Crevel book, the principle of the process is no different from that which resulted in Corot's cliché-verre prints or in those by Jack Sal (cat. nos. 114-118).
10
In the work of Ernst, birds have important iconographical significance. Ernst had a disturbing youthful experience involving the fate of a pet bird, and images of birds recur throughout his art.
11
Bib. V Ernst/Houston, p. 51, cat. no. 20.
12
Bib. V Picasso/Brassai, p. 37; and Bib. V Brassai/Brassai, intro.

unused photographic plate in Picasso's studio. When he returned the next day, he found that Picasso had engraved a miniature profile of his mistress Marie-Thérèse Walter on the surface. Although Brassai wanted to make a print from the plate right away, it was never done and the plate has disappeared. However, the seed for the cliché-verre idea was planted in Brassai's mind, and almost two years later he began to engrave on photographic plates as a means of injecting a Surrealism not possible in pure photography.

Unlike any of the artists who had attempted cliché-verre, Brassai preferred to scratch on a photographic plate that already had a camera-made image on it rather than draw on a blank transparent surface.[13] The camera-made image became a point of departure for his drawing, which then transformed the original picture into something else. Most of the images of *Transmutations* are nudes that have been metamorphosed into female-shaped musical instruments (pls. III, IV, VI), fruit (pl. I; see fig. 14), and a vase (pl. V). In other plates inanimate objects became primitive mask-like visages (pls. VII, XII; see fig. 15). The most spectacular image is the *Temptation of Saint Anthony* (pl. VIII; see cat. no. 85), in which the torso of a nude has been transformed into a ghostly countenance. Thus, the combination of engraving superimposed over the camera negative was a means for Brassai to transcend traditional photographic representation. Or, as the artist himself stated: "Enshrined in graphism, this debris (i.e., the vestige of reality captured by the camera) gives to our obsessions, to our dreams the flash of the instant, the breath of reality."[14]

The period of Surrealism sanctioned both experimentation with new media, styles, and ideas, and the juxtaposition of different techniques and unrelated subject matter as part of the quest to reveal a new reality. Some artists, like Brassai, were affected by this ambience that permeated the Parisian art world, while others, among whom Pablo Picasso is unrivaled, became creators of art movements. Throughout his lifelong career Picasso constantly sought pictorial form in any media and in any thing. In 1937, for a special issue of *Cahiers d'Art*,[15] Picasso focused his attention briefly on experimenting in photography. The five cameraless pictures included in this issue were probably made at the suggestion, or with the assistance, of Man Ray, who penned the issue's brief introduction "Picasso, Photographe," claiming that Picasso had re-invented the medium by bypassing the camera to create the four painterly, light-printed portraits of women and the one hand-altered camera picture of his studio. The method Picasso used to create these photographic images was not spelled out in the issue and, thus far, the authors' efforts to locate the original images from which the reproductions in *Cahiers d'Art* were made have proved unsuccessful. However, given the limited repertory of making photographic

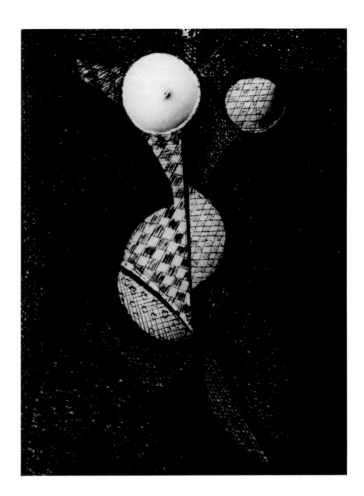

Fig. 14
Brassai (Gyula Halász) (Hungarian, b. 1899). *Fruit Woman (Femme-fruit)*, 1934-35 (1967). Cliché-verre; 23.5 x 17.8 cm (9¼ x 7 in.). Plate I from Brassai, *Transmutations*, published by Editions Galerie Les Coutards (Lacoste, Vaucluse, France), 1967. University of Michigan Museum of Art, Ann Arbor.

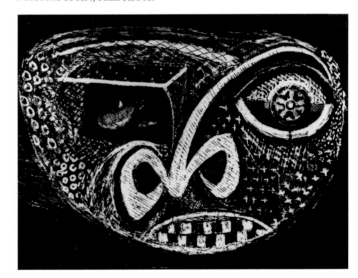

Fig. 15
Brassai. *Fair (Fête foraine)*, 1934-35 (1967). Cliché-verre; 17.8 x 23.5 cm (7 x 9¼ in.). Plate XII from Brassai, *Transmutations*, published by Editions Galerie Les Coutards (Lacoste, Vaucluse, France), 1967. University of Michigan Museum of Art, Ann Arbor.

prints that look like drawings without a camera, Picasso must have used the cliché-verre process to create these five images.

The first four works depict heads of women: two are of his mistress, Dora Maar, and they resemble Picasso's other 1936 paintings and drawings of her. The first, *Portrait of D.M.* (fig. 16), looks like a very loosely brushed ink drawing of a woman with a strong oval face. Rather than working negatively on a coated plate, Picasso probably drew freely on a transparent surface. The image was then contact-printed to film to produce the negative, which resulted in the print reproduced in *Cahiers d'Art*. In the second version of *Portrait of D.M.* (fig. 17), the view of the head is almost the same, but tonal areas

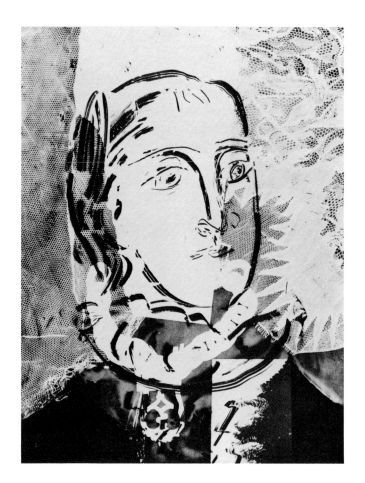

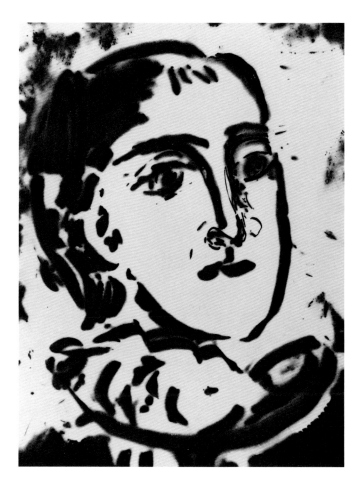

Fig. 16
Pablo Picasso (Spanish, 1881-1973). *Portrait of D.M.* Cliché-verre reproduced from *Cahiers d'Art* 12:6-7, 1937. Photo credit Patrick Young.

Fig. 17
Pablo Picasso. *Portrait of D.M.* (second version). Cliché-verre reproduced from *Cahiers d'Art* 12:6-7, 1937. Photo credit Patrick Young.

13
Brassai's *Transmutations*, as hand-altered photographs that are also considered cliché-verre, raise an important issue, since the branch of photography that most challenges the definition of cliché-verre (i.e., a print from a hand-drawn matrix on light-sensitive materials) is hand-altered photography (i.e., photographs from camera-made negatives that are scratched or drawn by hand to modify or enhance the camera image). However, not all hand-altered photographs are clichés-verre, and the issue is clouded by the question: when do hand-marks on a camera negative make the work cliché-verre? Hand-altered or hand-worked camera-made images, while related to clichés-verre, have their own tradition, which ranges from 19th-century retouched studio photographs to the hand-enhanced photographs of Pictorialist Frank Eugene and the sparse hand-markings on the contemporary photographs of Thomas Barrow or James Henkel. Camera-made photographs that may incorporate some cliché-verre techniques are not automatically cliché-verre. In the case of hand-altered photographs, the evidence of the artist's hand is not so much a statement about drawing as a reminder of the artist's presence, to contrast with the less autographic camera-made image. In cliché-verre, the element of drawing in forming the image is primary. In order to make a clear case for what is cliché-verre and what is not, the authors decided not to regard hand-altered photographs as clichés-verre, with the single exception of Brassai's portfolio, in which the images are considerably altered by drawing.

14
Bib. V Brassai/Brassai, English translation of intro.

15
Bib. V Picasso/Man Ray (n.p.).

115

have been added by photogram (or Rayogram), for example, the mesh-effect at the left from netting.[16] To create the fifth illustration (fig. 18), the hand-altered photograph of his studio, Picasso may have remembered the experimental engraving he did a few years earlier on one of Brassai's photographic plates, or perhaps he saw one of Brassai's *Transmutations*. In any case, in this image, Picasso drew on the negative to delineate in the positive print a ghost of a nude, seemingly created from the rays emitted from the far wall, who boldly struts amid the clutter of paint and paintings strewn about the room.

In the total oeuvre of Man Ray, Max Ernst, Brassai, and Picasso, the cliché-verre medium had a very minor part. Except for Man Ray, none of these artists sustained their activity in this medium beyond the execution of a single group of works. Although the cliché-verre played a small part in the careers of these great 20th-century artists, it is nevertheless important for this history that they worked in this medium at all. Probably the pervading aura of Surrealism was a key factor in the occurrence of their cliché-verre prints.

Surrealist art and ideas affected many non-Surrealist artists, including Francis Bruguière. Bruguière, an American professional photographer who had been living in London since 1927, had long experimented with a variety of nonrepresentational photographic techniques: multiple exposures, montages, photograms, solarization, and his own brand of "light abstractions"—pictures of light and shadow sculpted by cut-paper compositions. Bruguière was a lone pioneer in the history of abstract photography. Although his career coincided with the crucial formative years of abstract photography, Bruguière's private explorations with light were totally unaffected by the work by other pioneers in nonrepresentational photography until 1927, the date of the artist's first one-man exhibition, which included a section on his abstract photographic work, thereby bringing Bruguière's revolutionary efforts to the public eye. Bruguière had been investigating the process of multiple exposures since 1912, four years before Alvin Langdon Coburn called for a new, modern vision in photography that would throw off the "shackles of conventional representation" and parallel the spirit of abstraction in other visual arts.[17]

Given Bruguière's experimental nature, his desire to work directly with light on sensitized surfaces, and his interest in painting, it is not surprising that he tried painting on glass to make cliché-verre prints. It is more difficult to determine how Bruguière came to do cliché-verre prints, the exact number he made, and the dating of those prints. Although James Enyeart, author of the 1977 monograph on Bruguière, believes Bruguière could have made anywhere from six to twelve cliché-verre prints, only five images are extant.[18] Moreover, according to Enyeart, Bruguière's clichés-verre date from the

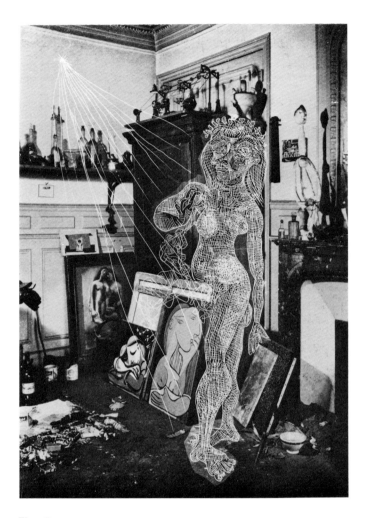

Fig. 18
Pablo Picasso. *Woman in the Artist's Studio*. Cliché-verre reproduced from *Cahiers d'Art* 12:6-7, 1937. Photo credit Patrick Young.

last decade of his life, more specifically, around 1936 to 1940.[19] This author, however, has found evidence that supports a date closer to 1936. What would have suddenly prompted Bruguière to make clichés-verre in 1936? Since the artist was extremely knowledgeable on photographic history and processes, and well read on the history of art as well as on current art movements, and since Bruguière was in London in 1936, he would have certainly known about and probably visited the "International Surrealist Exhibition" at London's New Burlington Galleries. The summer date of this exhibition coincided with the June 1936 issue of *Minotaure*, which featured an article on decalcomania by Benjamin Péret.[20]

Decalcomania is a process in which inks or water-based paints are transferred from one sheet of paper to another under pressure. The resulting effects are like Rorschach ink-blot designs, evoking bizarre grottoes, strange monsters, panoramas, or beautiful inundations of cloud-like tones. The process was introduced to Surrealist circles by Oscar Dominguez in 1935.[21] Obviously, the appeal of the technique for Surrealists was that uncontrolled, automatic drops of paint, pressed onto a smooth surface without any preconceived plan, could conjure up pictures that seemingly revealed landscapes of the subconscious. The images of decalcomanias probably inspired the form of Francis Bruguière's cliché-verre imagery, for it is unlikely that the strong resemblance of Bruguière's images to decalcomanias is mere coincidence. Most decalcomanias resulted in a sort of monotype, but in the hands of a photographer like Bruguière, it would have been a simple matter to conceive of creating decalcomanias on glass, which would act as a handmade negative that would then photographically produce decalcomania prints. The reticulated textures in Bruguière's clichés-verre (see cat. nos. 86, 87) were caused by pressing wet pigment between the glass plate and another smooth surface and then slowly peeling the second surface away.

To link his inspiration definitely to Surrealism and to pay homage to its concepts, Bruguière inscribed the verso of two impressions of his clichés-verre with quotations in French by two of the writers whose names are integrally connected with the development of the Surrealist movement: Isidore Ducasse (Comte de Lautréamont) and André Breton. (For discussion of these quotations, see cat. no. 87.)

Although Bruguière's cliché-verre oeuvre is small and not well known, he holds an important place because he was the first 20th-century artist to approach the medium from the photographic standpoint of cameraless light abstractions. Bruguière's clichés-verre are the first to display a textural and tonal quality unlike anything done in 19th- or early 20th-century photography. His sensitivity to photographically produced light and dark tones and to abstract forms could have resulted only

16
Bib. V Picasso/Barr, pp. 195 (ill.), 263; see also Bib. II Coke, p. 240.
17
A. L. Coburn, "The Future of Pictorial Photography," in Nathan Lyons, *Photographers on Photography*, Englewood Cliffs, New Jersey, 1966, p. 54; reprinted from *Photograms of the Year 1916*, pp. 23-24. Almost forecasting Surrealism, Coburn concluded that he hoped "that photography . . . with her infinite possibilities (would) do things stranger and more fascinating than the most fantastic dreams" (Ibid., p. 55). Coburn's vortographs (made with prisms to split images into Cubist sections) of 1917, in 1918 Schad's Schadographs, Man Ray's Rayographs of 1921, in 1922 Moholy-Nagy's photograms, John Heartfield's photomontages of the 1920s and 1930s, and the work of Bruguière in the 1920s and 1930s contributed to the fulfillment of Coburn's predictions. For a critical survey of the photographic work of Francis Bruguière, refer to Bib. V Bruguière/Enyeart. For a concise description of the development of abstraction in photography and Bruguière's place in this development, see Bib. II Rotzler, pp. 81-86. For a more complete description of the rise of abstraction in photography, refer to the chapter "Beyond Art" in Bib. II Scharf 1968, rev. ed. 1974, pp. 255-303.
18
In a conversation with the author on April 17, 1979, James Enyeart stated that Bruguière's investigations in an unusual photographic process usually resulted in a number of works, so it would have been in keeping with Bruguière's practice to have made about a dozen prints in the cliché-verre. However, this author has seen only four clichés-verre by Bruguière. Both New York's Museum of Modern Art and Rochester's International Museum of Photography at George Eastman House (the latter possesses the largest holdings of Bruguière's work) have these four clichés-verre in their collections. (Besides the two in this exhibition, the other two are, according to titles on the Museum of Modern Art impressions: *Attainment Mt. Everest* and *Il est rare que je trouve le repos*, a quote by the Comte de Lautréamont inscribed on the verso.) The fifth print is one of the two clichés-verre illustrated in Enyeart's book, Bib. V Bruguière/Enyeart, pl. 107, but the collection was not cited. Enyeart, in the above-mentioned conversation, said this fifth cliché-verre was in the George Eastman House collection, but this author did not find it among the catalogued Bruguière material there.
19
Bib. V Bruguière/Enyeart, p. 119 and credit lines for illustrations of clichés-verre, pls. 107, 108, pp. 138-139. If Bruguière was practicing cliché-verre before 1936, it is strange that he did not mention it in his article "Creative Photography" (Lyons [note 17], pp. 35-36, reprinted from *Modern Photography Annual*, 1935-36, pp. 9-14). However, something must have triggered Bruguière's initiation into the cliché-verre medium, for the Fall 1936 issue of *Transition* (25, p. 89) included an illustration of Bruguière's cliché-verre *St. George and the Dragon* (cat. no. 86).
20
Benjamin Péret, "D'une Décalcomanie sans objet préconçu (Décalcomanie du Désir)," *Minotaure* 8, 15 (June 1936), pp. 18-24, with illustrations of decalcomania by Jacqueline Breton, Oscar Dominguez, Georges Hugnet, Marcel Jean, Yves Tanguy, and an accompanying prose paragraph by André Breton. While it cannot be proved that Bruguière saw this specific article, its appearance at this time suggests that there would have been opportunities for Bruguière, who did keep up with the art movements of his day, to be exposed to decalcomania.
21
For more information on Oscar Dominguez and decalcomania, refer to Patrick Waldberg, *Surrealism*, Paris, 1962, pp. 10, 64, 95, 101. See also Bib. II Scharf, 1968, rev. ed. 1974, pp. 290-91.

from an assimilation of the avant-garde concepts and styles of his day, from a keen understanding of photographic materials, and from a daring, inquiring mind. Bruguière and László Moholy-Nagy are the two forefathers of abstract photography.

The startling Surrealist imagery of Bruguière's clichés-verre, combined with László Moholy-Nagy's dynamic philosophy of light as artistic medium, acted as a vanguard for the abstract cameraless work later created by others. Many artists experimented in photography in the 1920s and 1930s, but no one was more influential than László Moholy-Nagy, whose penetrating insights into the photographic process and the fundamental nature of light and transparency bridged science and art. Moholy's writings, such as *Painting, Photography and Film* (first published in German in 1925) and *The New Vision* (first published in German in 1928), and his innovative Bauhaus teachings strongly affected the work of Gyorgy Kepes, a fellow Hungarian (cat. nos. 100, 101), and Henry Holmes Smith (cat. nos. 121-123).

Most of Kepes' photographic work and abstract light experiments were done in the 1930s, after he had left Hungary to collaborate on numerous design projects with Moholy-Nagy in Berlin and London. When Moholy went to Chicago in 1937 to establish the New Bauhaus (later the Institute of Design), Kepes followed him to head the light and color department. One facet of Kepes' light explorations during this period was abstract cameraless photography, which resulted in works such as *Monuments* and *Abstraction, Surface Tension No. 2* (cat. nos. 100, 101), both dated 1939. Kepes called such works "photo-paintings," but as photographs from paintings on glass, they are unquestionably clichés-verre. However, since Kepes at that time was unaware of the 19th-century cliché-verre tradition and, apparently, the contemporary experiments in cliché-verre by Man Ray, Brassai, Bruguière, and Picasso, Kepes' photo-paintings (clichés-verre) must be viewed as products of his own involvement with abstract design, light play, and sensitized surfaces.

In the year 1937 Moholy, Kepes, and Henry Holmes Smith worked together. Early in his career, before 1937, Smith had come across the abstract photographs of Francis Bruguière and the writings of Moholy. Smith's discovery of the work of Bruguière through the issues of *Theater Arts Monthly* was a revelation.[22] Bruguière's images of stage productions and light reflections off cut paper helped Smith to realize that his primary concern must be the quality of light and not the realistic depiction of the object. In 1933 Smith first became acquainted with Moholy's book *The New Vision*. Moholy's philosophy, which was to lay the groundwork for Smith's views on teaching and photography, showed Smith a new world and esthetic potential of visual experience, where the dynamic interplay of light patterns on a sensitized surface was more important than representation.

Shortly after Moholy's arrival in Chicago, Smith joined the staff of the New Bauhaus to set up a photography darkroom and photography course with Kepes.

After the new design school closed in July 1938 because of financial difficulties, Smith independently explored the reflective and refractive properties of light transmitted through various transparent or translucent materials (glass, prisms, mirrors, mesh) to produce non-objective photographs. In 1949, two years after he had joined the Fine Arts Faculty of Bloomington's Indiana University, Smith made *Battles and Games* (cat. no. 121) and *Giant*, the first of his "refraction drawings," a phrase he coined to describe the photographic prints made from the refraction, or distortion, of rays of light through a pattern of an inexpensive, viscous substance (corn syrup) dripped on glass.

Although Smith never viewed his refraction drawings as clichés-verre, they are really a permutation of the technique. Instead of drawing on a transparent matrix with a conventional tool or material, Smith poured and dripped corn syrup (rendered more liquid with the addition of water) onto a glass plate in a spontaneous gesture akin to Abstract Expressionist Jackson Pollock's method of action painting. The image was then projected onto photographic paper to create a black-and-white print. Smith later selected a core of these black-and-white images to make as dye-transfer prints and silkscreens.

Even though Smith's early refraction drawings were created at the same time as early Abstract Expressionist paintings by Pollock, Hans Hofmann, and others, Smith was, at that time, totally unaware of the rise of abstraction in American painting. While Smith did see a few of Bruguière's cliché-verre images in New York in the early 1950s, he was not consciously influenced by them as he had been by Bruguière's other images in the 1930s and early 1940s. Smith's images seemingly were governed more by his own fascination with the mystery of light and his unique combination of gesture and chance that created a syrupy shape on glass.

While the images of Smith's clichés-verre (refraction drawings) are always abstract, Smith often linked them to a figurative reality by giving them heroic, mythological, metamorphic, or anthropomorphic titles. Usually the images suggested to Smith a theme of universal significance that he felt was expressed better through abstraction than through a representational camera-made image.

Surprisingly, an art world that has easily accepted Surrealist automatism has had difficulty accepting its counterpart in photography, namely, Smith's "liquid and light" photographs (i.e., clichés-verre). Smith's work in refraction drawing has been ignored by all major books on the history of photography and by many in the photographic art world. The abstract photograms of Moholy-Nagy and Man Ray have not suffered this same fate. Fortunately, the occurrence of a few token exhibi-

tions on abstract photography at New York's Museum of Modern Art in 1951 and 1961 presented a sampling of Smith's work, thereby according him a deserved niche in the development of abstract photography. Frederick Sommer, a contemporary of Smith, also figured in these exhibitions. Sommer's abstract cameraless work is probably more in the tradition of Bruguière than Moholy-Nagy because Sommer, like Bruguière, initially derived inspiration from the all-pervasive spirit of Surrealism. However, Sommer's assimilation of Surrealist ideas, especially automatism and collage, is so complete that this influence has been submerged under the layers of his totally individualistic mode of artistic expression.

In 1957, 20 years after he first took up photography, Sommer virtually re-invented the decalcomania idea by making negatives from paint manipulated between two small pieces of cellophane. After forming an image between plastic sheets measuring about 4-by-5 inches, Sommer pulled one layer of cellophane away from the pigment, which adhered to the other piece. The remaining piece with the image became his hand-made negative, which, instead of contact printing, Sommer placed in an enlarger to make a larger photographic print. He logically dubbed prints made from this process "paint on cellophane," producing images such as *Paracelsus* (cat. no. 125). This work, done in 1958, conveys such a remarkable textural and powerful sculptural quality that it ranks as a *tour de force* not only in the history of cliché-verre, but also in the history of photography.

From 1958 to 1961 Sommer created abstract graphic imagery on greased cellophane covered with soot, which he had discovered to be an even more pliable medium than paint. After 1962 Sommer explored another variant on the process, making negatives by transferring drawing from smoked aluminum foil onto glass. Again, Sommer named his process in honor of the materials used: smoke on glass (see cat. no. 128). However, whatever the materials, whether paint on cellophane, smoke on cellophane, or smoke on glass, Sommer's commitment to drawing and to exploring new thresholds of abstract form with light, photographic substances, and method has been of paramount importance to him. Thus, he has excelled as photographic experimenter, as the artist who unites the graphic with the photographic, and combines invention with technical mastery—a tradition that is fundamentally cliché-verre.

Jaromir Stephany, a former student of Henry Holmes Smith at Indiana University and an admirer of the work of Frederick Sommer, is another artist who has contributed to the development of abstract photography and whose cameraless work is cliché-verre. His images (see cat. nos. 130, 131) do not hint that Stephany knows anything about the 19th-century tradition of cliché-verre. Yet, unlike Kepes, Smith, and Sommer, Stephany, because of his five-year cataloguing job at George Eastman House and because of his extensive knowledge of the history of photography, was well aware of the 19th-century development. (Indeed, Stephany is one of the few contemporary artists to have firsthand knowledge of Ehninger's *Autograph Etchings by American Artists,* see cat. nos. 57-59, a copy of which he has owned since the early 1960s.)

While Stephany's process of painting and scratching on film is totally in keeping with the definition of cliché-verre (and he has acknowledged this tradition by calling his work cliché-verre), his artistic inspiration derives from the work and philosophies of his photography teachers, Minor White, at the Rochester Institute of Technology, and Smith. From White, Stephany learned that the principle of equivalence (a concept, handed down from Alfred Stieglitz, that something could stand for something else, or that one image could have more than one meaning) was applicable to photography. Like White's photographs, Stephany's images are skillfully printed abstract transmutations suggesting several meanings. However, unlike White, who found his abstract forms in nature, Stephany creates his own abstractions. In the role played by chance, Stephany's cameraless imagery is similar to Smith's refraction drawings. But in contrast to Smith's refraction drawings, such as *Battles and Games* (cat. no. 121), which was an effort to work directly with light through a refracting substance, Stephany prefers the act of painting substances on film to produce different shapes and textures when projected and printed onto photographic paper.

Although there is a visual similarity between Stephany's prints and the clichés-verre of Bruguière (cat. nos. 86, 87), and Stephany knew of Bruguière's oeuvre from the extensive holdings at George Eastman House, he claims that Bruguière's revolutionary tonal cameraless abstractions had no effect on his art. Instead, Stephany credits the images of Berlin photographer Heinz Hajek-Halke, whose work became known in this country through articles in photography journals in 1964 and the 1965 publication of the book *Abstract Pictures on Film,* as being a compelling influence on his technique

119

22
Author's correspondence with Henry Holmes Smith, September 11, 1978. For further information on the evolution of Smith's photographic career, see Bib. V Smith/Bossen, pp. 2-7.

and personal imagery.[23] Like Hajek-Halke's works, Stephany's reflect inspiration from technical and scientific applications of photography, which succeed in obtaining pictures of matter that could not be seen with the naked eye. The photographs of both Hajek-Halke and Stephany suggest crystallized surfaces, underwater organisms, organic cells and embryos, or stellar bodies and solar systems, and yet they are in fact images created by permutations of hand-applied, dried (and thus cracked) ink and film emulsion.

As indicated by this survey of the works of Bruguière, Kepes, Smith, Sommer, and Stephany, it is the hand-drawn or hand-made means by which each artist creates an image that justifies the appellation of cliché-verre for these abstract photographs. Each artist's individual manner and creative use of translucent substances and materials has resulted in the introduction to the cliché-verre medium of abstract tonal qualities that had not before been part of the tradition.

Until the 1950s, then, the development of the cliché-verre medium in this century was primarily carried on by photographers, some of whom did not even know their prints could be considered clichés-verre. The clichés-verre of Man Ray, Brassai, Bruguière, Kepes. Smith, and Sommer were an outgrowth of experimental and creative efforts in cameraless photography. Each of these artists understood the principles of light, light-sensitive materials, and darkroom techniques. They used this knowledge in their individual quests for novel modes of photographic abstraction. However, printmakers approached the cliché-verre medium as an innovative means of graphic expression without the same level of knowledge of photographic materials and techniques. Because they were not pre-conditioned by conventional methods of using photographic materials, they often introduced new ways of exploiting these materials that resulted in a rich and new potential for visual form.

In the 1950s, when Smith and Sommer were creating their innovative cameraless prints, two women artists, who were primarily printmakers, independently came upon the cliché-verre medium and created works that do not relate visually to those by the photographers. Caroline Durieux, a Southerner who was trained and works as an artist primarily in her native Louisiana, and Vera Berdich, a Northerner whose artistic career is linked with her native Chicago, both sought to explore cliché-verre from the point of view of printmaking. Although neither artist was aware of the other's efforts (or, indeed, of the earlier 20th-century clichés-verre), both artists transmitted their enthusiasms for the cliché-verre process to their students and thus initiated two separate lineages of followers. Through Caroline Durieux's one-time lithography student Aris Koutroulis, the cliché-verre medium was introduced to a number of Michigan artists, including Diane Escott (cat. nos. 90,

91), Barbara Greene (cat. no. 93), Steven Higgins (cat. no. 94), Sue Hirtzel (cat. nos. 95, 96), Yvonne Kafoury (cat. no. 99), James Nawara (cat. no. 104), Sally Winston Robinson (cat. no. 112), and Timothy Van Laar (cat. no. 132). Also, through the program devised by Aris Koutroulis in Detroit, the technique was taught to Shahrokh Rezvani (Hobbeheydar) (cat. no. 111), who currently practices the medium in Scottsdale, Arizona, and who brought the medium to the attention of the well-known Southwest painter Fritz Scholder (cat. nos. 119, 120).

Vera Berdich first introduced the cliché-verre process to her printmaking students at the School of the Art Institute of Chicago in 1959. To most of her students, except for Keith Smith (cat. no. 124), it was a process that was not more than an experimental curiosity. However, Smith was sufficiently interested to produce a body of work in the medium in the 1960s and 1970s.

Vera Berdich credits Hugh Edwards, who was Associate Curator of Prints and Drawings at the Art Institute of Chicago before he was made its first Curator of Photography, as the individual who brought the medium to her attention in the late 1950s. Edwards knew of Berdich's inventiveness in printmaking, and he thought she would be interested in seeing examples of the clichés-verre by Corot, Daubigny, and Millet in the museum's collection. Although Berdich had often used photography to transfer images to her etching plates, cliché-verre was an application of photography that was new to her. She was immediately struck by the simplicity and versatile expressive potential of this technique, and in 1959, a little more than a century after Corot made his first clichés-verre, Berdich attempted her first.

After researching the method used by 19th-century French artists, Berdich devised her own variation of coating a glass plate with India ink washes or with asphaltum. Before the coating dried, Berdich drew with pen or an etching needle and wiped certain areas with a cloth rag, paper, or a brush. Sometimes Berdich used a roller and printing ink to pick up textures from leaves, fabrics, or embossed surfaces, and then offset the image onto the glass. She also collaged found objects onto the plate. The resulting imagery was tonal (in contrast to the linear 19th-century clichés-verre she had seen) and a variant on what she was doing in her intaglio prints at that time. Like the imagery in her intaglios, Berdich's clichés-verre, such as *Lunar Eclipse* (cat. no. 79), present her personal brand of Surrealism: visualizations of nocturnal reveries.

Like Vera Berdich, Caroline Durieux's introduction to cliché-verre was triggered by seeing some 19th-century French clichés-verre. Durieux's acquaintance with cliché-verre in fact preceded by a few years Berdich's initial efforts in the same medium. Caroline Durieux became the first artist to devise a process for making multicolored cliché-verre prints.

In the 1950s Durieux began experimental research in electron printmaking,[24] which indirectly initiated her work in cliché-verre. In 1957 Durieux visited Boston and met with Arthur Heintzelman, then Curator of Prints at the Boston Public Library, to show him her revolutionary electron prints. The closest historical equivalent to her work Heintzelman could think of were Corot's clichés-verre, which he brought out to show her. Durieux, intrigued, was immediately curious about the possibilities of the medium. Could clichés-verre be made in color? If there were color photographs, why not color clichés-verre? She took her questions back to her scientist friends, who were also amateur photographers, at Louisiana State University, Baton Rouge.

With Dr. John F. Christman, a biochemist, Durieux attempted to update the cliché-verre medium with 20th-century photographic technology. The process they devised was a variation on using Kodak Matrix Film and the dye-transfer technique. In their initial experiments with adapting the dye-transfer process to the cliché-verre process, Durieux and Christman accidentally discovered that by exposing Matrix Film on the "wrong" (i.e., emulsion) side and soaking the film in water at 110-125 degrees Fahrenheit, the gelatinous emulsion would loosen slightly from the film surface and become soft and malleable. This happy discovery presented the artist with a means of creating a variety of textural effects. Durieux and Christman spent countless hours experimenting and recording their efforts so that they could repeat desired shapes and forms with the emulsion. After making the image on the matrix, it was then printed with dye-transfer colors on photographic paper. Again, Durieux kept careful records of what proportions of the dye produced what color. Durieux herself regards *Frail Banner* (cat. no. 88) as seminal in her understanding of the tonal and translucent qualities possible through stretching the film emulsion on the matrix and through the subtle coloration of the dye mixture.[25]

In the late 1950s and early 1960s Aris Koutroulis (cat. nos. 102, 103) studied lithography with Durieux at Louisiana State University and learned about her cliché-verre research. It was not until the summer of 1968, however, shortly after being appointed to teach lithography at Detroit's Wayne State University, that he returned to Baton Rouge to explore cliché-verre with his former teacher. Koutroulis mastered Durieux's black-and-white and color techniques, and cliché-verre became his primary mode of printmaking for the next eight years.

Koutroulis set up a cliché-verre workshop in the printmaking department at Wayne State University, and in 1971 he succeeded in establishing the first cliché-verre course in a university art curriculum. Koutroulis' interest in cliché-verre was transmitted to a number of his students, who, in turn, created a significant body of clichés-verre in the decade of the 1970s.

The black-and-white prints of former Koutroulis students Barbara Greene (cat. no. 93) and Steven Higgins (cat. no. 94), and of faculty member James Nawara (cat. no. 104) are vigorous linear works which reflect each artist's characteristic drawing style: Greene's playful, sinuous line; Higgins' frenetic linear network; and Nawara's pointillist precision. Yvonne Kafoury and Sally Winston Robinson both use black and white to create compositions of nuances of gray produced by varying translucencies on the matrix. Both Kafoury's *Light Trails No. 1* (cat. no. 99) and Robinson's *Within the Bridge* (cat. no. 112) display a photographic exploration and understanding of light, and yet both Kafoury and Robinson view their clichés-verre as prints.

Besides the work of Aris Koutroulis, the best examples of color clichés-verre by Michigan artists are by his former students Escott and Hirtzel, who print their subtle matrices in color by the gum bichromate process. In 1972-73, when Escott and Hirtzel first began to study cliché-verre, the course at Wayne State University was little more than a year old. At that time the technique taught was either a variation on the Durieux veil process printed in dye-transfer, or black-and-white printing on standard commercial photographic papers. Escott's imagery, which depends on soft, delicate nuances for its effect, was incompatible with the bright colors and

23
For information on Heinz Hajek-Halke and his photography, see Bib. V Hajek-Halke/Roh, pp. 32-41; Bib. V Hajek-Halke/Hajek-Halke. Hajek-Halke was lecturer in Photo-Graphics at the Hochschule für Bildende Künste, Berlin-Charlottenburg. He has been a photographer since 1925, although since 1951 he has concentrated on experimental cameraless photography, producing a number of images that were selected for his book. Hajek-Halke's works are theoretically cliché-verre. His emphasis on technique nevertheless raises the question of whether experimental preoccupation with technique to create abstract photography is necessarily viable esthetic expression. In the work of Hajek-Halke, excessive attention to flawless execution of innovative process seems to have overwhelmed his artistic statement. Thus, creative means do not always produce an esthetic result.
24
With the aid of a few scientist friends and research grants, Durieux (almost a solitary figure in this endeavor) has spent almost three decades researching and producing electron prints, which now number more than 80. In a demonstration of a peaceful use of nuclear technology, Durieux recreates her own style of satirical drawings with an ink or dye solution, to which a radioactive isotope has been added, contact-prints the drawing onto a sheet of photographic paper in a light-tight envelope, and, after a period of time and processing, the radioactivity produces an exact image of the drawing on the photographic paper. For more information on this aspect of her work, refer to the brochure printed for the November 1978 exhibition of her electron prints at Louisiana State University, Baton Rouge, "Art, the Atom, and LSU."
25
Letter from Durieux to the author, July 6, 1979. For discussion of her cliché-verre technique, see cat. no. 88.

glossy surfaces inherent in the dye-transfer method. In 1973 Escott set out to devise a formula that would suit the subtlety of her images; she found it in gum bichromate printing (see Glossary). Because Escott's method with gum bichromate produced prints that look like watercolors on beautiful rag paper, more and more of her fellow students and colleagues tried printing their clichés-verre in non-silver processes. By late 1975 Sue Hirtzel, who had just been named instructor of Wayne State's cliché-verre course, incorporated into the class a variety of non-silver printmaking techniques and new materials. She, in turn, introduced gum bichromate printing to others, for example, Van Laar.

Shahrokh Rezvani (Hobbeheydar), another Koutroulis student, has transported the cliché-verre process to Scottsdale, Arizona, where he continues to create his structural and illusionistically tactile and spatial images. Rezvani usually prints in black-and-white or in cyanotype. As the printer of many of Fritz Scholder's monotypes, he persuaded Scholder to try the cliché-verre medium, and in 1979 Scholder made four prints (see cat. nos. 119, 120).

While most of the contemporary American artists who make clichés-verre are in some way connected to the rediscovery of the medium and the flurry of activity in Detroit, other printmakers and photographers discovered the process independently. Some artists, for example, William Goodman (cat. no. 92), Meg Ojala (cat. no. 105), and Kent Rush (cat. no. 113), found the cliché-verre process to be an effortless way of making prints of their linear drawings. Other young artists, however, have come to the medium out of some individual creative need unsatisfied by other graphic or photographic media and have expanded the image-making possibilities of cliché-verre to new dimensions and directions. John Bloom's clichés-verre (cat. nos. 80-84) are revolutionary expressions of transparency, a factor inherent in the photographic process but rarely emphasized by the nature of the print surface itself. Bloom's clichés-verre are the first in the history of the medium which are not prints on paper, but, instead, prints on transparent film. The lines and amorphous tones seem to float on the print surface, thus underscoring the dematerialized aspect of a light-based medium. In her large gum bichromate prints (cat. nos. 97, 98), Lois Johnson superimposes sweeping gestural drawing over photographically derived and transferred imagery relating to the life and myths of the American West. Jack Sal's prints (cat. nos. 114-118) are masterful Minimalist statements using a limited calligraphic vocabulary in serial fashion. In the works of such artists, the categorical boundaries between printmaking and photography are no longer clearly defined, and cliché-verre continues to straddle both categories with its classification dependent on the individual artist's artistic leanings. For example, Bloom and Sal, both of whom were trained primarily in photography, freely experiment with various modes of graphic expression; and Hirtzel and Johnson, who have strong backgrounds in drawing and printmaking, borrow photographic methods to simplify or enrich their image-making. The photographers, such as Kepes, Smith, Sommer, Bloom, and Sal tend to categorize the technique as photography on the basis of the process (i.e., light and sensitized materials), while printmakers, like Durieux, Berdich, Koutroulis, Hirtzel, and others emphasize the image-making aspect of the matrix and claim that the principle of replicating a hand-drawn or hand-designed matrix makes the cliché-verre a printmaking medium. Fortunately, the question of definition and classification is now moot, since many contemporary artists feel free to mix media and seek to break down and challenge categorical boundaries.

Nineteenth-century artists initiated the development of photographically printed drawings; contemporary artists have the opportunity to realize its potential. László Moholy-Nagy, as early as 1923, regarded light as the most dematerialized medium and saw it as the key to the new vision of future art. One of our century's greatest artists, Henri Matisse, in an interview shortly before his death in 1954, was asked what direction he thought modern art would take. His answer was a succinct but powerful revelation: light.[26] Cliché-verre is one way to fulfill the prophecies of Moholy and Matisse.

26
Cited in John Hallmark Neff, "Matisse, His Cut-Outs and the Ultimate Method," *Henri Matisse, Paper Cut-Outs*, exh. cat., St. Louis and Detroit, 1977, p. 35, n. 28.

20th-Century Entries

Vera Berdich
American; b. Chicago, 1915

For more than 30 years Vera Berdich taught print-making at the School of the Art Institute of Chicago and creatively explored the technical possibilities of intaglio. She joined the faculty after receiving from the school a Bachelor of Fine Arts degree in 1946. As artist, printmaker, and teacher, Berdich has been imaginative, innovative, and never afraid of the technically complicated or experimental. She has exhibited widely in print exhibitions in Chicago and in other cities in the United States.

In 1959, after seeing some 19th-century cliché-verre prints in the Art Institute of Chicago collection, Berdich decided to try making her own. Shortly after her discovery of the process, Berdich introduced the medium to her etching class. In the 1960s she continued to encourage her etching students, such as Keith Smith (cat. no. 124), to expand beyond traditional printmaking by trying such techniques as cliché-verre.

Although Berdich no doubt created countless short-lived experimental demonstration prints, the body of her extant cliché-verre work numbers about 15. Since Berdich's clichés-verre have not been widely exhibited and thus are not well-known in the print world, her contribution to the history of the medium lies in the fact that she revived interest in the neglected 19th-century process by teaching it to a new generation of artists.

79
Lunar Eclipse
1959
Gelatin-silver print
Signed, dated, titled, and annotated in pencil on verso: lower left, *Vera Berdich*; upper left, *Lunar Eclipse 1959 / Size 5″ x 8″*
20.3 x 12.7 cm (8 x 5 in.)
Courtesy of the artist

The unlikely association of an idealized, Redon-like profile, a flying bird, and a leaf under a ghostly moon, creates an image of enchantment and charm. In fact, Berdich's *Lunar Eclipse* looks like a distant cousin of Ernst's illustrations for *Mr. Knife Miss Fork* (especially Pl. X; see cat. no. 89).

To achieve this mysterious effect, Berdich painted the glass plate with an oil-based ink and varnish so that the cliché-verre would print in a pallid gray-white color in the tonal areas, such as around the head beneath the moon. She used a stylus to draw through the coating to make the bird, drew the profile with India ink, and obtained the leaf texture by rolling ink over a real leaf and then rolling the leaf impression onto the glass plate. In her intaglio prints Berdich usually works with complicated combinations and variations of color printing. However, in a black-and-white cliché-verre, her color sense has been translated to textures and subtle nuances of white and gray. The title complements the effects possible in the cliché-verre medium and enhances the dream-like quality of the print.

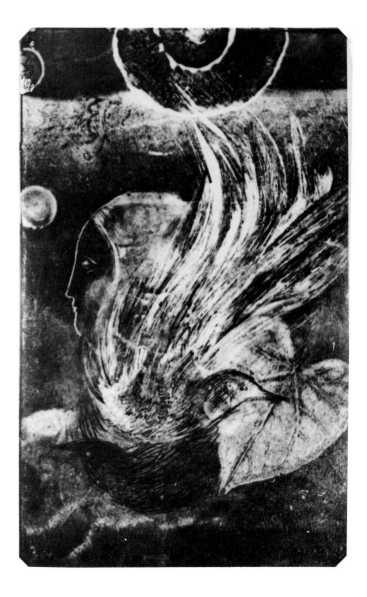

John Bloom
American; b. Providence, Rhode Island, 1948

From October 1976 through May 1978, John Bloom made 55 clichés-verre. In his 1978 Master of Arts in Photography thesis, "Cliché-Verre: A Scratch in the Surface" for the University of New Mexico, Bloom described his involvement with the medium. He had studied painting and drawing, but in the early 1970s, at Toronto's Ryerson Polytechnical Institute, he began to study photography. When he joined the graduate program at the University of New Mexico in 1976, Bloom was already seeking a way to go beyond camera photography without abandoning the artistic satisfaction he gained from the immediacy and directness of working with photosensitive materials. He also wanted to incorporate his experience in painting and drawing with photography. By chance, he saw some clichés-verre by Camille Corot and Paul Huet at the university's Museum of Art. Inspired by what he considered 19th-century photographs that looked like drawings, Bloom launched into a study of the process. Shortly thereafter, the example of Frederick Sommer's "smoke-on-glass" photographs (e.g., cat. no. 128) triggered the creation of Bloom's first cliché-verre.

After coating 4-by-5-inch plates with kerosene lantern smoke, Bloom drew his images with one of a number of assorted instruments, such as guitar strings, broken saw blades, or nails. The glass negatives were then enlarged and printed onto transparent film. According to Bloom, the very simplicity of the process, smoke on glass, makes it nonprecious—easy to prepare and easy to wipe away. Thus, as soon as Bloom printed the image on transparent film, he completely erased the glass negative. Besides doing away with the obvious problems of storage and preservation, Bloom views his disposal of the negative as an act of confidence. He prefers the challenge of creating new prints rather than relying on the means to reproduce former images. Thus, each cliché-verre print is intentionally unique.

Cliché-verre is but one facet of Bloom's work in photography. In late 1978 he stopped making traditional clichés-verre, turning instead to the exploration of hand-alterations and assemblage in photography. In late 1979, after completing his Master of Fine Arts degree in Photography from the University of New Mexico, Bloom moved to San Francisco where he continues to pursue his career in photography. He was one of the recipients of a 1980 National Endowment for the Arts Photographers' Fellowship, which is awarded to photographers with promising talent.

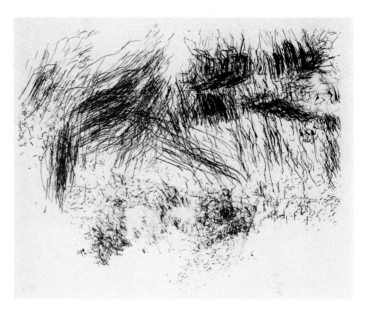

80
Cliché-Verre: Series 1, B
October 1976
Copper-toned Kodalith film over watercolor on paper
Scratched in film, lower right: *JB*
20.3 x 25.4 cm (8 x 10 in.)
Unique
Courtesy of the artist

This is one of seven images, each unique, that comprise Bloom's first series of clichés-verre. The "scratches on the surface" of the negative have been enlarged and transferred to the transparent film. The lines, which seem to float on the clear surface, also give the illusion of being richly inked, etched strokes, scribbled with energy and verve. This linear image, which is in the spirit of a Kandinsky improvisation, contrasts with the crisp edges of the blue-green, rectangular watercolor shape behind the film surface.

By printing on clear film instead of on opaque paper, Bloom acknowledged a basic physical principle intrinsic to the nature of photographic materials, namely its transparency, and made it an element inherent to the visual appreciation of his images. A photographic print is possible because of the transparency of the negative (i.e., the matrix which permits the passage of light through it to another surface), and this is taken for granted. However, Bloom makes the viewer confront this transparency by printing his negative onto a clear surface, through which one perceives the watercolor tone behind. The result is an image possible only with cliché-verre: rich, inkless lines superimposed over a watercolor.

125

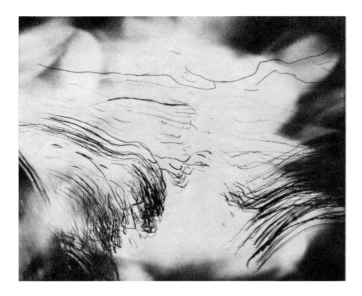

81
Cliché-Verre: Series 2, A
December 1976
Gold-toned Gevalith film
Scratched in film, lower right: *JB*
12.7 x 16.5 cm (5 x 6½ in.)
Unique
Courtesy of the artist

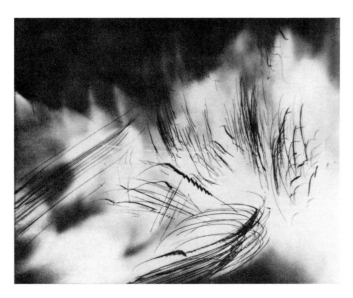

82
Cliché-Verre: Series 2, E
December 1976
Gold-toned Gevalith film
Scratched in film, lower right: *JB*
12.7 x 16.5 cm (5 x 6½ in.)
Unique
Courtesy of the artist

In Bloom's second cliché-verre series he abandoned color and explored the variations of tone possible only with photographic materials. These images, the first and last prints of *Series 2*, mediate between drawing and photography. The hair-like, hand-drawn lines provide a counterpoint to the amorphous, smoky photographic tone. The visual allusion to smoke is not accidental, for that was the source of the image on the matrix. However, unlike Sommer's smoke-on-glass image (cat. no. 128), which was printed on light-sensitive paper, Bloom's images are printed on transparent film. This permits Bloom to play with ambiguity—his positive cliché-verre prints take on the appearance of a black-and-white negative.

Perhaps a more important point exemplified by these two images is their translation into visual terms, with areas of light and shade, of the original meaning of the word "photograph," that is, "light writing." The action of light projected through the matrix, which had been partially obscured by smoke manipulated by the artist, has left its mark on each print.

83
Cliché-Verre: Series 4, E
February 1977
Gevalith film and oil pastel
Scratched on film, lower right: *JB*
33 x 40.6 cm (13 x 16 in.)
Unique
Courtesy of the artist

This image from Bloom's fourth series incorporates the linear and tonal qualities found in his prints from 1976 (cat. nos. 81, 82). However, for the first time in his clichés-verre, Bloom worked in a larger format and hand-applied color directly to the transparent film surface, instead of to the paper behind the film surface. The larger size allowed him to be bolder in his gestural lines and manipulation of smoke to create broad translucent tonal areas. The touches of purple-pink and yellow in the few hand-applied lines serve as little highlights to the photographically printed black lines. The squiggles of color suggest the movements of the artist's hand and reinforce the sense of drawing.

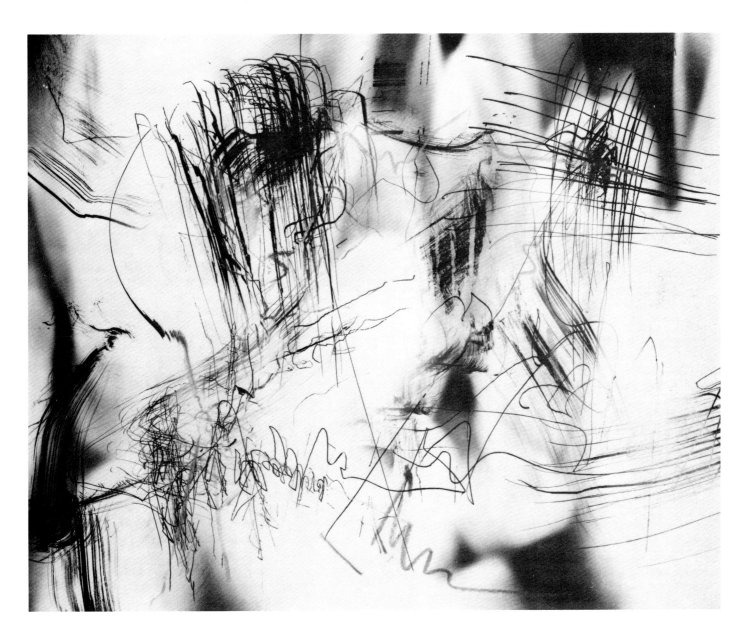

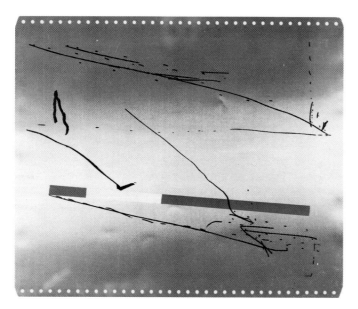

84
Cliché-Verre: Series 6, B
June 1977
Gevalith film, acrylic, aluminum offset plate
Scratched on film, lower right: *JB*
40.6 x 50.8 cm (16 x 20 in.)
Unique; second in series of 6
Courtesy of the artist

Here Bloom has used 20th-century materials, plastic film, and an aluminum offset plate (normally used as matrices to make prints on paper), as the actual surface of the print. The reflective surface of the buffed aluminum plate serves as a backdrop to the transparent film layer, and both surfaces contribute to the ambiguous sense of space by denying their inherent flatness. The rigidity and stability of the geometric, hard-edged white-and-red bar, painted onto the back of the film, contrast with the nervousness of the freely drawn lines. Yet the manual feel of the lines also creates a visual balance with the mechanical nature of the materials and the impersonal calculation of the painted area. In this cliché-verre, Bloom has combined unconventional materials with a composition created by painting, drawing, and photography.

Brassai (Gyula Halász)
French; b. Brassov, Transylvania, 1899

The art world is probably more familiar with Brassai's photographs than with his drawings or writings. Yet this latter work exhibits a talent and vitality that certainly rivals the quality of his most famous photographs. The fact that Brassai was a draftsman as well as a photographer makes his essay in cliché-verre not altogether surprising.

Brassai, who took his name from his birthplace, did not become a photographer until age 30. Before that time, he had studied drawing, painting, and sculpture at the art academies of Budapest and Berlin. By 1923 Brassai was in Paris supporting himself as a journalist for Hungarian newspapers and pursuing his painting. Paris presented Brassai with a wealth of fascinating sights and experiences, and he sought a medium that would record his fugitive impressions. Around 1930 a friend, photographer André Kertész, persuaded him to try photography. Armed with a new means of artistic expression, Brassai set out to capture the essence of prewar Paris. He was particularly intrigued by the picturesque, and often bizarre and tawdry, qualities of Parisian nightlife. The photographs that resulted from Brassai's nocturnal explorations were published in the book *Paris de Nuit* in 1933 (revised and republished in 1976 as *The Secret Paris of the 30s*).

In 1932 Brassai was commissioned by the art journal *Minotaure* to photograph Picasso's sculptures. The commission resulted in a long-term project through the Occupation years and in a devoted friendship between the two artists. Brassai's book *Les Sculptures de Picasso* was published in 1948, and the written account of their relationship over the years, which Brassai resurrected from vignettes he had preserved on scraps of paper, was first published in the book *Conversations avec Picasso* in 1964. It was Picasso who encouraged Brassai to continue drawing in the 1930s and 1940s and who sparked the cliché-verre idea that resulted in *Transmutations* (see "Cliché-verre in the 20th Century," p. 113).

Brassai has produced other books: *Camera in Paris* (1949) and *Seville en fête* (1959). His interest in spontaneous "wall scrawls" or graffiti resulted in a photographic essay exhibited at New York's Museum of Modern Art in 1956 and in a book in 1960. In 1963 Brassai had a retrospective exhibition at Paris' Bibliothèque Nationale, and in 1968 the Museum of Modern Art accorded him the same honor.

Dubbed by Henry Miller the "Eye of Paris," Brassai, in his keenly observed and sensitive photographs over a period of four decades, has created an unforgettable mosaic of the colorful world he inhabited.

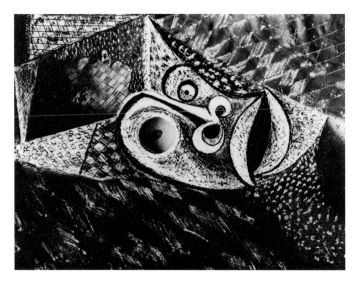

85
Transmutations
1967
Portfolio with 12 plates
Gelatin-silver print
Signed and numbered in black ink on colophon page: *8/Brassai*
Image: 23.5 x 17.8 cm (9¼ x 7 in.)
Sheet: 38.1 x 28.5 cm (15 x 11¼ in.)
Published by Editions Galerie Les Coutards (Lacoste, Vaucluse, France)
Edition 100 plus 10 hors de commerce
List of plates: I, *Fruit Woman (Femme-fruit)*; II, *Stripped Woman of Seville (Sévillane dénudée)*; III, *Odalisque*; IV, *Mandolin Woman (Femme-mandoline)*; V, *Amphora Woman (Femme-amphore)*; VI, *Girl Undressing (Fille de joie se déshabillant)*; VII, *Mineral Countenance (Visage Mineral)*; VIII, *Temptation of Saint Anthony (Tentation de Saint Antoine)*; IX, *Young Girl Dreaming (Jeune Fille rêvant)*; X, *Offering (Offrande)*; XI, *Woman in Veils (Femme aux voiles)*; XII, *Fair (Fête foraine)*
University of Michigan Museum of Art, Ann Arbor

Since very few of the original 1934-35 vintage prints by Brassai are extant in public collections, it is the 1967 publication of this portfolio *Transmutations* that has publicized Brassai's venture into the cliché-verre medium. Thus far, the author knows of only one vintage print, the *Temptation of Saint Anthony*, which differs from the 1967 publication because it is larger and is signed and dated "1935" (University of Missouri, Columbia, Museum of Art and Archaeology).

Brassai's 12 images fall completely in the Surrealist spirit that pervaded the art scene of the 1930s. In his introduction to the portfolio, Brassai likened his creative actions to that of a somnambulist who saw fragments of reality merged with strange visions. Like a sculptor, he tore away the outer layer of reality to reveal a hidden image. Even the title reinforces this Surrealist notion of metamorphosis. Since Brassai preferred to work with photographic plates which already had a camera-made image on them, his drawing transformed the original picture into something else. Thus, from images of nude women Brassai fashioned a bulbous musical instrument (pl. IV) or a vase (pl. V), and pictures of objects in a traveling carnival became the eyes for a bizarre mask (pl. XII, see fig. 15). In the latter plate, the transfiguration of carnival objects into a scowling Kanaka mask is complete, for the drawing entirely camouflages the camera-made source of the image.

The *Temptation of Saint Anthony* (pl. VIII, ill.) probably exhibits the most successful blending of camera image with drawing. The torso of a reclining nude has been transmuted into a spectral mask. Most of the rest of the surface is covered by a crudely scratched diaper pattern that is evidence of the artist's hand. However, parts of the woman's body are not concealed by drawing. The drawing incorporates fragments of the natural female form which remain the objects of worldly temptation, Thus, the initial perception—a representational camera-made image—was converted by Brassai into a symbolic mental picture. As the artist stated in his introduction, "From the photographic image to the engravings, realism was outweighed by oneirism." For Brassai, cliché-verre was a means of going beyond the reality of photography.

Francis Bruguière
American; San Francisco 1879-1945 London

Francis Bruguière was one of the pioneers of abstract photography in the early part of this century. Although his innovative experiments with "light abstractions" in the 1920s and 1930s are, perhaps, not so well-known as the photograms of Moholy-Nagy or Man Ray, Bruguière's contribution is no less significant. Independent of Moholy and Man Ray, Bruguière had long sought to free photography from its traditional role of representing external reality.

Biographical information on Bruguière is scarce; the best account of his life and his photographic work is the 1977 monograph by James Enyeart (see Bib. V Bruguière/Enyeart). Bruguière first studied painting, poetry, and music. In 1905 he visited New York, where he met one of the giants of American photography, Alfred Stieglitz, and one of the leading members of the Photo-Secession movement, Frank Eugene. Bruguière could not have asked for a better indoctrination into the art of photography. In 1906 he opened his own studio in his native San Francisco. Much of his early work was in the Pictorialist, soft-focus style. For the next ten years Bruguière kept himself informed on what was happening in modern art and tried to apply modernist theories to photography. He began experimenting with multiple exposures as early as 1912. In 1919 Bruguière moved to New York to pursue a career as a professional commercial photographer. In the 1920s he made photographs for *Vogue* and *Harper's Bazaar* and photographed stage productions for the Theater Guild. While his work by day was fairly conventional, at night Bruguière was exploring new thresholds of visual expression with light. In addition to his multiple exposures, which produced Surrealist combinations of images, Bruguière experimented with photographing light on cut-paper abstractions, photograms, solarization, and cliché-verre. It was this aspect of Bruguière's photographic oeuvre that accords him a key place in the history of the medium.

In 1927 Bruguière's first one-man show of paintings and photographs in New York allowed the art world to see his abstract photographs for the first time. (The following year much of this exhibition was shown at Berlin's Der Sturm Gallery.) Bruguière moved to London in 1927, and for the next decade experimented exclusively with abstract photography and film, including clichés-verre in the mid-1930s.

In 1937 Bruguière was one of the designers of the British Pavilion at the Paris Exposition. Until his death in 1945 he continued his experiments in photography and renewed his practice of painting.

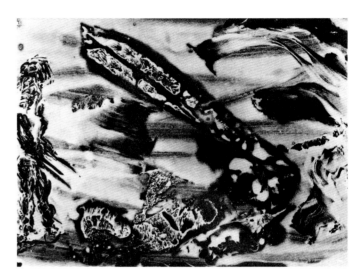

86
Saint George and the Dragon
1936
Gelatin-silver print
Signed, titled, and annotated in ink on verso: *Top/St. George and the Dragon/Bruguiere/55 Kings Court North/Chelsea, London*
16.9 x 23.8 cm (6¹¹⁄₁₆ x 9⅜ in.)
Museum of Modern Art, New York (Gift of James Johnson Sweeney)

Since none of the glass plates exist, it is not possible to know with certainty how Bruguière executed his clichés-verre. From the appearance of this print, it looks as though the artist brushed paint broadly across the glass surface. The figure of Saint George was probably drawn through the pigment with a blunt point, perhaps the handle of a brush. The reticulated textures at the lower center (the "dragon head") and in the strong diagonal shape of the "dragon tail" were produced by pressing the wet pigment against another smooth surface and then slowly peeling away that second surface.

This is the only one of Bruguière's clichés-verre that is vaguely representational. Probably the configurations and textures of the paint suggested the subject to the artist. The swirling on the right side of the image conjures up the idea of a mighty monster whose wrath is confronted and contained by the upright figure on the left.

A comparison of the Museum of Modern Art impression with one housed in the International Museum of Photography at George Eastman House (fig. 19) is instructive. This comparison was not made by Enyeart, who illustrated only the George Eastman House impression (see Bib. V Bruguière/Enyeart, pl. 108). The Rochester impression of *Saint George* is a negative *and* reverse version of the Museum of Modern Art impression and is untrimmed. In the print exhibited here, the details and textures printed black, while in the Rochester impression these same details and textures stand out in white with striking clarity. This comparison raises puzzling questions. Why does a negative version exist? Is one a camera-made photograph of the matrix and the other a print made from the matrix? Which is the real cliché-verre? The fact that the Museum of Modern Art version of *Saint George and the Dragon* was illustrated in the Fall 1936 issue of *Transition* (25, p. 89) would indicate that this was the version preferred by Bruguière. (The publication of this print in *Transition* also pinpoints the date of *Saint George*.) In keeping with his experimental nature, Bruguière was no doubt curious to see the two versions of the same image. It was as if he were playing with light to print opposite, but equally effective, results from the same matrix. However, without documentation of the artist's method of making these two versions, one can never fully know Bruguière's intentions.

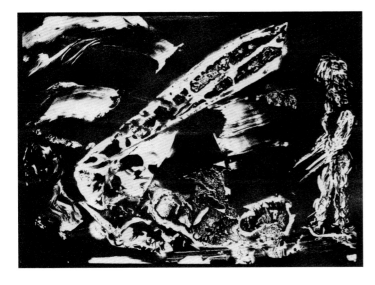

Fig. 19
Francis Bruguière (American, 1879-1945). *Saint George and the Dragon*, 1936. Cliché-verre; 20.3 x 25.4 cm (8 x 10 in.). International Museum of Photography at George Eastman House, Rochester.

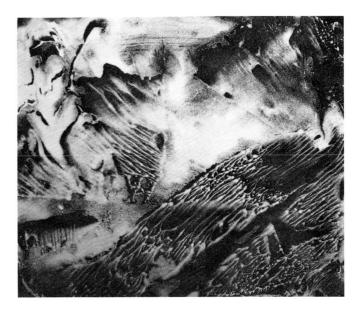

87
Sale nuit, nuit de fleurs, nuit de râles, nuit capiteuse, nuit sourde dont la main est un cerf-volant abject retenu par des fils de tous côtés de fils noirs, des fils honteux!
—*André Breton*
c. 1936
Gelatin-silver print
Signed, titled, and annotated in ink on verso, upper center: "*Sal* [sic] *nuit, nuit de fleurs, nuit de râles,/nuit capiteuse, nuit sourde dont la main/est un cerf—volant abject retenu par des/fils de tous côtes* [sic] *de fils noir* [sic]*, des fils/hontaux* [sic]" *Andre* [sic] *Breton*; center, *Bruguiere/55 Kings Court North/Chelsea London*
19.3 x 23.8 cm (7⅝ x 9⅜ in.)
Museum of Modern Art, New York (Gift of James Johnson Sweeney)

The textures of this abstract image evoke a lunar surface or ripples on a black lake—a kind of suggestive abstraction characteristic of all Bruguière clichés-verre except for *Saint George and the Dragon* (cat. no. 86). The textures of this image hint that a decalcomania technique was used. Adoption of this Surrealist technique is reinforced by the inscription on the verso of a quotation by André Breton, the great Surrealist poet and critic who was Bruguière's contemporary. Thus, Bruguière was obviously cognizant of and inspired by Surrealist ideas. A translation of this passage is: "Filthy night, night of flowers, night of death-rattles, sensuous night, deaf night whose hand is an abject kite held by strings in all directions, black strings (sons), shameful strings (sons)." (Breton played on the French word *fils*, which means both strings and sons. The author is deeply indebted to Professor Mary Ann Caws and to Professor J. H. Matthews for their translations and important insights regarding this quotation.)

The source of this quotation (as pointed out by Professor Matthews) is the poem "Poisson Soluble" ("Soluble Fish"), which was published with the first edition of Breton's *Manifeste du Surréalisme (Manifesto of Surrealism)* in 1924. Since the *Manifesto of Surrealism* was such

131

a major Surrealist publication, Bruguière could have easily consulted this work in the early 1930s for inspiration. The "Sale nuit" quote which impressed him is the first sentence of the ninth of thirty-two numbered sections of this prose poem. In this passage, like the rest of "Poisson Soluble," Breton conjures up bizarre images which dissolve like a mirage as soon as the reader perceives the next word. Breton's words evoke a haunting and unstable dreamlike atmosphere which must have conveyed the essence of the *surreal* to Bruguière.

The occurrence of a Surrealist quotation on this cliché-verre is not unique in the work of Bruguière. The Museum of Modern Art owns another Bruguière image bearing a quote from Isidore Ducasse, the 19th-century Symbolist poet and prophet for the Surrealists who was known as the Comte de Lautréamont: *"Il est rare que je trouve le repos dans la nuit/ car des rêves affreux me tourmentent..."* ("It is rare for me to find rest in the night, for atrocious dreams torment me"). Bruguière's murky, unsettling cliché-verre image complements this line from the Second Song (Part 26) of Lautréamont's most famous work, *Les Chants de Maldoror (The Songs of Maldoror,* first published in 1869).

Obviously, Bruguière considered the cliché-verre an appropriate medium for expressing nightmarish images that emerged from the deep recesses of his unconscious.

Caroline Durieux
American; b. New Orleans, 1896

Caroline Durieux's satirical lithographs of the 1930s and 1940s are more well-known in the art world than her pioneering efforts in the media of cliché-verre and electron printmaking. Durieux's early artistic career before 1950 is fairly well-documented. When Durieux (née Wogan) was studying art in the early part of this century, there was little encouragement for a woman artist from the then provincial cultural milieu of her native Louisiana. However, Durieux's independent nature, keen observation, genteel wit, coupled with her talent for drawing, carried her through an artistic training at Sophie Newcomb College (now part of Tulane University), where she obtained her Bachelor of Arts in 1917, and two years of study at the Pennsylvania Academy of the Fine Arts. After marrying Pierre Durieux in 1920, she spent the next 16 years in Cuba and Mexico, where her husband conducted his export business. Shortly after their move to Mexico City in 1926 Durieux was introduced to the art world of Diego Rivera, José Orozco, and David Siqueiros. In 1930, during a brief visit to New York, she met Carl Zigrosser (then director of Weyhe Gallery, New York, but later Curator of Prints, Drawings, and Rare Books at the Philadelphia Museum of Art) who, after seeing her drawings, suggested she try lithography. On her return to Mexico City she found a master printer and spent the next two decades producing lithographed social caricatures, in a spirit akin to the prints of Peggy Bacon, of the Latin American and Creole bourgeoisie.

In 1937 Durieux was back in New Orleans. From 1938 to 1943 she taught part-time at Newcomb College and was a consultant for Louisiana's Federal Art Project, Works Progress Administration. In 1943 she joined the faculty of Louisiana State University, Baton Rouge, where she taught drawing and printmaking courses for more than two decades. In 1949, in order to strengthen her own professional credentials, she got her Master of Fine Arts degree from Louisiana State University.

In the 1950s, when she, herself, was in her mid-50s, Durieux forged ahead with experimental research in the then totally unknown field of electron printmaking and afterward in cliché-verre—a medium that Durieux felt needed to be revived, but in color. In 1957 Durieux and Dr. John F. Christman, a biochemist, began experimenting with the imagery possible in color cliché-verre prints, using a variation of the Kodak Matrix Film and dye-transfer technique (see cat. no. 88 and Glossary).

In the 1960s Durieux made many color clichés-verre, which were more abstract in character, and a number of black-and-white clichés-verre, which continued her more representative satirical vein, from ink or pencil drawings on clear plastic sheets. While Durieux never taught a course in cliché-verre because her department

did not have the necessary darkroom facilities, her own work in the medium inspired some of her students (see "Cliché-verre in the 20th Century," p. 120). In June 1978 she made a visit to Detroit's Wayne State University to conduct a symposium on cliché-verre. It was only fitting that she visit an institution sponsoring a course inaugurated by former student Aris Koutroulis (cat. nos. 102, 103). Since 1965 when Durieux was made Professor Emeritus, she has tirelessly pursued her own activity in cliché-verre and electron prints with remarkable energy and dedication.

The museums with the largest holdings of Durieux's prints are the Anglo-American Art Museum of Louisiana State University and the Philadelphia Museum of Art (acquired by the late Carl Zigrosser, who championed her prints in all media). In January 1980 Durieux was one of five American women to receive an award for outstanding achievement in the visual arts from the National Women's Caucus for Art.

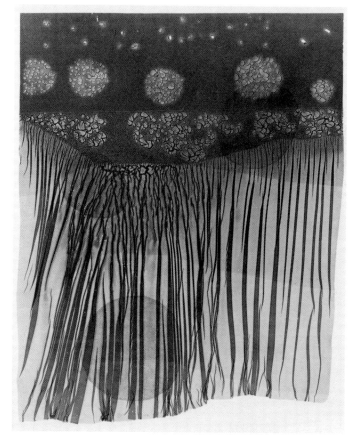

88
Frail Banner
1960
Dye-transfer print
Signed, titled, and numbered in pencil: lower right, *Caroline Durieux*; lower left, *1/5 Frail Banner*
Image: 38.1 x 30.2 cm (15 x 11⅞ in.)
Sheet: 50.2 x 40 cm (19¾ x 15¾ in.)
Edition: 5
Museum of Modern Art, New York (Gift of Herbert Kerkow, Inc.)

Frail Banner is one of Durieux's most successful and beautiful early images in color cliché-verre, created by what she called the "veil" technique, because the layer of film emulsion toned with dye-transfer colors resembles a veil. Illusionistic textural effects were created by gently pulling and pleating the emulsion coating on the film. Reticulation (like that on the upper section of the print), was caused by dropping hot water from an eye dropper. After making the image on the matrix, the film was removed from the water and allowed to dry and harden. Then the film was soaked in a mixture of dye-transfer colors (magenta, cyan or blue, and yellow) and contact-printed onto photographic paper. In the proper dye-transfer method used by photographers, the colors were never mixed. The film is usually placed in each color, one at a time, and printed consecutively, with the superimposition of the colors creating a new color. However, Durieux did not follow the method dictated by Eastman Kodak directions and instead mixed the three colors. Variations in the proportions of the three colors in the mixture determined the overall color. In the image, areas where the emulsion was thicker absorbed more of the color and created a darker tone than in the areas where the emulsion was thin. The film was then contact-printed onto printing paper. In this print Durieux combined harmonious dark-brown and rosy-maroon colors with a delicate speckled and striated patterning to create an image that evokes the decorative elegance of a tapestry.

Since Durieux did not actually date this print, there is some debate as to when it was actually done. According to the artist and Dr. Christman, the print was done in 1960. The records of the Museum of Modern Art, however, date this work to 1957/61. (It is interesting to note that as of 1979, this is the only cliché-verre in the Museum of Modern Art's print collection). The Louisiana State University Anglo-American Art Museum also owns an impression of this print which, according to their records, is dated 1963. However, since the Museum of Modern Art acquired its impression of *Frail Banner* in 1961, the earlier dating is most probably correct. This would place the creation of *Frail Banner* in the pivotal phase when Durieux had assimilated the lessons of experimentation and had mastered the technique of color cliché-verre.

Frail Banner is an outstanding example of Durieux's early efforts with the dye-transfer process, and, although datable around 1960 (i.e., relatively late in the history of cliché-verre), it is the oldest cliché-verre in color in this survey.

133

Max Ernst
German; Brühl (near Cologne) 1891-1976 Paris

Certainly Max Ernst is one of the august figures of 20th-century art. His artistic career spanned a 65-year period, and his name is inextricably linked with the art movements of Dada and Surrealism. His paintings, sculpture, and graphic work introduced new realms of invention as well as irrational, enigmatic elements to the visual arts.

A brief sojourn at the University of Bonn in 1908-1909 to study philosophy and psychology was superseded by Ernst's desire to become an artist. During the next decade—one of political turmoil, uncertainty, and artistic ferment—Ernst was exposed to a variety of styles and modernist ideas. Ernst befriended artist August Macke; was exposed to the art of Cézanne, Picasso, Matisse, and the Die Brücke Expressionists; pursued painting despite military service from 1914 to 1918; met Jean Arp and was introduced to Dada concepts. In 1919 Ernst found his own artistic focus: he established the Cologne Dada movement, exhibited in the first Dada exhibition there, and created his first collages. Collage enabled the artist to create bizarre juxtapositions of unrelated images and became one of his primary modes of expression.

In 1921 André Breton arranged for Ernst's first one-man show in Paris. In that year, too, Ernst met Paul Eluard, another French Surrealist poet, who was to become a lifelong friend. The following year in Paris Ernst found a niche in a circle that included poets and writers such as Breton, Eluard, and Tristan Tzara, and artists like Man Ray. When the Dada movement dissolved in 1924, and Surrealism was officially born, Ernst was one of the key members.

In 1925 Ernst developed frottage, a drawing technique in which he rubbed over vestiges of the outside world to suggest shapes of an imaginary inner world (see also Glossary). A selection of frottages was published in *Histoire Naturelle* in 1926. Ernst also used rubbings over different textures to create the clichés-verre used for the book *Mr. Knife Miss Fork* (cat. no. 89). The publication of this book in 1931 was preceded by the publication of Ernst's collage-novel *La Femme 100 têtes* in 1929, and followed by the first showing of his work in the United States at the Julien Levy Gallery, New York, in 1932. Two years later, another famous collage-novel, *Une Semaine de bonté*, appeared.

Ernst's works were featured in the 1936 Museum of Modern Art, New York exhibition *Fantastic Art, Dada, Surrealism*. Before the age of 50, Ernst had established himself as a remarkable figure in the history of art. During World War II the artist left Europe to settle in the United States where, from 1943 to 1953, he spent most of his time in Arizona, where he met Frederick Sommer (cat. nos. 125-129). In 1953 Ernst resettled in Paris and continued his inventive and productive career, which has been celebrated in many major retrospectives over the last 30 years.

89
Mr. Knife Miss Fork
1931
Text by René Crevel; translated by Kay Boyle
46 pages with 19 cliché-verre illustrations by Max Ernst
Published by the Black Sun Press, Paris
Sheet: 17.7 x 11.6 cm (7 x 4⁹⁄₁₆ in.)
Edition: 255 (50 on Hollande paper signed by authors; 200 on
Bristol paper; 5 special copies each with 4 of the original frottages
used for the illustrations and for cover design)
Leppien/Spies 13
Two copies:
a. Signed in pencil on frontispiece: *MAX ERNST*; signed in ink on
title page: *René Crevel*; stamped on colophon page: *21* (of edition
of 50)
Provenance: Caresse Crosby, Paris
Collection Marvin Watson, Jr., Houston
Authors' note: This copy is accompanied by a page proof for Pl.
XVII "... the hour struck for the lighting of the lamps ..." (title
inscribed in French by the artist in pencil along left edge)
b. Stamped on colophon page: *51* (of edition of 200)
Private Collection, Texas

The publication of this book occurred in the midst of
the fertile artistic period between the World Wars and
is an example of a successful collaboration between an
important Surrealist artist and a young Surrealist poet
and writer. As stated in the colophon, this book is a frag-
ment of the novel *Babylone* by René Crevel (1900-1935),
whose works, such as *L'Esprit contre la raison* (1927), as-
sured him a firm place among the Surrealists.

Ernst's illustrations, like Crevel's text, are dreamlike
and mysterious. Some illustrations such as *What is
Death?* (pl. II) and *But at this moment the apocalyptic
beast was death* (pl. VII) present fantastic, nightmarish,
Bosch-like creatures. Others, for example *Death is some-
thing like Cousin Cynthia* (pl. IV, ill.), are Redon-like
visions. *Mr. Knife Miss Fork* (pl. I, ill.), opposite the title
page, conjures up the elusive lovers who inspire the
story's intermingled reveries of Death and Desire.

Each of Ernst's original 19 frottage drawings was used
like a paper negative and contact-printed directly to
photographic paper. Ernst executed the drawings on
paper thin and translucent enough to permit the even
passage of light during exposure. Since the rubbed tex-
tural areas of the drawings blocked the light, those areas
translated into the white tones in the final prints (see
figs. 12, 13). Thus, the resulting clichés-verre were the
opposites, or negatives, of the rubbed pencil drawings.
However, Ernst must have intended the eerie effect cre-
ated by the white figures on a black background to rein-
force the hallucinatory mood of Crevel's story.

These 19 illustrations are the only examples of
clichés-verre in Ernst's graphic work. In 1932, however,
Ernst incorporated an impression of pl. XIX, *Cynthia,
her pearls, her feather, her miracles* ... into a collage en-
titled *About the Glass (Du Verre)* (See Bib. V Ernst/New
York, cat. no. 154, ill. p. 159).

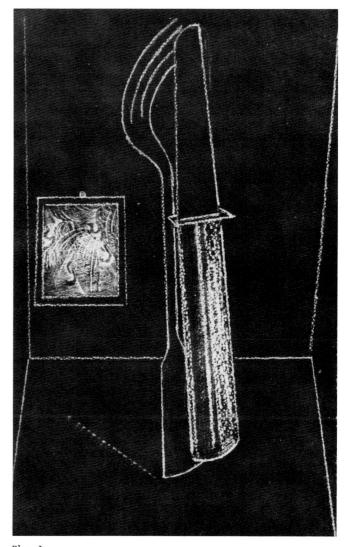

Plate I

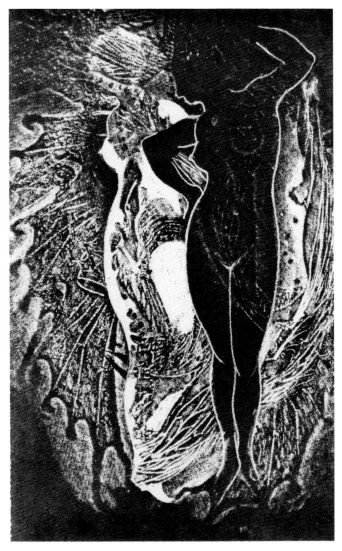

Plate IV

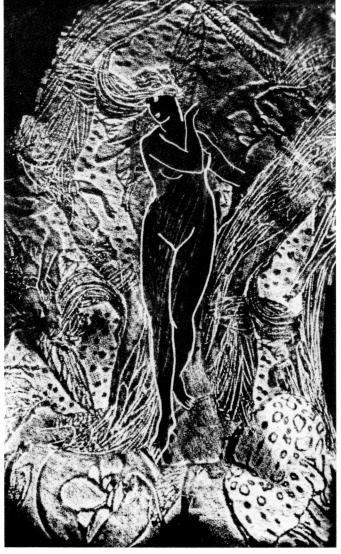

Plate XIX

136

Diane Escott
American; b. Chicopee, Massachusetts, 1949

Diane Escott obtained her Bachelor of Arts degree in Fine Arts from Mount Holyoke College in 1971. She went on to study painting at Detroit's Wayne State University, where she earned a Master of Arts degree in 1972. In Detroit she was introduced to the cliché-verre process in Aris Koutroulis' course, and she was immediately intrigued with the medium because it was the first printmaking technique she found that could recreate the poetic, painterly quality of her drawings. Although she realized the expressive potential of the medium, it took her a year of specialization to adapt the process to her imagery. By the end of 1973 she had a Master of Fine Arts degree in printmaking with an emphasis on cliché-verre and non-silver photographic processes. This degree crowned a period of intense experimental study of the gum bichromate process as a method of printing her delicate drawings. During that time she created about 25 different images, with innumerable color variations of each.

Besides student exhibitions, Escott has shown her cliché-verre prints in a 1975 one-person exhibition at the Saginaw Art Museum, Michigan, and in the 1976 Michigan Association of Printmakers 6th Biennial exhibition in Detroit. Since late 1976 Escott has been living in Easton, Pennsylvania.

90
Untitled Landscape
1973
Gum bichromate
Signed, dated, and annotated in pencil: lower right, *D. Escott '73*; lower left, *Artist's Proof*
21.2 x 20.3 cm (8⅜ x 8 in.)
Artist's proof, not editioned
Courtesy of the artist

Escott made this print from a matrix of an ink drawing on translucent paper. With sweeps of the brush she laid black ink on delicately textured rag paper. She placed the drawing on another sheet of rag paper coated with light-sensitive solutions including gum arabic and pigments. Escott then made the exposure and developed the image. The finished print is a vision of harmonious tones, the result of the artist's sensitivity to different shades of color and to the pure surface of fine rag paper.

Despite the small scale of this print, the broad horizontal strokes of soft brown evoke a vast panorama. Evident here is Escott's admiration of the great 19th-century British painter J. M. W. Turner, her avowed inspiration for her paintings, watercolors, and drawings. Like a Turner watercolor, Escott's subdued tones of brown and green create a mellow twilight mood and tranquil atmosphere.

137

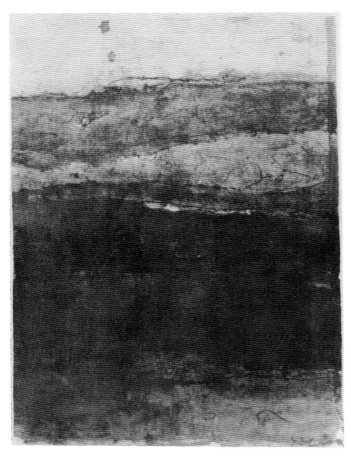

91
Untitled Landscape
1973
Gum bichromate
Signed, dated, and annotated in pencil: lower right, *D. Escott '73;*
lower left, *Artist's Proof*
49.5 x 39 cm (19½ x 15⅜ in.)
Artist's proof, not editioned
Courtesy of the artist

This cliché-verre is remarkable for its luminous aquamarine color. The watery hues and delicacy were inspired by the tonalism, poetic mood, and soft brushwork found in the paintings of the late 19th-century American artist Thomas W. Dewing. With the aid of light, the fluid character of the strokes was transferred to the print and the pre-sensitized coating became a diffused turquoise. No other printmaking technique could have created so perfectly the essence of painting.

Like Escott's other clichés-verre, this was made from an ink drawing on translucent paper (in this case, rice paper, with its fibrous texture transferred to the print). Escott knows that the varieties of color possible with gum bichromate are seemingly limitless: the slightest change in the proportions of a pigment produces different permutations of tone in the print. In addition to this version of *Untitled Landscape,* there is one other print, in paler tones of green-blue, in a Detroit private collection.

William Goodman
American; b. Wimbledon, England, 1937

Goodman's formal studio art training was at the San Francisco Art Institute, from which he received his Bachelor of Fine Arts degree in 1963 and, three years later, his Master of Fine Arts degree. From 1966 to 1968, Goodman taught drawing, sculpture, and art history at the University of New Mexico, Albuquerque. In the 1970s he concentrated on large, commissioned, welded-steel site sculpture in locations as far away as Prudhoe Bay, Alaska, or in various New Mexico cities such as Las Cruces, Roswell, and Albuquerque, where Goodman still resides.

Goodman also executes paintings, drawings, and prints that usually depict strange, other-worldly landscapes. His visions range from barren and arid unpeopled panoramas to scenes cluttered with lush, overgrown vegetation and illogically strewn objects. His work has been exhibited many times throughout New Mexico, as well as in Oklahoma City, New Orleans, Denver, and New York (most notably in the 1973 Whitney Museum of American Art exhibition, "Extraordinary Realities").

At the suggestion of New Mexico photographers Rod Lazorik and Betty Hahn, who recognized that Goodman's meticulous drawing style would be perfectly suited to the cliché-verre process, Goodman began making cliché-verre prints in 1979. In one year he has made four editions of prints in this medium.

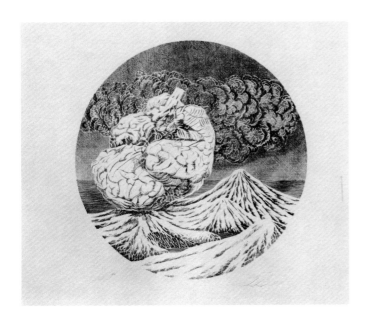

92
Brainscape No. 1
1979
Cyanotype
Signed, dated, titled, and annotated in pencil: lower right, *WG 79*; lower left, *AP*; verso, center, *William Goodman/Brainscape No. 1 1979/cyanotype, cliché-verre*
Image: diam. 25.4 cm (10 in.)
Sheet: 40.6 x 47.9 cm (16 x 18⅞ in.)
Courtesy of the artist

The basic simplicity of the cliché-verre process immediately appealed to Goodman. He drew carefully with a needle on sheets of exposed film, producing very fine, hatched effects apparent in the sky and ravines of the volcanic mountains of *Brainscape No. 1*.

The ultimate source of the bizarre and unexpected subject of this print is Goodman's experience working in a hospital pathology department in the early 1960s. At that time, Goodman was struck by the remarkable topographical character of the brain rather than by its function. His fascination with this organ has never ceased. His realistic drawing of the intricate, maze-like parts of the brain were based on photographs he took from life.

Even though all the elements—natural and organic—of his *Brainscape* are represented realistically, Goodman undermines the viewer's expectation of an illusion of reality by altering the viewer's accepted notion of scale (i.e., creating a brain as monumental as mountains or reducing mountains to the size of a brain) and by juxtaposing seemingly disparate objects (brain and volcano). However, the irrational juxtaposition presents some surprising similarities: the crevices of the brain are like the recesses of the big, puffy cloud, both of which hover over the similarly eroded Mount Fuji-like volcanoes.

Goodman's choice of a round format and the monochromatic blue of cyanotype introduces a decorative element reminiscent of 19th-century Japanese woodcut landscapes.

Barbara Greene
American; b. Detroit, 1948

Barbara Greene, a watercolorist and printmaker, received her Bachelor of Fine Arts degree, and, in 1974, her Master of Fine Arts degree in Printmaking from Wayne State University, Detroit. She works and exhibits primarily in her native city. Her subjects are places she has visited in Detroit: artists' studios, galleries in the Detroit Institute of Arts, the living rooms of friends. Greene's work, especially her drawings and watercolors, reveals a child-like delight and sense of wonder at the objects and the interiors she depicts. Greene's first experience with cliché-verre was in 1973 in the course taught by Aris Koutroulis. She never saw examples of 19th-century clichés-verre, nor was she influenced by the experiments of other artists in the class. Instead, she adapted the whimsical, animated style of her watercolors to the medium. Greene has done approximately 30 clichés-verre.

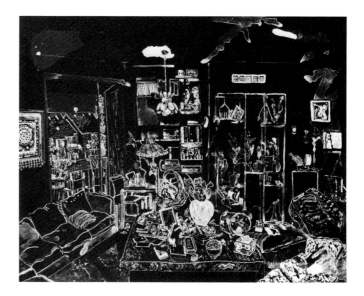

93
Stan's House
1975
Gelatin-silver print
Signed, dated, titled, and numbered in black ink: lower right, *B. Greene 75*; lower left, *Stan's House*; lower center, *13/50*
40.6 x 50.8 cm (16 x 20 in.)
Edition: 50
Detroit Institute of Arts (Anonymous Gift)

Stan's House was printed from a drawing on acetate. To make the negative/matrix, Greene painted on the clear plastic sheet with lithographic tusche and scratched through the ink only when she wanted a black line in the final print. Like James Nawara (cat. no. 104), Greene has used cliché-verre as a means to make multiples of her drawings; but unlike Nawara, Greene does not produce an intermediate negative that would result in a positive print of her drawing. Rather she exploits the negative effect (so that it looks like she has loosely drawn with white ink on black paper) by printing her drawing directly on photographic paper. She feels that no other printmaking medium can quite recreate the sense of drawing or painting in white.

The white-on-black world of *Stan's House* is seen as slightly distorted, perspective askew, with facile lines playing on the print's surface. To communicate her own fascination with the clutter of tiny objects and the textures of the furniture, Greene employed a freely rendered patterning to "color" the scene. The image captures the salient characteristics of the original room, but it has also been imbued with a captivating life of its own.

Steven Higgins
American; b. Spokane, Washington, 1946

Higgins, a sculptor and printmaker, has been an Assistant Professor in the School of Art at the University of Manitoba, Winnepeg since 1974. After obtaining his Bachelor of Fine Arts degree from the University of Washington in 1970, Higgins enrolled in the Master of Fine Arts program at Wayne State University, Detroit, where he was introduced to the cliché-verre process in the 1971 pilot course taught by Aris Koutroulis. Higgins immediately welcomed working in a medium that, as he has put it, facilitated image-making with a minimum of procedural slavery, in contrast to the hours of preparation required to produce a lithograph or an etching. Creating an image on an acetate matrix permitted Higgins an expediency and control that he did not find in other media, and he was intrigued as well by the challenge of printing without ink.

From 1971 to 1976 Higgins made approximately 50 clichés-verre, some of which have been exhibited in Detroit and in various cities in Canada. The period of Higgins' most intense activity in cliché-verre was from 1972 to 1974, when he was also an active figure in the Detroit art community. He balanced his duties as part-time drawing and printmaking instructor at various Detroit-area institutions, and his responsibilities as Gallery Director of the Detroit Artists Market, with creating sculpture and cliché-verre prints.

In 1974, shortly after he moved to Canada, he was awarded a research grant from the University of Manitoba to pursue a project entitled "Cliché-Verre: An Application of Dye Transfer Coloration Mechanisms." Higgins' research culminated in the 1976 publication of his portfolio *Ten Dye Transfer Cliché-Verres* [sic] by Vehicule Art Inc., Montreal, Quebec. Since 1976 Higgins has channeled much of his artistic energy into sculpture rather than into printmaking.

Higgins liked the contradictory nature of the cliché-verre, which is a neutral printmaking method that minimalizes the artist's involvement in the process and yet underscores the autograph character of the drawing.

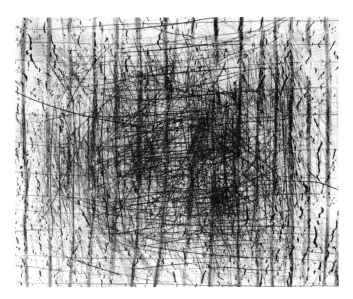

94
Koan XIX
1972
Gelatin-silver print
Signed, dated, titled, and numbered in pencil on verso: lower center, *Koan XIX 1/6 Steven B. Higgins 1972*; artist's stamp in black on verso, lower left: *sh*
40.6 x 50.8 cm (16 x 20 in.)
Edition: 10
Courtesy of the artist

To make the matrix for *Koan XIX*, Higgins sprayed a sheet of matte acetate with black enamel paint. While it was still damp, Higgins scratched lines through the paint film with a metal tool. The resulting negative of the scratched image was then contact-printed onto photographic paper.

The formal linear investigation displayed in *Koan XIX* parallels what Higgins was doing in his "Bundle" sculpture series in 1972-73: bundles of branches of wood literally conveyed Higgins' interest in clustering and layering linear elements. A structure was built branch by branch, just as the cumulative effect of drawing each individual line made a complete image.

Higgins' primary concern in this print was to construct a spatial, not a textural, linear arrangement. The vigorously scribbled grid creates an almost electric network of superimposed lines. Some of them seem to stand out with remarkable intensity, while the thinner, thread-like ones appear to recede, thus achieving the optical effect of layering.

141

Sue Hirtzel
American; b. Buffalo, New York, 1945

Sue Hirtzel works in intaglio, lithography, papermaking, and drawing, but since 1972 her primary artistic endeavor has been to adapt contemporary techniques in photography and printmaking to the cliché-verre process and to master image-making in the medium. Hirtzel got her Bachelor of Fine Arts degree from Daemen College, Buffalo, in 1969. After a year at Buffalo's State University of New York, Hirtzel decided to enroll in the graduate program of Detroit's Wayne State University, where she got her Master of Arts degree in 1972 and her Master of Fine Arts degree in printmaking in 1973. It was in 1972 that Hirtzel first studied cliché-verre in the course taught by Aris Koutroulis. She found that the shapes, tonalities, and textures possible in cliché-verre were compatible with the gossamer forms and quiet, pale colors of her drawings and lithographs. While many of Koutroulis' students shared Hirtzel's enthusiasm for the creative possibilities of cliché-verre, Hirtzel is one of the few students who went on to experiment with, perfect, and codify a variety of non-silver printing processes.

Hirtzel has been an instructor of printmaking and drawing at Wayne State University since 1973. Since 1975 she has been in charge of the university's cliché-verre course. In 1976 a university grant awarded to Koutroulis permitted her to conduct experiments with various cliché-verre techniques and to document the findings. Since 1977 she has lectured on the medium at several art conferences in Michigan, Ohio, and New York. Her cliché-verre prints have been in numerous Midwest exhibitions, and one was included in the 1976-77 Brooklyn Museum exhibition "30 Years of American Printmaking."

The cliché-verre renascence in Detroit originated with Caroline Durieux and Aris Koutroulis, but it is Sue Hirtzel who continues to refine the evolution of the medium in Detroit.

95
On the Other Side
1977
Gum bichromate
Signed, dated, titled, and numbered in pencil: lower right, *S. Hirtzel '77*; lower center, *On the Other Side*; lower left, *1/6*
Image: 40 x 43.1 cm (15¾ x 17 in.)
Sheet: 43.8 x 50.8 cm (17¼ x 20 in.)
Edition: 6
Detroit Institute of Arts (Gift of the Detroit Artists Market in Memory of Elizabeth Bigelow Graham)

Although Hirtzel has made color clichés-verre in dye-transfer, cyanotype, and Van Dyke brown, by 1977 she attained the skill and confidence to print her cliché-verre matrices by the gum bichromate process. *On the Other Side,* a cliché-verre that relies for its effect on the skillfully printed contrast of two subtle tones of gray (cool silver and warm pewter) instead of on drawing, is proof of her mastery. Rather than cover the surface with vigorous drawing and bold forms in brilliant colors, Hirtzel animated each tonal area with a sparse array of wispy, string-like lines, some of which have a white "shadow."

On the Other Side was created from collaging two negatives that were almost completely exposed, except for a few marks and lines. Indeed, the matrices give no clue to the latent image that they contain. Thus, the success of the print depended on several factors: 1) Hirtzel's control in contact-printing almost transparent matrices; 2) her choice of colors for the resulting large tonal areas; 3) her skill in printing those colors (the blend of three

overlays of color to create two grays); and 4) a compositional sensitivity to balance the lighter gray middle tone by flanking it with the bands of darker, tarnished-gray color. The result is a soothing, meditative image of classical simplicity.

96
Paul's Window
1979
Gum bichromate
Signed, dated, titled, and numbered in pencil: lower right, *S. Hirtzel '79*; lower center, *Paul's Window*; lower left, *1/6*
Image: 34.3 x 36.9 cm (13½ x 14½ in.)
Sheet: 45.9 x 56.6 cm (18 1/16 x 22 5/16 in.)
Edition: 6
Courtesy of the artist

The delicate, ethereal beauty of *Paul's Window* belies the utter simplicity and commonplace nature of the materials used as the matrices to make this print. A sheet of rice paper was the matrix for the background color. Light penetrated the subtle fibrous texture of the paper and transferred to the sensitized surfaces of the print. The negative for the "window" (the soft, rectangular shape) was created by placing a sponge on the film which, after the initial exposure, was highlighted with a flashlight to create the misty, cloud effect. The matrices then went through three different color printings: soft ochre-brown, thin brown-gray, and an airy blue-gray. The overlays of color blended to create exquisite tones of silver-gray against a background of muted golden brown. The illusion of atmospheric space and vaporous, cloud-like forms in the window contrast with the flat, two-dimensional quality of the surrounding tone. Hirtzel's keen understanding of the use of light in cliché-verre, the translucency of her materials, and her skill in printing colors in the gum bichromate process, have achieved in *Paul's Window* an image not possible in drawing, lithography, or photography.

Lois Johnson
American; b. Grand Forks, North Dakota, 1942

Although a resident of Philadelphia since 1967, Lois Johnson still considers herself a Western regionalist. She gradually adjusted her vision from the wide horizontal expanses of the Western landscape to the verticality of the city, but her imagery is still inspired by the nostalgic symbols of the outdoor lifestyle of the West: cowboys, horses, and ranch animals.

Johnson obtained her Bachelor of Science degree from the University of North Dakota in 1964. Two years later she received her Master of Fine Arts from the University of Wisconsin, Madison, with a specialization in printmaking. In 1965 a Corot cliché-verre at the Art Institute of Chicago prompted a period of independent experimentation that resulted in Johnson's 1966 Master of Fine Arts thesis on the cliché-verre medium. Since then she has been creating a number of works in cliché-verre and printing them in the gum bichromate process.

Since 1967 Johnson has been Associate Professor at the Philadelphia College of Art, where she has taught silkscreen, lithography, intaglio, and photomedia (including cliché-verre). She was Printmaking Department Chairman from 1972 to 1976. In 1979 Johnson took a brief leave of absence from the Philadelphia College of Art to teach printmaking at her alma mater, the University of Wisconsin.

Johnson's graphic works have been widely exhibited in the 1970s in Philadelphia, as well as in San Francisco, Los Angeles, New York, Marquette (Michigan), Grand Forks, and Madison. Most recently, because her prints incorporate a great deal of direct drawing, her clichés-verre were included in the 1979 exhibition "Contemporary Drawings" at the Philadelphia Museum of Art.

97
Elmer and Ewe Knew Best
1973
Gum bichromate with hand-applied color
Signed and titled in pencil: to left of lower center, *Lois Johnson*; lower left, *Elmer and Ewe Knew Best*
66 x 60.3 cm (26 x 23¾ in.)
Unique
Courtesy of the artist

Johnson cites this work as pivotal in her understanding of the medium and its successful incorporation of her imagery—a combination of collage and drawing. Most of this image is printed in a bright, fresh green, over which Johnson has drawn in pale blue, white, purple, and red to cover or highlight the representational images. The addition of drawing and some hand-coloring makes the work unique.

Johnson selected images of cattle (lower right), and a tractor (lower right), a snowmobile converted from a model T (left, center), and sheep (ewe at upper left), and used them as she would drawn elements to structure the composition. Like Robert Rauschenberg's collage-like prints, this work by Johnson embraces disparate fragments of reality that taken together create a new statement. These images, taken from journals such as *The Dakota Farmer,* are all associated with rural ranching. Original captions accompany the pictures of the sheep and snowmobile. The work is punctuated by such humorous elements as the captions, the pun of the title, and the indication of the sheep's cryptic thoughts. However, the entire image also deals with the more serious matter of what the artist, "Westerner turned Easterner," has culled and resurrected from her memories of growing up in North Dakota.

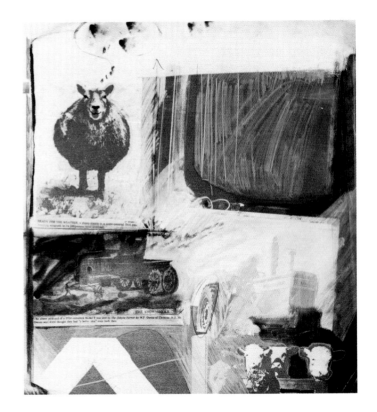

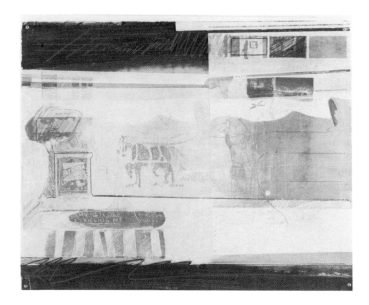

98
Heading West̶ East No. 2
1976
Gum bichromate, colored pencils
Numbered in yellow pencil, below image, lower left: #2
Image: 50.2 x 62.9 cm (19¾ x 24¾ in.)
Sheet: 76.2 x 101.5 cm (30 x 40 in.)
Unique
Courtesy of the artist

This is one print from a series of six in which Johnson again explored her favorite theme of the Westerner's move East (a 20th-century reversal of 19th-century frontier settlement), and the resulting shift in lifestyle and attitudes. The central image in *Heading West̶ East No. 2* of a standing cowboy waving to another in a horse-drawn, covered wagon is derived from narrative, comic strip imagery that has been transferred to a film matrix and printed in blue. The artist repeated this image in altered form on the right side of the print. She blurred the horse and covered wagon at the right and added the horse's remark, "my feet are killing me" and an airplane over the distant mountains. However, in spite of the inroads of civilization (symbolized by the blurring effect and the airplane) the inclusion of the standing cowboy, who waves to the wagon driver, is clearly printed as a surviving vestige of the Old West.

Johnson liked the idea of using "Western" means of attaching her print without adhesives to another paper surface, so she attached her print in each corner with rivets (an allusion to metal studs used as fastenings or ornaments on horse bridles or on leather cowboy clothing).

Johnson evolved her own cliché-verre process so that she could incorporate elements of collage, found imagery, phototransparency, hand-applied color, all of which are fundamental to the creation of her graphic art.

Yvonne M. Kafoury
American; b. Detroit, 1938

Yvonne Kafoury has been pursuing a career in art education since 1965, a year after she received a Masters degree in Education from Wayne State University, Detroit. In 1976-77 Kafoury returned to Wayne for a year of post-graduate work in the Department of Art and Art History. It was at that time that she took the cliché-verre course taught by Sue Hirtzel. Having had prior experience in printmaking and photography, Kafoury was interested in combining the two disciplines. While she experimented with making traditional cliché-verre, i.e., printing from a hand-drawn matrix, she was more excited with the possibility of working directly with light in totally new ways. Although Kafoury begins with a photogram technique, moving a prism on a thin sheet of light-sensitive paper while exposing it to light, she is emphatic in her belief that this manipulation of the action of light passing through the prism to the paper is "painting with light." The result is a paper negative which Kafoury then contact-prints to make an edition. Since 1977 Kafoury has made more than 20 clichés-verre in this fashion. She continues to teach art at the junior high school level in the Detroit area and is introducing the cliché-verre medium to her students.

While Kafoury's cliché-verre looks like a photogram, it is not. The print was made from a matrix and is, therefore, potentially not unique like a photogram. *Light Trails No. 1* also has the surface and tonal qualities of a black-and-white semi-glossy photograph, and yet the artist considers cliché-verre a printmaking technique. As if to reinforce her view, she entered this piece in the Michigan Association of Printmakers 7th Biennial Exhibition, where it won a prize. Moholy-Nagy, whose investigations on the potential of light as creative medium and its application to abstract cameraless photography were so revolutionary in the 1920s and 1930s, would have been pleased by this unquestioned acceptance of a work in which light is both subject and printing agent.

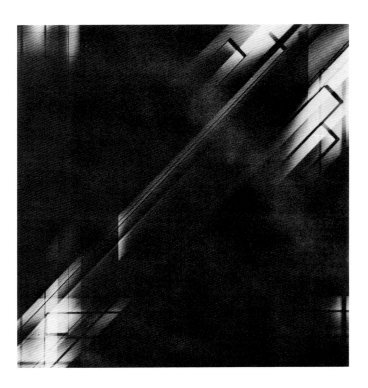

99
Light Trails No. 1
1977
Gelatin-silver print
Signed, dated, titled, and numbered in pencil: lower right, *Yvonne M. Kafoury 1977*; lower center, *Light Trails No. 1*; lower left, *1/5*; on verso, lower right, *Yvonne M. Kafoury. 1977*; lower center, *Light Trails #1*; lower left, *1/5*
Image: 33 x 33 cm (13 x 13 in.)
Sheet: 40.6 x 40.6 cm (16 x 16 in.)
Edition: 5
Detroit Institute of Arts (Michigan Association of Printmakers Purchase Prize)

Kafoury's *Light Trails No. 1* attests to her fascination with the mystery of light and light play. Precise placement of the prism and exact timing of the exposures are crucial to a successful image. The title "Light Trails" reminds the viewer that light is revealed only when it is interfered with. A trail is a mark or track of a thing (here light) that has passed by. In the case of this print, what looks like diagonal, crystallized beams of light is, in fact, the record of the passage of light through prisms. The strong patterning of the transparent bands is an indication of the artist's control of her technique, as well as of movement, and the refractive nature of light.

Gyorgy Kepes
American; b. Selyp, Hungary, 1906

For almost 50 years, from his student days in Budapest through his tenure as director at the Massachusetts Institute of Technology Center for Advanced Visual Studies, Kepes has believed in the interaction of art, science, and technology as a crucial factor of creative image-making and design. Although Kepes studied painting at Budapest's Academy of Art from 1924 to 1928, he abandoned it for photography and filmmaking. Kepes' interest in photography and the foundation of his lifelong artistic philosophy resulted from his affiliation with a group of politically and culturally revolutionary painters and poets in 1928-29. The group, called Munka, inspired by the movements of Futurism, Suprematism, and Constructivism, strived to create art that would be meaningful to 20th-century urban society. Photography, deemed modern, technological, democratic, and unaffected by conventional artistic styles, was considered the ideal mode for a new art.

In 1930 Kepes' pursuit of filmmaking prompted him to write his fellow countryman Moholy-Nagy in Berlin. From 1930 to 1937, Kepes and Moholy collaborated intermittently, first in Berlin, then in London, on various design projects and light experiments. During this period Kepes made many photograms, which exhibited the formal concerns of abstraction through the play of light, form, and motion. When Moholy went to Chicago in 1937 to found the New Bauhaus (later the Institute of Design), Kepes joined him to become head of the light and color department.

Kepes' research and teaching experiences resulted in an analytic approach to design, based on the principles of spatial relation, light, and color. His book, *Language of Vision*, written between 1939 and 1942, reflects his views. In 1945 MIT invited Kepes to establish a program on visual design at the School of Architecture and Planning. At MIT Kepes' frequent contact with scientists and engineers nurtured his ideas to integrate art and science. With the inventors and practitioners of technology so close at hand, Kepes and his students could explore new media, materials, and frontiers of imagery.

In the 1950s Kepes resumed painting, as a private artistic pursuit. His activities as a painter, sculptor, planner, designer, photographer, educator, and writer culminated in the Center for Advanced Visual Studies, which he conceived, founded (in 1967), and directed. (See Bib. V. Kepes/Kepes.) Kepes' indefatigable quest for new ideas and new forms of visual expression has been characterized by a fervor matched by few other artists.

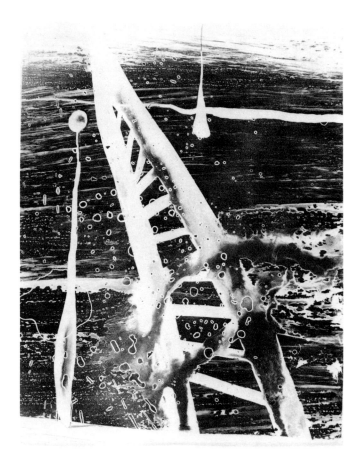

100
Monuments
1939
Gelatin-silver print
Signed, dated, and titled in ink on verso, upper right: *Gyorgy Kepes 1939/Monuments*
35.5 x 27.9 cm (14 x 11 in.)
Museum of Modern Art, New York (Gift of the photographer)

Kepes termed prints like these "photo-paintings," i.e., photographs from paintings on glass. Kepes' process was, in fact, an updated version of what Corot did in the 19th century, yet Kepes was completely unaware of the earlier cliché-verre tradition and technique. Rather, these images evolved from the artist's own experience with cameraless photography and from the inspiring example of Moholy-Nagy's experiments with light. Also, although Kepes gave up painting on canvas in 1928, he did not abandon his love of rich, painterly textures and graphic forms. Instead, he expressed these tactile concerns photographically, and the effects of enlarging dried paint (black casein, oil, or India ink) on glass onto sensitized paper pleased him enormously.

Both these works figured in Kepes' first one-man exhibition in the United States at the Katharine Kuh Gallery in Chicago in 1939. The monolithic, diagonal shape of *Monuments* is a bold structural statement, while *Abstraction, Surface Tension No. 2* exhibits a decorative concern with the textural pattern on the amoeboid white shape beneath the splotchy dark tonal area. Not only are these prints early examples of Kepes' interest in light as a creative medium (later evidenced in his light sculptures and light environments), but they are also key works in the evolution of abstract cameraless photography in the 1930s, as well as in the history of the cliché-verre medium.

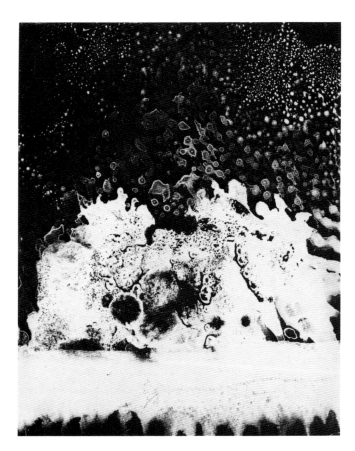

101
Abstraction, Surface Tension No. 2
1939
Gelatin-silver print
Signed, dated, and titled in ink on verso, lower left: *G. Kepes 1939/ Surface Tension*
35.5 x 28.2 cm (14 x 11⅛ in.)
Museum of Modern Art, New York (Gift of the photographer)

Aris Koutroulis
American; b. Athens, Greece, 1938

The cliché-verre medium was one of Koutroulis' primary modes of artistic expression from 1968 to 1976. Before this time he was active as an expert lithographer and master printer. In 1961 he earned his Bachelor of Arts degree in Fine Arts from Louisiana State University, Baton Rouge, where he had studied lithography with Caroline Durieux (see cat. no. 88). In 1963 Koutroulis was awarded a Ford Foundation Tamarind Grant which enabled him to study lithography with Garo Antreasian at the John Herron Art Institute, Indianapolis. After a term as Master Printer at the Tamarind Lithography Workshop in Los Angeles in 1963-64, Koutroulis enrolled at the Cranbrook Academy of Art in Bloomfield Hills, Michigan, to pursue his studies in painting and printmaking. In 1966 he earned his Master of Fine Arts degree, and was appointed Assistant Professor and head of the new lithography workshop in the Department of Art at Detroit's Wayne State University.

In 1968 Koutroulis used a faculty research grant to spend a summer in Baton Rouge studying the cliché-verre medium with Durieux. On his return to Detroit Koutroulis immediately set up darkroom facilities to make clichés-verre in the printmaking department at Wayne State, and three years later in 1971, he devised a formal university course on the medium.

By 1969 cliché-verre had temporarily pre-empted Koutroulis' creative energies in other printmaking media. In that year he received a grant from the Michigan Council for the Arts, which sponsored a traveling exhibition of his cliché-verre prints throughout the state of Michigan. Shortly after he had organized the cliché-verre course, he received another faculty research grant, which enabled him to found the Detroit Workshop of Fine Prints. The Workshop produced and published in 1972 the first suite of cliché-verre prints entitled *Ten in Black and White.* In addition to Koutroulis, the other Detroit artists who participated were Jim Chatelain, John Egner, George Ettl, Steve Foust, Bradley Jones, Michael Luchs, Gordon Newton, Ellen Phelan, and Cynthia Rush. While the idea behind the portfolio was an excellent one, most of the resulting prints were not really successful. Experimental darkroom efforts do not automatically make exciting esthetic statements, and none of the other artists pursued the medium.

Although his cliché-verre course continued to inspire other artists to create primarily in this medium, after 1972 Koutroulis himself was gradually working more and more in painting, lithography, and with paper. His non-cliché-verre work was featured in numerous exhibitions in Detroit and New York. In 1976 Koutroulis left Wayne State University to head the painting department at the Center for Creative Studies, Detroit. Since 1976 he has divided his time between the Center and his New York studio and lithography workshop,

leaving the legacy of contemporary cliché-verre to those who took the course he designed at Wayne State University.

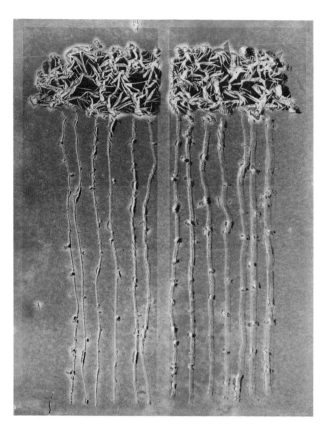

102
Caroline's Garden II
1968
Dye-transfer print
Signed, dated, titled, and numbered in pencil: lower right, *Aris Koutroulis '68;* lower center, *"Caroline's Garden" II;* lower left, *3/3*
Image: 45.4 x 36.1 cm (17⅞ x 14³⁄₁₆ in.)
Sheet: 50.8 x 40.6 cm (20 x 16 in.)
Edition: 3
Collection Mr. and Mrs. Arnold Klein

This cliché-verre dates from the year in which Aris Koutroulis first learned the veil technique with Kodak Matrix Film and dye-transfer colors from Caroline Durieux, who inspired the title. This print is a fitting tribute to the teacher who guided and nurtured Koutroulis through the various steps of the color cliché-verre process because, with its lovely grass-green color and vaguely organic shapes, it suggests a bountiful garden from which beautiful things grow. Although the print also exists in a black-and-white edition, this color version in bright green demonstrates how well Koutroulis understood the process of printing a textural treatment of the film emulsion with the perfect blend of dye colors.

149

103
Flight
1968
Dye-transfer print
Signed, dated, titled, and numbered in pencil: lower right, *Aris Koutroulis '68*; lower center, *"Flight"*; lower left, *4/5*
40.6 x 50.5 cm (16 x 19⅞ in.)
Edition: 5
Detroit Institute of Arts (Gift of Mr. and Mrs. Arnold Klein in memory of Fritz and Marie Ernst)

In *Flight* Koutroulis' main visual concern was creating out of photographic materials a sense of forms moving in space, whereas in *Caroline's Garden* (cat. no. 102) color and texture were primary. The large central, irregularly shaped, dense-black tonal area was created by direct exposure to light. The matrix was completely transparent, stripped of emulsion except for the two small floating shapes, and thus it printed solid black on the photographic paper. This black contrasts with the whiteness of the edges, where Koutroulis, by tearing paper and placing it on the matrix, masked light from reaching the top and bottom portions of the print. Koutroulis manipulated only a small area of the film emulsion to create the two fragile, translucent veils, connected over the jet-black void by horizontal strands, printed in a subtle olive-green. Thus, the resulting stark and powerful image was achieved with a minimum of means.

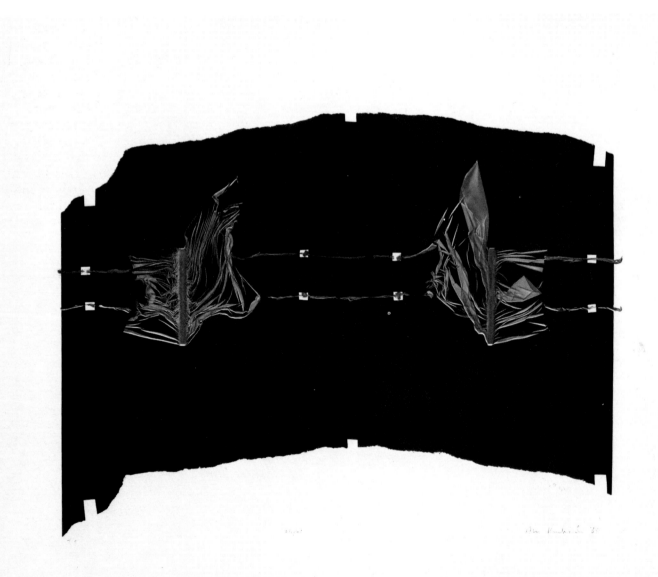

James Nawara
American; b. Chicago, 1945

Nawara first learned about the cliché-verre medium in 1963 in an introductory photography course with Kenneth Josephson at the School of the Art Institute of Chicago, where he got his degree in 1967. Since earning his Master of Fine Arts degree at the University of Illinois in 1969, Nawara has taught drawing at Detroit's Wayne State University where he is an Associate Professor.

Nawara is primarily a painter and draftsman who views his prints as a means of making multiples of his drawings. He has made only two clichés-verre, both dated 1972—almost a decade after he was first introduced to the process. Vera Berdich's explorations in cliché-verre may have accounted for the inclusion of the technique in a course at the Art Institute School, but Aris Koutroulis' cliché-verre course at Wayne no doubt explains Nawara's renewed interest. Furthermore, Nawara's interest in the cliché-verre work of his friend Steven Higgins helped Nawara to see how easily his black-and-white drawings could be adapted to this medium.

While the directness of printing from a drawing on a clear acetate sheet (in contrast to the tedious work of making an image on a metal plate), and the speed and ease of editioning afforded by cliché-verre greatly appealed to Nawara, he did not pursue the medium. Nawara says he felt restricted by the unchanging quality of photographic black and the slickness of the photographic paper. He preferred the nuances possible in printing with different inks and inkings on a wide selection of fine rag papers. Still, both of Nawara's cliché-verre prints, *Horseshoe Mound* (cat. no. 104) and *Moraine*, have received a degree of national and international exposure: in numerous Detroit exhibitions since 1972; San Francisco (1973); Ljubljana, Yugoslavia (1973); Boston (1973); Segovia, Spain (1974); Bradford, England (1974); and most recently in an exhibition organized by London's Victoria and Albert Museum (1979).

104
Horseshoe Mound
1972
Gelatin-silver print
Signed, dated, titled, and annotated in black ink: lower right, *J. Nawara '72*; lower left, *Horseshoe Mound*; lower center, *Artist's proof*
Image: 35.7 x 45.7 cm (14¹/₁₆ x 18 in.)
Sheet: 40.6 x 50.8 cm (16 x 20 in.)
Edition: 20
Courtesy of the artist

The image of this print resembles a high aerial view of a giant earthwork. While the image gives the illusion of being an exact rendering of an actual site seen from above, the view is, in fact, imaginary. The earth seen from the air is a theme Nawara delineates in his etchings, lithographs, watercolors, and paintings, as well as in his two clichés-verre. In an image such as *Horseshoe Mound*, the space seems at once vast and shallow—an ambiguity also found in aerial photography.

In this cliché-verre Nawara's primary interest and skill lie in his careful linear, almost pointillist, draftsmanship. He drew the image entirely in precise black dots and flicks of the pen. For shading, he clustered the marks more densely, suggesting the complex pattern of iron filings that are attracted to a source of magnetism. In contrast to the complexity of the drawing, the process he used to print the image was simple and required only basic knowledge of darkroom techniques. Nawara made an ink drawing on clear acetate; he then contact-printed the drawing to a sheet of Kodalith film to produce a negative; the negative was then contact-printed onto a matte photographic paper.

In 1974 *Horseshoe Mound* entered the arena of art in public places. To publicize the print and multiples exhibition "Markings" in Kalamazoo, Michigan, a 1-by-2-inch detail of the shrubbery and terrain in the central part of Nawara's image was blown-up to make seven 8½-by-15-foot screenprints, six of which were then displayed on billboards there. The seventh screenprint was mounted on a Detroit billboard in July 1979. The gigantic scale of the section of Nawara's print not only attested to the extraordinary skill and quality of his draftsmanship, but also in a literally grand way, drew attention to the fact that the source of the billboard image was a cliché-verre, which had never before attained such magnitude.

Meg Ojala
American; b. International Falls, Minnesota, 1953

Meg Ojala obtained her Bachelor of Fine Arts degree from the University of Minnesota in 1976. Her introduction to cliché-verre evolved out of an independent study project in a Fall 1978 seminar in the history of photography with Alex Sweetman at the School of the Art Institute of Chicago, where Ojala is a 1980 Master of Fine Arts candidate in photography. Since Ojala's photographic work is hand-manipulated, she was interested in learning more about the tradition of hand-altered photography into which cliché-verre can fall, but she quickly found that written material on the subject was scant. She sought to learn about cliché-verre by studying examples by Corot, Brassai, and Sommer. Without any formal training in the technique, Ojala applied her darkroom skills to make works with photographically printed drawn lines. Ojala feels she is just beginning to discover the potential of artistic expression in a medium that combines drawing, transparency, light, and photosensitive surfaces.

105
Untitled
1979
Gelatin-silver print
Signed and dated in pencil on verso, lower right: *Meg Ojala 1979*
50.8 x 60.6 cm (20 x 23 ⅞ in.)
Unique
Courtesy of the artist

Although this image was produced from a totally hand-drawn matrix, much of Ojala's photographic work includes hand-drawn marks or overlays with camera-made images. The literal layering of two types of imagery onto the same surface is intended to parallel the actual perception since, to form a total picture of an object, the mind combines views of it from different perspectives. Objects in the landscape—trees, fields, a pile of sticks—are the subjects of Ojala's camera-made imagery, and the sources for her hand-drawn imagery.

This image is comprised of wispy hand-drawn marks suggesting individual strands of straw or grass found in a landscape. The cluster of slightly curved white lines seems to float against a backdrop of murky black. The image probably relates to Ojala's photographs of tall grass or thin sticks on a bank of snow, which she translated to drawn lines on paper and transformed photographically in the print into the "negative" effect of white lines against a black ground. Thus, Ojala has used the cliché-verre process to transcend the camera's representation of reality.

This print was made from the layering of two drawings. A smaller drawing on vellum was taped to a larger graphite drawing on thin paper. The superimposed drawings were then contact-printed onto lightweight Kodak Ad-type paper. This paper can be exposed with ordinary overhead indoor lighting over a relatively long period of time, thereby giving Ojala time to manipulate (by prolonging or reducing) the length of the exposure to light on large areas not covered by the drawing, so that the result would be an even background tone. Like all Ojala's clichés-verre, this print is unique, even though Ojala retains the drawn matrix and could print more. Ojala uses thin photographic paper so that she can have the option later of using the resulting print as a matrix in combination with another negative to make a new image. She does not see the necessity of editioning her prints when her primary interest is exploring new images and printing them photographically.

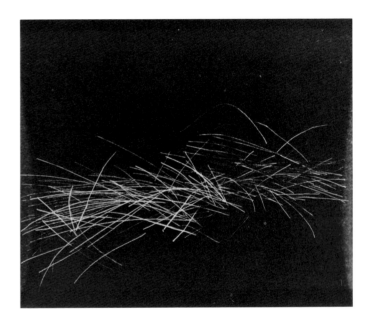

Man Ray
American; Philadelphia 1890-1976 Paris

Perhaps the best key to understanding the independent, creative spirit of Man Ray lies in Marcel Duchamp's concise definition of this artist: "MAN RAY noun. masculine. synonymous with joy, play, enjoy" ("MAN RAY n.m. synon. de joie, jouer, jouir"; see Bib. V Man Ray/ Penrose, p. 12). Man Ray's unconventional paintings, collages, assemblages, ready-mades, photographs, and films are examples of the most exalted form of play. His imaginative ideas often resulted in contradictory, punning masterpieces. Like Duchamp, Man Ray has remained one of the great figures of Dada and of Surrealism.

Although he considered painting to be the most important thing in his life, Man Ray established a reputation as an accomplished and innovative photographer. In 1911 he first visited Alfred Stieglitz's 291 Gallery in New York. The modern art and photographs he saw at 291 had greater influence on Man Ray than did his academic training. In 1915, on the occasion of the first one-man exhibition of his paintings at Daniel Gallery, New York, Man Ray became a photographer in order to produce the best reproductions of his paintings for publicity purposes. Between 1915 and 1921 Man Ray first produced aerographs (brushless paintings), his first ready-mades, and, in 1917, his first clichés-verre. He was also one of the founders of the Société Anonyme and the New York Dada school. When he arrived in Paris in 1921 he was immediately accepted by the Paris Dadaists. In the 1920s and 1930s in Paris he supported himself by his work in photography. Not only was he a leading portrait and fashion photographer, but also, because of an accidental darkroom discovery in 1921 which gave birth to the Rayograph, he became one of the pioneers of abstract cameraless photography. *Les Champs délicieux*, an album of 12 Rayographs with a preface by Tristan Tzara, was published in 1922. This album demonstrates Man Ray's excitement with capturing light on sensitized surfaces. His Rayographs, like his earlier clichés-verre, show light at work. In 1931 Man Ray published another album of ten Rayographs, *Electricité*, which proclaimed light as creator.

In the 1920s Man Ray exhibited with the Surrealists, had several one-man exhibitions of his paintings and Rayographs in Paris, and made four avant-garde films. Around 1929 another accidental darkroom discovery, this time with his assistant Lee Miller, resulted in the solarization effect, which he successfully used on many of his subsequent photographs. In the 1930s he continued to produce fashion photographs for *Vogue*, contributed to *Minotaure*, created and exhibited his Rayographs, and figured in the major international Surrealist exhibitions (London and New York, 1936; Brussels, 1937; Paris, 1938). Man Ray left German-occupied France in 1940 and returned to the United States, settling in Hollywood. The 1940s were for him an intense period of painting—an effort to replace, in a way, what he had left behind in France. In 1941 Man Ray again tried his hand at cliché-verre.

By 1951, when he again became an "American in Paris," Man Ray no longer practiced commercial photography, but continued his facile inventiveness in other media until his death.

106
The Eggbeater
1917 (1923)
Gelatin-silver print
Signed, dated, and annotated in pencil: lower right, *Man Ray/ 1923/ I/II*; lower left, *cliché verre*; on verso, upper center, *Man Ray 1923/ (cliché-verre)/ 2 epreuves*
39.6 x 27.3 cm (15⅝ x 10¾ in.)
Metropolitan Museum of Art, New York (John B. Turner Fund)

In Arturo Schwarz's book *Man Ray*, this print is titled *The Eggbeater*, while in other sources, authors refrain from titling it other than "cliché-verre." This cliché-verre has appeared in various publications (see Bib. V Man Ray) with the date "17" handwritten on the recto. It is curious, then, that this impression is inscribed with the date: *1923/ I/II*. One logical explanation is that Man Ray executed the plate and made three impressions of it in 1917 which he signed, dated, and numbered; and in 1923, he printed two more impressions (of which this is one) and signed, dated, and numbered them accordingly. The date, then, refers to the year the print was made, and not to the date the matrix was executed. Man Ray, in proper Dada fashion, would probably have been delighted by the curatorial confusion created by the existence of several impressions of the same print bearing different dates and edition numbers. This problem is further complicated by the fact that, according to the exhibition catalogue prepared by the Alexander Iolas Gallery (see Bib. V Man Ray/New York), three more impressions of this print were made in 1967. Since the Metropolitan Museum of Art acquired this print from the artist in 1967, it may be an example of the 1967 edition. However, as the author has not been able to compare a vintage impression with a 1967 one, no definitive conclusions can be drawn here. A 1967 impression would also indicate that the plate existed at least 50 years after it was initially executed. However, further efforts to prove the plate's present existence have been inconclusive.

The eggbeater, to which this print relates, was the subject of Man Ray's first ready-made *Man* (1918), documented in a photograph made that same year. (See Bib. V Man Ray/Schwarz, pp. 158, 233-234, ill. p. 149.) By

153

titling the utensil, Man Ray succeeded in anthropomorphizing it; and the object's function, beating eggs (a female symbol), suggested the gender as well. In addition, the title, being the artist's first name, also implied that the piece was a self-portrait.

It is odd that the ready-made and the cliché-verre do not date from the same year. If the 1917 execution date for this cliché-verre is correct, then Man Ray executed this precisely drawn, linear print of an eggbeater (with other utilitarian-looking utensils behind) one year before he had the idea of making the actual object itself an anthropomorphic work of art. Thus, his earliest explorations of his Dada fascination with small domestic objects/machines occurred first in cliché-verre.

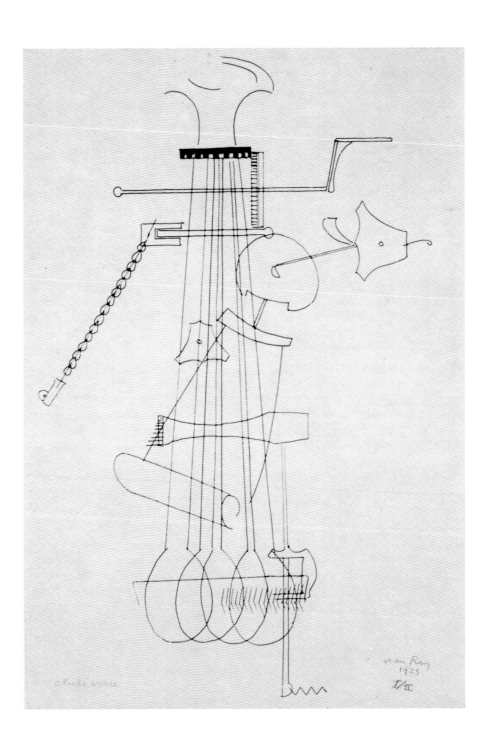

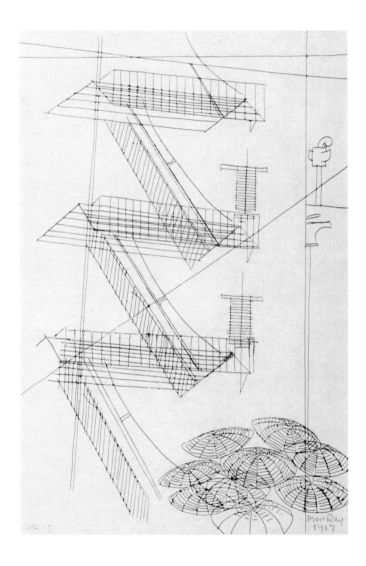

107
Umbrellas
1917
Gelatin-silver print
Signed and dated in pencil: lower right, *Man Ray / 1917*; lower left,
MR 17
17.5 x 12.4 cm (6⅞ x 4⅞ in.)
Collection Arnold H. Crane, Chicago

To date, this impression of *Umbrellas* is the only one
known to the authors. The regularity and linearity of
the drawing style, in this print more than in other
clichés-verre by Man Ray, recalls his part-time employ-
ment as an architectural and mechanical draftsman for
a firm that published engineering books. Also, the sub-
ject, composed of fire-escape stairs and a cluster of um-
brellas resembling a cobweb at the lower right, reveals
his fascination with the arresting juxtaposition of
mechanical constructions and objects.

The random arrangement of diagonal, horizontal (at
top), and vertical (at left) lines superimposed on the
drawing of the stairs is a puzzling contrast to the neatly
drawn overall composition. Perhaps the lines were
meant to reinforce compositional axes. Thus, the
vaguely representational image converts into a pattern
of loosely connecting diagonal and vertical cross-
hatched shapes which play off the tightly grouped, seg-
mented discs. Linear arrangements with discs appeared
in Man Ray's aerograph paintings of 1917 such as *The
Rope-Dancer Accompanies Herself with Her Shadows*
(see Bib. V Man Ray/Penrose, p. 48, fig. 20).

108
Standing Woman, Seen from Behind
1917
Gelatin-silver print
Signed, dated, and numbered in pencil: lower right, *Man Ray 1917*;
lower left, *2/1*
17.2 x 12.4 cm (6¾ x 4⅞ in.)
Collection Arnold H. Crane, Chicago

It is strange that Man Ray, an extremely inventive artist, never exploited tonal effects in clichés-verre, but, instead, sustained a linear style throughout his oeuvre. Like 19th-century Barbizon school artists, he scratched on a darkened photographic plate to make his matrix, but unlike the former, Man Ray did not coat his plates with a substance; he merely worked on exposed plates.

What is unusual about this cliché-verre is that the woman's hair must have been completely scraped on the matrix to print in a continuous tone of black. In Man Ray's other clichés-verre, he indicated tone by linear crosshatching alone.

This is the only example of this cliché-verre print known to the authors. The subject of a standing woman is also relatively unusual in Man Ray's work, being a rather conventional figure study more typical of Matisse's drawings than Man Ray's. While his clichés-verre, like this one, are obviously hand-drawn, many of his abstract paintings of 1917 were created by airbrushing, a more mechanical, and less obviously manual means.

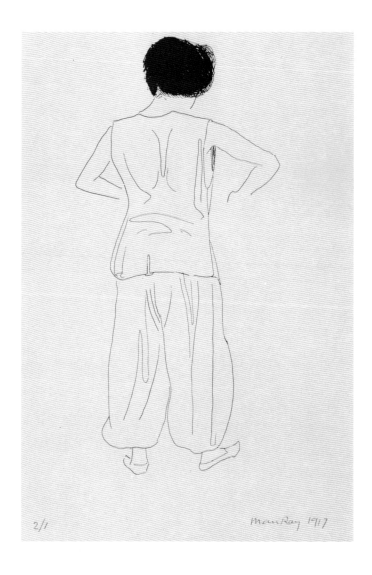

109
Head of a Woman, No. 1
1922
Gelatin-silver print
Signed and dated in pencil, lower left: *Man Ray 1922/No 1*
25.1 x 20.3 cm (9⅞ x 8 in.)
Collection Arnold H. Crane, Chicago

This cliché-verre is most probably a portrait of Kiki of
Montparnasse, an extraordinary-looking woman with
black hair, a pointed nose, large eyes, and a cupid
mouth, who was renowned as an artists' model in Paris,
a vivacious cabaret singer, and a sensuous, free spirit.
Man Ray met her soon after his arrival in Paris, and for
six years they had a rather tempestuous relationship.
Kiki was a model for Man Ray's photographs, drawings,
and even a star in his short film *L'Etoile de mer* (1928).
This print presents a classic aquiline profile, while an-
other cliché-verre, *Portrait of Kiki* (1922, see Bib. V Man
Ray/Schwarz, p. 87, fig. 67), is a more seductive image of
Kiki asleep. The fact that this print is inscribed *No 1*
suggests that it was the first of two cliché-verre portraits
of Kiki. This print appears to be unique.

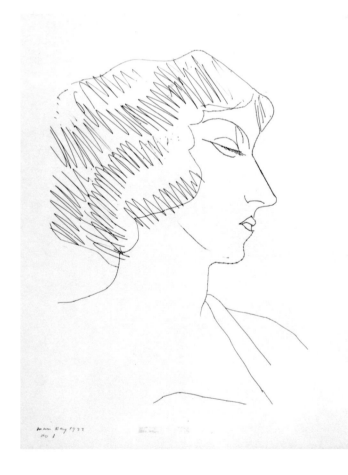

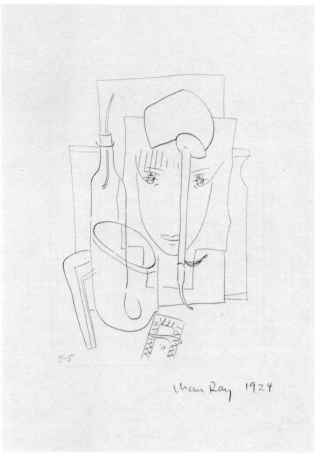

110
Still Life
1924
Gelatin-silver print
Signed, dated, and annotated in pencil: lower right, *Man Ray
1924*; lower left, *4-5*; on verso, center, *Nature Morte*; lower right,
cliché-verre
Image: 17.8 x 12.7 cm (7 x 5 in.)
Sheet: 27 x 20.6 cm (10⅝ x 8⅛ in.)
Collection Arnold H. Crane, Chicago

Although this impression is dated 1924, there are other
impressions dated 1922 (see Bib. V Man Ray/New York,
p. 47). The inspiration for the woman's face with three
pairs of eyes in this still life was Man Ray's 1922 pho-
tographic portrait of the Marquise Casati. During the
long exposure she had moved her head slightly, and
when Man Ray developed the negatives he noticed that
they were all blurred. He considered the camera picture
with the three pairs of eyes a failure, but the Marquise
herself was enchanted with the Surrealist result and
said Man Ray had portrayed her soul (see Bib. V Man
Ray/Schwarz, pp. 283-284). It is interesting that Man
Ray considered the accidental effect in the photograph
a failure, but was sufficiently intrigued with the eerie
sets of eyes to repeat them intentionally in this cliché-
verre composition.

157

Shahrokh Rezvani (Hobbeheydar)
Persian; b. Teheran, 1943

Rezvani first arrived in the United States in 1964. From 1965 to 1972 he attended Ball State University in Muncie, Indiana, studying art education, printmaking, and drawing. After receiving his Master of Arts degree, he continued his studies in printmaking at Wayne State University, Detroit, where he earned a Master of Fine Arts degree in 1974. Rezvani's interest in experimenting with different printmaking techniques, which in turn allowed him to create new shapes, textures, and colors, had prompted his enrollment at Wayne State University. He knew the printmaking department there offered a course on cliché-verre, and he presumed it was some experimental process. As Rezvani had hoped, the cliché-verre course with Aris Koutroulis in 1973 introduced him to a medium with potential for new types of imagery.

In 1975-76 Rezvani returned briefly to Iran to set up lithography and intaglio workshop facilities for the College of Decorative Arts in Teheran's Farabi University. In 1977 Rezvani went to Scottsdale, Arizona, to establish the Rezvani Workshop of Intaglio and Cliché-Verre. In addition to doing his own work, Rezvani is the printer of Fritz Scholder's monotypes and cliché-verre prints (cat. nos. 119, 120).

Rezvani's clichés-verre, which exhibit an angular mathematical clarity, differ from his abstract work in intaglio, hand-made paper collage, and monotype, which either feature organic-looking forms or contrast surface patterns and textures. In his clichés-verre, Rezvani attempts to create effects not possible in his inked prints by exploring the appearance of textures and the illusion of geometric objects floating in an eerie, airless space. Although Rezvani has used gum bichromate and Van Dyke processes (see Glossary), he usually prints his cliché-verre matrices in black-and-white or in cyanotype.

Rezvani's clichés-verre were included in "20 Arizona Artists" (1978-80), a traveling exhibition organized by the Phoenix Art Museum, and in a one-man exhibition at the Scottsdale Center for the Arts in April 1979.

Congruous was made from a frosted mylar matrix (i.e., a translucent sheet of polyester film) in which Rezvani sprayed and rolled paint. The shapes of certain areas were controlled by masking. By varying the gradations of paint, squeezing the pigment between the smooth surfaces of nonabsorbent mylar, and dropping beads of water on the painted surface, Rezvani achieved subtly patterned surfaces which, when printed on light-sensitive paper, resulted in an extraordinary range of textures.

The image looks like a close-up view of the angular sides of adjoining polygons. However, the perception of this image is ambiguous in two ways. On one level, the image appears to be a scientific camera-made image of a magnified crystallized substance. On another, the image looks like it could not possibly be derived from reality. The crisp shapes, tones, and spatial illusion could only have been the product of an artist's imagination. Rezvani's technical finesse was in keeping with the image's exactitude, but both these qualities belie the print's nonrepresentational origin.

It is ironic that an artist who came from a printmaking background could understand and exploit the photographic qualities of the cliché-verre medium so successfully and maintain that he uses cliché-verre as a printmaking technique only.

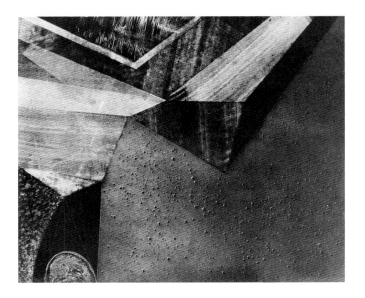

111
Congruous
November 1978
Gelatin-silver print
Signed, dated, titled, and numbered in pencil: lower right, signature in Persian; lower center, *Nov 1978*; lower left, *Congruous*; to left of lower right, *1/50*
40.6 x 50.8 cm (16 x 20 in.)
Edition: 50
Courtesy of the artist

Sally Winston Robinson
American; b. Detroit. 1924

Before she began graduate study in printmaking at Detroit's Wayne State University in 1973, Sally Robinson's career as an artist had already been nurtured by a number of earlier experiences. In the 1940s Robinson attended Bennington College in Vermont, studying with Karl Knaths and Paul Feeley, and later pursued painting studies in New York with Leon Kroll and Hans Hofmann. This first-hand exposure to 20th-century art from some of the artists who shaped the course of Abstract and Abstract Expressionist painting in America was supplemented by the artistic inspiration, understanding, and energy she derived from the Futurist and Cobra art collected by her parents. Her sensitivity to painterly color, gesture, and movement derives from this formative phase in her artistic career.

Robinson's introduction to cliché-verre occurred in 1973-74 at Wayne State University. In 1974 she received a Master of Fine Arts in Printmaking degree with a specialization in cliché-verre, under the guidance of Aris Koutroulis. Since 1974 Robinson's production of clichés-verre has been prolific. Countless hours in the darkroom have resulted in prints from the veil technique and from collaged matrices. Robinson works both in color, primarily in the dye-transfer process, and in black-and-white, exploring the countless permutations of light penetrating matrices of various opacities. She has also adapted her darkroom techniques to painting. In addition to her cliché-verre work, she has begun painting with the developing chemicals directly on the light-sensitive paper. By using spatter techniques and gesture, which recall Abstract Expressionist forms, and then brushing Kodak dyes to color the image, Robinson has created a medium tailor-made to her painterly needs.

Robinson's preference for the cliché-verre medium is simple. She likes to create images of photochemical reactions, and she likes the quality of lights and darks possible only with cliché-verre. Although its photographic qualities are what attract her, Robinson is convinced that cliché-verre is a printmaking medium.

Robinson has exhibited her clichés-verre throughout the Detroit area as well as at the Rina Gallery, New York (1976), and at the Williams College Museum, Williamstown, Massachusetts (1976).

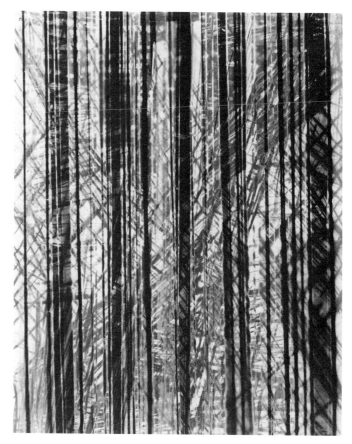

112
Within the Bridge
1977
Gelatin-silver print
Signed in pencil, lower right: *SWR*
50.2 x 40.5 cm (19¾ x 15¹⁵⁄₁₆ in.)
Unique
Detroit Institute of Arts (Elliott T. Slocum Fund)

This dynamic, linear image is the product of a complex webbing made from the superimposition of drawn and scored matrices. The dark vertical bands reinforce the picture plane, while the criss-cross of lighter-gray diagonals seems to recede into space. Robinson's grid-like image is more than a decorative plaid, for it attempts to explore the quality of light, the illusion of space and movement. Robinson's title and the image itself suggest an architectonic structure; at the same time the print possesses a sense of movement and energy that recalls Futurism or even, perhaps, a Joseph Stella *Brooklyn Bridge*. The occasional blurring effect strengthens the illusion of motion.

This print, like all of Robinson's clichés-verre, is unique. Since the artist keeps her matrices, she retains the option of editioning her work. Nevertheless, Robinson prefers to make new images rather than print multiples of ones she has already made.

159

Kent Rush
American; b. Hayward, California, 1948

Rush is primarily a graphic artist whose prints and drawings generally exhibit an aura of understated elegance. He obtained his Bachelor of Fine Arts degree from California College of Arts and Crafts, Oakland, in 1970. From 1973 to 1975 Rush was enrolled in the Master of Arts program in lithography at the University of New Mexico. While studying in Albuquerque he was an apprentice technical assistant to master printers at the Tamarind Institute of Lithography. From 1976 to 1979 Rush taught lithography, drawing, and general printmaking at the San Antonio Art Institute, Texas. In May 1979 Rush received his Master of Fine Arts degree in lithography from the University of Texas at Austin. In Summer 1979, after teaching a course in lithography and intaglio at California College of Arts and Crafts, Rush moved to Pasadena, California, to establish his own workshop. His graphic works have been included in numerous exhibitions throughout California, New Mexico, Texas, and the Midwest from 1970 to the present.

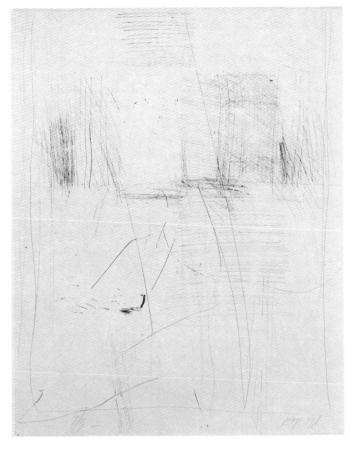

113
Untitled
1978
Gelatin-silver print
Signed, dated, and numbered in pencil: lower right, *KTR 78*; lower left, *9/9*
25.4 x 20.3 cm (10 x 8 in.)
Edition: 9
Private Collection

Rush's cliché-verre matrix was made in the classic method used by 19th-century artists, but with contemporary materials and tools. After spraying a piece of glass with red paint, Rush scratched the surface with nails, pins, needles, sandpaper, and a wire brush. He then printed an edition on a now outdated opal-type Kodak photographic paper.

Like most 19th-century clichés-verre, Rush's print is a linear composition. His concern was with the quiet beauty of the arrangement of delicate thin lines. The simplicity of the basic cliché-verre printmaking process was in perfect accord with the austere purity of Rush's refined image.

Jack Sal
American; b. Waterbury, Connecticut, 1954

A first look at Jack Sal's Minimalist clichés-verre would not immediately provide the viewer with a clue that Sal was trained as a photographer. His clichés-verre are a contradiction—photographs that do not look like photographs—and yet, they are technically very close to the experimental work on photosensitive paper by the man often credited with the invention of photography, William Henry Fox Talbot.

In 1976 Sal earned a degree in photography from the Philadelphia College of Art, where one of his teachers was Lois Johnson (see cat. nos. 97, 98). He received his Master of Fine Arts degree in photography and painting from the School of the Art Institute of Chicago in 1978. Sal's clichés-verre evolved out of his quest for more direct photographic representation. Wanting to unite the photochemical and optical processes, he proceeded from photographing paper objects (like corrugated cardboard) onto film and paper negatives, to using his drawings as the negatives themselves. Sal's drawings on such translucent papers as washi, rice, and wax paper act as "negatives" or "matrices" to be printed by the action of light onto photographic paper known as "printing-out paper." In the tradition of 19th-century "sun pictures," Sal places his drawings on top of light-sensitive paper in a frame and exposes it in direct sunlight to form an image from each matrix without needing a chemical developer. Exposure times vary from a period of days, weeks, or months, with the usual time being three weeks before the image "burns" through the matrix layer to the light-sensitive paper.

Since 1976 Sal has produced over 1000 different prints in this technique. Each one is unique, although repeatable, since the matrix is a drawing retained by the artist.

Sal's clichés-verre have been exhibited in the cities where he has studied, worked, and taught. Since 1978 Sal has taught painting and drawing at the Education Center for the Arts in New Haven, Connecticut, and he has been an Instructor of Photography at Fairfield University and the University of Bridgeport (Connecticut). He served as Visiting Chairman of the Photography Department for the 1979 summer session of the Lake Placid School of Art (New York), where in previous summers he has conducted workshops on non-camera photography.

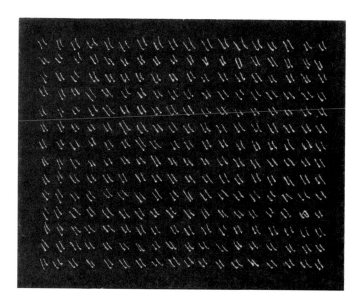

114
Untitled
1977
Printing-out paper print
Signed in pencil on verso, lower right: *Jack Sal*
10.2 x 12.7 cm (4 x 5 in.)
Unique
Courtesy of the artist

115
Untitled
1977
Printing-out paper print
Signed in pencil on verso, lower left: *Jack Sal*
10.2 x 12.7 cm (4 x 5 in.)
Unique
Courtesy of the artist

161

Although Sal cites the linear grid art of Agnes Martin as a source of inspiration for his work, his symmetrical, rhythmic drawings do not exhibit the austere hard-edged, grid-like geometry of Martin's paintings and drawings. Sal's "grids" differ in appearance, even though his works are in the Minimalist spirit of Martin's art. Another, more autobiographical source for Sal's cliché-verre imagery is his love of calligraphy, which dates from his boyhood reading of Hebrew texts. Like Hebraic, Japanese, or Chinese characters, each cross-mark or pair of short strokes is carefully penned and evenly spaced, one after the other, in measured rows. The contemplative simplicity of these works depends on the visual beauty of the repetition of delicate strokes and the even spaces between them rather than on allusion to verbal meaning. The 4-by-5-inch format of these clichés-verre is an intimate size that invites a comparison of each cliché-verre to a page from a small book. The viewer can "read" each print like a page of text. While the brown tone of the exposed printing-out paper is inherently photographic and recalls the sepia tones of 19th-century photographs and clichés-verre, it also looks like a drawing with white ink on a rich, dark-brown colored paper. Sal's successful merger of drawing and photography has resulted in works of remarkable visual poetry.

116
Untitled
1978-79
Gelatin-silver print
Signed in pencil on verso, lower right: *Jack Sal*
28 x 35.5 cm (11 x 14 in.)
Unique
Courtesy of the artist

117
Untitled
1978-79
Gelatin-silver print
Signed in pencil on verso, lower right: *Jack Sal*
28 x 35.5 cm (11 x 14 in.)
Unique
Courtesy of the artist

Like the two smaller works by Sal, the basic components of these two clichés-verre rely on calligraphic pattern, repetition, and symmetry. Even with this restricted visual vocabulary, where the only variables are the unit, repeated in horizontal and vertical rows, and the size of the sheet, Sal achieves compositions of compelling interest.

This format presents the viewer with larger "pages" to be "read." By choosing to contact-print the drawings for these works on a gelatin-silver photographic paper, Sal produced two cliché-verre prints that reverse the notion of a standard black-on-white page. Instead, Sal presents white marks on solid black, like chalk on a blackboard, or like light against the backdrop of night.

118
Untitled
1978
Printing-out paper print
Signed in pencil on verso, lower right: *Jack Sal*
Sheet: 50.5 x 60.3 cm (19⅞ x 23¾ in.) from drawn matrix 33.6 x 45.3 cm (13¼ x 17⅞ in.)
Unique
Courtesy of the artist

Sal prefers to draw on Oriental papers with beautiful fibrous textures. This cliché-verre demonstrates that for Sal the translucency of the paper, as well as the drawing, is an important factor in the image. This translucency brings a new tonal quality to the final print—a muted, mottled light-brown color. In addition to the tonal and textural quality derived from the sheet which bears the grid drawing of tiny flicks, Sal introduced the element of placement in arranging the final composition. Instead of being a "negative" twin version of the drawn matrix, this print includes the matrix as only a part (albeit a key part) of the final image. The artist placed the drawing off-center on the larger piece of photographic printing-out paper. This asymmetrical placement of a symmetrical matrix adds to the complexity of the work.

163

Fritz Scholder
American; b. Breckenridge, Minnesota, 1937

In the past 20 years Scholder's reputation as an artist has shifted from that of a talented Western painter to an important American painter and printmaker. Although the subjects for much of his work are derived and inspired from the environment and people of the Southwest, where he resides, Scholder is no longer a regional artist.

Scholder's first exposure to modern art was through his Pierre, South Dakota, high school teacher, the Sioux painter Oscar Howe. Then, in 1957-58, after moving to California, Scholder studied painting and art history at Sacramento City College with Wayne Thiebaud. Scholder's paintings of this period reflect his artistic training in the California brand of Abstract Expressionism—a style developed by such painters as Richard Diebenkorn, Nathan Oliveira, and Thiebaud. In 1958 he had his first one-man show at the Sacramento City College Art Gallery, and the following year at the E. B. Crocker Art Gallery in Sacramento.

In 1961 Scholder was awarded a Rockefeller Foundation scholarship to participate in the Southwest Indian Art Project. It was the first time Scholder consciously acknowledged his heritage as an Indian in relation to his studies and his pursuit of art. In 1962 he moved to Tucson to join the Master of Fine Arts program at the University of Arizona. After receiving his degree in 1964 he went to Santa Fe, New Mexico, to teach advanced painting and art history at the newly established Institute of American Indian Arts. This exposure to Indian traditions and artifacts strengthened his awareness of his own heritage. However, it was not until 1967 that Scholder painted his first Indian subject. Scholder was one of the first artists to depict the dilemma of the contemporary American Indian caught between the desire to perpetuate traditional customs and the need to abandon them in order to be accepted by contemporary American society. Scholder's work broke away from the stereotype of Indian art.

Scholder taught in Santa Fe until 1969. Throughout the 1960s he exhibited his paintings in various shows in California, Arizona, New Mexico, and Texas, where they usually received major prizes. In 1970 he had his first one-man exhibition in New York. Later that same year Scholder was invited by the Tamarind Institute to do their first major lithography project in their new Albuquerque location. Since the 1971 *Indians Forever* suite, Scholder has created well over 100 lithographs. (An excellent account of his lithographic oeuvre can be found in Clinton Adam's 1975 monograph, see Bib. V Scholder/Adams.) In 1972 the National Collection of Fine Arts in Washington, D.C. organized a two-man exhibition with the works of Scholder and his former student T. C. Cannon. This exhibition later toured major cities of Europe.

During the 1970s, Scholder continued to exhibit his work extensively, and expanded to other subjects: women, cowboys, cats, dogs, butterflies. However, he also continues to explore the theme of the American Indian, and it is these paintings and prints for which he is best-known. In early 1978 Scholder began to try his hand at etching and monotype. The ease and painterly quality of monotype appealed to him greatly, and it is in this printmaking technique that he has been most prolific. Since December 1978, when Scholder began to produce his monotypes at the Rezvani Workshop (see cat. no. 111), he has made more than 220 monotypes. In January 1979 Shahrokh Rezvani, who printed Scholder's monotypes, suggested that he try doing some images in cliché-verre. Scholder made four clichés-verre which, like his monotypes, reflect his loose, free style of drawing with paint on a smooth surface.

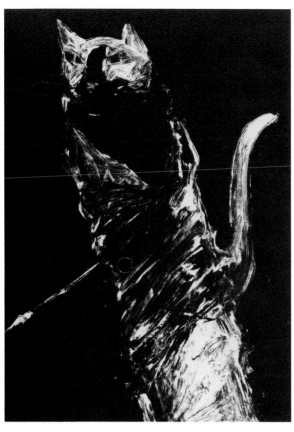

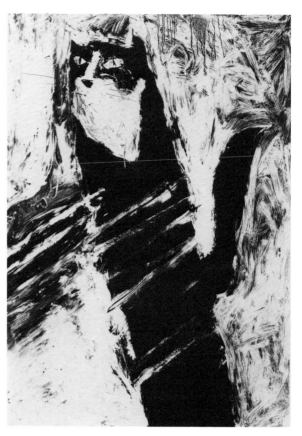

119
Cat Ghost
1979
Cyanotype
Signed, titled, and numbered in pencil: lower right, *Scholder*;
lower left, *Cat Ghost*; lower center, 6•20
Scholder chop mark (buffalo head), lower right; Rezvani Workshop
chop mark (rw), lower left
Image: 47.5 x 34.2 cm (18¾ x 13½ in.)
Sheet: 75 x 55.8 cm (29½ x 22 in.)
Edition: 20
Courtesy of the artist

120
Cat Person
1979
Cyanotype
Signed, titled, and numbered in pencil: lower right, *Scholder*;
lower left, *Cat Person*; lower center, 5•20
Scholder chop mark (buffalo head), lower right; Rezvani Workshop
chop mark (rw), lower left
Image: 47.5 x 34.2 cm (18¾ x 13½ in.)
Sheet: 75 x 55.8 cm (29½ x 22 in.)
Edition: 20
Courtesy of the artist

Cat Ghost and *Cat Person* were the second and third clichés-verre Scholder made in early 1979. The figure of the cat in each print relates to a painting, *Cat Person #1* (oil on canvas, 20 x 16 in.), which Scholder did at about the same time. *Cat Ghost*, where the cat is literally a white apparition against a pure blue background, was created first. The matrix for this print was easier for Scholder to conceive and execute, since he freely drew an image of a cat on a clear plastic sheet (as he would have done on paper). The image simply converted to a "negative" image when printed. Scholder decided to reinterpret the cat figure, so he created a new matrix by brushing a negative image of the cat on a sheet of clear plastic (i.e., he painted all the areas around the cat) which, when printed, revealed a cat articulated in a blue color against a white background *(Cat Person)*.

These two prints, as all of Scholder's clichés-verre, were printed in cyanotype. Cyanotype creates a tint of blue—vivid, intense, and fresh—that is unlike any other. It has a crisp, unfaded appearance.

Scholder is one of the few major artists in contemporary American painting who has recognized the potential of the cliché-verre medium as a means of making multiples that capture the spontaneity of the act of painting.

165

Henry Holmes Smith
American; b. Bloomington, Illinois, 1909

Henry Holmes Smith has been exploring the nonrepresentational photographic image and experimenting with various light studies and processes of dye-transfer color printing since the 1930s. He studied art and art education at Illinois State University, Normal from 1927 to 1932, then transferred to Ohio State University, where he got his degree in 1933. By age 24 Smith had encountered two major forces that were to affect the course of his career: the photographs of Francis Bruguière (cat. nos. 86, 87) and the writings of Moholy-Nagy. Fortunately for Smith, he was working in Chicago as a darkroom assistant in the portrait studio of Marshall Field's department store when Moholy-Nagy arrived in that city in 1937 to establish the New Bauhaus, American School of Design (later Institute of Design). Smith was recruited by Moholy-Nagy to help set up the photography darkroom for the course that Smith taught with Gyorgy Kepes (see cat. nos. 100, 101). From 1938 to 1946 (except for the time he was in service during the war), Smith conducted his own light experiments, and for a short time he wrote articles for and was associate editor of *Minicam Photography*. After the war, Smith investigated printing his abstract images in color with dye-transfer. At this point, the artist's nonobjective images and his work in color were still in the nascent stages.

In 1947 Smith was appointed to the newly created position of instructor in photography in the Department of Fine Arts at Bloomington's Indiana University. Smith originated the university's first history of photography course and devised a teaching method that initiated students into the potential of light as a medium. Through various modulation exercises, students learned to manipulate light by refraction, reflection, and projection. Smith was on the faculty of Indiana University for almost 30 years, and his vital role in this position established him as one of the foremost photographic educators in the profession. Indeed, in the early 1960s, he was one of the founders of the Society for Photographic Education.

It was shortly after Smith arrived in Bloomington that he made a discovery that triggered his 30-year exploration of what he termed "refraction drawings" (see "Cliché-verre in the 20th Century," p. 118).

In 1977 Smith gave the voluminous body of his work and writings to the Indiana University Art Museum to establish the Henry Holmes Smith Archive, where one can study Smith's prolific contribution to cameraless photography.

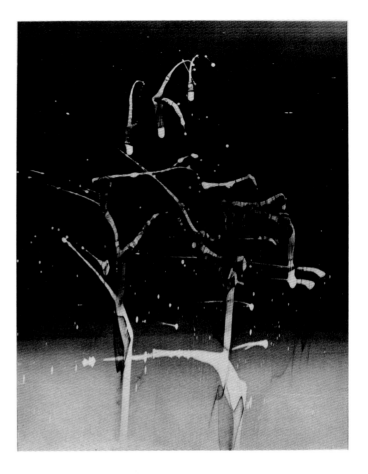

121
Battles and Games
1949
Gelatin-silver print
Signed, dated, titled, and annotated in pencil on mount: lower right, *Henry Holmes Smith*; lower left, *First image of syrup drawing method/ Battles and Games, 1949*
34.9 x 26.6 cm (13¾ x 10½ in.)
Unique
Indiana University Art Museum, Bloomington, Henry Holmes Smith Archive

Along with *Giant* (the original black-and-white image which was later reprinted in color as *Golden Giant*, cat. no. 122), this print ranks as the most important of Smith's earliest refraction drawings. Both *Battles and Games* and *Giant* were seminal in Smith's recognition of the visual potential for abstraction and metaphor in photography. His recollection of the birth of this image is quite distinct:

I remember one time going into the darkroom and working with these various things and then, on an impulse, just taking some syrup on the end of my finger and flicking it at the glass and then printing it. That's when I got my picture "Battles and Games" which

was a reference to the Trojan War. I'd been reading about the ancient Greeks and their habits of combat (see Bib. V Smith/Hill, p. 146).

After splattering the plate, Smith tilted the glass so gravity would make the drips stream down the smooth surface.

To print refraction drawings like this one, Smith placed the matrix at some distance from the light source, and about four inches or more from the paper, so that the light could refract and cast shadows on the sensitized surface during exposure. The image was developed like any other black-and-white photograph. The result was a print which Smith could leave as is, copy onto a negative to make a positive, or print on Matrix Film to print in dye-transfer. Smith usually made one print from the matrix, so each of his refraction drawings, like this one, is unique. He would then wipe the glass clean to make it ready to receive another syrupy design.

This image is the vintage refraction drawing from 1949. However, in the 1960s and early 1970s, Smith used this image to make a variety of dye-transfer prints in different color combinations.

In one of the most direct uses of transparency and light, Smith's random splatter pattern of clear drops on the matrix surface deflected light to create this print. In one way, *Battles and Games* is an extension of the tradition of Surrealism which encouraged the use of automatism, the intuitive gesture, and the accidental element in the making of a work of art. Smith has also spoken of his interest in Zen with its emphasis on the significance of chance. At the same time, *Battles and Games* introduced a novel form of abstraction to photography. However, the full impact of the importance of this image to the evolution of abstraction in photography is yet to be realized.

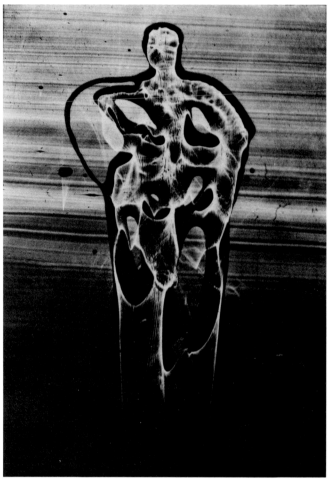

122
Golden Giant
1949 (1975)
Dye-transfer print from refraction drawing
Signed, dated, and titled in black ink on verso: lower right, *henry holmes smith 1975*; lower left, *giant 1949-1975*; stamp in blue, lower left, *APR. 4 1975*
Image: 22.3 x 15.9 cm (8¾ x 6¼ in.)
Sheet: 25.4 x 20.3 cm (10 x 8 in.)
Indiana University Art Museum, Bloomington, Henry Holmes Smith Archive

This is the most powerful and monumental of Smith's figurative images in the refraction technique. The figure's rounded head and body, riddled with gaping voids, recalls the smoothly contoured sculpture of Henry Moore; yet, this art historical allusion was not intentional on Smith's part.

Golden Giant is an example of black-and-white refraction drawing that was successfully reprinted in 1975 in dye-transfer. The golden honey color enhances the surface of the image by recreating the sheen and glistening quality of light, which seems to emanate from within the image.

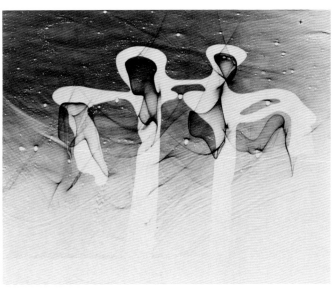

123
Angels
1952
Gelatin-silver print
Signed, dated, and titled in pencil on verso: lower right, *henry holmes smith*; lower left, *Angels 1952*; top (upside down), *1951-1952 Henry Holmes Smith*
17.2 x 21.6 cm (6¾ x 8½ in.)
Indiana University Art Museum, Bloomington, Henry Holmes Smith Archive

Smith's simple manipulation of a viscous fluid through which light passes has here resulted in shapes that evoke incorporeal, celestial beings. The angels, cloaked in white, hover against the translucent gray tones of an elusive space.

Traditionally, in the history of Western painting, light has symbolized divine presence; the divine apparitions in this print were literally illuminated with the aid of light.

Keith Smith
American; b. Tipton, Indiana, 1938

Keith Smith first learned about the cliché-verre process in an etching course taught by Vera Berdich (cat. no. 79) at the School of the Art Institute of Chicago in 1964. During that same period Smith was also taking a color photography class, so it seemed like a natural next step for him to combine what he was learning about the two techniques to create color clichés-verre. From 1964 to 1966 Smith produced dozens of clichés-verre, and, in 1968, Photography Curator Hugh Edwards selected a number of these for display in Smith's first one-man exhibition at the Art Institute of Chicago. In these prints, Smith fitted camera-made images into a drawn framework and then covered the entire image with loose hand-marks in a style vaguely reminiscent of what Robert Rauschenberg was doing in lithography at that same time. The images were printed like color camera-made photographs.

After receiving a degree in 1967 from the School of the Art Institute of Chicago, Smith went on to earn his Master of Science degree in Photography in 1968 from the Institute of Design, Illinois Institute of Technology. For the next decade, Smith did not make any clichés-verre. However, he was extremely active in other media: photography, generative systems (i.e., photocopy art), etching, photo-etching, silkscreen, drawing, and collage. In 1972 Smith was awarded a Guggenheim grant in photography. During this period Smith also taught photography (and occasionally printmaking courses) at the University of California at Los Angeles (1970), the School of the Art Institute of Chicago (1971-75), and the Visual Studies Workshop in Rochester, New York, where he has been a full-time faculty member since 1975. In 1978 Smith was awarded a National Endowment for the Arts grant to pursue his own work in photographic processes.

It was in 1978 also that Smith revived his interest in cliché-verre, but this time his images were totally drawn, figurative, and larger in format. Although most of the work Smith has created to date has not been in cliché-verre, his renewed activity in the medium attests to his preference for combining drawing with photographic surfaces.

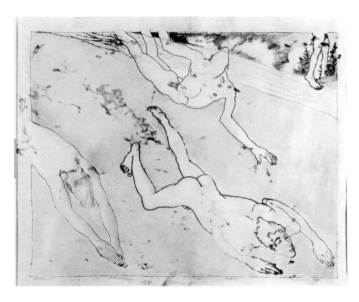

124
The Swimmers
March 12, 1979
Print on photo-mural paper, hand-colored with photo oils and
retouching colors
Signed, dated, titled, and annotated in pencil: to right of lower
center, *Ke•th*; lower right, *12 March 1979*; lower left, *The Swim-
mers*; to right of lower left, *cliché-verre*
Image: 62.9 x 80.6 cm (24¾ x 31⅞ in.)
Sheet: 71.8 x 89.8 cm (28¼ x 35⅜ in.)
Unique
Courtesy of the artist

To make clichés-verre like *The Swimmers,* Smith used
a variation on the monotype process. After rolling ink
on a 29-by-41-inch piece of glass, over which he laid a
sheet of paper, he then drew the image with a thick pen-
cil on the paper. Wherever Smith made a line, the ink
was picked up on the reverse of the sheet, thus exposing
the glass plate. When Smith finished the drawing, he
lifted off the sheet of paper, which had become a two-
sided work: on one side a drawing, and on the other, a
monoprint. However, it was the glass plate that was now
ready to use as negative for contact-printing (drawing
face down) on a piece of photo-mural paper. This pro-
cess produced a print in reverse of his original drawing
with the difference being that the printed lines, unlike
the crisp pencil lines, resemble fuzzy black yarn—a
quality of line impossible to achieve any other way. The
artist then colored the print by hand. The only shading
is a slight mottling effect caused by the paper randomly
picking up ink and thereby exposing the glass in areas
adjacent to the drawn lines.

Like that of the 19th-century Barbizon school artists,
Smith's matrix is a drawing on a glass plate. Yet Smith's
method is so easy, direct, and quick (making it possible
to complete the entire process in a day, as suggested by
the inscribed date), it is amazing that this process did not
occur to any of the 19th-century artists. It would have

been such an uncomplicated way for them to make
multiples of their drawings. Smith's cliché-verre tech-
nique also has an advantage over the drawing-on-mylar
method, as used by Nawara (cat. no. 104), because it does
away with the intermediate step of making a negative,
which is necessary when the artist draws on a clear plas-
tic sheet if a positive print is desired. Nineteenth-century
artists, however, preferred wiry, etched-like lines, and
Nawara, who draws with crisp hard lines, would prob-
ably consider the thick, soft line produced by Smith's
method a drawback.

The curvilinear rhythm of Smith's outline drawing
of three male nudes floating in the pale turquoise aque-
ous space reflects an exuberance similar to that found
in Henri Matisse's paintings of dance. There is a delight-
ful sense of movement generated from the diver at the
upper left to the swimmer at the lower right, who seems
about to swim out of the picture frame. The subject of
this print is similar to that of a much smaller photo-
etching titled *Two Swimmers,* that Smith did in May
1977.

The Swimmers, like all of Smith's clichés-verre made
with the monotype process, is unique. Smith is not in-
terested in editioning his clichés-verre; instead, he pre-
fers to keep each one as a "monoprint." As soon as the
cliché-verre print is made, the glass plate is wiped clean
and ready for re-use.

Frederick Sommer
American; b. Angri, Italy, 1905

A review of Sommer's oeuvre reveals a commitment to extraordinary high technical and esthetic standards and a diverse range of subjects. Over a four-decade period Sommer has photographed Arizona desert landscapes, Surrealist-like assemblages of found objects, desiccated remains of animals, soft-focus nudes, automatic "drawings" made of cut-paper; he has made abstract cameraless images from paint-on-cellophane or smoke-on-glass negatives. In addition to his photographs, Sommer also has created musical scores (on the basis of calligraphic design rather than musical notation) and Klee-like linear drawings on black paper.

Before the 1960s Sommer's photographic work was not generally well-known, and his drawings and scores even less so. Although he sporadically exhibited, Sommer was not mentioned in Beaumont Newhall's *History of Photography*. This meant that until recently Sommer's work was appreciated by a relatively small audience of connoisseurs.

As a young man, Sommer lived in Brazil and prepared to be a landscape architect. From 1925 to 1927 he completed his landscape architecture studies at Cornell University, Ithaca, New York, and then returned to Rio de Janeiro to set up practice. His career was interrupted by tuberculosis in 1930, and after a year of convalescing and traveling in Europe, he decided to settle in Tucson, Arizona. At this point, Sommer turned to painting and drawing. He did not concentrate on photography until 1935. In that year he moved to Prescott, Arizona, where he still resides. Later that year he made a trip to New York, where he met Alfred Stieglitz, who instilled in Sommer an enthusiasm for photography as an art medium. His next trip was to California, where he met the master photographer Edward Weston.

In the 1940s Sommer made his first views of unpeopled, cactus-strewn landscapes and other images which showed evidence of the forces of destruction (e.g., assemblages of broken toys, animal skeletons). It was in this period, too, that Sommer became friendly with Max Ernst, who, no doubt, expressed support for Sommer's Surrealist efforts in photography.

Sommer had his first one-man exhibition in 1946 at the Santa Barbara Museum of Art, California. In the early 1950s his work was included in several major photography exhibitions: "Photography at Mid-Century," Los Angeles County Museum of Art, 1950; "Abstraction in Photography," 1951, and "Diogenes with a Camera," 1952, both at New York's Museum of Modern Art; and "Contemporary American Photography," Musée National d'Art Moderne, Paris, 1956. In 1957 Sommer had a one-man exhibition of his photographs, drawings, and paintings at Chicago's Institute of Design, Illinois Institute of Technology, where he taught for a year.

Sommer's first exploration of images from paint-on-cellophane negatives dates from this 1957-58 period. From 1958 to 1961 he made smoke-on-cellophane images and, after 1962, Sommer's main abstract concern was photographs from smoke-on-glass negatives. These cameraless inventions fall into the tradition of abstract photography *and* cliché-verre.

The 1962 publication of the monograph, *Frederick Sommer, 1939-1962 Photographs,* by Aperture Press, and the 1968 one-man exhibition organized by the Philadelphia College of Art succeeded in alerting a greater number of people to the spellbinding sensibility—intellectual and visual—of Sommer's images. Since then, his work has received more critical attention. In May 1979 Sommer was awarded an Honorary Degree from the University of Arizona. Later that year, Sommer was honored with an appointment to Princeton University as Visiting Senior Fellow of Humanities and Visual Arts. In 1980 major one-man exhibitions were organized on each coast of the United States: one at the Delaware Art Museum, Wilmington, and a traveling exhibition initiated by guest curator Leland D. Rice and California State University at Long Beach. Finally at the age of 75, Sommer—the man, his ideas, and his art—has received the esteem he has so long deserved.

125
Paracelsus
1958
Gelatin-silver print
Signed, dated, and titled in pencil on verso of mount: center, *Frederick Sommer;* upper left, *Paracelsus 1958*
34 x 26 cm (13⅜ x 10¼ in.)
Anonymous loan

Sommer regards *Paracelsus* as the best of all his paint-on-cellophane images. Its burnished, sculptural quality suggests the beauty of gleaming armor. Perhaps Sommer chose the title, which is the name of a 16th-century Swiss alchemist, to reinforce the illusion that photographic lights and darks were transformed into a surface of silvery metal.

The negative that was projected onto photographic paper was a fragile sheet of cellophane, approximately 4-by-5 inches. Sommer had to work the pigment carefully into areas of thickness (resulting in opacity when projected) and thinness (transparent when projected and thus a dark tonal area when printed) on a very small scale. Thus, what looks like a texture created by a sweeping hand movement through the pigment was, in fact, made with very small strokes. The skillful printing of the negative enhanced its exquisite, painterly qualities to produce a work that is artistically and technically superb.

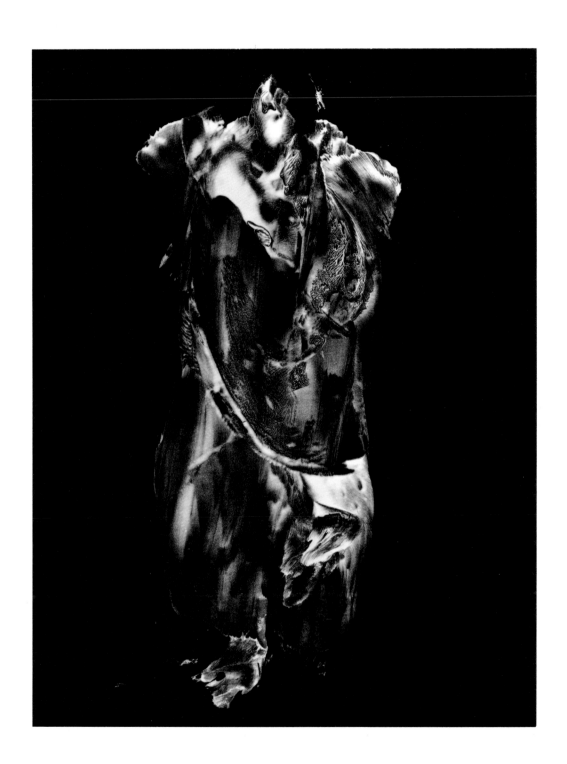

126
Gothic Image
1958
Gelatin-silver print
Signed, dated, and titled in pencil on verso: center, *Frederick Sommer*; upper left, *Gothic*
48.9 x 39.4 cm (19¼ x 15½ in.)
Anonymous loan
Not illustrated

Here Sommer's paint-on-cellophane technique achieved a texture that suggests the coarse, splintery character of wood. The stark monolith dramatically punctuates the intense black surface. A configuration like this evolved out of Sommer's personal exploration of the logic and poetry of abstract structures in photographic terms, a quest mirrored in his drawings and musical scores, which date from the early 1930s.

127
Hadrian's Villa
1961
Gelatin-silver print
Signed, dated, and titled in pencil on verso: center, *Frederick Sommer 1961*; upper left, *HADRIAN'S VILLA 1961*
28 x 35.5 cm (11 x 14 in.)
Anonymous loan
Not illustrated

In contrast to the stark outline of the shape made by paint on cellophane (cat. nos. 125, 126) or the crisp linearity of drawing on film (cat. no. 129), this print, made from smoke on cellophane, presents a complex convolution of form, line, and tone. Although the image could suggest a close-up view of a membranous substance, the intricate maze-like structure prompted Sommer to nickname this work "Hadrian's Villa." Sommer's title thus reminds the viewer of the artist's architectural background, and his former interest in the architectural styles, villas, and gardens of Italy.

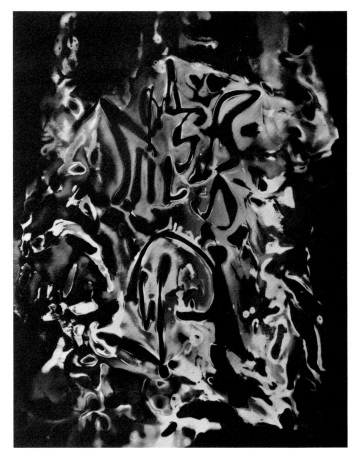

128
Smoke on Glass
1962
Gelatin-silver print
Signed and titled in pencil on verso, center: *Frederick Sommer*; *Smoke on Glass*; upper left, *1962*
33.6 x 26.4 cm (13¼ x 10⅜ in.)
Anonymous loan

To make the negative for this print, Sommer first drew on a piece of aluminum foil. Then he put the foil over candle smoke to blacken it with soot. After greasing a piece of glass with a roller, he then pressed the soot-side of the foil onto the glass with a piece of cotton and the drawing transferred easily. Thus, the glass plate was ready for the enlarger.

The images that result from this process are usually amorphous. Although the linear elements are not strong, the drawing is completely autographic, and the artist's gestural marks are faithfully recorded. Where the soot was dense on the glass, the photographic paper printed white. Ironically, those areas appear to be fiery flames that devour the black swirls caused by Sommer's drawing.

Even though the images themselves usually bear witness to how they were made, Sommer usually titles his abstract cameraless photographs with the descriptive phrase for the process that made the negative for the print: hence "paint on cellophane" or "smoke on glass."

129
Drawing on Film
1978
Gelatin-silver print
Signed, dated, and annotated in pencil on verso of mount: center,
Frederick Sommer 1978; upper left, *Drawing 1978 / (Printed from
developer drawing on film)*
24.8 x 20.2 cm (9¾ x 7¹⁵⁄₁₆ in.)
Anonymous loan

This is Sommer's most recent cliché-verre. When con-
temporary artists first work in this medium, they usu-
ally begin by making linear drawings on film or glass,
and then work up to making tonal or painterly cliché-
verre effects. With Sommer, it was the reverse. He began
his abstract cameraless work 20 years earlier by painting
on a transparent surface, and then proceeded to achieve
a linear purity that echoes the style of his drawings
(colored inks on black paper). To make this print, Som-
mer drew with a fountain pen and developer fluid on an
8-by-10-inch piece of film which was then contact-
printed.

Drawings like this are Sommer's personal shorthand
of a structure, made of points and linkages, which is a
type of conceptual map. To the casual viewer, the image
could appear to have a playful "connect-the-dots" qual-
ity, or it could look like a camera-made picture of an
abstract wire sculpture. Sommer's intention was prob-
ably more cerebral; but what clearly emerges is that
Sommer simply likes to draw and is fascinated by the
act of creating an imaginary system of lines.

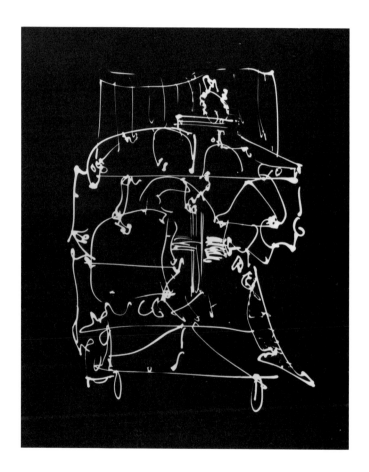

Jaromir Stephany
American; b. Rochester, New York, 1930

Although Jaromir Stephany was an army photograper in the early 1950s, he did not view photography as an art form until he studied photography and photographic illustration with Ralph Hattersly and Minor White at the Rochester Institute of Technology, where he got his Bachelor of Fine Arts degree in 1958. Stephany's first attempt at painting on film and printing on light-sensitive paper was done under the guidance of Minor White, and it was he who suggested that Stephany go to Indiana University to study with Henry Holmes Smith (cat. nos. 121-123), since Smith was known to experiment with photographic processes and was an innovator in the realm of abstract photography. Stephany obtained his Master of Fine Arts degree from Indiana University in 1960. Stephany's experiences with White and Smith reinforced his belief that: 1) a photograph should combine precise, technical mastery with personal, individual creative expression; and 2) that the pictorialized image need not be camera-made to be a symbolic form.

For two decades Stephany has diligently and capably applied himself in the role of photographic educator. From 1961 to 1966, Stephany's knowledge of the history of photography was strengthened by two simultaneous jobs: he was co-lecturer with Beaumont Newhall on the history of photography at Rochester Institute of Technology; and he was on the staff of George Eastman House (now the International Museum of Photography), where he catalogued countless photographs. In 1966 he joined the Department of Photography and Film of the Maryland Institute as instructor on photographic history and film. However, in addition to that position, Stephany has been Associate Professor of Art and Screen Arts at the University of Maryland, Baltimore County, since 1973, including a term as Chairman of its Visual Arts Department from 1976 to 1977. He has lectured on numerous occasions on the different facets of photography and film at various institutions in Maryland, Washington, D.C., and Delaware as part of the Smithsonian Institute Associates Program. In 1977-78 he researched and created an eight-part television series titled "The Developing Image" on the history and esthetics of photography.

Besides photography, Stephany has an almost all-consuming interest in science fiction, and this interest manifests itself in his photographic imagery. There is an other-worldly or visionary quality about his photographs, which seems to suggest what might be instead of what is. Stephany produces his images either from 4-by-5-inch negatives or 35 mm negatives, which have been painted with inks, stained, or otherwise altered with other viscous materials. His work is in black-and-white, although recently he has been experimenting with making works in color. He has an index file of over 800 negatives, culled from two decades of creating his own brand of abstract photography, i.e., cliché-verre.

130
Adhara III from the series *Landscapes of Outer Space*
1969-1972
Signed in ink on mount below image, lower right: *Jaromir Stephany*
50.8 x 40.6 cm (20 x 16 in.)
Courtesy of the artist

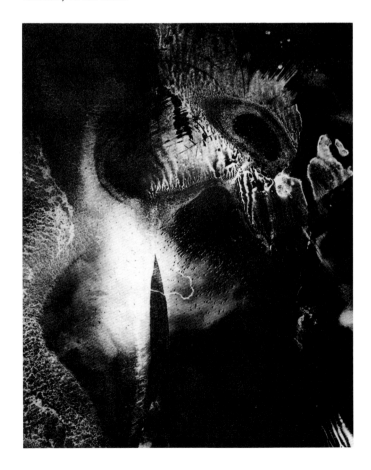

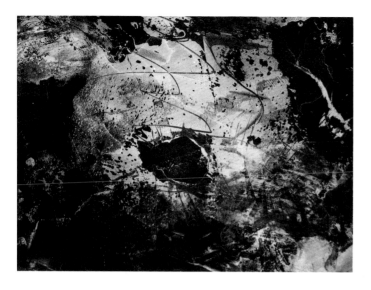

131
Antares VIII from the series *Landscapes of Outer Space*
1975-1976
Signed in ink on mount below image, lower right: *Jaromir Stephany*
40.6 x 50.8 cm (16 x 20 in.)
Courtesy of the artist

Stephany's usual practice is to select a group of images
from his vast and ever-growing collection of abstract
cameraless negatives to form a series that illustrates a
theme or idea, usually inspired by the science fiction
novels of Edward Elmer Smith, like *Galactic Patrol* or
Children of the Lens. Both of these prints are from
Landscapes of Outer Space, a series Stephany started
in 1969 and which now numbers over 200 images.
Instead of illustrating specific episodes in Smith's books,
Stephany's fantastic images are triggered by the general
ideas about galaxy exploration described by Smith. Even
without the titles that evoke planetary systems, these
two images suggest more than decorative patterns and
textures, conjuring up allusions to cosmic phenomena.
In *Adhara III* amorphous shapes emerge from the void,
and light seems to radiate from a mysterious pointed
shape in the center of the image. In *Antares VIII* the
focal point is a black form placed in the middle of a
brilliant, iridescent-gray, reticulated tonal area. Both
images suggest that they are views of some strange
lunar-like region.

Stephany's clichés-verre introduce a new vocabulary
of shapes, textures, and tonal gradations to abstract
photography. While evidence of the artist's hand is
minimal, the presence of the artist's imagination is para-
mount. Thus, Stephany uses the tools of painting and
photography to create fantastic visions of what is
beyond the visible world.

Timothy Van Laar
American; b. Ann Arbor, Michigan, 1951

After completing his undergraduate work at Calvin College in Grand Rapids, Michigan, Van Laar went on to get his Master of Fine Arts degree in Printmaking at Wayne State University, Detroit, in 1975. Since 1977 Van Laar has been teaching drawing and printmaking at Calvin College. While at Wayne State University, Van Laar began cliché-verre work in courses taught by Aris Koutroulis and Sue Hirtzel. Since that time he has done about 20 clichés-verre. However, most of Van Laar's artistic energies have been focused on making lithographs and intaglios, drawings, and sculpture.

The cliché-verre medium is a natural, if infrequent, extension of Van Laar's artistic expression, because most of his art is concerned with the qualities and mysteries of light. His initial interest in cliché-verre was sparked at a time when he was very involved with creating wood sculpture in which his main concern was the reflection of light.

Van Laar's earliest clichés-verre were black-and-white on standard photographic paper and dye-transfer prints. However, he found commercial papers too slick and impersonal, and he preferred other printmaking media in which he could use a fine quality rag paper. Then Hirtzel introduced him to the gum bichromate process and to Van Dyke printing, which permitted Van Laar to coat and use any paper he wanted. As a result, most of the cliché-verre prints Van Laar has done in 1978 and 1979 have been printed by these two methods.

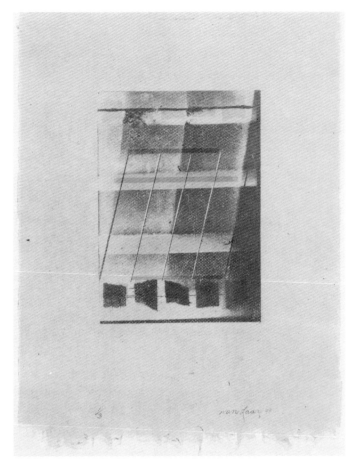

132
Untitled
1979
Gum bichromate
Signed, dated, and numbered in pencil: lower right, *Van Laar 79*; lower center, *1/3*
34.3 x 26.6 cm (13½ x 10½ in.)
Edition: 3
Courtesy of the artist

This print was made from three stencil-like matrices of spray-painted, frosted acetate (i.e., translucent plastic film). The image was not formed through drawing, but rather from a collaged composition of masking tape, string, and gradations of spray paint (which were scored by a scissor point and razor blade) on the matrices. Van Laar sought to recreate the diffused, variable quality of reflected light by printing in three muted colors: green, yellow, and pink-red. The overlay of these hues produced a fourth color: steel gray.

It is interesting to note that Van Laar chose to print an image that denies the artist's hand on an obviously hand-made Dutch paper. In this print, Van Laar's sculptural interests in light, in the illusion of three-dimensional space, in an image "constructed" of strong girder-like shapes, fuse with his printmaker's sensitivity to the quality of an unusual buff-colored, textured, hand-crafted paper.

Appendix

A Survey of 19th-Century Clichés-verre

While prints by Corot, Daubigny, Delacroix, Huet, Millet, and Rousseau have been catalogued, documented, and published by Loys Delteil and other scholars who have consulted the Paris Bibliothèque Nationale collection, other 19th-century clichés-verre are neither well-known nor listed in any one source. Thus, the purpose of this appendix is both to document the existence of extant 19th-century clichés-verre known to the authors and to cite collections where impressions of those clichés-verre are to be found. Arranged alphabetically by artist, this list contains an entry for every print seen by one or both of the authors, or documented by questionnaires as existing in a particular collection. This record, the most complete to date, is a first step toward a catalogue raisonné of 19th-century clichés-verre, a project which may be undertaken in the future. The authors hope that this publication will stimulate the addition of more 19th-century clichés-verre titles.

Although several references (cited in the Bibliography) mention that Adolphe Appian (1818-1898), Antoine-Louis Barye (1795-1875), Félix Bracquemond (1833-1914), Augustus John (1878-1961), Adolf von Menzel (1815-1905), and Horace Vernet (1789-1863) made one or more clichés-verre, the authors did not include entries for these artists because, despite extensive efforts, no impressions have been found. Although it is possible that some of the clichés-verre listed as "unknown" are in fact by some of these artists, there is no evidence to establish attribution.

A large group of "clichés-verre" by Henri Fantin-Latour (1836-1904) in the André Jammes collection, Paris (one of which was published in Bib. II Coke, p. 239), also poses a puzzling problem. While the prints resemble faithful photographic reproductions of Fantin-Latour's drawings (even to recording the laid lines of the paper on which the artist drew), the authors are not convinced that they are clichés-verre, and thus omitted these works. If they are clichés-verre, Fantin-Latour would have had to have made a drawing transparent (with wax or grease), laid it on a light-sensitive material to make a negative, and then made a positive print. That Fantin-Latour would sacrifice his drawings in this manner for the sake of photographic contact prints would be unusual. The authors would like to suggest that perhaps these are photographic prints after Fantin-Latour's drawings by Germain Hédiard, cataloguer of Fantin-Latour's lithographs and an experimenter with various photographic processes. However, more research on these prints remains to be done.

Apparent from this list is the activity in this medium by French artists or by artists in some way associated with the Arras/Barbizon group. There are few 19th-century clichés-verre by German, Italian, and other European artists. A major exception is the outstanding group of 29 clichés-verre by the Italian artist Antonio Fontanesi. (Fontanesi's work in the medium became known to the authors too late to be included in this exhibition.) Perhaps this publication will prompt a re-examination of print holdings and more non-French works like those of Fontanesi, G. E. Castan, and others, will surface. Nineteenth-century American clichés-verre are also sparse. Except for the artists contacted by John W. Ehninger, very few American artists seem to have tried the medium. The New York Public Library Prints Division houses what are possibly three prints by Thomas Moran (1837-1926), but it is likely that they are photographic reproductions of prints in another medium. A section on Hamilton's glass etchings issued after the artist's death by the Philadelphia Art Union in 1882-83 is included in Arlene Jacobowitz, *James Hamilton 1819-1878, American Marine Painter*, exh. cat., Brooklyn Museum, 1966 (see pp. 78-81). Again, the authors felt these prints were made by another photographic process. Three of Hamilton's glass etchings, formerly in a Philadelphia private collection, are now part of the collection of the Pennsylvania Historical Society, Philadelphia.

Impressions of clichés-verre in public collections, private collections of dealers and galleries, and other private collections have been included in this survey. Clichés-verre in the recent art market are not recorded since this information would be quickly outdated. Individual impressions from the 1921 Sagot-Le Garrec edition *Quarante Clichés-Glace* (edition 150; each im-

pression from this edition is numbered in pencil and stamped; see Lugt 1766a) occur so frequently in public and private collections (not to mention the art market), that they have not been included. However, collections which own the complete Sagot-Le Garrec portfolio are listed at the end of this Appendix.

This list does not distinguish among vintage 19th-century impressions, Desavary-Dutilleux impressions, Charles Desavary impressions, Hédiard impressions, Robaut impressions, or Bouasse-Lebel (Paul Desavary) impressions, since it was not possible to study each one first-hand. Also, often the only record of the existence of a 19th-century cliché-verre is through a Bouasse-Lebel impression (e.g., Brendel). The list does provide a guide to strong cliché-verre collections, and establishes that scholars can study many fine 19th-century clichés-verre in this country.

The Entry Format

Since most of the French clichés-verre have been published in French, the French titles are given first. For works where no title is known, the authors devised a general descriptive title in English. When there is more than one cliché-verre by an artist, the works are listed chronologically whenever the date is known; for works already catalogued by Delteil, Delteil's numbering is given. All previously published catalogue raisonné numbers also accompany the respective entry.

Works not illustrated in Delteil, Melot, Bibliothèque Nationale publications, or elsewhere in this catalogue, are accompanied by an illustration whenever possible. Clichés-verre included in this exhibition are signalled by an asterisk next to the entry. Otherwise, the collection which provided the illustration in this list is noted with two asterisks.

Image size, as the most consistently reliable measurement, has been given in centimeters; height precedes width. Signatures and inscriptions are noted when they occur. The signature location described (e.g., LL, LR) is from impressions contact-printed from a plate with emulsion-side down (i.e., not from reverse impressions even if signature reads correctly on reverse impression).

The location of known glass plates is included. If the plate was printed in a 20th-century edition, that fact is indicated in the entry.

A key to the abbreviations used for the collections follows. Since the Bibliothèque Nationale, Paris (BN) is the primary collection of 19th-century clichés-verre and most often cited and published, it is always listed first. Most of the clichés-verre at the BN are to be found in either the more accessible Cabinet des Estampes collection (cab.) or in the Réserve collection of the Cabinet des Estampes (rés.). Corot clichés-verre are in both collections, although the Réserve impressions are the ones usually published. To facilitate future research, the authors have noted the number of Corot impressions in each collection. Following the BN, public collections are listed alphabetically by their abbreviations, followed by private collections.

Abbreviations for Collections

Albuquerque	University Art Museum, University of New Mexico, Albuquerque	Fogg	Fogg Art Museum, Cambridge, Massachusetts
Amherst	Mead Art Museum, Amherst College, Amherst, Massachusetts	Geneva	Musée d'Art et d'Histoire, Geneva
Ann Arbor	University of Michigan Museum of Art, Ann Arbor	Hamburg	Hamburger Kunsthalle
		Indiana Univ.	Indiana University Art Museum, Bloomington
Austin	University Art Museum, University of Texas at Austin	Iowa Univ.	University of Iowa Museum of Art, Iowa City
Austin (Gernsheim)	Gernsheim Collection, Humanities Research Center, University of Texas at Austin	A. Jammes	André Jammes, Paris
		LC	Library of Congress, Washington, D.C.
Baltimore	Baltimore Museum of Art	G. Lévy	Gérard Lévy, Paris
Baltimore (Lucas)	George A. Lucas Collection, the Maryland Institute College of Art, housed in the Baltimore Museum of Art	R. E. Lewis	R. E. Lewis, Inc.
		Los Angeles (Grunwald)	Grunwald Center for the Graphic Arts, University of California at Los Angeles
Basel	Kunstmuseum Basel		
H. Berès	Huguette Berès, Paris	Louvre	Musée du Louvre, Paris
Berlin (E.)	Staatliche Museen zu Berlin, East Germany	MMA	Metropolitan Museum of Art, New York
Berlin (W.)	Staatliche Museen Preussischer Kulturbesitz, Berlin, West Germany	Minneapolis	Minneapolis Institute of Arts
		Minnesota Univ.	University Gallery, University of Minnesota, Minneapolis
BM	British Museum, London	NCFA	National Collection of Fine Arts, Smithsonian Institution, Washington, D.C.
BN	Bibliothèque Nationale, Paris		
Boston	Museum of Fine Arts, Boston		
Budapest	Szépmüvészeti Muzeum, Budapest	NGA	National Gallery of Art, Washington, D.C.
Chicago	Art Institute of Chicago		
Cleveland	Cleveland Museum of Art	North Carolina Univ.	William Hayes Ackland Art Center, University of North Carolina, Chapel Hill
Cologne	Wallraf-Richartz-Museum, Cologne		
Copenhagen	Statens Museum for Kunst, Copenhagen	NYPL	S. P. Avery Collection, Prints Division, the New York Public Library, Astor, Lenox, and Tilden Foundations
Detroit	Detroit Institute of Arts		
Dresden	Staatliche Kunstsammlungen, Dresden	Ottawa	National Gallery of Canada, Ottawa, Ontario
R. Fine	Ruth E. Fine	Philadelphia	Philadelphia Museum of Art
Fitzwilliam	Fitzwilliam Museum, Cambridge	Pittsburgh	Museum of Art, Carnegie Institute, Pittsburgh

Princeton	Art Museum, Princeton University, Princeton
Prouté	Paul Prouté, Paris
RISD	Museum of Art, Rhode Island School of Design, Providence
Sagot-Le Garrec	Galerie Sagot-Le Garrec, Paris
San Francisco	Achenbach Foundation for Graphic Arts, the Fine Arts Museums of San Francisco, California Palace of the Legion of Honor
Smithsonian	National Museum of History and Technology, Smithsonian Institution, Washington, D.C.
Stanford	Stanford University Museum of Art, Stanford
Texbraun	Collection Texbraun, Paris
Turin	Galleria Civica d'Arte Moderna, Turin
Williamstown	Sterling and Francine Clark Art Institute, Williamstown
Worcester	Worcester Art Museum, Worcester
Yale	Yale University Art Gallery, New Haven

Public Collections which own the complete Sagot-Le Garrec portfolio, *Quarante Clichés-Glace*, published by Maurice Le Garrec, 1921.

Each portfolio is numbered as one of the 150 edition. Portfolio number follows the name of each collection. The collections are listed alphabetically by city.

Gernsheim Collection, Humanities Research Center, University of Texas at Austin (101/150)

Boston, Museum of Fine Arts (18/150)

Boston Public Library (92/150)

Cambridge, Fogg Art Museum (28/150)

Art Institute of Chicago (38/150)

Cincinnati Art Museum (42/150)

Cleveland Museum of Art (13/150)

Johannesburg Art Gallery, South Africa (133/150)

London, British Museum (8/150)

London, Victoria and Albert Museum (7/150)

Milwaukee Art Center (16/150)

Minneapolis, University Gallery, University of Minnesota (95/150)

New York, Metropolitan Museum of Art (31/150)

Philadelphia Museum of Art (4/150)

Providence, Rhode Island School of Design, Museum of Art (23/150)

San Francisco, Achenbach Foundation for Graphic Arts, the Fine Arts Museums of San Francisco, California Palace of the Legion of Honor (81/150)

Julius Bakof
German 1819-1857
Chaumière (Cottage), c. 1857
15.2 x 18.4 cm
In plate LL: *J Bakof*
Impressions: Hamburg; Sagot-Le Garrec

Gilberto Borromeo
Italian 1817-1885
Tower and Arched Wall in a Landscape,
1864
14.3 x 20 cm
In plate in reverse LR: *Borromeo*; in ink on
mount below image LL: *G. Borromeo f. 1864*
Impressions: Geneva

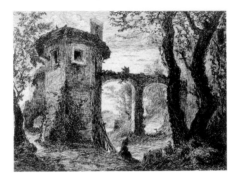

George Henry Boughton
American 1833-1905
See Ehninger

Jacques-Emile-Edouard Brandon
French 1831-1897
*Souvenir de Nice—Jeune Mère fait
boire son enfant (Souvenir of Nice—Young
Mother Giving Her Child a Drink)*, Jan. 1854
15.1 x 18.9 cm
In plate in reverse on rock: *E Brandon/54*;
LC (below margin in reverse), *Souvenir de
Nice—Une jeune mere fait boir son enfant*
Impressions: Sagot-Le Garrec

Albert Heinrich Brendel
German 1827-1895
1
*Lisière de forêt (Woman at the Edge of a
Forest)*, March 1859
Glass plate 19.2 x 15.9 cm; image 17.8 x
14.3 cm
In margin at L: *N° 1. Mars. 59*
Plate and modern impression from plate:
Chicago (acquired as Corot but not
described by Delteil; for discussion on
attribution, see "Cliché-verre in the 19th
Century," p. 39, n. 23)

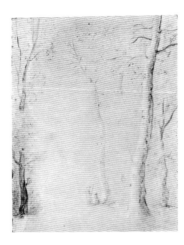

Plate

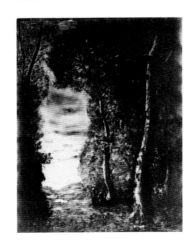

Modern Impression

2
*Les Deux Chevaux à l'abreuvoir (Two
Horses at a Watering Place)*, c. 1859/62
18.5 x 14.3 cm
As Daubigny: Delteil 150; Melot D150
Impressions: BN; Baltimore (Lucas)**
For discussion on attribution, see "Cliché-
verre in the 19th Century," p. 39, n. 23)

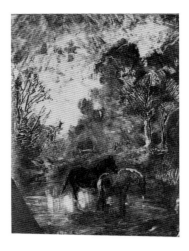

*3
Grande Bergerie (Sheepfold, Large Plate),
1861
With remarque, 24.2 x 29.8 cm; without
remarque, 17.5 x 28.2 cm
In plate LL: *Brendel 61* (6 in reverse)
Impressions: Boston; Sagot-Le Garrec

4
Petite Bergerie (Sheepfold, Small Plate),
c. 1861
14.6 x 18 cm
In plate LL: *Brendel*
Impressions: Baltimore (Lucas); G. Lévy**;
Sagot-Le Garrec

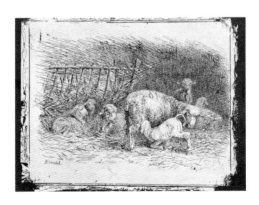

*5
*Trois Chevaux au labourage (Three Work
Horses)*, 1862
With remarque, 16.5 x 20.3 cm; without
remarque, 14 x 18.4 cm
In plate to R of LC: *Brendel 1862* (6 in re-
verse); in reverse in margin LL: *Croquis*
Impressions: Sagot-Le Garrec

*6
*Planche de croquis (Plate of Sketches: Farm
Horse; Canal Scene; Head of a Man;
Horseman)*, c. 1862
Plate 30.5 x 23.8 cm; images within plate,
(horse) 17.8 x 22.9 cm, in plate LL: *Brendel*;
(canal) 18.4 x 11.4 cm, in plate LR: *Brendel*;
(head) 4.4 x 3.8 cm; (horseman) 4.1 x 6.9 cm
Impressions: Sagot-Le Garrec

John William Casilear
American 1811-1893
See Ehninger

Gustave-Eugène Castan
Swiss 1823-1892
1
*Le Chemin de bois à Cernay (Road in the
Wood at Cernay)*
12 x 19.2 cm
In plate: LL, *Gustav Castan*; in margin LC,
Le Chemin de Bois a Cernay; LR, *Dessinne
a l'encre de Chine*; in reverse LL, *No 16*
Glass plate: Geneva (4 modern impressions
made in 1979)

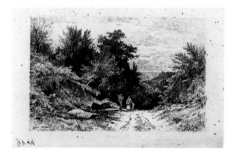

2
*A La Belotte, Lac de Genève (At La Belotte,
Lake Geneva)*
11.5 x 17.2 cm
In plate: LL, *G. Castan*; LC, *à la Belotte
Lac de Geneve*
Glass plate: Geneva (4 modern impressions
made in 1979)

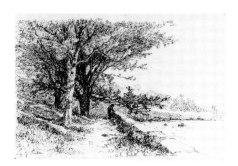

3
View of River with Fisherman
15 x 23 cm
In plate LR: *G. Castan*; in margin UR:
No 17
Glass plate: Geneva (3 modern impressions
made in 1979)

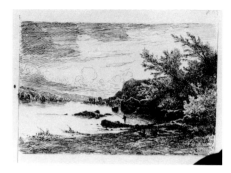

4
*Landscape with Two Figures beside a
Campfire*
13.1 x 21 cm
In plate LL: *Gustave Castan*
Glass plate: Geneva (3 modern impressions
made in 1979)

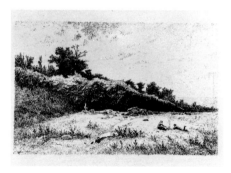

5
Country Road
14.5 x 22.4 cm
In plate LL: *G Castan*
Glass plate: Geneva (3 modern impressions
made in 1979)

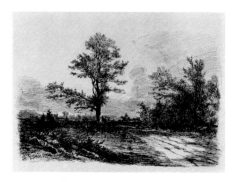

Editor's note: A modern impression is
illustrated for each Castan entry.

Antoine Chintreuil
French 1814-1873
*Plate of Sketches: Reclining Nude in Land-
scape and Others*, Jan. 1854
Sheet: 15 x 18.8 cm
In plate C (in reverse three times; UL in
reverse once at base of tree): *Chintreuil*
Impressions: G. Lévy

César de Cock
Belgian 1823-1904
Forest Stream, 1875
11.4 x 18.1 cm
In plate LR: *C. de Cock/1875*
Glass plate: BN

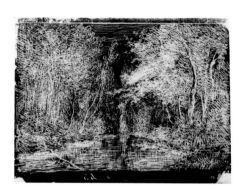

Alexandre-Désiré Collette
French 1814-1876
Allegory
17.8 x 23.8 cm
In plate LL: *A. Collette Inv.*
Impressions: Sagot-Le Garrec

Jean-Baptiste-Camille Corot
French 1796-1875
*1
*Le Bucheron de Rembrandt (The Wood-
cutter of Rembrandt)*, May 1853
10.2 x 6.3 cm
In plate LL: *COROT*
Delteil 35; Robaut 3158; Melot C35
Impressions: BN (rés. 5/cab. 4); BM; Buda-
pest; Dresden; Fitzwilliam; MMA; NGA;
Philadelphia; H. Berès; G. Lévy
[Photogravure plate, 11 x 10 cm, by Charles
Nègre of this image and modern prints
from that plate, coll. A. Jammes]

2
Les Enfants de la ferme (Farm Children),
May 1853
8.9 x 11.1 cm
Delteil 36; Robaut 3161; Melot C36
Impressions: BN (rés. 2/cab. 3); Budapest;
NGA; Philadelphia (2); Stanford;
A. Jammes

3
La Source fraiche (The Cool Spring), May
1853
14 x 12.5 cm
In plate LR: *COROT*
Delteil 37; Robaut 3157; Melot C37
Impressions: BN (rés.); Budapest

4
La Carte de visite au cavalier (Carte-de-visite with Horseman), May 1853
3.4 x 7.9 cm
Delteil 38; Robaut 3156; Melot C38
Glass plate: BN
Impressions: BN (rés.3/cab.2); Budapest;
NGA; NYPL (2); Philadelphia; H. Berès;
A. Jammes
Editions: Robaut 1905

5
*Le Bain du berger (Souvenir du paysage
Italien du Musée de Douai) (Shepherd's
Bath [Souvenir of an Italian Landscape in
the Douai Museum])*, May 1853
10.9 x 15.4 cm
Delteil 39; Robaut 3159; Melot C39
Impressions: BN (rés.2/cab.2); Budapest;
Fitzwilliam; NGA; NYPL; Philadelphia

6
Souvenir de Fampoux (Souvenir of Fampoux), 1854
9.5 x 6.9 cm
In plate LR: *CO* or *CC*
Delteil 40; Robaut 3160; Melot C40
Impressions: BN (rés.3/cab.1); Budapest;
Dresden; NGA; NYPL

184

7
La Petite Soeur (The Little Sister), Jan. 1854
15.2 x 19 cm
In plate in reverse LL: *COROT*
Delteil 41; Robaut 3162; Melot C41
Glass plate: Sagot-Le Garrec
Impressions: BN (rés.3/cab.2); Berlin (W.);
Boston; Budapest; NGA; NYPL; RISD; U.S.
priv. coll.
Editions: Sagot-Le Garrec 1921

*8
*Le Petit Cavalier sous bois (Horseman in
the Woods, Small Plate)*, Jan. 1854
18.7 x 15 cm
In plate LR: *COROT*
Delteil 42; Robaut 3163; Melot C42
Impressions: BN (rés.2/cab.2); Berlin (W.);
Budapest; Dresden; NYPL; G. Lévy; Sagot-Le Garrec; Paris priv. coll.
Editions: Sagot-Le Garrec 1921

*9
Le Songeur (The Dreamer), Jan. 1854
14.6 x 19 cm
In plate LL: *COROT*
Delteil 43; Robaut 3164; Melot C43
Glass plate: MMA
Impressions: BN (rés.2/cab.2); Berlin (W.);
Budapest; Dresden; NGA; NYPL; Sagot-Le
Garrec; M.P. Schab coll., New York
Editions: Sagot-Le Garrec 1921

10
*Souvenir des fortifications de Douai, Effet
du soir (Souvenir of the Fortifications of
Douai, Evening)*, Jan. 1854
18.4 x 14.3 cm
Delteil 44; Robaut 3165; Melot C44
Impressions: BN (rés.2); Berlin (E.)

*11
*La Jeune Fille et la mort (Young Woman
and Death)*, March 1854
18.3 x 13.3 cm
In plate LR: *COROT*
Delteil 45; Robaut 3166; Melot C45
Impressions: BN (rés.1/cab.2); Berlin (E.);
Boston; Budapest; Cologne; Dresden; NGA;
NYPL; Sagot-Le Garrec; U.S. priv. coll. (2)
Editions: Sagot-Le Garrec 1921

*12
*Le Grand Cavalier sous bois (Horseman in
the Woods, Large Plate)*, c. 1854
28.5 x 22.6 cm
In plate in reverse LL: *COROT*
Delteil 46; Robaut 3167; Melot C46
Glass plate: BM
Impressions: BN (rés.2/cab.2); Berlin (E.);
Budapest; Indiana Univ.; NGA; NYPL;
Sagot-Le Garrec
Editions: Sagot-Le Garrec 1921

*13
Le Tombeau de Sémiramis (Tomb of Semiramis), Jan. 1854
13.7 x 18.7 cm
In plate LR: *COROT*
Delteil 47; Robaut 3168; Melot C47
Impressions: BN (rés.3); Budapest; Dresden;
NYPL; Paris priv. coll.

14
*Le Cavalier en forêt et le piéton (Horseman
and Vagabond in the Forest)*, Jan. 1854
15.1 x 18.8 cm
In plate in reverse LL: *COROT*
Delteil 48; Robaut 3169; Melot C48
Impressions: BN (rés.2/cab.2); Budapest;
NYPL; Philadelphia; Yale

15
Le Petit Berger (1er planche) (Little Shepherd, 1st Plate), 1855
32.5 x 24.5 cm
Delteil 49; Robaut 3170; Melot C49
Impressions: BN (rés.1/cab.1); Berlin (W.);
Budapest; Dresden; Sagot-Le Garrec
Editions: Sagot-Le Garrec 1921
See fig. 9

*16
Le Petit Berger (2e planche) (Little Shepherd, 2nd Plate), c. 1855
34.2 x 26.3 cm
In LL margin of plate: *COROT* (some impressions exist without inscr.)
Delteil 50; Robaut 3172; Melot C50
Glass plate: MMA
Impressions: BN (rés.3/cab.1); Berlin (E.);
Budapest; Cleveland; NYPL; U.S. priv. coll.
Editions: Sagot-Le Garrec 1921

17
Le Ruisseau sous bois (Brook under Trees),
1855
18.6 x 15.2 cm
In plate in reverse LR: *COROT*
Delteil 51; Robaut 3171; Melot C51
Impressions: BN (rés.)

*18-22
Five Landscapes
The following images are on the same plate.
According to Delteil's entry for *Le Jardin de
Périclès* (Delteil 52), he did not know of an
impression with the five images printed
together. Robaut cites one impression from
the sale of Millet's widow (sale 310, April

1894). Furthermore, several public collections indicated that they had such an impression: BN (rés.); Berlin (E.); Budapest; San Francisco
Edition: Sagot-Le Garrec 1921 (5 images printed together, 27.3 x 34.2 cm; *Le Jardin de Périclès* signed LL: *COROT*)

18
Le Jardin de Périclès (Garden of Pericles), 1856
15.2 x 15.9 cm
Delteil 52; Robaut 3173; Melot C52
Individual impression: BN (rés.)

19
L'Allée des peintres (Painters' Path), 1856
12.4 x 17.1 cm
Delteil 53; Robaut 3174; Melot C53
Individual impression: BN (rés.)

20
Griffonage (Scribblings), 1856
14.9 x 10.2 cm
Delteil 54; Robaut 3175; Melot C54
Individual impression: BN (rés.)

21
Le Grand Bucheron (Woodcutter, Large Plate), 1856
14.6 x 8.5 cm
Delteil 55; Robaut 3176; Melot C55
Individual impression: BN (rés.)

22
La Tour d'Henri VIII (Tower of Henry VIII), 1856
11.5 x 15.9 cm
Delteil 56; Robaut 3177; Melot C56
Individual impression: BN (rés.)

*23
Souvenir d'Ostie (Souvenir of Ostia), 1855
26.8 x 33.9 cm
In plate in reverse LL: *COROT* (some impressions exist without inscr.)
Delteil 57; Robaut 3178; Melot C57
Glass plate: BN
Impressions: BN (rés.3/cab.2); Basel; Berlin (E.); Budapest; Chicago; Indiana Univ.; NGA; NYPL (2); San Francisco; Sagot-Le Garrec
Editions: Sagot-Le Garrec 1921

*24
Les Jardins d'Horace (The Gardens of Horace), 1855
35.6 x 28.5 cm
In plate in reverse LL: *COROT* (some impressions exist without inscr.)
Delteil 58; Robaut 3179; Melot C58
Glass plate: Louvre
Impressions: BN (rés.3/cab.2); Berlin (E.); Boston; Budapest; Copenhagen; NGA (2); NYPL (2); Sagot-Le Garrec; Paris priv. coll. (2)
Edition: Sagot-Le Garrec 1921

25
Jeune Mère à l'entrée d'un bois (Young Mother at the Entrance of a Wood), 1856
33 x 26 cm
In plate LL: *COROT*
Delteil 59; Robaut 3180; Melot C59
Glass plate: Paris priv. coll.
Impressions: BN (rés.2/cab.1); Berlin (E.); Boston; Budapest; Copenhagen; NYPL; Sagot-Le Garrec
Editions: Sagot-Le Garrec 1921
See fig. 7

26
Les Arbres dans la montagne (Trees on a Mountain), 1856
19 x 15.3 cm
Delteil 60; Robaut 3181; Melot C60
Impressions: BN (rés.2); Basel; Berlin (E.); Budapest; Sagot-Le Garrec
Edition: Sagot-Le Garrec 1921
See fig. 6

27
Un Philosophe (Philosopher), c. 1855/60
Delteil 61; Robaut 3182; Melot C61
No impression located

28
Le Petit Berger (3eme planche) (Little Shepherd, 3rd Plate), c. 1856
36.2 x 27.3 cm
Delteil 62; Robaut 3183; Melot C62
Impressions: BN (rés.4); Paris priv. coll.

29
L'Artiste en Italie (The Artist in Italy), 1857
18.9 x 15 cm
In plate LL: *COROT*
Delteil 63; Robaut 3205; Melot C63
Glass plate: A. Jammes
Impressions: BN (rés.4); Budapest; Dresden; NYPL
Editions: A. Jammes, 1962 (impressions inscr. on verso to indicate that they are modern Jammes impressions, ed. 100)

*30
L'Embuscade (Ambush), 1858
22.3 x 16.2 cm
In plate LR: *COROT*
Delteil 64; Robaut 3184; Melot C64
Glass plate: BN
Impressions: BN (rés.2/cab.1); Boston; Budapest; Dresden; Geneva; Hamburg; NGA; NYPL; Philadelphia

31
Un Déjeuner dans la clairière (Luncheon in a Clearing), 1857
15.6 x 19 cm
In plate margin in reverse LR: *COROT 1857*
Delteil 65; Robaut 3185; Melot C65
Impressions: BN (rés.3); Berlin (E.); Budapest; NGA; NYPL
Editions: Sagot-Le Garrec 1921

32
La Ronde gauloise (Gallic Round), 1857
18.4 x 14.2 cm
In plate in reverse LR: *COROT*
Delteil 66; Robaut 3186; Melot C66
Glass plate: Boston
Impressions: BN (rés.2); Berlin (E.); Budapest; NYPL; Worcester; Sagot-Le Garrec
Editions: Sagot-Le Garrec 1921

33
Madeleine à genoux (Mary Magdalen Kneeling), 1858
17 x 12 cm
Delteil 67; Robaut 3187; Melot C67
Glass plate: BN (on plate with Delteil 68 listed below)
Impressions: BN (rés.2/cab.1); Baltimore; Budapest; NGA; NYPL; Philadelphia; A. Jammes
Editions: Robaut 1905

34
Madeleine en méditation (Mary Magdalen in Meditation), 1858
10.8 x 17.1 cm
Delteil 68; Robaut 3188; Melot C68
Glass plate: BN (on plate with Delteil 67 listed above)
Impressions: BN (rés.2/cab.1); Budapest; NGA; NYPL; A. Jammes
Editions: Robaut 1905

*35
Corot par lui-même (Self Portrait), 1858
21.7 x 15.8 cm
Delteil 69; Robaut 3189; Melot C69
Glass plate: BN
Impressions: BN (rés.2/cab.1); Berlin (W.); Budapest; Detroit; Geneva; NGA; NYPL
Editions: Robaut 1905

*36
Cache-cache (Hide and Seek), 1858
23.1 x 16.8 cm
In plate LR: COROT
Delteil 70; Robaut 3190; Melot C70
Glass plate: BN
Impressions: BN (rés.2/cab.1); Albuquerque; Budapest; NGA; NYPL; Philadelphia; A. Jammes
Editions: Robaut 1905

37
Le Bouquet de Belle Forière (Cluster of Trees at Belle Forière), 1858
15.9 x 23.5 cm
In plate LR: COROT
Delteil 71; Robaut 3191; Melot C71
Glass plate: BN
Impressions: BN (rés.3); Baltimore (Lucas); Boston; Budapest; NYPL
Editions: Robaut 1905

38
Le Bois de l'ermite (Hermit's Woods), 1858
16.5 x 23.2 cm
In plate LL: COROT
Delteil 72; Robaut 3192; Melot C72
Glass plate: BN
Impressions: BN (rés.3); Austin; Boston; Budapest; Cologne; Dresden; NGA; NYPL; Philadelphia; A. Jammes
Editions: Robaut 1905

39
Souvenir du Bas-Bréau (Souvenir of Bas-Bréau), 1858
19 x 16.5 cm
In plate LR: COROT
Delteil 73; Robaut 3196; Melot C73
Impressions: BN (rés); Berlin (E.); Budapest; Chicago; Geneva; NGA
Editions: Sagot-Le Garrec 1921

40
Les Rives du Po (Banks of the Po River), 1858
16.5 x 22.7 cm
In plate LC: COROT
Delteil 74; Robaut 3193; Melot C74
Impressions: BN (rés.3); Boston; Budapest; Dresden; Geneva; NYPL

*41
Saltarelle (Saltarello), 1858
22.5 x 16.5 cm
In plate LR: COROT
Delteil 75; Robaut 3194; Melot C75
Glass plate: BN
Impressions: BN (rés.2); BM; Budapest; Dresden; NGA; NYPL; Philadelphia; H. Berès; A. Jammes; Paris priv. coll.
Editions: Robaut 1905

*42
Dante et Virgile (Dante and Virgil), 1858
22.2 x 16.8 cm
In plate LR: COROT
Delteil 76; Robaut 3195; Melot C76
Glass plate: BN
Impressions: BN (rés.3); Boston; Budapest; NGA; NYPL; Pittsburgh; H. Berès
Editions: Robaut 1905

43
Orphée entraînant Eurydice (Orpheus Leading Eurydice), 1860
10.9 x 15.2 cm
In plate LR: COROT
Delteil 77; Robaut 3197; Melot C77
Impressions: BN (rés.2); Budapest; Cologne; Minnesota Univ.; NGA; NYPL; Philadelphia

*44
Orphée charmant les fauves (Orpheus Soothing Wild Beasts), 1860
13.4 x 10.2 cm
In plate in reverse LR: COROT
Delteil 78; Robaut 3198; Melot C78
Impressions: BN (rés.); Budapest; Dresden; NYPL; Philadelphia

45
La Fête de Pan (Feast of Pan), 1860
11.2 x 15.6 cm
Delteil 79; Robaut 3199; Melot C79
Glass plate: BN
Impressions: BN (rés.2); Boston; Budapest; Cologne; Geneva; NGA; NYPL; Philadelphia; G. Lévy

46
Environs de Gênes (Environs of Genoa), 1860
21 x 16.5 cm
In plate in reverse LR: COROT
Delteil 80; Robaut 3200; Melot C80
Glass plate: BN
Impressions: BN (rés.4); Budapest; Dresden; NGA; NYPL; Philadelphia

47
Le Paysage à la tour (Landscape with a Tower), c. 1858/60
21.4 x 27.9 cm
Delteil 81; Robaut 3201; Melot C81
Glass plate: BN
Impressions: BN (rés.); Basel; Budapest

48
Souvenir des environs de Monaco (Souvenir of the Environs of Monaco), 1860
10.2 x 16.2 cm
In plate in reverse LR: COROT
Delteil 82; Robaut 3202; Melot C82
Glass plate: BN
Impressions: BN (rés.3); Budapest; NGA; NYPL; H. Berès
Editions: Robaut 1905

49
Le Chariot allant à la ville (Wagon Going to Town), 1860
10.4 x 15.5 cm
Delteil 83; Robaut 3203; Melot C83
Impressions: BN (rés.3); Boston; Budapest; Geneva; NGA; NYPL

50
Souvenir de la Villa Pamphili (Souvenir of the Villa Pamphili), 1871
15.2 x 12.4 cm
Delteil 84; Robaut 3204; Melot C84
Glass plate: BN
Impressions: BN (rés.); Berlin (W.); Budapest; MMA; NYPL; Philadelphia; H. Berès (2)
Editions: Robaut 1905

51
Souvenir du Lac Majeur (Souvenir of Lake Maggiore), 1871
16.7 x 22.2 cm
Delteil 85; Robaut 3208; Melot C85
Glass plate: BN
Impressions: BN (rés.); Budapest; NGA; NYPL; Philadelphia; Paris priv. coll.
Editions: Robaut 1905

52
La Vache et sa gardienne (Cow and Its Keeper), 1860
10.4 x 13.9 cm
Delteil 86; Robaut 3206; Melot C86
Impressions: BN (rés.3); Los Angeles (Grunwald); NGA; NYPL

53
Agar et l'ange (Hagar and the Angel), 1871
16.7 x 13 cm
Delteil 87; Robaut 3207; Melot C87
Glass plate: BN
Impressions: BN (rés.); Budapest; Dresden; NGA; NYPL; Philadelphia
Editions: Robaut 1905

*54
Souvenir de Salerne (Souvenir of Salerno), 1871
16.5 x 12 cm
Delteil 88; Robaut 3209; Melot C88
Glass plate: BN
Impressions: BN (rés.); Budapest; NGA; NYPL
Editions: Robaut 1905

55
Souvenir du Lac de Nemi (Souvenir of Lake Nemi), 1871
12.7 x 16.7 cm
Delteil 89; Robaut 3210; Melot C89
Glass plate: BN
Impressions: BN (rés.); Budapest; Dresden; NYPL
Editions: Robaut 1905

56
La Demeure du poète (Poet's Dwelling), 1871
13 x 17.2 cm
Delteil 90; Robaut 3211; Melot C90
Glass plate: BN
Impressions: BN (rés.); Budapest; NGA; NYPL; Philadelphia
Editions: Robaut 1905

57
Souvenir de la Vallée de la Sole (Souvenir of the Sole Valley), 1871
16.5 x 11.5 cm
Delteil 91; Robaut 3212; Melot C91
Glass plate: BN (on plate with Delteil 92 listed below)
Impressions: BN (rés.); Budapest; NGA; NYPL; H. Berès

*58
Les Paladins (The Paladins), 1871
11.2 x 16.8 cm
Delteil 92; Robaut 3213; Melot C92
Glass plate: BN (on plate with Delteil 91 listed above)
Impressions: BN (rés.); Berlin (E.); Budapest; MMA; NGA; NYPL; RISD; Smithsonian; H. Berès
Editions: Robaut 1905 (Yale impression exhibited)

59
Tour à l'horizon d'un lac (Tower on the Horizon of a Lake), 1871
12 x 16.5 cm
Delteil 93; Robaut 3214; Melot C93
Glass plate: BN
Impressions: BN (rés.); Baltimore; Berlin (E.); Budapest; MMA; NGA (2); NYPL
Editions: Robaut 1905

60
Le Poète et la muse (The Poet and His Muse), 1871
19 x 15.5 cm
In plate in reverse LC: COROT
Delteil 94; Robaut 3215; Melot C94
Glass plate: BN
Impressions: BN (rés.); Basel; Budapest; NGA; NYPL; Philadelphia
Editions: Robaut 1905

61
Berger luttant avec sa chèvre (Shepherd Struggling with a Goat), July 1874
17.8 x 13.3 cm

In plate LR: COROT
Delteil 95; Robaut 3216; Melot C95
Glass plate: BN
Impressions: BN (rés.); Budapest; NGA; NYPL; Philadelphia

62
Le Rêveur sous les grands arbres (Dreamer under Tall Trees), 1874
17.8 x 13 cm
Delteil 96; Robaut 3217; Melot C96
Glass plate: BN
Impressions: BN (rés.2); Budapest; NGA; NYPL; Philadelphia

63
Souvenir d'Eza (Souvenir of Eza), 1874
13 x 17.5 cm
In plate LR: COROT
Delteil 97; Robaut 3218; Melot C97
Glass plate: BN
Impressions: BN (rés.); Budapest; Geneva; NYPL; San Francisco

64
Souvenir d'Antibes (Souvenir of Antibes), 1874
12 x 15.2 cm
In plate LR: COROT
Delteil 98; Robaut 3219; Melot C98
Impressions: BN (rés.); Budapest; NGA; NYPL

65
Cavalier arrêté dans la campagne (Horseman Halted in the Countryside), 1874
12.7 x 17.5 cm
In plate LL: COROT
Delteil 99; Robaut 3220; Melot C99
Glass plate: BN
Impressions: BN (rés.3); Budapest; NGA; NYPL

66
Le Batelier (Souvenir d'Arleux-du-Nord) (Boatman [Souvenir of Arleux-du-Nord]), 1874
12.4 x 17.2 cm
In plate LR: COROT
Delteil 100; Robaut 3221; Melot C100
Glass plate: BN
Impressions: BN (rés.); Austin; Budapest; NGA; NYPL; H. Berès

Attributed to Corot
See Brendel no. 1,
Unknown no. 3

George Cruikshank
English 1792-1878
*Portrait of Peter Wickens Fry, 1851
11.7 x 8.3 cm
In plate below: *Geo. Cruikshank/ Dec. 19th 1851*; top: *Etched on Glass/Dear me! how very curious!*
Impressions: Austin (Gernsheim)

Joseph Cundall, Publisher (Cundall, Downes & Co., London)
Electro-Photography or Etching on Glass. Short Account of an Entirely New Process for the Reproduction of Artists' own Drawings upon Surface-Printing Electro-Plates, 1864
Page 19.6 x 13.6 cm
 Illustrations incl. 2 clichés-verre:
 1. James Clarke Hook
 English 1819-1907
 Portrait of a Boy in Profile, opp. title page
 In plate LC: *JCH* (interlaced)

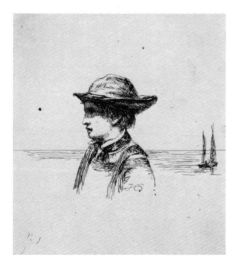

 2. Frederick Walker
 English 1840-1875
 Man, Seated beside a Dresser, Reading a Letter, opp. p. 8
 In plate LL: *FW*
 See fig. 2
 Coll.: BM

Eugène Cuvelier
French, c. 1830-1900
Allée en forêt (Forest Path), c. 1859/62
20 x 16.5 cm
In plate vertically LR: *E Cuvelier*
Impressions: Sagot-Le Garrec

William Parsons Winchester Dana
American 1833-1927
See Ehninger

Felix Octavius Carr Darley
American 1822-1888
See Ehninger

Charles-François Daubigny
French 1817-1878
1
Le Marais aux canards (Duck Pond), 1862
11.4 x 18.4 (impressions are usually without top margin with remarque); with remarque, 16.5 x 18.4
In plate margin LR: *D Aubigny*
Delteil 133; Henriet 114; Melot D133
Glass plate: Ottawa
Impressions: BN (2); Ann Arbor; Baltimore (Lucas 7); Berlin (W.); BM; Copenhagen; Dresden; MMA; NYPL; Yale; H. Berès; Sagot-Le Garrec
Editions: Sagot-Le Garrec 1921

*2
Les Cerfs (Deer), 1862
15.2 x 19 cm
In plate margin in reverse LR: *D Aubigny*
Delteil 134; Henriet 115; Melot D134
Glass plate: Cleveland
Impressions: BN (2); Baltimore (Lucas 5); Berlin (W.); Budapest; LC; Minneapolis; NGA; NYPL; RISD; Sagot-Le Garrec
Editions: Sagot-Le Garrec 1921

3
Sentier dans les blés (Path through a Wheatfield), 1862
15.9 x 18.7 cm
In plate LR: *D Aubigny*
Delteil 135; Henriet 116; Melot D135
Impressions: BN; Baltimore (Lucas 4); Berlin (W.); NYPL (2); Sagot-Le Garrec
Editions: Sagot-Le Garrec 1921

4
Le Pont (Bridge), 1862
14.9 x 18.7 cm
Delteil 136; Henriet 117; Melot D136
Impressions: BN (2); Baltimore (Lucas 4); Berlin (E.); NYPL; Ottawa; A. Jammes; Sagot-Le Garrec
Editions: Sagot-Le Garrec 1921

*5
Le Ruisseau dans la clairière (Brook in a Clearing), 1862
19 x 15.7 cm
In plate margin LL: *Daubigny*
Delteil 137; Henriet 118; Melot D137
Glass plate: Boston
Impressions: BN; Baltimore (Lucas 5); Berlin (E.); Budapest; Dresden (2); NYPL; Stanford; Williamstown; A. Jammes; Sagot-Le Garrec
Editions: Sagot-Le Garrec 1921

*6
Le Grand Parc à moutons (The Large Sheep Pasture), 1862
19 x 35 cm; with remarque 29.5 x 36.6 cm
In plate in reverse LL: *DAUBIGNY*
Delteil 138; Henriet 119; Melot D138
Glass plate: Louvre
Impressions: BN; Baltimore (Lucas); Berlin (E.); Budapest; Minneapolis; NYPL; Sagot-Le Garrec
Editions: Sagot-Le Garrec 1921

*7
Le Gué (The Ford), 1862
27 x 35.5 cm
In plate LR: *Daubigny* (some impressions exist without sig.)
Delteil 139; Henriet 120; Melot D139
Glass plate: BN
Impressions: BN; Baltimore (Lucas 4); Berlin (E.); Budapest; Chicago; Dresden; NYPL; Sagot-Le Garrec; Paris priv. coll.
Editions: Sagot-Le Garrec 1921

8
La Rentrée du troupeau (Return of the Flock), 1862
34.2 x 27 cm
In plate in reverse LL: *D Aubigny*
Delteil 140; Henriet 121; Melot D140
Impressions: BN; Baltimore (Lucas); Berlin (E.); Chicago; NYPL; H. Berès; Sagot-Le Garrec; Paris priv. coll.
Editions: Sagot-Le Garrec 1921

9
La Gardeuse de chèvres (Goatherdess), 1862
34 x 26.8 cm
Delteil 141; Henriet 122; Melot D141
Glass plate: MMA
Impressions: BN; Baltimore (Lucas 2); Berlin (E.); Budapest; NYPL; Sagot-Le Garrec; Paris priv. coll.
Editions: Sagot-Le Garrec 1921

10
La Fenaison (Harvest), 1862
21.3 x 34.5 cm
In plate in reverse LL: *DAUbigny*
Delteil 142; Henriet 123; Melot D142
Impressions: BN (2); Baltimore (Lucas); Berlin (E.); NYPL (2); Sagot-Le Garrec
Editions: Sagot-Le Garrec 1921

*11
L'Ane au pré (Donkey in a Field), 1862
16 x 19 cm
In plate in reverse LL: *Daubigny*
Delteil 143; Henriet 124; Melot D143
Impressions: BN; Baltimore (Lucas 4); Berlin (E.); Budapest; Dresden; NGA; NYPL (2); H. Berès (3); G. Lévy
Editions: Sagot-Le Garrec 1921

*12
Effet de nuit (Night Impression), 1862
15 x 18.8 cm
Delteil 144; Henriet 125; Melot D144
Impressions: BN (2); Baltimore (Lucas); Berlin (E.); Chicago; Dresden; Iowa Univ.; NYPL; Sagot-Le Garrec
Editions: Sagot-Le Garrec 1921

*13
Le Bouquet d'aunes (Cluster of Alders), 1862
15.8 x 19.3 cm
In plate margin LL: *DAubigny* (some impressions exist without sig.)
Delteil 145; Henriet 126; Melot D145
Impressions: BN (2); Basel; Baltimore (Lucas 4); Berlin (E.); Dresden; Fitzwilliam; NGA; NYPL (2); H. Berès (2); Sagot-Le Garrec
Editions: Sagot-Le Garrec 1921

*14
Vaches à l'abreuvoir (Cows at a Watering Place), 1862
15.5 x 18.6 cm
In plate in reverse LL: *Daubigny*
Delteil 146; Henriet 127; Melot D146
Impressions: BN; Baltimore (Lucas 4); Berlin (E.); Budapest; Chicago; Copenhagen; Dresden; LC; A. Jammes; Sagot-Le Garrec
Editions: Sagot-Le Garrec 1921

15
La Machine hydraulique (Hydraulic Engine), 1862
22.9 x 34.9 cm
In plate LL: *D Aubigny*
Delteil 147; Henriet 128; Melot D147
Impressions: BN (2); Basel; Baltimore (Lucas 3); Berlin (E.); Minneapolis; NYPL; Sagot-Le Garrec
Editions: Sagot-Le Garrec 1921

*16
Les Saules étêtés (Souvenir de Bezons) (Pollard Willows [Souvenir of Bezons]), 1862
21.6 x 35 cm; with remarque 27.6 x 35 cm
Delteil 148; Henriet 129; Melot D148
Impressions: Baltimore (Lucas); NYPL

*17
Vaches sous bois (Cows in the Woods), 1862
15.9 x 18.6 cm
Delteil 149; Henriet 130; Melot D149
Impressions: BN (3); Baltimore (Lucas 3); Berlin (E.); Budapest; Dresden; Indiana Univ.; Minneapolis; North Carolina Univ.; NYPL (2); H. Berès (2)
Editions: Sagot-Le Garrec 1921

Attributed to Daubigny
Les Deux Chevaux à l'abreuvoir (Two Horses at a Watering Place)
Delteil 150; Melot D150
See Brendel no. 2

Ferdinand-Victor-Eugène Delacroix
French 1798-1863
Tigre en arrêt (Tiger at Bay), 1854
15.5 x 18.8; often trimmed to 14.2 x 17.6 cm
In plate of larger image LR: *DELACROIX*
Delteil 131; Robaut 1282
Glass plate: Louvre
Impressions: BN (2); Baltimore (Lucas); Berlin (E.); Boston; Copenhagen; Detroit; Minneapolis; G. Lévy
Editions: Sagot-Le Garrec 1921

Charles-Paul-Etienne Desavary
French 1837-1885
1
Les Baigneuses (Bathers), c. 1858/72
16.8 x 21.5 cm
Not inscr. in plate; Berès impression inscr. in black ink on verso LR: *Ch. Desavary*
Impressions: H. Berès

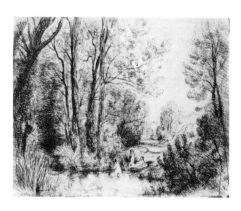

*2
Cavaliers dans la clairière (Souvenir de Fontainebleau) (Horsemen in a Clearing [Souvenir of Fontainebleau]), c. 1858/72
15.2 x 18.7 cm
In plate in reverse LR: *Ch. Desavary*
Impressions: H. Berès (4); R. E. Lewis; Sagot-Le Garrec

*3
Vue de Scarpe (View of the Scarpe River), c. 1858/72
9.5 x 14.6 cm
In plate LR: *Charles Desavary*
Impressions: H. Berès (2); Sagot-Le Garrec

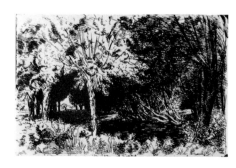

*4
Vue des bateaux (Boats on a Canal), c. 1858/72
13.7 x 11.5 cm
Impressions: Sagot-Le Garrec

Asher Brown Durand
American 1796-1886
See Ehninger

Henri-Joseph-Constant Dutilleux
French 1807-1865

1
Landscape: Figures on Road beside Wooded Knoll, May 1853
14 x 10.7 cm
BN impression inscr. in pencil on mount LC: *Dutilleux Mai 1853*
Impressions: BN**; A. Jammes

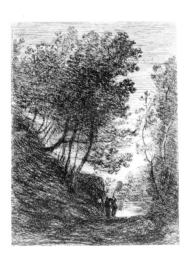

*2
Lisière de forêt (Edge of the Forest), 1853
16.5 x 11.5 cm
BN impression inscr. in black ink on mount below: *C'est à la suite de la premier Essai imaginé par Constant Dutilleux, à Arras, que Corot en fit de son côté*
Impressions: BN; Sagot-Le Garrec

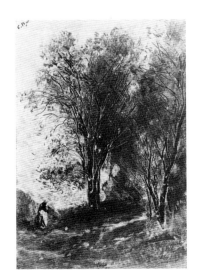

3
Man in Marshy Landscape, Aug. 1853
15.9 x 19.6 cm
BN impression inscr. in black ink on mount below: *Essai photographique—Peinture sur Verre—Ct Dutilleux Aout 1853.*
Impressions: BN

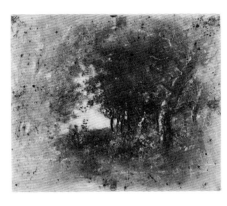

*4
Paysage (Man Walking in Marsh), c. 1853
14 x 19 cm
In plate UL: *C.D.* with artist's marks (see Lugt 2914 and Bénézit)
Impressions: A. Jammes; R. E. Lewis

5
Figures on the Banks of a Pond, c. 1853
19.4 x 15.2 cm
BN impression inscr. in pencil on mount LC: *Dutilleux*
Impressions: BN

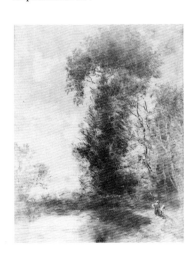

*6
Landscape with Bridge over Stream, 1857
9.5 x 13.3 cm
In plate LR: *C.D.* with artist's mark (see Bénézit)
BN impression 1 inscr. in brown ink on mount LC: *Peinture monochrome sur verre pour photographie. 1857*; BN impression 2 inscr. in brown ink on mount LL: *compos [?] de Ct Dutilleux/executé par lui sur verre deux tirages differents.*
Impressions: BN (2); A. Jammes

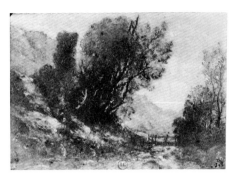

7
Horseman and Vagabond in the Country, 1857
7.5 x 14 cm
BN impression inscr. in brown ink on mount: *Dessin sur verre pour photographie. épreuve unique. 1857*
Glass plate: BN
Impressions: BN**; A. Jammes

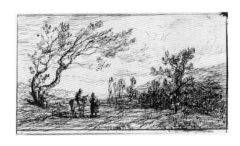

8
Cottage, 1857
14 x 18.7 cm
In plate in reverse LR: *C.D.* with artist's mark (Lugt 2914)
BN impression inscr. in brown ink on mount LL: *Dessin sur verre pour photographie. épreuve unique. 1857*
Impressions: BN

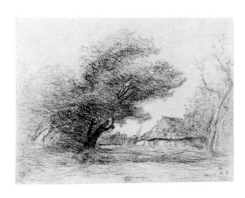

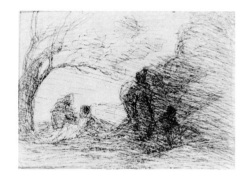

9
Kneeling Figure beside a Boulder (Mary Magdalen?), 1857
10.2 x 13.6 cm
BN impression inscr. in brown ink on mount: *Dessin sur verre pour photographie. épreuve unique. 1857*
Impressions: BN

10
Boatman and Boat on Riverbank, 1857
13.5 x 9.5 cm
BN impression inscr. in brown ink on mount: *dessin sur verre pour photographie. épreuve unique. 1857*
Impressions: BN

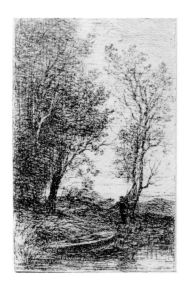

*11
Two Boatmen in Marsh near Cluster of Trees, c. 1857
12 x 16.5 cm
Impressions: Sagot-Le Garrec

*12
Le Soir—Pêcheurs (Evening—Fishermen), c. 1857
12.5 x 16 cm
Impressions: BN; H. Berès; A. Jammes

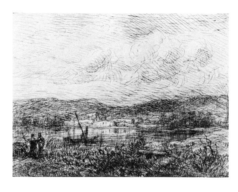

13
Figures on Wooded Bank of Stream, c. 1857
19.3 x 15.2 cm
BN impression inscr. in pencil on mount LC: *Dutilleux*
Impressions: BN

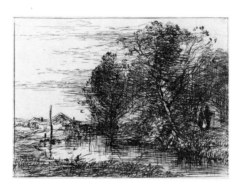

John Whetton Ehninger
American 1827-1889
Autograph Etchings by American Artists Produced by a New Application of Photographic Art, Under the Supervision of John W. Ehninger. Illustrated by Selections from American Poets. New York, W. A. Townsend & Co., 1859
12 cliché-verre illustrations printed by P. C. Duchochois
Page 33.6 x 25.4 cm

This volume can be found in the following coll.: Ann Arbor; Austin (Gernsheim); Boston; Boston Public Library; Chicago; Dickinson College Library, Carlisle, Pa.; Kent State Univ. Library, Ohio; LC; Calif. Univ. Library, Los Angeles; MMA; NCFA; NYPL (3); Princeton (2); George Eastman House, Rochester; Yale; Wm. B. Becker; A. H. Crane, Chicago; J. Stephany

List of plates (in order of appearance in bound volume):
*1
Asher Brown Durand 1796-1886
The Pool. 20.3 x 15 cm
In plate in reverse LL: *A B Durand*
Ill. for poem by F. S. Cozzens

2
Emmanuel Gottlieb Leutze 1816-1868
The Puritan. 20.5 x 15.9 cm
In plate LL: *E. Leutze*
Ill. for poem by J. G. Whittier

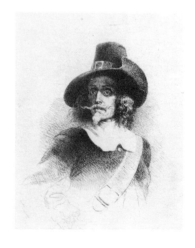

3
John Frederick Kensett 1816-1872
Autumn. 20.3 x 14.5 cm
In plate LL: *J.F.K.* (JF interlaced)
Ill. for poem by J. R. Lowell

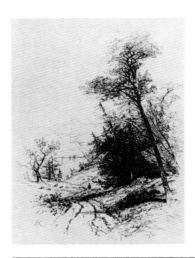

4
Felix Octavius Carr Darley 1822-1888
Noon. 15.2 x 20.3
In plate LR: *Darley*
Ill. for poem by W. C. Bryant

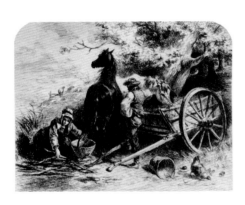

5
John William Casilear 1811-1893
The Lake. 20.3 x 15.4 cm
In plate LR: *J.W.C.*
Ill. for poem by Alfred B. Street
See fig. 4

*6
Eastman Johnson 1824-1906
The Wigwam. 13.5 x 12.6 cm
Ill. for poem by Charles Sprague

7
Sanford Robinson Gifford 1823-1880
Spring. 17.8 x 14.9 cm
In plate in reverse LL: *S. Gifford*
Ill. for poem by N. P. Willis

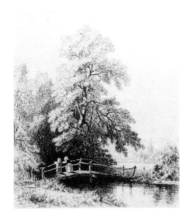

8
George Cochran Lambdin 1830-1896
Childhood. 15.2 x 18.2 cm
In plate LR: *Geo. C. Lambdin*
Ill. for poem by J. W. Parsons

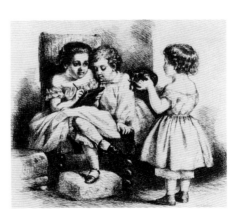

9
George Henry Boughton 1833-1905
Winter. 20 x 15 cm
In plate LR: *G. H. B.*
Ill. for poem by T. B. Read

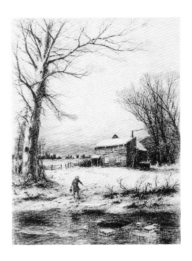

10
William Parsons Winchester Dana
1833-1927
The Seashore. 15 x 20.3 cm
In plate C (on boat): *WPW DANA*
Ill. for poem by Bayard Taylor
See fig. 3

*11
Louis Remy Mignot 1831-1870
The Tropics. 13.6 x 20.3 cm
In plate LL: *MIGNOT*
Ill. for poem by R. H. Stoddard

12
John Whetton Ehninger 1827-1889
The Exiles. 16 x 21.5 cm
In plate LL: *Ehninger*
Ill. for poem by H. W. Longfellow

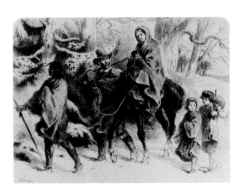

Stephen James Ferris
American 1835-1915
Portrait of Fortuny, 1873
17.8 x 12.8 cm
In plate LL: *Ferris Del/ Phot 1873*
Impressions: Smithsonian

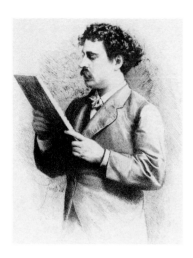

Camille Flers
French 1802-1868
*1
Peasant Woman and Boy Walking on Road,
1861
13.1 x 8.4 cm
In plate LR: *CF fe 1861* (*CF* interlaced)
Impressions: Texbraun

*2
Portuguese Rider, 1861
13.1 x 8.4 cm
In plate LL: *CF fe 1861/ Cintra* (*CF* interlaced)
Impressions: Texbraun

3
Dog Resting, 1861
6.3 x 8.2 cm
In plate LR: *CF fec. 1861/ Cintra* (*CF* interlaced)
Impressions: G. Lévy

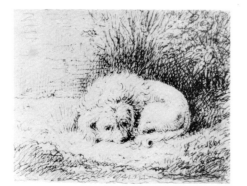

Antonio Fontanesi
Italian 1818-1882
1
*Title Page for an Album: Man Playing
Guitar*, 1863
13.9 x 17.4 cm
Glass plate: Geneva
Impressions: Geneva**; Turin

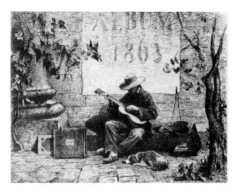

2
*Sur La Treille, Genève (On La Treille,
Geneva: Promenade under Trees)*, c. 1863
18.8 x 13.7 cm
Glass plate: Geneva
Impressions: Geneva**; Turin

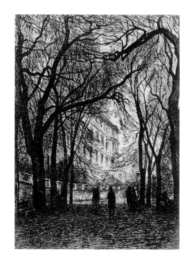

3
*Sur La Treille, Genève (On La Treille,
Geneva: Figures in the Park)*, c. 1863
16 x 23.2 cm
In plate UL: *A Fontanesi*
Glass plate: Geneva
Impressions: Geneva**; Turin priv. coll.

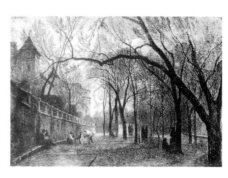

4
*Sur La Treille, maison Rigaud, Genève (On
La Treille: Rigaud House, Geneva)*, c. 1863
17.2 x 12.2 cm
In plate UL: *AF*
Glass plate: Geneva
Impressions: Geneva**; Turin

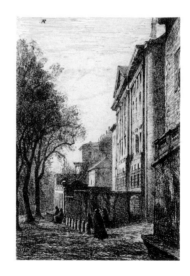

5
La Tour Baudet, Genève (Baudet Tower, Geneva), c. 1863
18 x 12.5 cm
In plate UL: *A Fontanesi*
Glass plate: Geneva
Impressions: Geneva**; Turin

7
Country Cottage at Hermance (later version of above image?), c. 1863
16.9 x 12.2 cm
Glass plate: Geneva
Impressions: Geneva**; Turin

9
Rural Buildings beyond a Meadow Stream, c. 1863
17 x 12.8 cm
In plate UL: *Fontanesi*
Glass plate: Geneva
Impressions: Geneva**; Turin

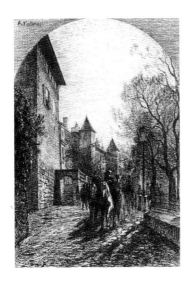

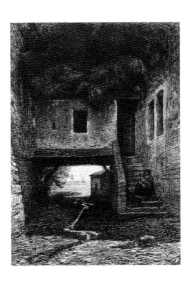

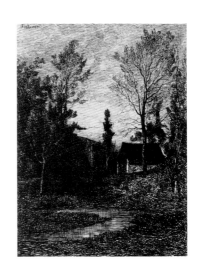

6
Country Cottage at Hermance: Woman and Child Seated on Steps, c. 1863
16.9 x 12.2 cm
In plate UL: *A Fontanesi*
Impressions: Geneva**; Turin priv. coll.

8
Landscape: River Bank with Cottage among Trees, c. 1863
17.1 x 12.4 cm
In plate UL: *A Fontanesi*
Glass plate: Geneva
Impressions: Geneva**; Turin

10
Landscape: Figure on Path at the Base of a Cliff, c. 1863
20.2 x 14.5 cm
In plate LR: *A Fontanesi*
Impressions: Geneva**; Turin

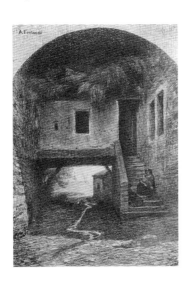

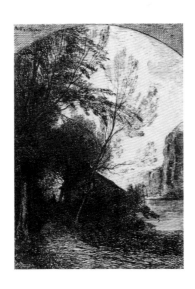

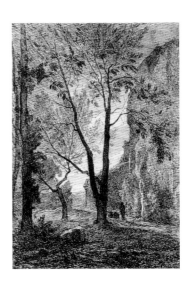

11
Landscape with Artist Sketching, c. 1863
25.8 x 15.2 cm
In plate UL: *AFontanesi*
Glass plate: Geneva
Impressions: Geneva**; Turin

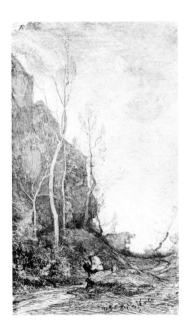

12
Wooded Landscape: Figure Reaching for Tree Branches with a Staff, c. 1863
19.8 x 15 cm
In plate UR: *A Fontanesi*
Impressions: Geneva

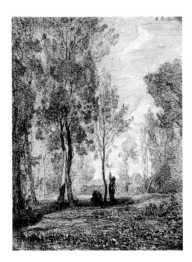

13
Figures in Deserted Landscape, c. 1863
13.6 x 21 cm
In plate UL: *A Fontanesi*
Impressions: Geneva

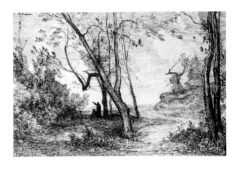

14
A Spring in the Wood, c. 1863
20 x 13.3 cm
In plate UL: *A Fontanesi*; in margin LC
(in reverse) and UL: *No 11*
Glass plate: Geneva (3 modern impressions made in 1979)

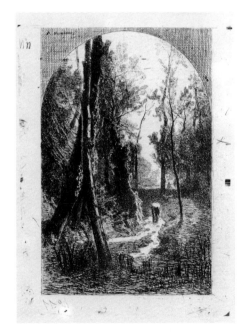

15
Woman at a Well in a Wooded Valley,
c. 1863
17.9 x 12.7 cm
In plate UL: *A Fontanesi*; in margin UR:
No 2
Glass plate: Geneva (3 modern impressions made in 1979)
Impressions: Turin

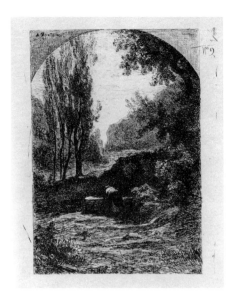

16
Women Drawing Water from a Spring in a Wood, c. 1863
24.4 x 34.4 cm
Impressions: Turin
Not ill.

17
Landscape with Ruined Castle, c. 1863
13 x 19.5 cm
In margin L: *No 4*
Glass plate: Geneva (3 modern impressions made in 1979)
Impressions: Turin

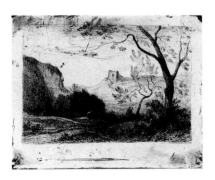

195

18
View of a Brook with an Italianate Castle in Background, c. 1863
14 x 18.5 cm
In margin LC (in reverse) and UL: *No 5*
Glass plate: Geneva (3 modern impressions made in 1979)
Impressions: Turin

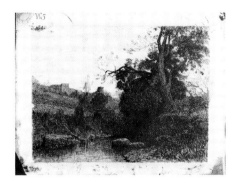

19
Landscape with a Peasant Kneeling beside a Stream, c. 1863
15.1 x 26.2 cm
In plate UL: *A Fontanesi*; in margin in reverse UL: *No 13*
Glass plate: Geneva (4 modern impressions made in 1979)
Impressions: Turin

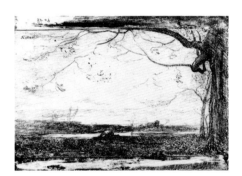

20
Frontispiece for an Album "Sketches of London," 1866
20.4 x 10.3 cm
In plate UC: *SKETCHES OF LONDON/ By/ A. FONTANESI* (N in reverse)
Impressions: Turin
Not ill.

21
London: Westminster Abbey with the Victoria Tower of the House of Lords, 1866
20.7 x 14.3 cm
In plate LL: *AFontanesi*
Impressions: Turin
Not ill.

22
London: Bank of the Thames with Big Ben and Houses of Parliament, 1866
15.5 x 21.2 cm
Impressions: Turin
Not ill.

23
London: St. Paul's Cathedral, beyond the Holborn Viaduct, seen from Fleet Street, 1866
16.8 x 12 cm
In plate LL: *AFontanesi*
Impressions: Turin
Not ill.

24
London: Entrance to the National Gallery, Trafalgar Square, 1866
18 x 13.2 cm
In plate LR: *AFontanesi*
Impressions: Turin
Not ill.

25
London: Prayers in St. Paul's, 1866
21 x 13.7 cm
In plate LR: *AF*
Impressions: Turin
Not ill.

26
London: Interior of St. Paul's
19.8 x 15.1 cm
In plate LR: *AF*
Impressions: Turin
Not ill.

27
London: The Church of St. Martin's-in-the-Fields, seen from St. Martin's Lane towards Trafalgar Square, with Nelson's Column, 1866
11.5 x 22 cm.
Impressions: Turin
Not ill.

28
London: Entrance to St. Paul's Cathedral, 1866
18.4 x 11.6 cm
Impressions: Turin
Not. ill.

29
A London Street with an Old Arch, 1866
19.4 x 14.1 cm
Impressions: Turin
Not. ill.

Lorenz Frölich
Danish 1820-1908
Figure Studies
19.7 x 20 cm
Glass plate: Copenhagen

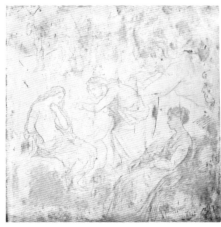

Sanford Robinson Gifford
American 1823-1880
See Ehninger

Adolphe-François Gosset
French 1815-1896
**Les Ramasseurs de bois (Woodgatherers)*, c. 1859/62
15 x 19 cm
In plate LR: *Gosset*
Impressions: Sagot-Le Garrec

Marcelin de Groiseilliez
French 1837-1880
*View of a Harbor, c. 1859/62
13 x 17.7 cm
In plate in reverse LR: *M. de Groiseilliez*
Impressions: Sagot-Le Garrec

Charles-François-Prosper Guérin
French 1875-1939
1
Bathsheba, c. 1900
21.1 x 27 cm
Impressions: Philadelphia (see Guérin no. 2
for inscr. information)

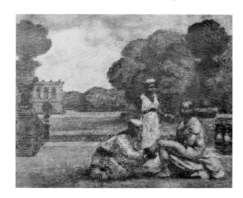

2
*Le Jardin aux marronniers (Garden with
Chestnut Trees)*, c. 1900
17.8 x 12.7 cm
Impressions: Philadelphia
On mounts of Philadelphia impressions
there are pencil inscr. LL: *Ch. Guérin*. In
the coll. A. Jammes, there are 4 cliché-verre
images, different from those cited above,
which are possibly in the style of Charles
Guérin; three depict costumed women, one
is of a costumed couple.

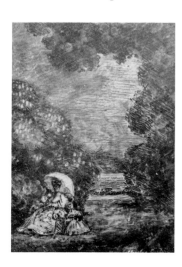

James Clarke Hook
English 1819-1907
See Cundall

Paul Huet
French 1803-1869
*1
*Bords de rivière ou La Mare aux trois
saules (Banks of a Stream or Pond with
Three Willows)*, c. 1861/68
15.7 x 22 cm
Delteil 92
Impressions: BN; Albuquerque; Baltimore
(Lucas); Boston; MMA; NGA; San Fran-
cisco; A. Jammes; Boston priv. coll.

*2
Le Pont (Bridge), c. 1861/68
14.5 x 22.3 cm
Delteil 93
Glass plate: BN (as School of Arras)
Impressions: BN; Austin; Boston; MMA;
Sagot-Le Garrec

*3
Le Torrent (Torrent), c. 1861/68
17 x 22.2 cm
Delteil 94
Impressions: BN; Baltimore (Lucas); MMA

4
*Vieilles Maisons à Honfleur (Old Houses
at Honfleur)*, c. 1855
15.7 x 11.5 cm
Delteil 95
Impressions: BN

*5
*Marécage ou Le Voyageur (Marsh or
Traveler)*, c. 1861/68
17.1 x 22.2 cm
Delteil 96
Impressions: Budapest; Fogg; MMA;
A. Jammes; Sagot-Le Garrec

*6
*Ruisseau sous bois ou Intérieur de forêt
(Brook under Trees or Forest Interior)*,
c. 1861/68
15.2 x 21.5 cm
Delteil 97
Impressions: BN; A. Jammes

7
*Souvenir de Bretagne ou Pâturages
d'Auvergne (Souvenir of Brittany or
Auvergne Pastures)*, c. 1861/68
15.7 x 21.6 cm
Delteil 98
Impressions: BN; Budapest; MMA

Charles-Emile Jacque
French 1813-1894
*1
*Chevaux de labour, près d'un hangar (Work
Horses near a Shed)*, c. 1859/62
15.3 x 18.7 cm
In plate in reverse LR: *Ch Jacque*
BN Inventaire 642
Impressions: BN; Baltimore (Lucas); Buda-
pest; Minneapolis; A. Jammes; Prouté;
Sagot-Le Garrec

*2
*Chemin à l'entrée d'un bois (Road at the
Entrance of a Wood)*, c. 1859/62
17.6 x 13.6 cm
In plate in reverse LL: *Ch Jacque*
BN Inventaire 643
Impressions: BN; Budapest; A. Jammes (2);
G. Lévy; Prouté (3); Sagot-Le Garrec

Eastman Johnson
American 1824-1906
See Ehninger

John Frederick Kensett
American 1816-1872
See Ehninger

Frederik Christian Kiaerskou
Danish 1805-1891
1
Stag beside Forest Stream, 1865
24 x 19.3 cm
In plate: LL, *Kiaersckou*; LR, *1865* (6 in reverse)
Impressions: Copenhagen

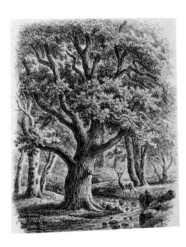

2
A Deer behind Beech Trees, c. 1865
23.4 x 17.8 cm
In plate LR: *Kiaersckou*
Impressions: Copenhagen

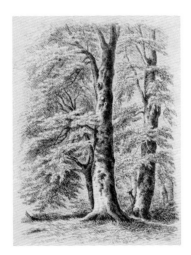

Victor Lainé
French 1817-1907
Berger gardant son troupeau (Shepherd Tending His Flock), 1862
12 x 18 cm
Plate with remarque 16.5 x 20.3 cm
In plate LR: *V Lainé 1862*
Impressions: Sagot-Le Garrec

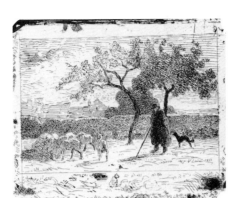

George Cochran Lambdin
American 1830-1896
See Ehninger

Emmanuel Gottlieb Leutze
American 1816-1868
See Ehninger

Paul Mallard
French 1809-?
Bridge across Mountain Stream
23.5 x 17.8 cm
In plate LR: *P. Mallard*
Impressions: A. Jammes

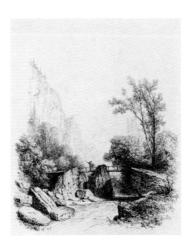

Louis Remy Mignot
American 1831-1870
See Ehninger

Jean-François Millet
French 1814-1875
1
La Précaution maternelle (Maternal Care), 1862
28.4 x 22.2 cm
In plate LR: *J. F. Millet*
Delteil 27; Lebrun 25; Melot M27
Glass plate: Louvre
Impressions: BN; Austin; Berlin (W.); Budapest; Chicago; Cleveland; Copenhagen; Minneapolis; NYPL; Ottawa; Sagot-Le Garrec; London priv. coll.
Editions: Sagot-Le Garrec 1921

*2
Femme vidant un seau (Woman Emptying a Bucket), 1862
28.6 x 22.2 cm
In plate in reverse LL: *J. F. Millet*
Delteil 28; Lebrun 26; Melot M28
Glass plate: BN
Impressions: BN; Baltimore; Berlin (W.); Boston; Budapest; Chicago; Copenhagen; Detroit; NYPL; H. Berès; G. Lévy; Sagot-Le Garrec; U.S. priv. coll.
Editions: Sagot-Le Garrec 1921

Jules-Achille Noël
French 1815-1881
Moonlit Landscape, 1855
8.9 x 12.7 cm
In plate UL: *JULES NOEL./1855* (N and *1855* in reverse)
Impressions: Austin (Gernsheim)

Jean-Amable-Amédée Pastelot
French c. 1820-1870
*1
In Vino Veritas, c. 1868
14 x 19.7 cm
In plate: LR, *Pastelot;* UR, *In Vino Veritas!*
Impressions: R. Fine

2
*Six Eaux-fortes, gravées sur verre par
A. Pastelot, procédé héliotypique*
Paris, Alp. Daix, 1868
Booklet of 6 cliché-verre prints plus cover
Each mounted on sheet 25.4 x 32.3 cm
 List of plates:
 1. *Title Page: Two Cupids Opening
 Portfolio,* 15.5 x 10.7 cm
 In plate UR: *No. 1*

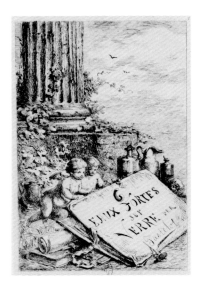

2. *Marshy Landscape,* 8.5 x 11.4 cm
 In plate: LR, *Pastelot;* UL, *1 bis*

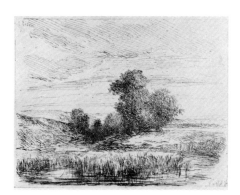

3. *Head of a Cavalier,* 14.5 x 11.4 cm
 In plate: LL, *Pastelot;* UR, 2

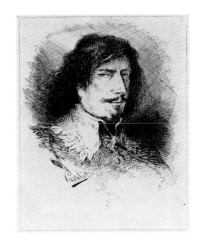

4. *River Scene,* 10.4 x 15.5 cm
 In plate: LR, *Pastelot;* UR, 3

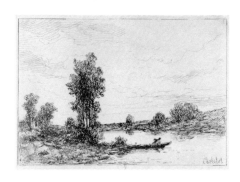

5. *Vanitas: Old Woman and Death,*
 11 x 7.6 cm
 In plate: UL, *Pastelot;* UR, *Va mieux!*
 and *4*
 Individual impression: Amherst

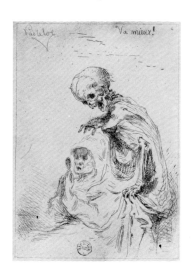

6. *Man Contemplating Skull,* 10 x 7.4 cm
 In plate: LR, *Pastelot 68;* above, *pulvis
 et umbra sumus;* UR, *5*
Coll.: BN

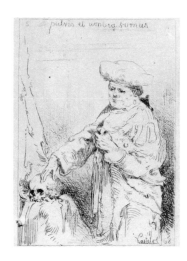

André-Toussaint Petitjean
French, active 1860s
Album including 3 clichés-verre, 1864-66
Each mounted on sheet 17.3 x 26.1 cm
 List of clichés-verre:
 *1. *Vue du Rio-Chico, 1ère étape de
 Durango à Mazatlan (View of the
 Chico River, 1st stage from Durango
 to Mazatlan),* c. 1865
 3 impressions, each 5.9 x 10.1 cm

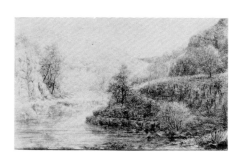

2. *Procession du Mercredi Saint à Durango (Procession of Holy Wednesday in Durango),* 1866
8.7 x 12.4 cm
In plate LC: *Pet. 1866*

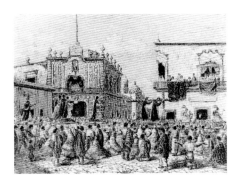

3. *Mill,* c. 1866
4.4 x 8 cm
In plate LR: *A.P.*
Coll.: Texbraun

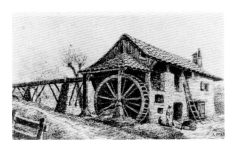

Alfred-Ernest Robaut
French 1830-1909
Standing Italian Boy with Staff (after Corot's painting *Jeune Italien marchant, un bâton dans la main droite,* 1826/28, see Bib. V Corot/Robaut, cat. no. 104)
17.8 x 11 cm
In plate in reverse LR: *COROT/A ROBAUT*
Impressions: A. Jammes (2)

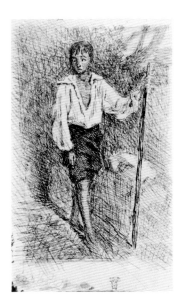

Félicien Rops
Belgian 1833-1898
Sketches, Including Standing Man, 1858
10.8 x 21.1 cm
In plate: UL, *Verographie/ F. Rops;* UR, *Felicien Rops/ Verographie/ Dandoy;* LR, *F Rops/ Verographie/ Dandoy;* LL, *1er Essai*
Impressions: A. Jammes

Pierre-Etienne-Théodore Rousseau
French 1812-1867
*1
Le Cerisier de la Plante-à-Biau (Cherry Tree at Plante-à-Biau), 1862
21.9 x 27.7 cm
In plate LL: *TH. Rousseau*
Delteil 5; Melot R5
Glass plate: BN
Impressions: BN (2); Boston; Budapest; Copenhagen; LC; Minneapolis; NGA; NYPL; H. Berès (3); A. Jammes (2); Sagot-Le Garrec
Editions: Sagot-Le Garrec 1921

2
La Plaine de la Plante-à-Biau (The Plain at Plante-à-Biau), 1862
22.3 x 28.2 cm
In plate LL: *TH. Rousseau*
Delteil 6; Melot R6
Glass plate: Louvre
Impressions: BN; Albuquerque; Boston; Budapest; Copenhagen; NYPL; Princeton; H. Berès (2); Sagot-Le Garrec
Editions: Sagot-Le Garrec 1921

Axel Schovelin
Danish 1827-1893
A Country Lane beside a Meadow
19.9 x 25.3 cm
In plate LL: *Schovelin*
Impressions: Copenhagen

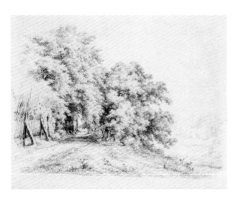

Nicolas-Eugène Trouvé
French 1808-1888
La Chaumière dans les arbres (Cottage among Trees), c. 1859/62
18.6 x 15 cm
In plate in reverse LL: *N. E. Trouvé*
Impressions: G. Lévy**; Sagot-Le Garrec

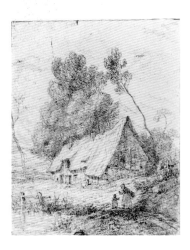

Jules-Jacques Veyrassat
French 1828-1893
Man Currying Horse outside a Stable,
c. 1859/62
11.9 x 16.5 cm
In plate LL: *J. Veyrassat*
Impressions: Baltimore (Lucas)

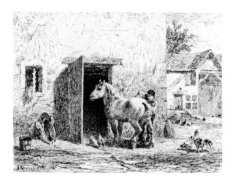

Adolphe-André Wacquez
French 1814- after 1865
*1
Le Bodmer au Bas-Bréau or *La Futaie au
Bas-Bréau (The Bodmer at Bas-Bréau* or
Thicket at Bas-Bréau), 1860
23.5 x 29.4 cm
In plate: LR, *A. Wacquez 1860;* LL, *Le
Bodmer au Bas Breau*
Impressions: Baltimore (Lucas 2); NGA;
G. Lévy; Sagot-Le Garrec

*2
*Arbres au bord d'une mare (Trees at the
Edge of a Pond),* 1860
22.6 x 28.9 cm
In plate LL: *A Wacquez 1860*
Impressions: Sagot-Le Garrec

*3
Ferme de Bodelu (Bodelu Farm), 1860
22.3 x 28.6 cm
In plate: LL, *A Wacquez 1860;* LR, *Ferme
de Bodelu*
Impressions: Sagot-Le Garrec**; Paris priv.
coll.

Frederick Walker
English 1840-1875
See Cundall

Unknown
1
*Plate with Three Images: Figures in a Cot-
tage Interior; River Landscape with Three
Trees; Figures in a Forest Landscape*
Plate: 19.6 x 16.5 cm; images: interior 8.9 x
15.2 cm, river landscape 5.6 x 9.8 cm, forest
landscape 9.6 x 9.5 cm
Impression of entire plate: Sagot-Le
Garrec**; impression of forest landscape:
H. Berès

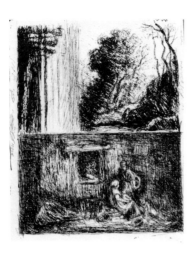

2
Landscape
6.9 x 4.6 cm
Impression: A. Jammes
Not ill.

3
Landscape: Figures beside a Log, attributed
to Corot
9 x 13.3 cm; plate: 11 x 15 cm
In plate LL: *COROT*
Glass plate: Paris priv. coll. (with modern
impression)
Not ill.

4
School of Arras
Tree Trunks
15.6 x 17 cm
Glass plate: BN
No impressions known

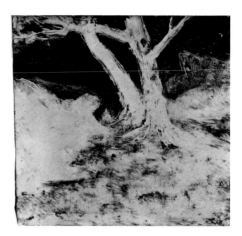

Glossary

Albumen

Albumen, or the white of an egg, was used for coating glass plate negatives in the 1850s, and for coating positive printing paper from 1850 to the 1890s. In 1847 Abel Niépce de Saint-Victor discovered that a glass plate covered with a thin layer of egg white (plus a few drops of potassium iodide) was a practical means of making a photographic negative. In 1850 Louis Desiré Blanquart-Evrard introduced glossy positive printing paper coated with albumen (sensitized with silver salts). The advantage of this paper was that it retained the sharpness and fine detail of a glass negative (whether camera-made or cliché-verre) better than previously used types of salted papers. Thus, an albumen print is a photograph on albumen-coated printing paper.

Blue Line Print

A process formulated in 1860 by the French chemist and photographic inventor Alphonse-Louis Poitevin, the blue line process or cyanofer produced blue lines on a white ground, the opposite of a cyanotype.

Collodion

A mixture of guncotton (a thick, viscous liquid made by treating cotton with concentrated nitric acid), alcohol, and ether that was first employed for dressing wounds. In 1851 Frederick Scott Archer first adapted the substance to photography as an emulsion for sensitizing silver on glass plates instead of on paper. As the plates were exposed in the camera while wet, the process came to be called "the wet plate process." The collodion coating for cliché-verre plates was allowed to dry in order to form a tight, thin skin across the glass. Thus, the cliché-verre artist ignored the light-sensitive properties of this material and instead drew through the dried collodion coating.

Contact Print

A print made by placing the negative on top (in contact with) light-sensitive material, usually paper. After exposure, the resulting image is the same size as the negative.

Countertype

A reproduction or copy from a waxed cliché-verre print or collodion-on-glass negative, usually done by Charles Desavary from Corot's clichés-verre. If from an original print, the cliché-verre was waxed so that it would be transparent enough to use as a paper negative. It was then contact-printed to a sensitized glass plate which would become the new glass plate negative. Prints made from this glass negative were countertypes. Some of the details of the cliché-verre prints from the original cliché-verre plate would be lost in the transposition of the image to a countertype. However, the risk to the fragile original plate, since it was thereby spared excessive use, was reduced.

Cyanofer

See Blue Line Print.

Cyanotype

This print, commonly known as blueprint, is made by a contact-printing process which uses the light sensitivity of iron salts to produce a deep blue color. Cyanotype was discovered in 1839 by Sir John Frederick William Herschel, the English astronomer and scientist. Cyanotypes are characterized by white lines against a blue ground.

Decalcomania

The word is from the French word *decalquer* (to transfer). The process was popularized by Surrealist artists such as Oscar Dominguez. The artist placed inks or water-based paints on a smooth surface, usually paper, and then placed another sheet on top of the painted surface, and, by pressure, transferred the paint to the second sheet. The resulting print was a variant of the monotype. The image usually looked like Rorshach ink-blot designs.

Dye-Transfer Method of Making Color Prints

The term "dye-transfer" is virtually self-explanatory. This color process uses three basic dyes: cyan (blue), magenta, and yellow. Color prints are made by transferring the dye absorbed in the film emulsion to commercial printing paper. The multiple-step process, which must be made from Matrix Film, is described in detail in pamphlets published by Kodak. The procedure can be done in a well-lit studio rather than in a darkroom. In the standard process, the image on a transparency or negative is used to make three separation matrices, one for each dye. Each matrix is then soaked individually in a separate color, and after the emulsion absorbs the dye, each matrix is contact-printed consecutively (cyan, magenta, then yellow), after each matrix is registered exactly on the printing paper. The dye is drawn from the emulsion to the paper. Superimposition of the three basic colors creates a variety of others. Caroline Durieux and Dr. John F. Christman adapted this basic technique to their cliché-verre process. They created a single matrix which they soaked in a mixture of the three dyes and then printed on paper. Varying the proportions of each dye in the mixture resulted in a different color.

Electron Printmaking

This process of printmaking with radioactive isotopes was first explored by Caroline Durieux in 1952, and developed by her for almost 30 years. To make an electron print, the artist drew with an ink or dye solution (to which a radioactive isotope was added) on a smooth surface (paper, acetate, film, glass). The resulting radioactive drawing was then placed in direct contact with a sheet of photographic paper in a light-tight envelope. The isotopes in the ink or dye solution gradually affected the halides in the photo-

graphic paper emulsion to produce, after processing, a mirror-image of the drawing wherever it touched the photographic paper. The duration of the contact-printing depends on the amount of radiation in the isotope and can vary from several hours to days. After that period, the drawing is removed and the photographic paper is developed. The resulting black-and-white print, made on photographic paper without the aid of light, is not radioactive. · Electron drawings transferred to Matrix Film produce color prints. Electron printmaking is a highly technical process which demonstrates the union of the graphic arts and nuclear energy.

Electrophotography

A photomechanical technique devised by Charles Hancock (act. 1860-1895) in which an artist drew on opaqued glass with an etching needle and the linear image was transferred by exposure to light to a photosensitized metal plate, which was then etched in relief, inked, and printed in the letterpress. The resulting print had the look of a wood engraving, even though it was produced by a photorelief printing process. The process is fully described in *Electrophotography or Etching on Glass* (Bib. IV Cundall; copy housed in the British Museum, London) and by Hancock in the preface to George Cruikshank's autobiography (Bib. V Cruikshank/Cruikshank; copy housed in the Prints Division, the New York Public Library).

Emulsion

The layer coated on the surface of paper or film which carries the light-sensitive chemicals. In the gelatin-silver process, for example, the coating consists of silver halide crystals, which are light-sensitive, supported in gelatin. Gelatin, the basis for modern photography since its emulsion properties were discovered by Dr. Richard Leech Maddox in 1871, is standardly used as emulsion on film and on commercially prepared printing papers.

Exposure

The act of letting light fall on light-sensitive material, either sensitized glass plates, film, or paper. The duration of the exposure depends on the sensitivity of the emulsion (on the plates, film, or paper) and on the intensity of the light source.

Frottage

A drawing technique in which an artist places paper on top of a textured surface (like wood), and with a pencil (or chalk or crayon), vigorously rubs across the paper, thereby obtaining a "shadow" of the texture. It is a means of visually translating three-dimensional texture into two-dimensional terms. Max Ernst came upon this technique in 1925 and frequently used it in his art.

Gelatin-Silver Print

The sensitivity of silver salts to light was first scientifically established by the German physicist Johann Heinrich Schulze in 1727. Gelatin is a natural protein substance (derived from animal skins and bones) that was used as a binding medium for holding the light-sensitive silver-halide crystals in suspension (see Emulsion). Many late-19th-century and 20th-century black-and-white photographic prints were made by exposing a negative onto commercially prepared printing paper, which is coated with a gelatinous emulsion containing either silver chloride, silver bromide, or silver iodide. The resulting print is known as a silver print, or, more properly, a gelatin-silver print.

Gum Bichromate Process

A contact-printing process onto a sheet of paper coated with a sensitized gum solution containing a colored pigment. The colors are determined by the artist's choice of pigment rather than the inherent tonality of the exposed emulsion. The initial steps of the gum process were originated by Alphonse-Louis Poitevin in 1855 (see Photolithography), but it was not fully developed until the 1890s, when its use was popularized by the photographer Robert Demachy. Because of the hand-manipulation involved in preparing and printing the paper, the gum bichromate freed the photographer who wanted to work with light-sensitive materials but who did not want to rely on those produced by photographic manufacturers. With gum bichromate, the artist could print his images with watercolors on rag paper sensitized with solutions of dichromate salts, such as potassium or ammonium dichromates, combined with gum arabic. For detailed information on the process, see Bib. IV Scopick.

Halation

A diffused halo effect around a line or edge of an image in a photographic print. In cliché-verre, this effect is caused by light rays being bent and scattered as they pass through the glass plate (placed with the drawn or emulsion coating side up rather than with the coating in direct contact with the printing paper), and being reflected back from the sensitized emulsion on the paper.

Matrix Film

A film with a thick emulsion manufactured by Kodak. After exposure, the emulsion that was exposed to light becomes insoluble, opaque, and stands out in barely perceptible relief. Unexposed portions of the film will wash away, leaving a clear or transparent area on the film surface.

203

Negative

An image on film or glass or other semi-transparent material (like thin paper) which can be used to make an unlimited number of photographic prints. The tones in the negative are the reverse of those in the final print (positive).

Photogram

An image made without a camera or lens by placing an arrangement of objects or materials directly onto photosensitive paper, and then exposing it to light and developing the paper photochemically. The resulting image is a design or silhouette pattern of varying tones of gray (depending on the opacity, transparency, or translucency of the objects placed on the paper). Since there is no matrix, each image is unique. The process is as old as the history of photography, since William Henry Fox Talbot's "photogenic drawings" were virtually photograms or self-made shadow likenesses of leaves and lace on sensitized paper. In 1918 Christian Schad invented in Zurich his own version of the process, which he called Schadographs. In 1921 Man Ray accidentally came upon the Rayograph or Rayogram, his term for photogram. Moholy-Nagy's cameraless experiments led to his independent discovery of the photogram technique in 1922, and he viewed it as the most direct way to create with light. Usually, photograms are nonrepresentational and abstract.

Photolithography

In 1855 Alphonse-Louis Poitevin invented a photolithographic technique founded on his discovering the effect of light on bichromated gelatin, glue, albumen, or gum (see Gum Bichromate), which were used as binders or emulsion bases for light-sensitive substances: light made these materials insoluble and water repellent, while parts not exposed to light absorbed water. He then adapted this discovery to lithography: greasy lithographic ink could be applied to those portions of emulsion-covered stone, which, after exposure under a negative, had been made water repellent by the light, and the grease would not stick to the moist areas unaffected by the light. After the greased image was transferred with the aid of photographic means, the stone was then inked and printed in the usual manner of lithography.

Positive

A photographic print made from a negative matrix or transparency. The dark areas of the positive print correspond to the transparent areas of the negative and the light areas of the positive print correspond to the dark, opaque areas of the negative.

Rayogram/Rayograph

See Photogram.

Reduction or Reduced Print

A photographic print that is smaller than the size of the negative or original cliché-verre matrix.

Reticulation

A wrinkling or vein-like crackling of the gelatinous emulsion on film that can be caused by temperature extremes during processing.

Salt Print

A photographic print made from glass or paper negatives on salted paper, i.e., paper that was soaked in a solution of common salt (sodium chloride) in water and a silver nitrate solution, forming silver chloride paper. As the silver salts were not coated in an emulsion on the paper but rather imbedded in it, the paper has a matte, nonglossy surface. Sometimes the salt prints, which tended to fade, were further stabilized with an after-treatment (varnished); other times the prints were toned in a chemical bath, which altered the usual tonalities of the salted paper print. Salted printing paper was widely used in the 19th century before the advent of albumen paper and gelatin-silver papers.

Schadograph

See Photogram.

Silver Print

See Gelatin-Silver Print.

Solarization

An aureole effect caused by the partial reversal of the negative by exposure to light during development. This is also known as the Sabattier effect. Man Ray accidentally discovered solarization in 1929 and often used it on his camera-made images after 1930.

Tamponnage

A French word for the "tapping" technique of softly hitting the coated glass plate with the stiff bristles of a brush to create a tonal area with dots in the cliché-verre ground. This method for making tone was used by Corot, Daubigny, and other 19th-century cliché-verre artists.

Van Dyke Brown Printing

A method of contact-printing a matrix when a print in a rich monochromatic brown is desired by the artist. A sheet of paper is first coated with the light-sensitive solution of ferric ammonium citrate, tartaric acid, silver nitrate, and water. After the paper is dry, it is exposed to light through a matrix. After exposure, the paper is processed and the brown color appears where light penetrated the negative and contacted the paper.

Bibliography

I.
General Works: Standard Catalogues Raisonnés and Reference Books

Bailly-Herzberg, Janine. *L'Eau-forte de peintre au dix-neuvième siècle: La Société des Aquafortistes (1862-1867).* 2 vols. Paris: Léonce Laget, 1972.

Bénézit, E. *Dictionnaire critique et documentaire des peintres, sculpteurs, dessinateurs et graveurs.* 10 vols. Paris: Librairie Grund, 1976.

Beraldi, Henri. *Les Graveurs du XIXe siècle.* 12 vols. Paris: Librairie L. Conquet, 1885-92 (see Bib. V for specific vols.).

Delteil, Loys. *Le Peintre-Graveur illustré.* 31 vols. Paris: the author, 1906-26 (see Bib. V for specific vols.).

Lugt, Frits. *Les Marques de collections de dessins et d'estampes.* Amsterdam: Vereenigde Druk, 1921; Supplement. The Hague: Martinus Nijhoff, 1956.

Paris, Bibliothèque Nationale, Département des Estampes. *Inventaire du Fonds Français après 1800* by Jean Laran, Jean Adhémar, and others (see Bib. V for specific vols.).

Thieme, Ulrich and Becker, Felix. *Allgemeines Lexikon der bildenden Künstler von der antike bis zur gegenwart.* 37 vols. Leipzig: W. Engelmann, 1907-50.

II.
General Works: Books and Catalogues with General Histories, which either specifically discuss cliché-verre, provide a context for the medium, or furnish information on artists and works represented in the exhibition.

Barbizon, France. *Barbizon au temps de J. F. Millet, 1849-1875,* exh. cat., May 3-June 2, 1975.

Baro, Gene. *30 Years of American Printmaking.* Brooklyn, New York: Brooklyn Museum, 1976.

Coke, Van Deren. *The Painter and the Photograph.* Albuquerque: University of New Mexico Press, 1972.

Fielding, T. H. *The Art of Engraving.* London: Ackerman & Co., 1841.

Gassies, Jean-Georges. *Le Vieux Barbizon. Souvenirs du jeunesse d'un paysagiste 1852-1875.* Intro. by G. (Gaston) Lafenestre. Paris: Librairie Hachette & Cie, 1907.

Gernsheim, Helmut and Alison. *The History of Photography, from the Camera Obscura to the Beginning of the Modern Era.* New York, St. Louis, San Francisco: McGraw-Hill Book Co., 1969.

Herbert, Robert L. *Barbizon Revisited.* New York: Clarke and Way, 1962.

Hitchcock, Ripley. *Etching in America.* New York: White, Stokes and Allen, 1886.

Hunt, Robert. *A Popular Treatise on the Art of Photography.* Glasgow: Richard Griffin & Co., 1841.

Ivins, William, M., Jr. *Prints and Visual Communication.* 2nd ed. Cambridge, Massachusetts and London, England: The M.I.T. Press, 1968.

Jussim, Estelle. *Visual Communication and the Graphic Arts, Photographic Technologies in the Nineteenth Century.* New York, London: R. R. Bowker Co., 1974.

Newhall, Beaumont. *On Photography, a Source Book of Photo History in Facsimile.* Watkins Glen, New York: Century House, 1956.

Newhall, Beaumont. *Latent Image, The Discovery of Photography.* Garden City, New York: Doubleday, 1967.

New York, Shepherd Gallery. *The Forest of Fontainebleau, Refuge of Reality: French Landscape 1800 to 1870.* Intro. by John Minor Wisdom, Jr.; catalogue by John Ittmann, Robert Kashery, Martin L. H. Reymert; Corot entries by Victor Carlson, 1972.

Philadelphia Museum of Art. *The Second Empire, Art in France under Napoleon III,* exh. cat. by V. Beyer, K. B. Hiesinger, J.-M. Moulin, J. Rishel, 1978.

Pollack, Peter. *The Picture History of Photography, from the Earliest Beginnings to the Present Day.* Rev. and enlarged ed. New York: H. N. Abrams, 1969.

Rotzler, W. *Photography as Artistic Experiment from Fox Talbot to Moholy-Nagy.* New York: Amphoto, 1976.

Scharf, Aaron. *Creative Photography.* London: Studio Vista Ltd., 1965.

Scharf, Aaron. *Art and Photography.* London: Allen Lane, The Penguin Press, 1968. Rev. ed. Harmondsworth, England and Baltimore: The Penguin Press, 1974.

White, Minor. Intro. to *French Primitive Photography.* Commentaries by André Jammes and Robert Sobieszek. New York: Aperture, 1969.

Zigrosser, Carl. *Prints and their Creators, A World History.* 2nd rev. ed. New York: Crown Publishers, Inc., 1974.

III.
Cliché-Verre: Books, Articles, and Catalogues on the Medium

"The Elliottype," *The Art Journal* (London, May 1858), p. 148.

The Athenaeum: Journal of Literature, Science and the Fine Arts (London), 589 (Feb. 9, 1839), pp. 114-117; 591 (Feb. 23, 1839), p. 156; 597 (April 6, 1839), pp. 26, 259. (Series of articles about Talbot's, Havell and Willmore's findings.)

Aubry, Yves. "Photostories, Les Clichés-Verre I: Corot, L'Initiateur," *Zoom* 51 (March 1978), pp. 100-105.

Aubry, Yves. "Photostories, Les Clichés-Verre II: La Collection Sagot-Le Garrec," *Zoom* 53 (May 1978), pp. 16-21.

Aubry, Yves. "Photostories, Les Clichés-Verre III: L'Ecole d'Arras et de Barbizon," *Zoom* 54 (June 1978), pp. 122-129.

Bailly-Herzberg, Janine. "Les Clichés-Verre," *Connaissance des Arts* 277 (March 1975), pp. 45-50.

Bailly-Herzberg, Janine. "L'Ecole de Barbizon: Rousseau, Daubigny et 'petits maîtres,' " *Connaissance des Arts* 293 (July 1976), pp. 75-82.

Barnard, Osbert H. "The 'Clichés-Verre' of the Barbizon School," *Print Collector's Quarterly* 9, 2 (April 1922), pp. 149-172.

Bement, Alon. "The Making of Cliché Glass Prints, A Forgotten Process," *Art Center Bulletin* 4 (Dec. 1925), pp. 109-112.

Billeter, Erika. *Malerei und Photographie im Dialog von 1840 bis Heute*. Zurich: Kunsthaus Zurich and Bern: Benteli Verlag, 1977. (See chapter "Die Sonderleistung: das Cliché-Verre," pp. 142-147.)

"Clichés-Verre Again," *The Bookman's Journal and Print Collector* 10 (Sept. 1924), p. 206.

"Cliché-Glace Prints," *Bulletin of the Milwaukee Art Institute* 16, 3 (Nov. 1941), p. 2.

Cailac, Jean. "Le Cliché-Verre: Tirages, Contretypes, Conclusion," *L'Information artistique* 11 (May 1954), pp. 78-81.

Cate, Phillip Dennis. "The Revolutionary Intrigue among 19th-century Printmakers," *Art News* 77, 3 (March 1978), pp. 77-84.

Congrès International de Photographie. *Rapports et Documents.* Paris: Gautier-Villars et fils (1890), p. 44; (1891), pp. 37, 84-85.

M(onsieur). Cuvelier (d'Arras). "Sur Plusieurs Méthodes de Dessins Héliographique," *Bulletin de la Société Française de Photographie* 2, 1 (Jan. 1856), pp. 23-24.

Dembling, Merwin. "Cliches Verres," *Minicam Photography* 12 (June 1949), pp. 82-85.

Edwards, Hugh. "Cliché-Verre and Corot," *Art Institute of Chicago Quarterly* 54, 3 (Sept. 1960), pp. 4-5.

Frank, Thomas. "Cliché-Verre Revient," *Michigan Art Journal* 1, 4 (Winter 1977), p. 10.

Gernsheim, Helmut and Alison. "1800-Talsmalarna och den fotografiska Konsten," *Konstrevy* (Stockholm) 30, 5-6 (1954), pp. 211-214.

Glassman, Elizabeth. "The Cliché-Verre in the Nineteenth Century." Unpublished Master of Arts thesis, University of New Mexico, Albuquerque, December 1977.

Gusman, Pierre. "Le Dessin sur Verre ou Cristallographie," *Byblis* 2 (Spring 1923), pp. 22-24.

Harville and Pont, B. "Nouveau Procédé de gravure et d'impression photographique," *Bulletin de la Société Française de Photographie* 1, 12 (Dec. 1855), pp. 358-369.

Hausberg, Meg Dunwoody. "Cliché-Verre," *Print Review* 9 (March 1979), pp. 39-48.

Hédiard, Germain. "Les Procédés sur Verre," *Gazette des Beaux-Arts* 30 (Nov. 1903), pp. 408-426.

Heintzelman, Arthur W. "Cliché-Verre," *The Boston Public Library Quarterly* 5 (July 1953), pp. 159-163.

Le Garrec, Maurice. Intro. to *Quarante Clichés-glace de Corot, Daubigny, Delacroix, Millet, Rousseau tirés sur les plaques provenant de la collection de M. Cuvelier.* Paris: Maurice Le Garrec, 1921.

The Literary Gazette (London) 1150 (Feb. 2, 1839), pp. 72-75; 1157 (March 23, 1839), p. 187; 1158 (March 30, 1839), pp. 201-204; 1159 (April 6, 1839), p. 215; 1160 (April 13, 1839), pp. 235-236 (articles on Talbot's process and Havell and Willmore's process).

"The Exhibition of Photographs and Daguerreotypes by the London Photographic Society," *The Liverpool Photographic Journal* 1 (1854), pp. 17-18.

London, Sotheby and Co. *Important Nineteenth Century and Modern Prints, Comprising the Property of the Late Dr. Felix Somary, etc.*, sale cat., April 23, 1974.

Lucerne, Gilhofer and Ranschburg. *Une Collection merveilleuse des eaux-fortes, lithographies, clichés-verres des grand maîtres français du XIXe siècle*, foreword by Dr. Simon Meller, sale cat., June 8-9, 1926 (Collection Albert Bouasse-Lebel).

Melot, Michel. *L'Oeuvre gravé de Boudin, Corot, Daubigny, Dupré, Jongkind, Millet, Théodore Rousseau.* Paris: Arts et Métiers Graphiques, 1978 (see "Note sur les clichés-verre," pp. 21-24).

Paris, Hôtel Drouot. *Catalogue des lithographies, eaux-fortes . . . dessins, composant la seconde partie de la collection Germain Hédiard*, sale cat., Nov. 29-30, 1904.

Rochester, New York, International Museum of Photography at George Eastman House. *The Photographers' Hand*, exh. cat. by Susan Dodge Peters, July 17-Sept. 16, 1979 (to be published 1980).

San Francisco, Thackrey and Robertson. *The R. E. Lewis Collection of Prints in Cliché-Verre*, exh. cat., intro. by Sean H. Thackrey, Oct. 15-Nov. 31, 1977.

Symmes, Marilyn F. "Clichés-verre: prints made without ink or press," *Print News* 2, 2 (April/May 1980), pp. 1-5.

Tabarant, Charles. "Les Procédés sur Verre," *Le Bulletin de la Vie Artistique* (Nov. 15, 1921), pp. 577-581.

Time-Life Books. *The Print.* New York: Time-Life, 1970.

IV.
Cliché-Verre: Articles and Books About the Technique and Photographic Printing Processes Applicable to this Medium

"More about Lumiprinting," *American Artist* 7, 2 (Feb. 1943), pp. 35-36.

"Interest in Lumiprinting Continues," *American Artist* 7, 4 (April 1943), pp. 32, 38.

"Making Prints by the Cliché-Verre Process," *Art Instruction* (Nov. 1938), pp. 10-11.

"Photo-Electrographs, or Etchings on Glass," *The Builder* (London, June 18, 1864), p. 457.

Cundall, Joseph. *Electrophotography or Etching on Glass.* London: Joseph Cundall, Downes & Co., 1864.

Davy, H. "An Account of a Method of Copying Paintings upon Glass and of Making Profiles by the Agency of Light upon Nitrate of Silver. Invented by T. Wedgwood Esq.," *Journal of the Royal Institution* (London, June 22, 1802), pp. 170-174 (authors' note: also reprinted in Bib. II Newhall, pp. 8-13).

"A Classroom Art Project, Helioprints," *Design* 53, 4 (Jan. 1952), p. 95.

Di Gemma, Joseph. *Lumiprinting, a New Graphic Art.* New York: Watson-Guptill Publications, Inc., 1942.

Guptill, Arthur L. "Lumiprinting, a New Graphic Art as Developed by Joseph di Gemma," *American Artist* 6, 10 (Dec. 1942), pp. 27-29.

Holter, Patra. *Photography without a Camera.* London: Studio Vista and New York: Van Nostrand Reinhold Co., 1972.

Nettles, Bea. *Breaking the Rules, A Photo Media Cookbook.* Rochester, New York: Inky Press Productions, 1977.

"To Produce Etchings in Imitation of the Old Masters," *The Photographic Journal* 13, 193 (London, May 16, 1868), p. 60.

Rice, William S. "Glass Prints," *Design* 54, 2 (Nov. 1952), pp. 35, 44.

Rice, William S. "Pseudo-Etchings," *Design* 57, 4 (March 1956), p. 144.

"Making Glass Prints," *School Arts* 41 (March 1942), pp. 238-239.

Scopick, David. *The Gum Bichromate Book, Contemporary Methods for Photographic Printmaking.* Rochester, New York: Light Impressions, 1978.

V.
Works by or about Artists who have made clichés-verre, listed alphabetically by artist

Blondeau
Lebe, David, Redmond, Joan S., and Walker, Ron, eds. *Barbara Blondeau 1938-1974.* Rochester, New York: Visual Studies Workshop, 1976. (Authors' note: In 1966 Blondeau, a photographer, experimented with the cliché-verre process.)

Hagen, Charles. "Barbara Blondeau," *Afterimage* 3, 9 (March 1976), pp. 10-13.

Bloom
Bloom, John. "Cliché-Verre: A Scratch in the Surface." Unpublished Master of Arts in Photography thesis, University of New Mexico, Albuquerque, May 1978.

Brassai
Brassai. Intro. to *Transmutations.* Lacoste, Vaucluse, France: Editions Galerie les Coutards, 1967.

Hill, Paul and Cooper, Thomas. *Dialogue with Photography.* New York: Farrar, Straus, Giroux, 1979, pp. 37-43 (interview with Brassai).

Bruguière
Enyeart, James. *Bruguière, His Photographs and His Life.* New York: Alfred A. Knopf, 1977.

Chintreuil
Fizelière, Albert de la, Champfleury, and Henriet, Frédéric. *La Vie et l'oeuvre de Chintreuil.* Paris: A. Cadart, 1874.

Collette
Paris, Bibliothèque Nationale. *Inventaire du Fonds Français après 1800.* Vol. 5 by Jean Adhémar. Paris: Bibliothèque Nationale, 1949, pp. 111-118.

Corot
Arras, France, Musée d'Arras. *Corot, Constant Dutilleux, leurs amis et leurs élèves,* exh. cat., June 20-Oct. 24, 1954.

Art Institute of Chicago. *Corot (1796-1875), an Exhibition of His Paintings and Graphic Works,* exh. cat., with essays by S. Lane Faison, Jr. and James Merrill, Oct. 6-Nov. 13, 1960.

(Corot, J.-B.-C.). See Beraldi, vol. 5 (1886), pp. 48-54.

Delteil, Loys. *Le Peintre-Graveur illustré—Corot.* Vol. 5. Paris: the author, 1910.

Lemoisne, Paul-André and Laran, Jean. *Estampes et dessins de Corot.* Paris: Bibliothèque Nationale, 1931.

Moreau-Nelaton, Etienne. *Corot, raconté par lui-même.* 2 vols. Paris: Laurens, 1926.

Paris, Bibliothèque Nationale. *Inventaire du Fonds Français après 1800.* Vol. 5 by Jean Adhémar. Paris: Bibliothèque Nationale, 1949, pp. 184-196.

Paris, Orangerie des Tuileries. *Hommage à Corot,* exh. cat., June 6-Sept. 29, 1975.

Robaut, Alfred. *L'Oeuvre de Corot.* 4 vols. Paris: H. Floury, 1905.

Turin, L'Arte Antica. *J. B. Camille Corot e i Maestri del Cliché-Verre attiva tra il 1850 e il 1875,* exh. cat. by Harry Salaman, April 26-May 26, 1966.

Cruikshank
Cohn, Albert M. *George Cruikshank, a Catalogue Raisonné of the Works Executed during the Years 1806-1877.* London: from the office of "The Bookman's Journal," 1924.

Cruikshank, George. *A Handbook for Posterity, or Recollections of Twiddle Twaddle.* Preface by Charles Hancock. London: W. T. Spenser, 1896.

Douglas, Richard John Hardy. *The Works of George Cruikshank: Classified and Arranged with References to Reid's Catalogue.* London: J. Davy and Sons at the Dryden Press, 1903.

Feaver, William. *George Cruikshank.* London: Arts Council of Great Britain, 1974.

Daubigny
Bailly-Herzberg, Janine and Fidell-Beaufort, Madeleine. *Daubigny.* Paris: Geoffroy-Dechaume, "La Vie et l'oeuvre," 1975.

(Daubigny, C.-F.). See Beraldi, vol. 5 (1886), pp. 91-98.

Delteil, Loys. *Le Peintre-Graveur illustré—Daubigny.* Vol. 13. Paris: the author, 1921.

Fidell-Beaufort, Madeleine. "The Graphic Art of Charles-François Daubigny." Unpublished Doctor of Philosophy dissertation, 2 vols., Department of Fine Arts, New York University, 1974.

Henriet, Frédéric. *C. Daubigny et son oeuvre gravé.* Paris: A. Lévy, 1875.

Paris, Bibliothèque Nationale. *Inventaire du Fonds Français après 1800.* Vol. 5 by Jean Adhémar. Paris: Bibliothèque Nationale, 1949, pp. 411-424.

Delacroix

(Delacroix, E.). See Beraldi, vol. 5 (1886), pp. 154-166.

Delteil, Loys. *Le Peintre-Graveur illustré—Delacroix*. Vol. 3. Paris: the author, 1908.

Joubin, André. *Correspondance générale d'Eugène Delacroix*. 5 vols. Paris: Librairie Plon, 1936-38.

Paris, Bibliothèque Nationale. *Inventaire du Fonds Français après 1800*. Vol. 6 by Jean Adhémar and Jacques Lethève. Paris: Bibliothèque Nationale, 1953, pp. 119-129.

Robaut, Alfred. *L'Oeuvre complet d'Eugène Delacroix*. Paris: Charavay Frères, Editeurs, 1885 (with comments by Ernest Chesneau and the collaboration of Fernand Calmettes).

Desavary

(Desavary, C.-P.). See Beraldi, vol. 5 (1886), pp. 187-188.

Paris, Bibliothèque Nationale. *Inventaire du Fonds Français après 1800*. Vol. 6 by Jean Adhémar and Jacques Lethève. Paris: Bibliothèque Nationale, 1953, pp. 323-324.

Durieux

Archives of American Art, Smithsonian Institution. Unpublished transcript of tape-recorded interview with Caroline Durieux (interviewer: Dennis Barrie), June 1, 2, 1978.

Cox, Richard. *Caroline Durieux, Lithographs of the Thirties and Forties*. Baton Rouge and London: Louisiana State University Press, 1977.

Durieux, Caroline. *43 Lithographs and Drawings*. Foreword by Carl Zigrosser. Baton Rouge: Louisiana State University Press, 1949.

Dutilleux

(Dutilleux, C.). See Beraldi, vol. 6 (1877), pp. 79-80.

Oursel, Hervé. *Constant Dutilleux, 1807-1865, Commémoration du centenaire de la mort de l'artiste*, exh. cat., Musée d'Arras, Aug.-Nov. 1965.

Paris, Bibliothèque Nationale. *Inventaire du Fonds Français après 1800*. Vol. 7 by Jean Adhémar and Jacques Lethève. Paris: Bibliothèque Nationale, 1954, pp. 285-286.

Ehninger

Becker, William B. "The American 'Cliché-Verre,'" *History of Photography* 3, 1 (Jan. 1979), pp. 71-80.

Boston, Museum of Fine Arts. *M. & M. Karolik Collection of American Water Colors and Drawings 1800-1875*. Boston: 1962, I, pp. 149-151.

Ehninger, John W. "Publisher's Preface," *Autograph Etchings by American Artists*. New York: W. A. Townsend and Company, 1859.

Ernst

Leppien, Helmut R. *Max Ernst, Das graphische Werk*. Essay by Werner Spies. Cologne: Verlag M. DuMont Schauberg and Houston: Menil Foundation, 1975.

New York, Solomon R. Guggenheim Museum. *Max Ernst: a Retrospective*. Essay by Diane Waldman, 1975.

Spies, Werner and Konnertz, Winfried. *Max Ernst Books and Graphic Work*. Cologne: DuMont Buchverlag, 1977.

Flers

Paris, Bibliothèque Nationale. *Inventaire du Fonds Français après 1800*. Vol. 7 by Jean Adhémar and Jacques Lethève. Paris: Bibliothèque Nationale, 1954, p. 596.

Florence

Kossoy, Boris. "Hercules Florence, Pioneer of Photography in Brazil," *Image* 20, 1 (March 1977), pp. 12-21.

Fontanesi

Turin, Palazzo Chiablese. *Antonio Fontanesi, L'Opera Grafica*, exh. cat. by Angelo Dragone, Nov. 23-Dec. 16, 1979.

Hajek-Halke

Hajek-Halke, Abstract Pictures on Film, The Technique of Making Light Graphics. Intro. by Franz Roh. New York: A Studio Book, The Viking Press, 1965.

Roh, Franz. "Light-Graphics, Hajek-Halke," *Camera* 43, 12 (Dec. 1964), pp. 32-34, 41.

Havell

The Reading Museum and Art Gallery, England. *William Havell, 1782-1857*, exh. cat., Feb. 20-March 21, 1970.

The Reading Museum and Art Gallery, England. *The Havell Family*, exh. cat., Feb. 10-March 17, 1973.

Huet

(Huet, Paul). See Beraldi, vol. 8 (1889), pp. 128-133.

Delteil, Loys. *Le Peintre-Graveur illustré—Huet*. Vol. 7. Paris: the author, 1911.

Paris, Bibliothèque Nationale. *Inventaire du Fonds Français après 1800*. Vol. 10 by Jean Adhémar, Jacques Lethève, and Françoise Garday. Paris: Bibliothèque Nationale, 1958, pp. 519-522.

Jacque

(Jacque, C.-E.). See Beraldi, vol. 8 (1889), pp. 162-192.

Paris, Bibliothèque Nationale. *Inventaire du Fonds Français après 1800*. Vol. 11 by Jean Adhémar, Jacques Lethève, and Françoise Garday. Paris: Bibliothèque Nationale, 1960, pp. 99-132.

Johnson

Johnson, Lois. "Cliché-Verre." Unpublished Master of Fine Arts thesis, University of Wisconsin, Madison, 1966.

Kepes

Gyorgy Kepes, The MIT Years 1945-1977, exh. cat. with essays by Jan van der Marck and Judith Wechsler. Cambridge, Massachusetts: Massachusetts Institute of Technology and the MIT Press Visual Arts Series, 1978.

Kepes, Gyorgy. *Language of Vision*. Chicago: Paul Theobald, 1944.

Klee

Baumgartner, Marcel. *Paul Klee und die Photographie*. Bern: Kunstmuseum, 1978, pp. 23-28.

Klee, Felix, ed. *The Diaries of Paul Klee 1898-1918*. London: Peter Owen, 1965.

Lainé

Wever, Charles. "Victor Lainé 1817-1907," *Bulletin de la Société d'Archéologie, Sciences, Lettres et Arts de Département de Seine-en-Marne* 13 (1910), pp. 211-228.

Menzel

Wiener Photographische Blätter 3 (Jan. 1896), p. 18.

Migliori

Quintavalle, Arturo Carlo. *Antonio Migliori*. Parma, Italy: Università di Parma, 1977. (Authors' note: Migliori made clichés-verre 1950-70; see pp. 33-35.)

Millet

Bailly-Herzberg, Janine. "Millet," *Connaissance des Arts* 284 (Oct. 1975), pp. 115-120.

Delteil, Loys. *Le Peintre-Graveur illustré—Millet, Rousseau, Jongkind, Dupré*. Vol. 1. Paris: the author, 1906.

208

Herbert, Robert L. *Jean-François Millet*, exh. cat., Paris, Galeries nationales du Grand Palais, Oct. 17, 1975-Jan. 5, 1976.

Lebrun, Alfred. *The Etchings and Other Prints of Jean-François Millet*, translated by Frederick Keppel. New York: Frederick Keppel and Co., 1887.

(Millet, J.-F.). See Beraldi, vol. 10 (1890), pp. 63-71.

Picasso
Barr, Alfred. *Picasso: Fifty Years of His Art*. New York: Museum of Modern Art, 1974 (1st ed. 1946).

Brassai. *Conversations avec Picasso*. Paris: Gallimard, 1964 (English ed.: *Picasso and Company*, preface by Henry Miller; intro. by Roland Penrose. New York: Doubleday, 1966).

Man Ray. "Picasso Photographe," *Cahiers d'Art* 12, 6-7 (1937), pp. 167-175.

Man Ray
Hill, Paul and Cooper, Thomas. *Dialogue with Photography*. New York: Farrar, Straus, Giroux, 1979, pp. 9-20 (interview with Man Ray).

Janus. *Man Ray, L'immagine fotografica*. Venice: Edizioni "La Biennale di Venezia," 1977.

Milwaukee Art Center. *Man Ray Photo Graphics from the Collection of Arnold H. Crane*, exh. cat., intro. by Arnold H. Crane, Feb. 10-March 11, 1973.

New York, Alexander Iolas Gallery. *Man Ray*. Intro. by Janus. Italy: Grafic Olimpia, 1974.

Penrose, Roland. *Man Ray*. Boston: New York Graphic Society, 1975.

Schwarz, Arturo. *Man Ray, the Rigour of Imagination*. New York: Rizzoli, 1977.

Rezvani (Hobbeheydar)
Scottsdale, Arizona, Scottsdale Center for the Arts. *Shahrokh Rezvani (Hobbeheydar) Prints, Paperworks, Mixed Media, Monotypes*, exh. cat., April 7-30, 1979.

Robaut
(Robaut, A.). See Beraldi, vol. 11 (1891), pp. 202-203.

Rousseau
Delteil, Loys. *Le Peintre-Graveur illustré—Millet, Rousseau, Jongkind, Dupré*. Vol. 1. Paris: the author, 1906.

Paris, Musée du Louvre. *Théodore Rousseau, 1812-1867*, exh. cat. by Hélène Toussaint, Nov. 29, 1967-Feb. 12, 1968.

(Rousseau, T.). See Beraldi, vol. 11 (1891), pp. 268-270.

Sal
Sal, Jack. "Cliché-verre: Cameraless Imagery," *Portfolio* 6, 2 (Fall 1979), pp. 20-21.

Scholder
Adams, Clinton. *Fritz Scholder Lithographs*. Boston: New York Graphic Society, 1975.

Scholder, Fritz. "Scholder on Scholder, A Self Interview," *American Indian Art Magazine* 1, 2 (Spring 1976), pp. 50-55.

Smith, H. H.
Bloomington, University of Indiana Art Museum. *Henry Holmes Smith's Art: Fifty Years in Retrospect*, exh. cat. ed. by Wanda Lee Smith, Fall, 1973.

Bossen, Howard. "Henry Holmes Smith: More Than an Educator," *Field of Vision* 6 (Pittsburgh, Spring 1979), pp. 2-7.

Hahn, Betty. "Henry Holmes Smith: Speaking with a Genuine Voice," *Image* 16, 4 (Dec. 1973), pp. 2-3.

Hill, Paul and Cooper, Thomas. *Dialogue with Photography*. New York: Farrar, Straus, Giroux, 1979, pp. 132-159 (interview with Smith).

Pitts, Terence, ed. *Henry Holmes Smith: Selected Critical Writings*. Tucson: Center for Creative Photography, University of Arizona, Oct. 1977 (issue 5).

Smith, Henry Holmes. Artist's statement for *Portfolio II: Refraction Prints by Henry Holmes Smith*. Louisville, Kentucky: Center for Photographic Studies, 1973.

Smith, Henry Holmes. "Across the Atlantic and Out of the Woods: Moholy-Nagy's Contribution to Photography in the United States," in *Photographs of Moholy-Nagy from the Collection of William Larson*, ed. by Leland D. Rice and David W. Steadman. Claremont, California: Pomona College, 1975, pp. 13-18.

Smith, Henry Holmes, "Image Process." Unpublished statement sent to Marilyn F. Symmes, Sept. 13, 1977.

Sommer
Long Beach, Art Museum and Galleries, California State University. "Frederick Sommer at Seventy-Five, a Retrospective," exh. cat. ed. by Constance W. Glenn and Jane K. Bledsoe, exh. organized by Leland D. Rice, Feb. 11-March 9, 1980.

Philadelphia, College of Art. *Frederick Sommer: An Exhibition of Photographs*, exh. cat. by Gerald Nordland, Nov. 1-30, 1968.

Sommer, Frederick. "Frederick Sommer: An Extemporaneous Talk at the Art Institute of Chicago, October 1970," *Aperture* 16, 2 (1971), pp. 18-25 (unpaginated).

Sommer, Frederick in collaboration with Stephen Aldrich. *The Poetic Logic of Art and Asthetics*. Stockton, New Jersey: the author, 1972.

Talbot
Arnold, H. J. P. *William Henry Fox Talbot, Pioneer of Photography and Man of Science*. London: Hutchinson Benhan, 1977.

Talbot, William Henry Fox. *Some Account of the Art of Photogenic Drawing* (Report to the Royal Society, London, Jan. 31, 1839). London: R. and J. E. Taylor, 1839 (also reprinted in Bib. II Newhall, pp. 60-78).

Veyrassat
(Veyrassat, J.-J.). See Beraldi, vol. 12 (1892), pp. 227-228.

Wacquez
(Wacquez, A.-A.) See Beraldi, vol. 12 (1892), p. 253.

Index of Artists*

Artists in catalogue and/or appendix

Photography Credits

Except in the instances listed below, photographs of works in the exhibition were provided by the lenders. Figure illustrations are credited in the caption accompanying each figure.

Baltimore Museum of Art
Appendix, Brendel no. 2, Veyrassat

Huguette Berès, Paris
Appendix, Desavary no. 1

Bibliothèque Nationale, Paris
Appendix, de Cock, Dutilleux nos. 1, 3, 5, 7-10, 12, Pastelot no. 2, Unknown no. 4

Trustees of the British Museum, London
Figure 2; Appendix, Cundall (Hook)

Photos Cauvin, Paris
Cat. nos. 1-5, 33, 51, 52, 55, 62, 63, 69, 77, 78; Appendix, Lainé, Unknown no. 1

Art Institute of Chicago
Appendix, Brendel no. 1

Detroit Institute of Arts
Cat. nos. 18, 49, 71, 73, 79-84, 90-99, 102-105, 111-120, 124, 132; Appendix, Castan nos. 1-5, Fontanesi nos. 14-19

Eleonore and Franck Dieleman, Paris
Cat. nos. 60, 61, 74; Appendix, Petitjean

Jean Dubout, Paris
Cat. nos. 26, 53, 54, 68; Appendix, Mallard, Robaut, Rops

Gernsheim Collection, The Humanities Research Center, University of Texas at Austin
Appendix, Ehninger (Leutze, Kensett, Darley, Gifford, Lambdin, Boughton, Ehninger)

Hans Peterson for Statens Museum for Kunst, Copenhagen
Appendix, Frölich, Kiaerskou, Schovelin

Philadelphia Museum of Art (Gift of Mr. and Mrs. Adrian Siegel)
Appendix, Guérin

Fred Pillonel, Geneva
Appendix, Borromeo, Fontanesi nos. 1-13

Smithsonian Institution, Washington, D.C.
Appendix, Ferris